The Color of Time

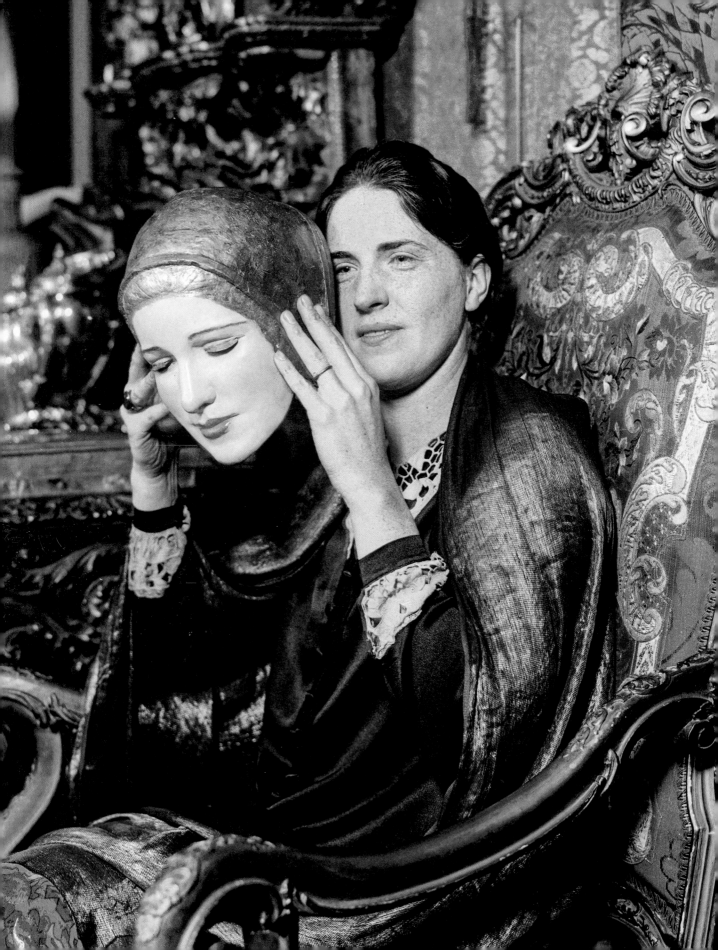

The Color of Time

Women in History:
1850–1960

DAN JONES and
MARINA AMARAL

PEGASUS BOOKS
NEW YORK LONDON

THE COLOR OF TIME: WOMEN IN HISTORY
1850–1960

Pegasus Books, Ltd.
148 West 37th Street, 13th Floor
New York, NY 10018

Designed by Isambard Thomas / CORVO

Color separation by DawkinsColour

First Pegasus Books hardcover edition September 2022

ISBN: 978-1-63936-285-1

10 9 8 7 6 5 4 3 2 1 0

Printed in the United States of America
Distributed by Simon & Schuster
www.pegasusbooks.com

Previous page
Romola Campfield, wife of painter, illustrator, designer
and maskmaker, W. T. Benda, 1926.

PICTURE CREDITS

All images are credited to Getty Images except:

Wikimedia Commons
p.18, p.23, p.78, pp.90–1, pp.92–3, pp.96–7, pp.102–3, p.128, p.166,
p.205, p.208, p.214, p.218, pp.220–1, p.238, p.287, p.320, p.333,
p.350, p.369, p.390, p.398, p.400, p.406.

Library of Congress
pp.56–7, p.61, p.62, pp.74–5, pp.82–3, p.180, pp.272–3, p.317,
pp.328–9, p.349.

Tasmanian Archives: NS1553/1/1798
pp.64–5

Wellcome Images
p.360

Alamy Stock Photo
p.69

The LIFE Picture Collection / Shutterstock
p.13, p.47, p.87, pp.116–7, p.125, p.144, pp.152–3, pp.186–7, p.222,
pp.224–5, p.277, pp.382–3, p.384, pp.426–7.

Embryo Project Encyclopedia
p.410

Scurlock Studio Records, Archives Center, National Museum of
American History, Smithsonian Institution
p.359

Introduction
7

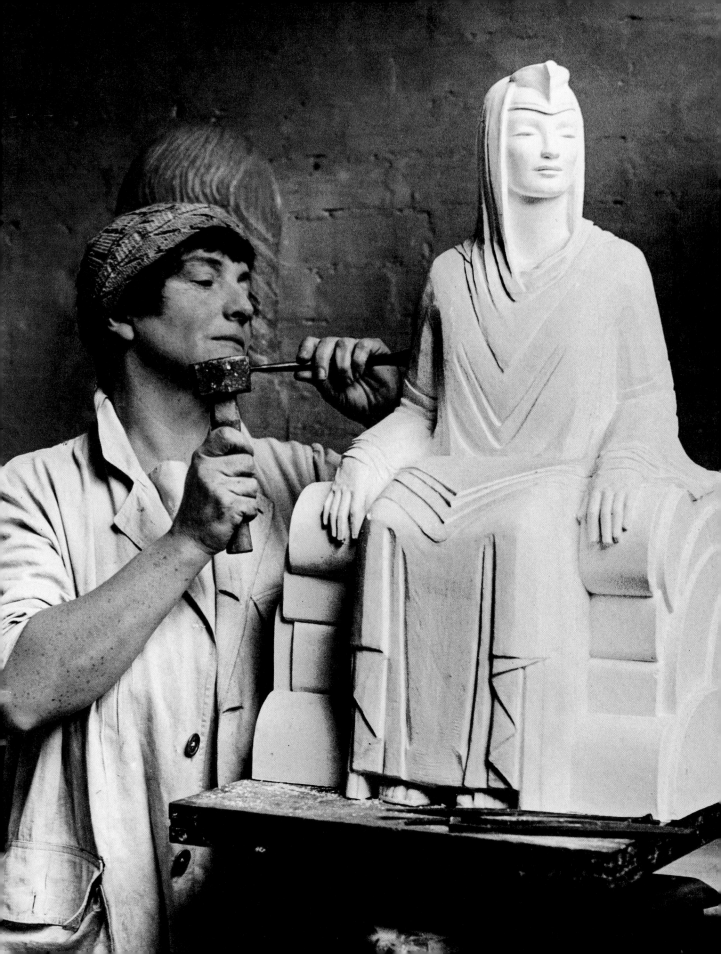

'For most of history, Anonymous was a woman.'
Virginia Woolf

In 2017–18, when we were working on our first book together, *The Colour of Time*, we found ourselves repeating what would, over the months, become a familiar lament. That book, like this one, was a world history told through digitally colourized photographs from the 'black-and-white' era – roughly speaking, 1850–1960.

Then, as now, the historical parameters we set ourselves were broad: we wanted our story to range far and wide, mingling the famous with the unfamiliar and the everyday with the extraordinary, using colourized photography, based on thorough historical research, to tell a big story about a changing world. Yet as we worked, we kept coming back to a single observation.

There aren't enough women in here.

That's not to say there were none. It would have been an old-fashioned history indeed, which told the story of the late nineteenth and early twentieth centuries without any reference to women's contribution to the world. And we felt we did what we could to bend the arc of our storytelling towards inclusion and representation. We were proud of *The Colour of Time*, and remain so today.

Yet at times during the production of that book – and again during our second, *The World Aflame* – it felt as though we were battling with history itself. No matter how much we willed the past – or, more precisely, the photographic archives – to offer us an equal balance of men and women through whom to tell our story, all too often we would find ourselves surrounded by dudes with bushy beards. The big beasts of history, in their top hats and military uniforms, with their famous names and glorious (or notorious) reputations.

There were just so many of them. And sometimes it felt that all we could do was shrug and say to ourselves: well, that's history for you. It's a man's world.

Except, of course, it's not. The historian blaming her or his sources is no better than the workman blaming their tools. History makes us. But we also make it. And although it is true that for most of human civilization, patriarchy has underpinned most forms of social and political organization, that, today, is no excuse for laziness.

That is why we decided that in this, our third book, we would set ourselves a challenge.

No dudes.
No beards.
No men allowed.

What you hold in your hands today is the result. This book recounts a history of humanity between 1850 and 1960, told through women's pictures, lives and experiences. It is designed to serve as a tribute, a tableau, and, in its way, an example. It is a both a conventional history – arranged chronologically and thematically, with an eye for events and important individuals – and a radical one.

This book is created to show that we can frame our histories just as we frame our photographs: focusing on the things we think are important or arresting or terrifying or beautiful, and cutting out what does not, in the moment we press the shutter, capture our interest.

Sculptor Phoebe Stabler completes her latest work, *The Onlooker*, c.1926.

There are many ways historians can frame this particular age of history. There are many ways to tell an infinitely fascinating story.

This is *A Woman's World*.

Between the middle of the nineteenth century and the middle of the twentieth, the world changed almost beyond all recognition.

Telegraph cables, ocean liners, roads and railway lines connected people across vast distances at previously unimaginable speeds. People flew, first in hot air balloons and zeppelins, then in bi-planes and fighter jets, and finally at the speed of sound and into space. European imperial powers laid claim to the lands, labour and resources of other nations and exploited them for all they could, before two World Wars redrew the map of the globe, to reflect the pre-eminence of nuclear-armed superpowers.

Technology brought about a revolution in entertainment: film and television made actors and performers into national and international celebrities. Writers and artists found ever-larger audiences. Sports were codified, organized as mass spectator events and eventually televised.

Meanwhile, scientists began to unravel some of the most fundamental mysteries of the universe, with mindboggling advances in genetics, nuclear physics and computing, as well as in mundane but essential fields like food production and preservation.

In all of these fields and more, women were involved in critical ways.

Women's and men's history are not independent, but they are distinct. Female and male experiences are profoundly shaped and defined by social norms, gendered 'rules', and religious or even 'scientific' beliefs. Yet it is hardly bold to say that historical writing has both absorbed and reflected a view of the past that revolves chiefly around men.

A traditional history of the First World War would typically focus on powerful tanks, bloody battlefields and the stories of men who sacrificed everything they had to fight for their country. But if we look more closely at the Western Front of that war, we will find Marie Curie – the world's leading chemist and physicist – together with her 17-year-old daughter, Irène, driving and operating mobile X-ray machines that saved the lives of thousands of wounded soldiers.

Step back to the Crimean War in the 1850s and we will find the British nurse and social reformer Florence Nightingale transforming field hospitals by emphasizing sanitation, and not only alleviating generalized misery but cutting death rates among the wounded by two-thirds.

Step forward to the 1950s and we will meet Rosalind Franklin – who sits alongside Curie as one of the most important scientists of the twentieth century. Franklin, a research associate at King's College London, headed the team that took what has been dubbed 'the most important photo ever taken', which revealed the double helix structure of DNA. Her work was of world-changing importance, yet she was cited only briefly at the end of the *Nature* paper published by scientists Francis Crick and James Watson in 1953 as having merely 'stimulated' them. Crick and Watson were awarded a Nobel prize and were eventually recognized as the actual 'discoverers', although they later admitted

their formulation 'would have been most unlikely, if not impossible', without Franklin's work.

There are similar stories in almost every field we might care to examine.

The most famous aviator before the Moon landings of 1966 was Amelia Earhart, whose disappearance during a voyage across the Pacific in 1937 still fascinates people today. The greatest monarchs of the age included Queen Victoria, Taytu Betul and Empress Dowager Cixi. The greatest athlete was Mildred 'Babe' Didrikson Zaharias. The greatest actor was Sarah Bernhardt. Rosa Parks sat at the forefront of the civil rights movement, while Eleanor Roosevelt codified human rights in a model for the whole world to follow. Only Elvis Presley could challenge Marilyn Monroe for the name of the most famous celebrity of this time. No story of achievement despite physical disability is so well-known or inspirational than that of Helen Keller.

Of course, we have given much space in this book to women who fought for equality, freedom and opportunity during an age where, across the world, women's rights were curtailed and suppressed. That story is told most explicitly in Chapter 2 (Women in School) and Chapter 7 (Women in the Streets). But it is implicit everywhere else, too. The bare truth is that almost every woman we have featured in this book had to do more than a man would have done in her position to achieve the same result. It would be repetitious to point that out on every page, but it would be foolish and historically ignorant to forget it.

One of the most dangerous assumptions about progress is that its path leads inevitably and irreversibly towards the light. This is not true, and never has been. As we finished work on this book, the US Supreme Court was preparing to strike down *Roe v. Wade*, the landmark 1973 ruling that decided the US Constitution protected an American woman's freedom to choose an abortion. If nothing else, this moment should have reminded us all that progress is never guaranteed. Rights and freedoms can be given and they can be taken away. History is never over.

All that being said, while this book is strongly concerned with women's rights, it is *not* primarily an essay on social justice or injustice. The women we have chosen here feature because their stories are interesting and (in the majority of cases) admirable. It is a celebration of their existence and a platform to highlight their stories.

We give you this compilation in the spirit that we first imagined it: as a bright and colourful journey through a great historical age, in the company of some of the most brilliant people who lived in it.

Welcome to *A Woman's World*.

Marina Amaral & Dan Jones
Spring 2022

Women
at Play

Historically, female athletes have not only been in competition with one another. They have also had to contend with the dominance of men's professional sport, which has traditionally offered participants more prize money, public attention and prestige. Certain sports have been deemed unsuitable for women, while in others women have been allowed to take part but denied the chance to make a comfortable living. Mildred Burke, pictured here in a photograph taken by *Life* magazine's Myron Davis in 1943, was a prime example of this. Throughout her long career she was the finest wrestler in the world, competing in thousands of matches over more than two decades. Yet after she retired she had to sell her jewellery to pay the rent.

In professional wrestling, many matches are choreographed as much as they are contested, and results are often fixed beforehand. That can lead detractors to scorn its status as a sport. However, the athleticism of wrestlers is very real. Burke was muscular and strong. She wanted to win every match on merit. And whenever she was involved in a 'shoot' match – one where no winner was decided beforehand – she showed what she could really do.

Burke fell into wrestling in 1932 when, aged 17, she saw a wrestling match in Kansas City and fantasized about being in the ring. She was encouraged to follow her dream by Billy Wolfe, a promoter, former wrestler and huckster. By the time she was 19, Wolfe was her husband and manager. Since women's wrestling was outlawed in most US states, Wolfe took Burke on the carnival circuit, offering a prize of $25 to any man who could beat her – or go ten minutes without being pinned.

Burke recorded about 200 wins and only one loss, a fluke knock-out from a flying knee.

By 1936, Burke was fighting, and winning, legal matches and Wolfe arranged a shot at the world title. In January 1937, she won the women's world championship from Clara Mortenson. A rematch the following month went, (as pre-arranged), to Mortenson. For the deciding third match, in April, Burke refused to stay on script and the match became a shoot, which Burke won. She remained world champion for the next 17 years.

In 1944, Burke defended her world title in Mexico City in front of 12,000 fans. Four years later, she came sixth in an Associated Press poll for female athlete of the year. At the height of her fame, she was earning as much as a top male baseball player. However, Wolfe siphoned most of her money for himself. He also physically abused her. He and Burke divorced in 1952.

In 1954, having been ostracized from organized women's wrestling by Wolfe, Burke started the World Women's Wrestling Association. She wrestled for the final time in 1956, after which she became a promoter, manager and trainer of female wrestlers at her gym in Encino, California, also known as Mildred Burke's School for Lady Wrestlers. She died in February 1989, a legend of her game. Like the athletes, golfers, cyclists, gymnasts, boxers, dancers and daredevils featured in this chapter, she had changed her sport for good.

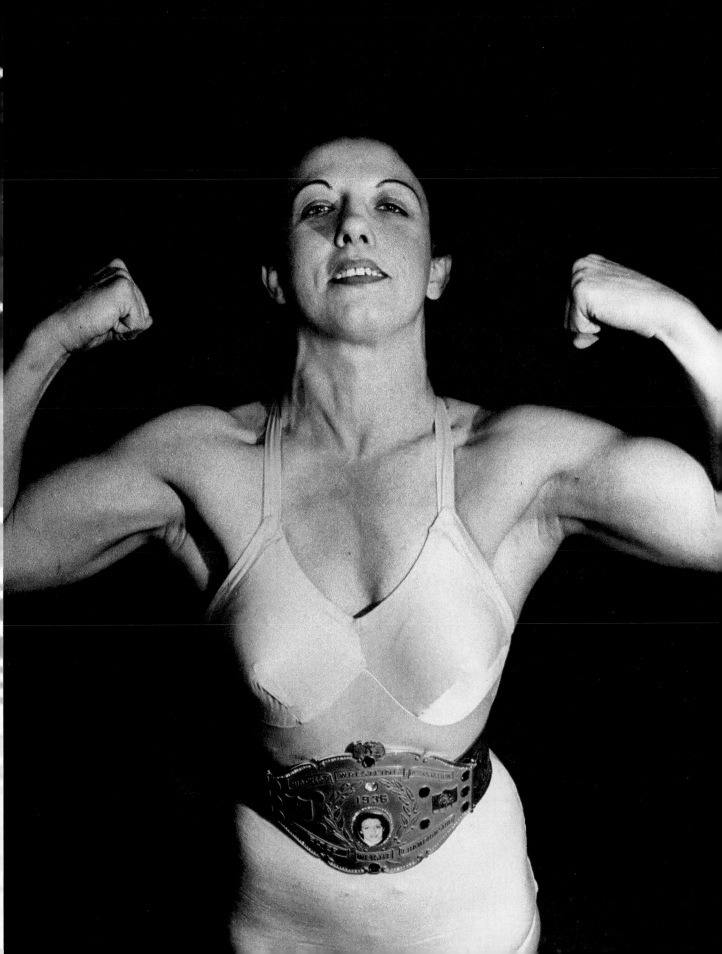

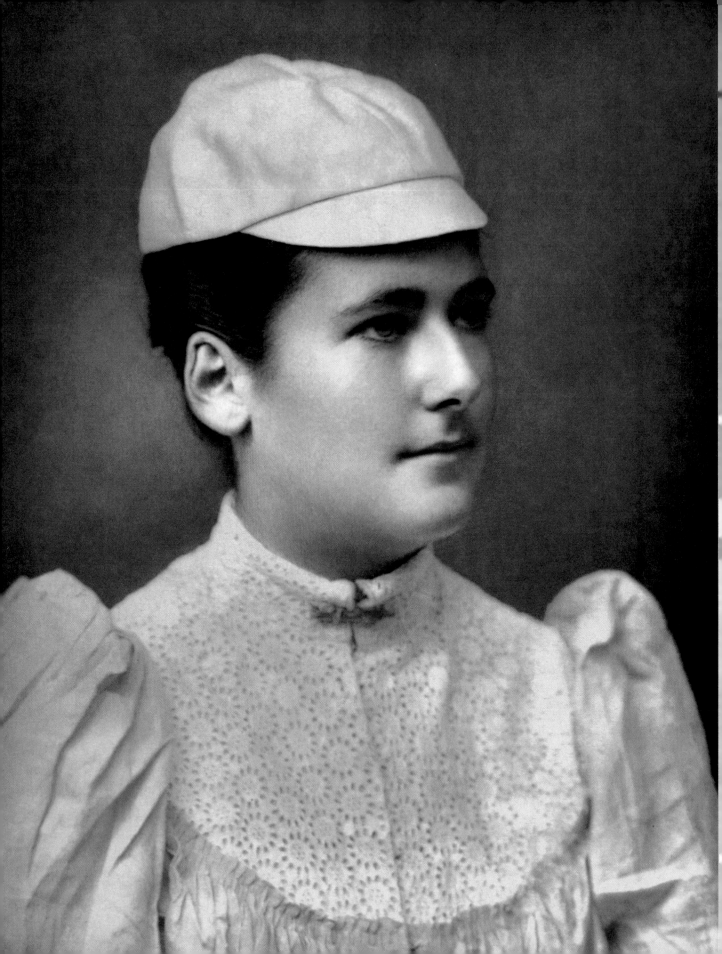

Lottie Dod

In the first week of July 1887, at the All England Lawn Tennis Club in Wimbledon, south-west London, a teenager nicknamed 'Little Wonder' won the Ladies' Singles title in handsome fashion. Charlotte 'Lottie' Dod was only 15, but she swept through the small field, defeating the defending champion, Blanche Bingley, in straight sets in the final, dropping only two games in the process.

This was not a complete shock – Dod had been winning tennis titles around Britain and Ireland since she was 13. But as Wimbledon's youngest champion, she set a record that has never been bettered. She also launched a spectacular sporting career. During the next two decades, Dod won four more Wimbledon titles. She also won the Ladies' Amateur Golf Championship in 1904, played hockey for England, climbed some of the highest mountains in the Alps, tried figure skating, tobogganed the Cresta Run, cycled around northern Italy and won an Olympic silver medal at archery in 1908.

Dod, pictured here around the age of 20, came from a wealthy, well-educated and prodigiously gifted sporting family; her brother William was also an Olympic archer, while other siblings excelled at billiards and chess. She once put her success at tennis down to her competitors' lack of drive – most women, she said 'are too lazy at tennis'. In truth, Dod's own determination and versatility was almost superhuman. In the history of sport, only Babe Zaharias (see page 37) ever performed at such a high level, across so many sports, for so long.

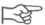

Teeing Off

In 1908, four years after Lottie Dod won the Ladies' Amateur Golf Championship, the competition was held on the world's most prestigious course: the 'Old Course' at St Andrew's, Scotland. This photograph, taken at the first tee, shows a large crowd watching Dorothy Campbell, 25, drive her first shot of a round.

Golf was already a game with a long pedigree. The first secure historical record of female players comes from the eighteenth century, although women were probably striding down fairways as long ago as medieval times. However, the ladies' championship was only founded in 1893, so when this photograph was taken, it was a relative novelty.

Campbell, however, was on her way to golfing stardom. She had been playing since she was a toddler, and won her first Scottish Ladies' title on her home course at Berwick in 1905. In 1908 she finished second at St Andrew's (the title was won by Maud Titterton), but she won the competition the following year, and again in 1911. Campbell also won elite tournaments in the US and Canada; her last major title came in 1924, when she was 41. She credited several of her finest wins to a lucky club nicknamed 'Thomas'.

Despite the dazzling success of players like Campbell, golf has never been entirely receptive to female players. This photograph shows the famous backdrop to the Old Course's first tee: the Royal & Ancient Clubhouse. Women were only permitted to join R&A and enter this clubhouse in 2014.

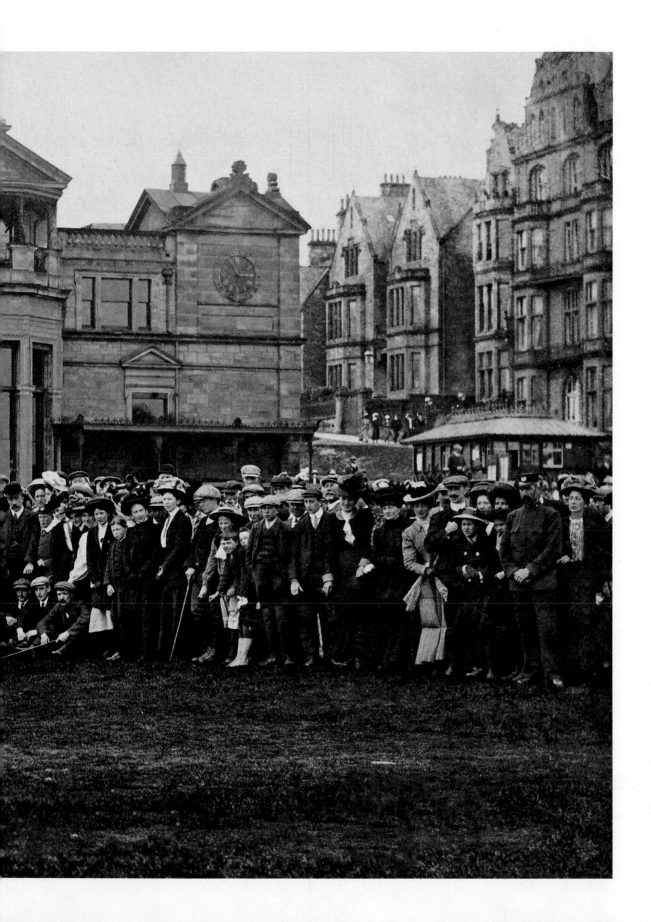

'Tillie rides a Thistle'

Like golf and tennis, cycling produced outstanding female champions around the turn of the twentieth century. Bicycles became wildly popular in the Victorian era, with formal road races held from the 1860s. In the 1890s, race organizers in the US built fast, steeply banked tracks around which competitors would fly at speeds in excess of 25mph, in contests featuring six consecutive days of racing. One of the most famous and successful cyclists this brave new sporting world produced was the woman pictured here: Tillie Anderson.

Anderson was born in Sweden and moved to Chicago in 1891, where she worked as a seamstress. When she started cycling and racing a few years later, she made an immediate impact. Travelling from city to city, she won more than 100 races and thousands of dollars in prize money before she retired in 1902. Anderson's bike of choice was a model known as a Thistle – on which she is photographed here. One newspaper writer who saw her racing a bicycle like this on the track said Anderson 'flashed around the turns like an unchained meteor'.

For many women in this era, bicycles and cycling were a symbol of freedom and emancipation. While Anderson was winning races, in 1894–5 Annie Cohen Kopchovsky, aka 'Annie Londonderry', became the first woman to cycle all the way around the globe. The civil rights leader Susan B. Anthony once said bicycles had 'done more to emancipate women than any one thing in the world'.

☞

New Olympians

The modern Olympics were first organized in Athens in 1896, with no women competing. However, the 1900 Games in Paris featured female contests in sailing, equestrianism, golf, tennis and croquet. At subsequent Games, a few more women's disciplines were added, including archery and figure skating. By the time of the 1912 Stockholm Games – the last before the outbreak of the First World War – women could take part in swimming and diving, although events like athletics, rowing, shooting and cycling were still restricted to men.

One grey area, however, was gymnastics. This photograph was taken at the Stockholm Olympic Stadium at around midday on Monday 8 July 1912 and shows a display of gymnastics by a team of Norwegian women. Although the official report of the Games recorded that their routine was 'beautiful as a whole', there were no medals at stake for the 22 female gymnasts on the team. They were simply performing – along with teams from Denmark, Sweden, Norway, Finland and Hungary – as part of a programme of entertainment to amuse spectators.

For most of the early years of the modern Olympics, only a handful of women took part in full competitions at each Games. At Stockholm 1912, nearly 2,500 athletes, representing 28 nations, competed for honours. Just 48 of them were female. It was 1928 before women were allowed to compete for medals in gymnastics – the same year that women's athletics was also added to the roster.

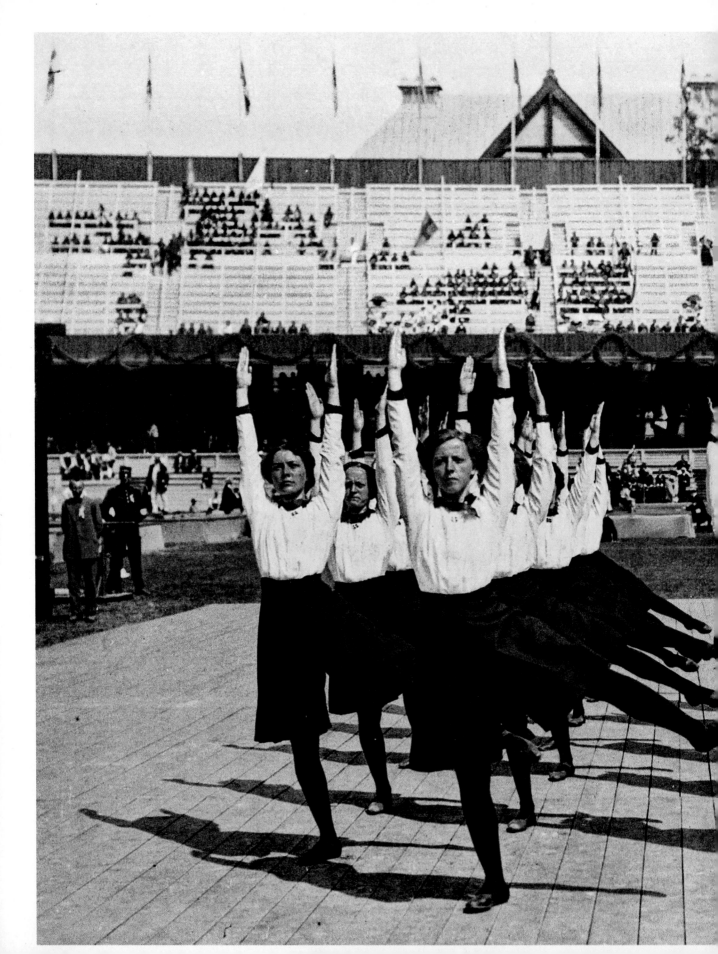

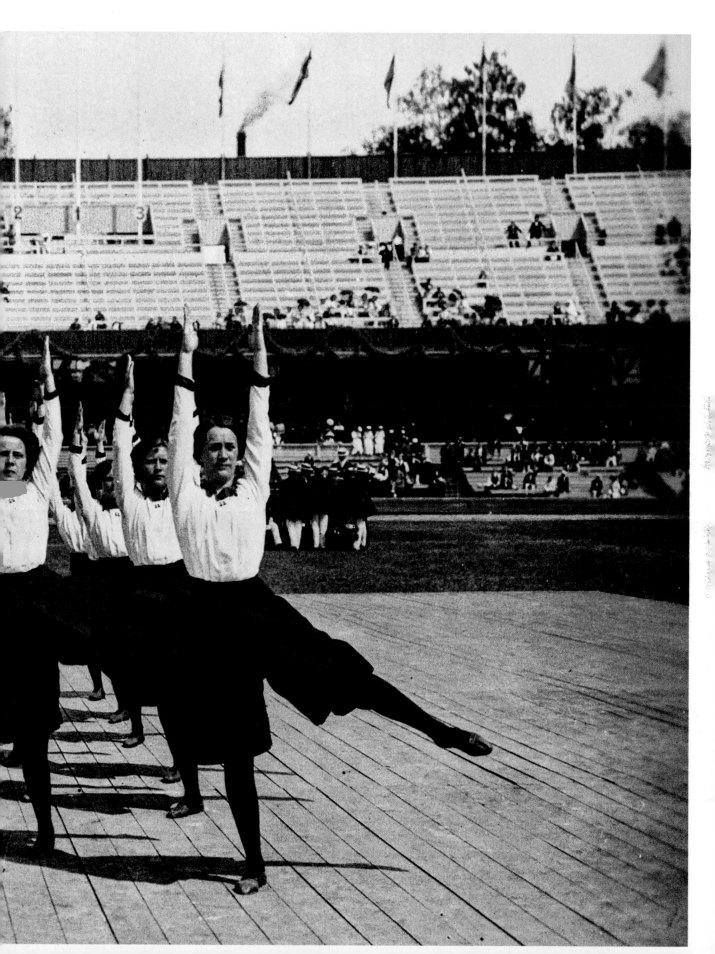

'The Mascot'

Competing in sports in the early twentieth century was possible for women, even if it was not equal. Owning a sports franchise was different. But that changed in 1911, when the owner of the National League Baseball team the St Louis Cardinals died, leaving his controlling stake to his niece, Helene Robison Britton. A baseball fan, Britton decided she would run the Cardinals herself, despite jeers from journalists, who thought a wife and mother had no place in charge of a men's sporting outfit.

The problems that faced Britton (photographed here in December 1911) were those familiar to team owners throughout the modern age: fluctuating results, unhappy players and the pressure to improve facilities at the Cardinals' ground, Robison Park. Britton found these exacerbated by deep-rooted sexism. She fired Cardinals' manager Roger Bresnahan after he informed her that 'no woman can tell me how to run a ball game'. She also removed her husband, Schuyler Britton, as club president, when the couple divorced acrimoniously in 1917.

Britton – nicknamed 'The Mascot' by fans – controlled the Cardinals for seven years. During that time, she resisted pressure from other franchise owners to sell up, and tried to attract more women to baseball, sometimes allowing female fans into Robison Park for free. She finally sold in 1918, on her own terms and for a lot of money – $350,000 – although later in life she lamented her decision. Today, there are scarcely any more female team owners than in her time.

Annie Newton

At the 1904 Olympic Games, women's boxing featured as a demonstration sport. This was not outrageous: it had a long history dating back to the seventeenth century and nothing barred women from taking part. While no female boxer in the early twentieth century had a profile to match that of the first official world heavyweight champion Jack Dempsey, the ring was a place women could earn recognition and money – if they were tough and skilful enough.

Annie Newton, pictured here in the mid-1920s when she was around 30, was certainly tough and skilful. A North London girl, she was taught to box by her uncle, 'Professor' Andrew Newton, one of Britain's finest trainers. Annie was known on the London music-hall scene as a member of the Professor's performing troupe 'the Newton Midgets'. She also took part in exhibitions where she fought men over three rounds and showed off her punching power and dexterity.

In 1926, however, a plan for Newton to fight another well-regarded London boxer, Madge Baker, gained enough public attention to cause a flurry of moral panic, led by priggish social reformers and the tabloid press. The *Daily Express* called for women's boxing to be banned by law. Britain's home secretary declined to legislate but agreed the planned Newton-Baker bout was an 'outrage'. So the fight was called off – much to Newton's irritation. Not every woman was fit enough to box, she said. 'But neither are some men.'

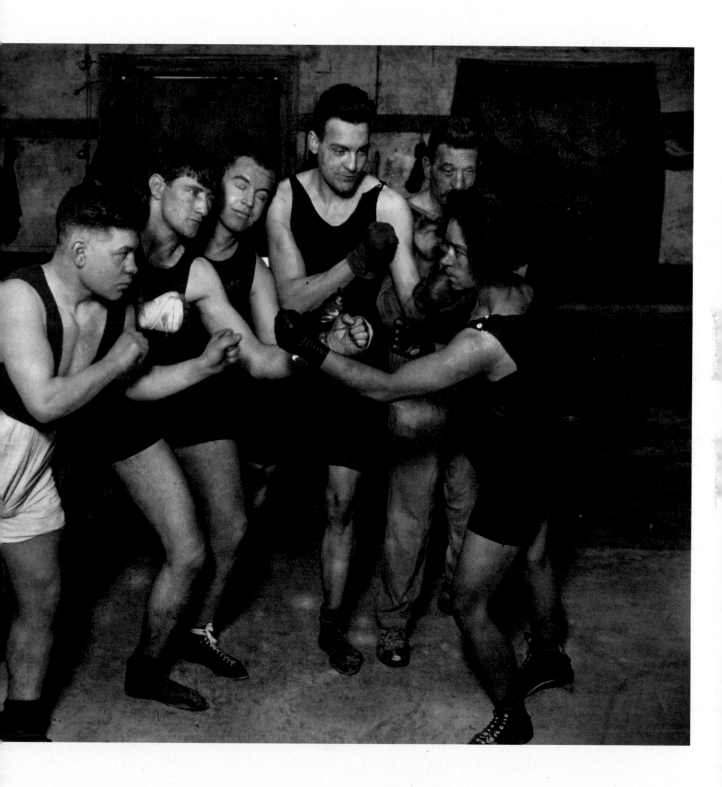

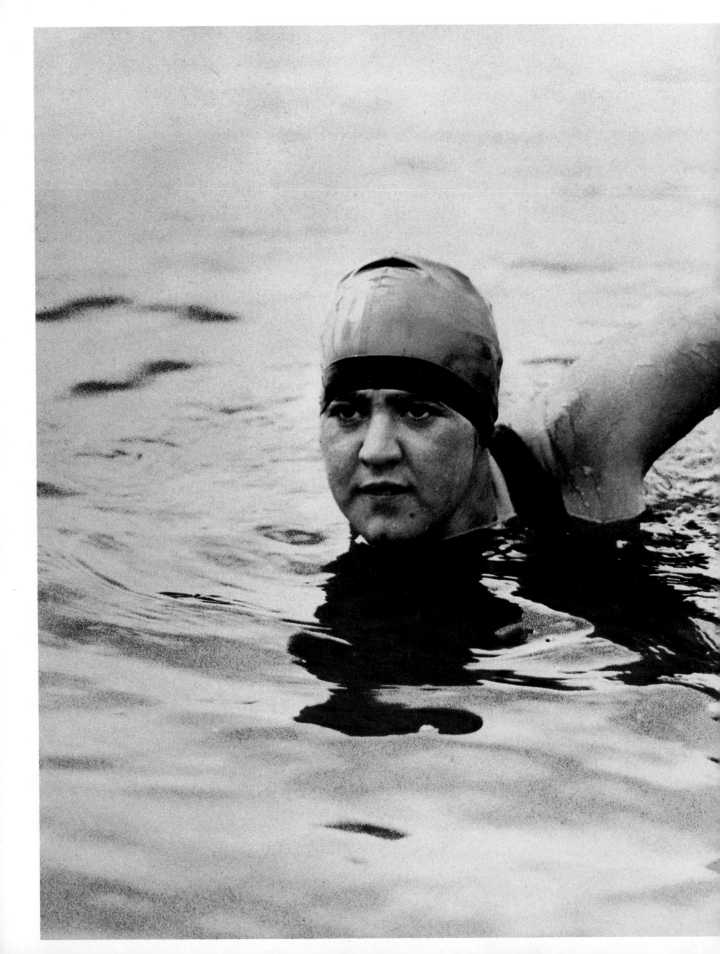

'Queen of the Waves'

In the 1920s, women's swimming enjoyed a golden age, led by American swimmers such as Gertrude Ederle, pictured here during a training session in 1926. When this photograph was taken, Ederle was already a world-record holder and multiple Olympic champion, having won a gold and two bronze medals at the 1924 Paris Games. Since then, she had set her sights on an even greater challenge: becoming the first woman to swim the English Channel.

After a failed attempt in 1925 – stymied when her trainer pulled her out midway through the attempt – Ederle set off from the French coast on 6 August 1926. She was followed by tugboats carrying reporters from American newspapers that were paying for the rights to her story; the press nicknamed her 'Queen of the Waves'. She swam front crawl (then a recently developed stroke), wearing motorbike goggles sealed with paraffin to keep out the salt water.

After a fast swim in deteriorating sea conditions, Ederle walked out of the sea in Kent a little over 14 and a half hours later. This was the fastest crossing then recorded by nearly two hours, as well as the first by a woman. She was just 20 years old.

Arriving home in the US, Ederle was greeted as a celebrity, with a ticker-tape parade and a meeting with President Calvin Coolidge. She made a guest appearance in a silent movie about her Channel crossing, and in 1965 she was inducted into the International Swimming Hall of Fame.

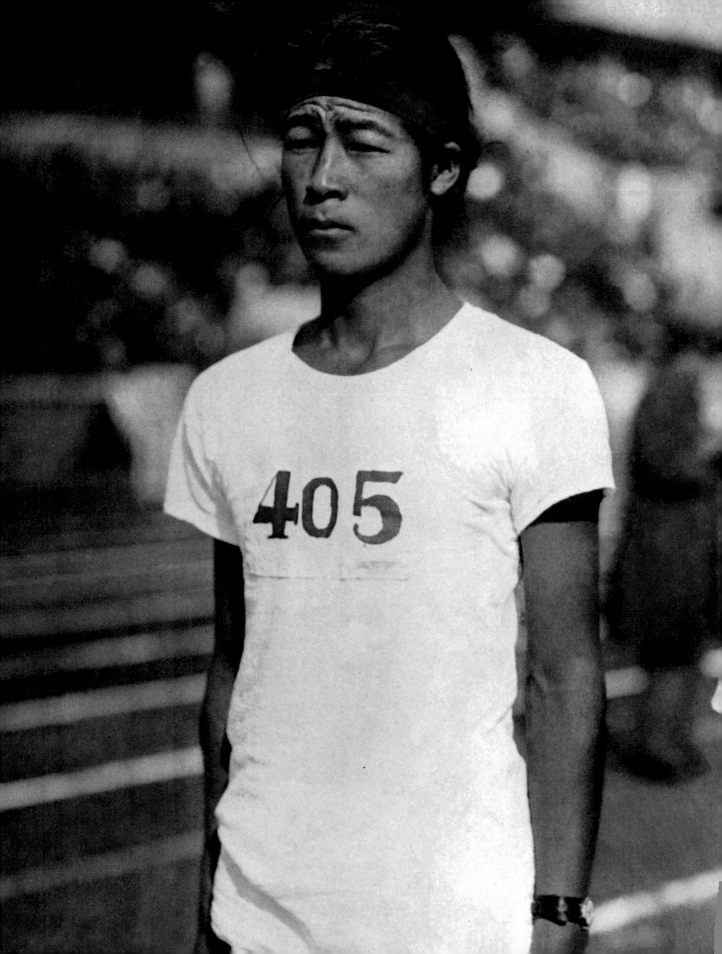

Kinue Hitomi

In 1867, Japan emerged from a long period of isolation under the Tokugawa shogunate. Participation in international sports events like the Olympic Games was part of the process of re-entering the global fray. And one of Japan's most successful early Olympians was Kinue Hitomi, pictured here around 1925, when she was in her late teens.

Hitomi was a track and field athlete who set Japanese and world records at long jump, triple jump, shot put, 100m, 200m and 400m. After starring in several international sports meets, including the 1926 Women's World Games, she was selected for the Japanese Olympic team at the 1928 Amsterdam Games – the first to include women's track and field events in the programme. No woman had ever represented Japan at the Olympics before.

Hitomi had a strange Games. She was knocked out of the 100m in the semi-finals and failed to make a mark in the high jump or discus. But she won a silver medal in the 800m – an event she had never raced before. Two years later she starred again at the Women's World Games in Prague, taking medals in the long jump, javelin and 60m.

Despite her success, which inspired many other Japanese women to take up athletics, Hitomi had to endure media sniping about her appearance and weight. Critics suggested her athletic build was too 'Western'. Although she ignored the barbs, in 1931 her health failed. Hitomi died of pneumonia in hospital. She was just 24 years old.

☞

The 'Vera Menchik Club'

The first Women's World Chess Championship was held in London in the summer of 1927. Its star was Vera Menchik, a 21-year-old English-Czechoslovakian woman who was born in Moscow but had settled in Hastings, in Kent. At this time, Menchik had only been playing chess for four years. But she was a natural, and she would go on to become one of the most formidable chess players of her generation.

In this picture, taken at a Christmas tournament in Hastings in 1937, Menchik is playing Sir George Thomas, who had tied for first place in the same event two years previously. Menchik was particularly adept at showing up those who doubted her talent. When she entered a mixed tournament in 1929 one participating chess master suggested that anyone who lost to her could consider themselves a member of the 'Vera Menchik Club'. He lost to her.

Having won her first world title in 1927, Menchik defended it five times, playing at a level far beyond any other woman in the field. She was world champion for 17 unbroken years, a record that still stands. She was still the reigning champion in 1944 when her house in South London was hit by a German doodlebug during the Second World War, killing Menchik, her mother and her sister. Today, the trophy awarded to the winning women's team in the international Chess Olympiad is called the Vera Menchik Cup.

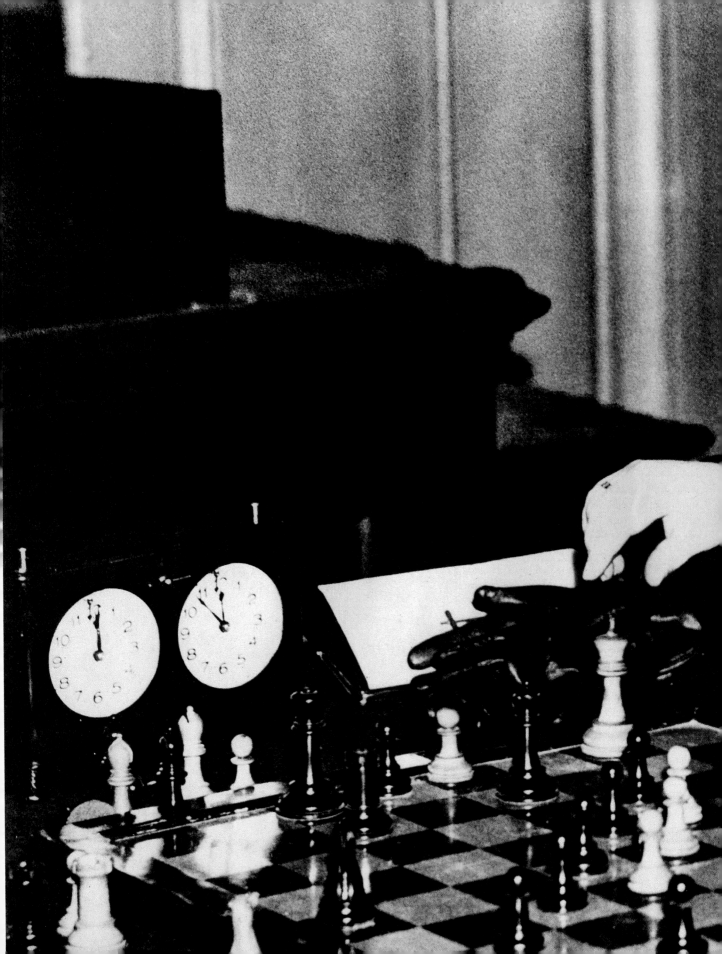

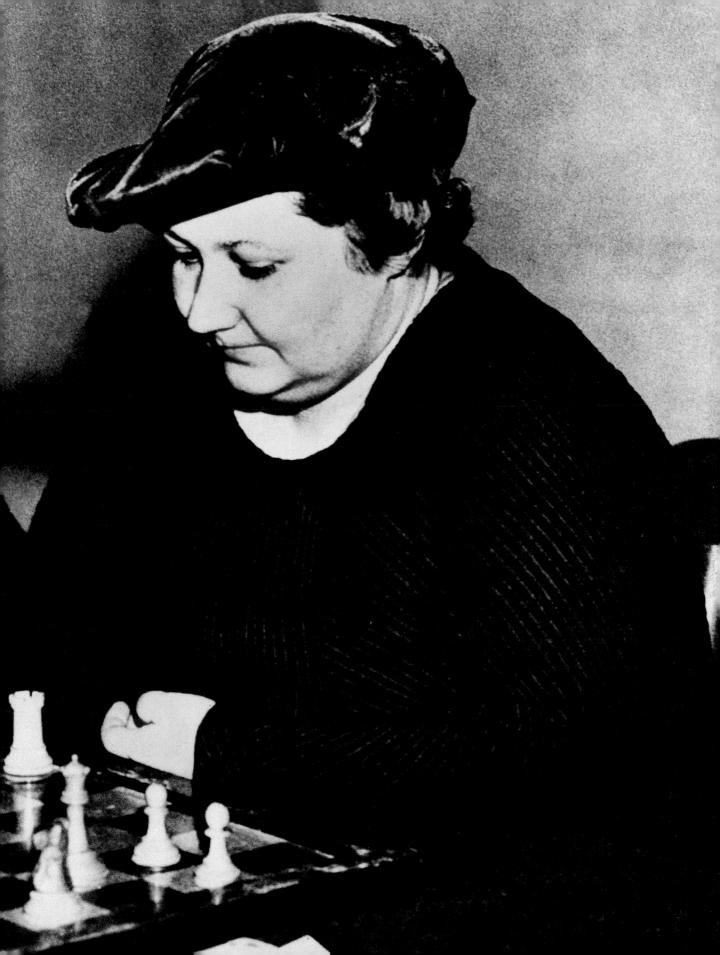

Hitler's Fencer

In 1936, the German fencer Helene Mayer was one of the most skilful athletes in the world. She was also in a terrible moral quandary. As the daughter of a Jewish father and a Christian mother, she was defined as part-Jewish by Hitler's Nazi regime: her civil rights heavily circumscribed and her life at risk. She was selected for the German team at the 1936 Berlin Olympics, yet she was there as a 'token Jew', to cover for persecutions already being committed by the Nazi regime and see off threats of an American boycott of the Games. Despite having been one of the most famous sportswomen in Germany before the Nazis' rise to power, newspapers were forbidden to print her name or cover her career.

Mayer fenced beautifully at the Games – as she had eight years earlier at the Amsterdam Games, when she won the gold medal. But she was defeated in the final, and when she took her position in second place on the podium, she gave the obligatory Nazi salute – an action that would dog her for the rest of her days.

This photograph of Mayer was taken in 1936 by the pioneering American photographer Imogen Cunningham. And it was in America that Mayer settled once the Second World War broke out. She returned to Germany shortly before her death at the age of 42 in 1953, but did not speak publicly about her experiences in Berlin – the morality of which still animates historians today.

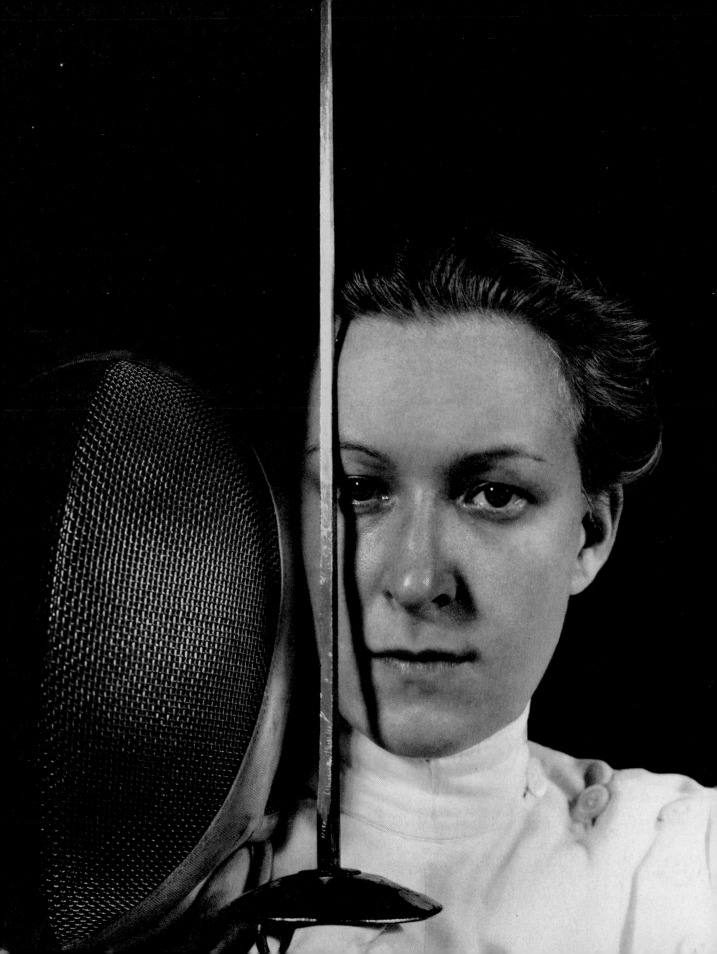

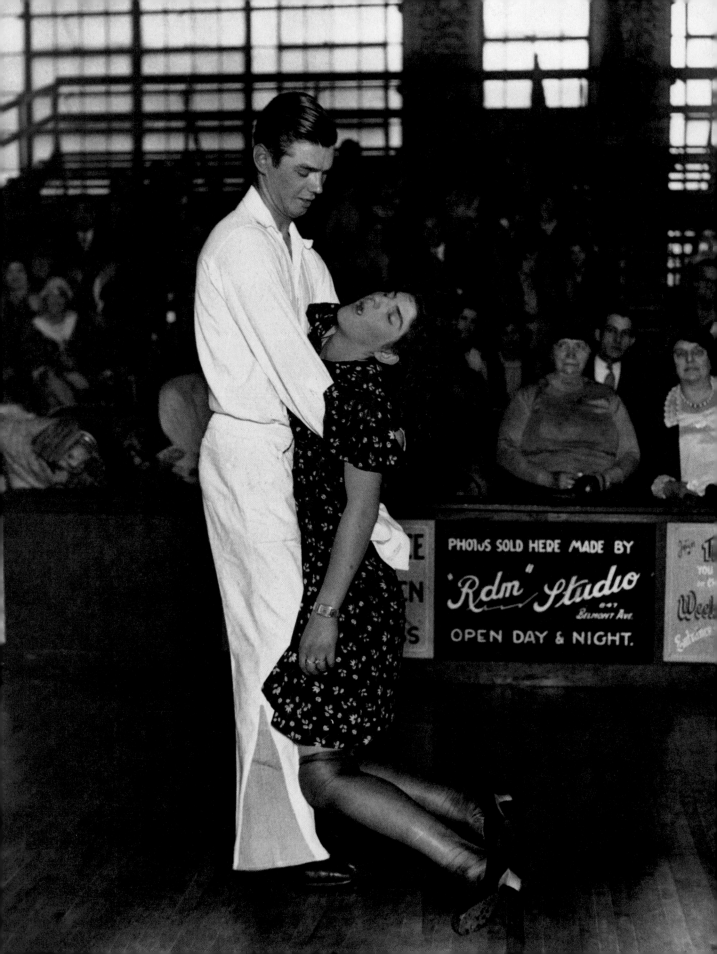

Dance Until You Drop

In 1935, during the Great Depression, the American author Horace McCoy published a dark existential novel, *They Shoot Horses, Don't They?*, in which much of the action was set at a gruelling dance marathon in California. This type of event was a well-known phenomenon at the time, as this picture, taken in Chicago in 1931, illustrates.

Dance marathons were usually organized as open competitions, which couples entered in the hope of winning a cash prize. Paying spectators watched as the entrants danced for hours on end, taking only short breaks and often sleeping at the venue, clocking up hundreds of hours on the dance floor across the course of several weeks until only one couple remained on their feet.

The dancers pictured here are Marie Micholowsky and her brother Frank. Marie appears to have passed out due to the exertion of the contest – although since the advertisement visible by her feet is for a souvenir photo-postcard company near Chicago's waterfront, it is possible that the picture was staged. Besides monetary gain (and the free food provided to entrants), dance marathons attracted contestants who thought they might become famous if they performed well.

However, the toll these competitions took on entrants was real. In McCoy's novel, various of the dancers lose their minds. This was no flight of fancy. Dance marathoners often collapsed and occasionally even died on the dance floor. Unsurprisingly, religious organizations, social reformers and city governments often took a dim view of the craze.

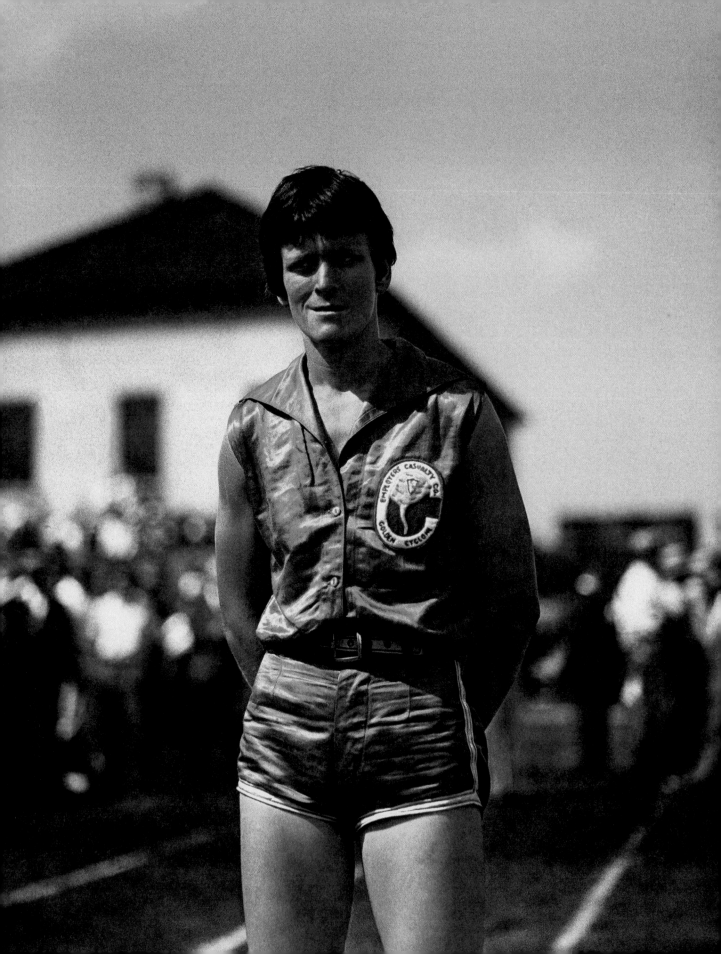

'Babe' Didrikson Zaharias

Texas-born Mildred Ella Didrikson was around 20 when this photograph was taken, and had already earned her nickname 'Babe', supposedly thanks to her childhood prowess at baseball; her friends likened her to the legendary Babe Ruth. Now, she was at the peak of her athletic talent. She was employed by an insurance organization, Employers Casualty Company, and starred for their amateur basketball team, the Golden Cyclones.

'Babe' was a good basketball player, but a supremely gifted athlete. Representing her company's team (here, she is wearing their liveried uniform), she went to the 1932 Amateur Athletics Union Championships and won the team contest despite being the only member of her team. Qualifying for the 1932 Olympics, she won gold in javelin and hurdles and silver in high jump, and set four world records. Had she been allowed to enter more events, she would almost certainly have taken even more medals.

After the Olympics she took up golf, learning from scratch, practising for ten hours a day until her hands bled, and beginning a glittering career that eventually returned 17 major championship titles, dozens of amateur titles and a husband – wrestler George Zaharias, with whom she was paired at a tournament in 1938. She was one of the greatest golfers in history, winning tournaments even as she struggled with the cancer that would eventually kill her. As a teenager, she said she wanted to be 'the greatest athlete who ever lived'. She gave it a very good shot.

'The Flying Housewife'

The Second World War forced a 12-year hiatus in the Olympics, but when the sporting calendar began its return to normality, at the London Games in 1948, Dutch athlete Fanny Blankers-Koen was the star. She entered four of the nine women's events (the maximum allowed under competition rules) and took gold in each, winning the 100m, 200m, 4x100m relay and 80m hurdles, a race she is leading in this picture, and which she won on a photo-finish.

Among the nicknames given to Blankers-Koen in 1948 was 'the flying housewife', a reference to the fact that she was 30 years old and married to the Dutch coach Jan Blankers, with whom she had two children (she was in fact pregnant with her third during the Games). This was unusual for the time, and Blankers-Koen had received hate mail in the Netherlands for competing rather than staying home with her children. Yet she showed the world conclusively that marriage and motherhood had no bearing on athletic brilliance. By the end of the Games, it was said that she was as well known to spectators as King George VI of England himself.

In addition to her Olympic titles, Blankers-Koen won European gold medals in 1946 and 1950, and for nearly eight years held simultaneous world records in the 80m hurdles, 100m, high jump and long jump. In 1999 she was voted by the International Athletics Federation as the greatest female athlete of the twentieth century.

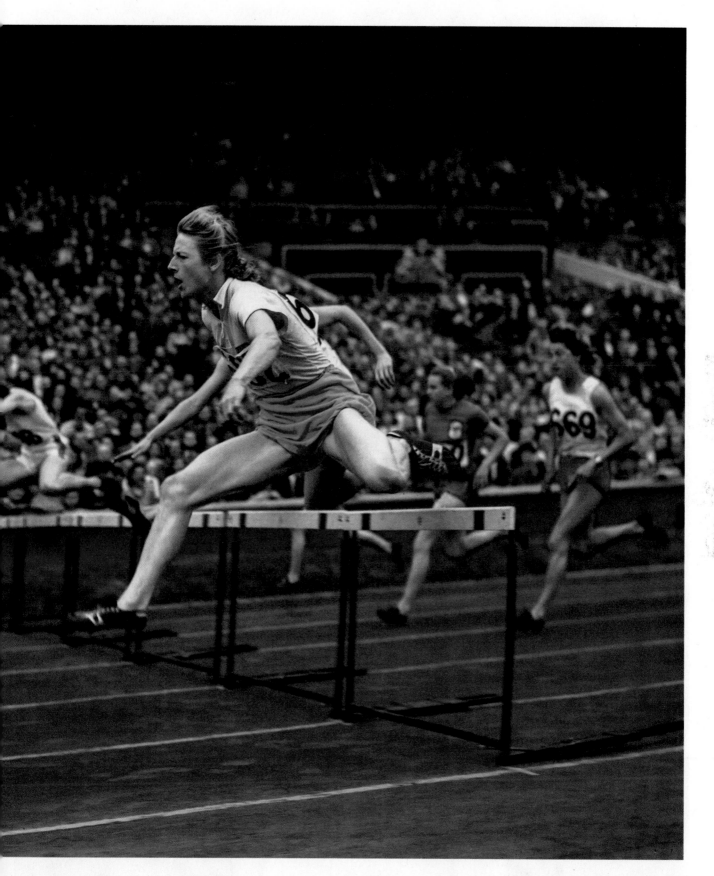

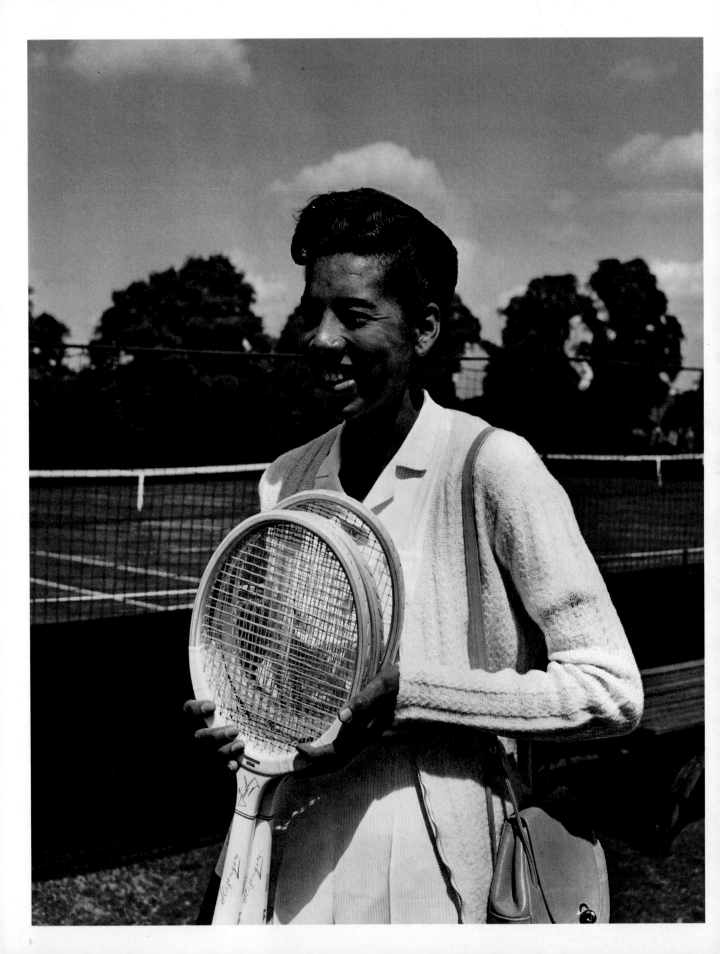

Althea Gibson

The 23-year-old American tennis player Althea Gibson posed for this photograph while participating in a tournament at Beckenham, Kent, in 1951. The image appeared in *Picture Post* magazine, in a feature entitled 'The Different Gibson Girl'. A Gibson Girl was once a slang term for a 'classical' American beauty – fair-skinned, swan-necked, willowy, slightly fragile and fussily dressed. Althea Gibson could not have been more different – and her rise towards sporting stardom suggested that times were changing.

That same summer, Gibson played at Wimbledon. She was one of the first Black women ever to do so, and although she was knocked out in the third round, she had begun a career that would break both racial barriers and sporting records. Five years after her Wimbledon debut she reached her sporting peak, and in three glittering seasons between 1956 and 1958 she won eleven Grand Slam titles: the Wimbledon singles tournament twice and doubles three times, along with trophies in the French, US and Australian Championships. She then retired and took up a career in professional golf, with occasional forays into music and acting.

For any sportsperson, these would have been stellar accomplishments. For a Black woman in the 1950s, during a time of widespread racial prejudice and segregation, particularly in the US, it was nothing short of triumphant. Not until 1999 would another Black woman win Wimbledon: Serena Williams, who later said that Gibson 'paved the way for all women of color in sport'.

Sara Christian

Motor racing in the mid-twentieth century was not an easy sport for a woman to break into. But in 1949 the newly formed NASCAR company launched a series of stock-car races, held at tracks in the eastern US. At its inaugural meet, held at the Charlotte Speedway in North Carolina, the pool of 33 drivers included three women. One of them was Sara Christian, photographed here behind the wheel of her husband Frank's Ford.

Stock-car racing was an exciting spectacle, whose origins were said to lie in America's Prohibition Era, when alcohol bootleggers modified their cars to outrun police. By the time Christian was racing, it had developed its sporting essentials: drivers tore around an oval-shaped track for 200 laps in cars that were driven *without* mechanical enhancements. It was therefore supposed to be a strict measure of a driver's ability. Christian showed she had plenty of that.

Although she did not finish the first race – her team pulled her out when another driver's car overheated – in the second meet of the season, Christian crossed the line eighteenth. Later in the season she recorded sixth and fifth places, and at the end of the year, she was declared the USA Drivers Association Woman Driver of the Year. After this she barely raced again, but she had made her mark on a sport that still attracts millions of ardent fans every year.

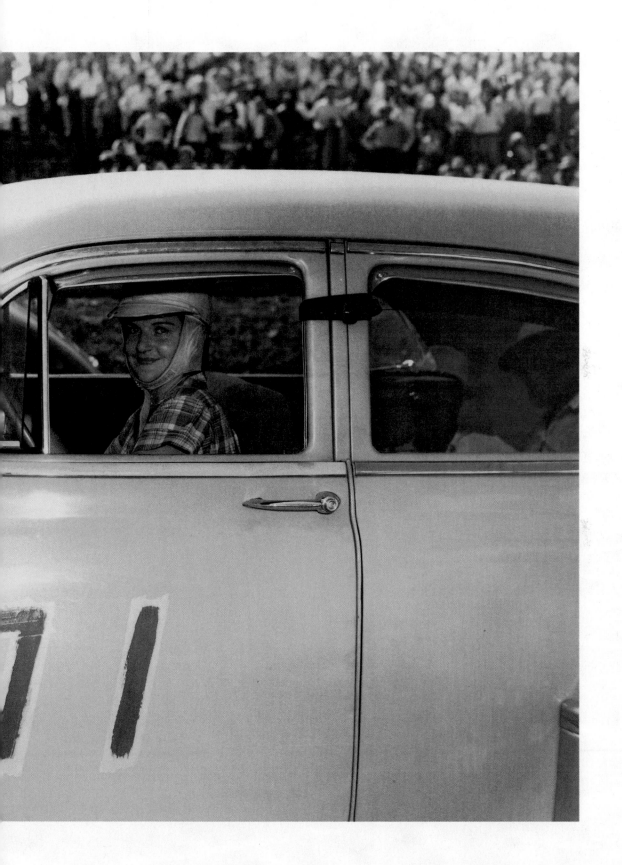

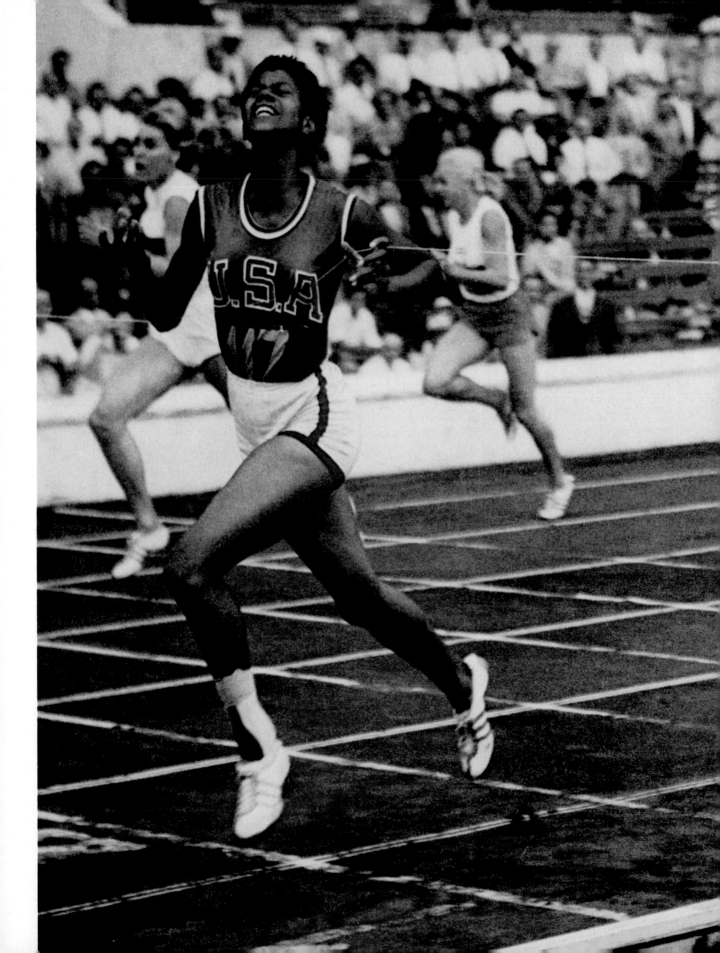

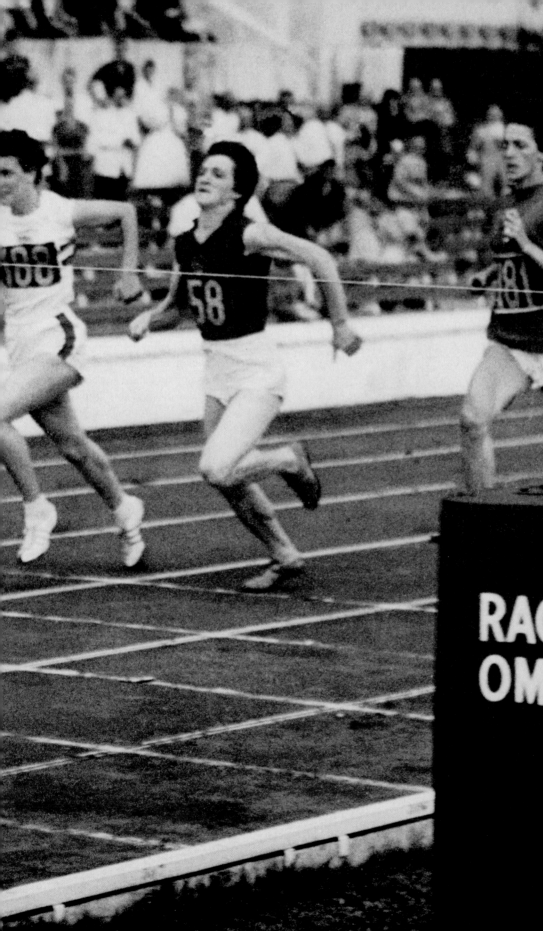

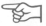

'The Tornado'

In childhood, Wilma Rudolph was an unlikely candidate for the role of fastest woman in the world: a bout of scarlet fever weakened her left leg so badly she walked with a brace until about the age of 12. However, by high school she had been fully rehabilitated, and began to shine at basketball and track athletics. Aged just 16, she qualified for the 1956 Olympic Games and won a bronze medal on the 4x100m relay team.

Four years later, at the 1960 Olympics in Rome, Rudolph was back. Still a college student, albeit at Tennessee State, which produced a glut of superb female athletes, she was the star of the Games. In stifling heat, Rudolph won gold in the 100m, 200m and 4x100m – the first American ever to do so. One of her many media nicknames was 'the Tornado'. But like a tornado, she was not around for long. In 1962 Rudolph retired from athletics, as Olympic champion and world record holder in all three distances. Of her last race, she said, 'That was it, I knew it… time to retire, with a sweet taste.'

Both during her sporting career and in her retirement, Rudolph used her fame to advocate for civil rights, particularly racial integration in her home state of Tennessee. Like Muhammad Ali, the boxer whom she briefly dated, Rudolph grasped that sporting celebrity was a powerful vehicle for giving voice to social protest. This lesson has not been lost on sports stars today.

Nurse Pilates

'Contrology' was not a competitive sport. But an athletic system invented in the early twentieth century garnered millions of eager participants. Its founding father and most famous teacher were Joseph and Clara Pilates, photographed here at their studio in Hell's Kitchen, New York City, in 1951. (Clara is standing, leftmost of the group pictured.)

Clara, a nurse, met Joseph on a transatlantic ocean liner in 1926 when they were emigrating separately from Germany to the United States. By this stage, Joseph had developed most of the principles of his 'contrology', drawing on aspects of gymnastics, martial arts, bodybuilding, wrestling, yoga and anatomical biology. Clara was persuaded of its benefits and, after arriving in New York, the two married. Together they founded the studio, known as the Joseph H. Pilates Universal Gymnasium, and began teaching the new method to the city's beautiful and well-heeled inhabitants.

Early adopters of the Pilates system included musicians, ballet dancers and entertainers, including the actress Lauren Bacall. The figure being worked over in the foreground of this photograph is the singer Roberta Peters, a famous soprano who had recently made her debut with New York's Metropolitan Opera, and would go on to sing with the company for 35 years. She already had formidable core strength – during her training with the couple that day she was able to balance Joseph Pilates on her stomach by clenching her powerful abs.

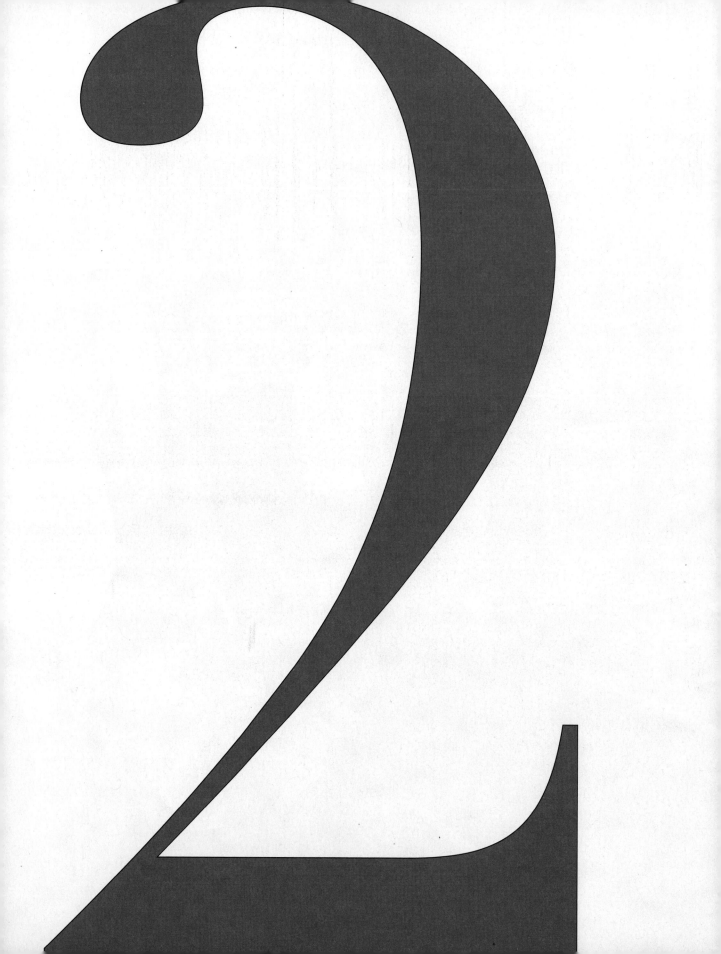

Women
in School

'The greatest woman since Joan of Arc.' Thus was Helen Keller – a blind and deaf woman who learned to read, write and communicate with others – described by her friend Mark Twain. Keller was, Twain thought, 'the eighth wonder of the world', a titan to compare with such historical greats as Julius Caesar and Napoleon. She, for her part, appreciated Twain's enlightened regard for her brilliance as well as the challenges of her condition. He treated her 'not as a freak', she once wrote, but as a disabled person 'seeking a way to circumvent extraordinary difficulties'.

The two had met when Keller was 14, in 1895, and Twain had watched, and occasionally helped, as his young friend graduated from school and went to study at Radcliffe College – the female equivalent of all-male Harvard – in Cambridge, Massachusetts. This was a great accomplishment for any young woman at the turn of the twentieth century. But for someone who could neither see nor hear, nor read in a conventional manner, it was all the more amazing.

Keller was 19 months old when an illness – perhaps scarlet fever – took her sight and hearing from her. As a young child she was angry and frustrated. But when she was six, in 1887, an institute for the blind found her a governess, Anne Sullivan, a 20-year-old who was also partially sighted. Sullivan, whom Keller always called 'Teacher', used innovative teaching methods to help Keller learn a manual alphabet. Within three months, Keller could spell words. Aged 11, she could speak.

Sullivan was thereafter Keller's constant companion, all the way through school and Radcliffe, where she spelled out lectures. Keller graduated with honours in English and German in 1904, from when this picture dates. By then, she was already a household name in America, and had published her first autobiography, *The Story of My Life*, which explained to the general public that disabled people could be educated. Some commentators said she was a fraud, their theory mostly pegged on an instance of plagiarism found in a short story Keller wrote when she was ten.

From there, her fame grew. Her life was dramatized for theatre, film and television, and recorded in documentaries and her own words in a dozen books; she even played herself in a biopic (*Deliverance*, 1919) released before she was 40. She was a tireless disability rights advocate. She was also a socialist, a pacifist and a feminist, positions that made her unpopular at the time of the First World War. From 1920 to 1923, Keller and Sullivan toured with a popular vaudeville show, in which Keller told jokes. Sullivan died in 1936; Keller had two further companions before her death, aged 87, in 1968. By then, the Oscar-winning film *The Miracle Worker* (1962) had replanted her story in the cultural mainstream.

In a 1913 speech to a sociology conference in Massachusetts, Keller said, 'I have the advantage of a mind trained to think, and that is the difference between myself and most people, not my blindness and their sight.' She was one of relatively few women to have graduated from higher education at that time. But she was not entirely alone. As the company she keeps in the following pages will show, Keller lived through an age in which many women yearned – and at times fought – for the right to learn. These students, teachers, college principals and academics blazed a trail for generations of women who went to school after them to follow.

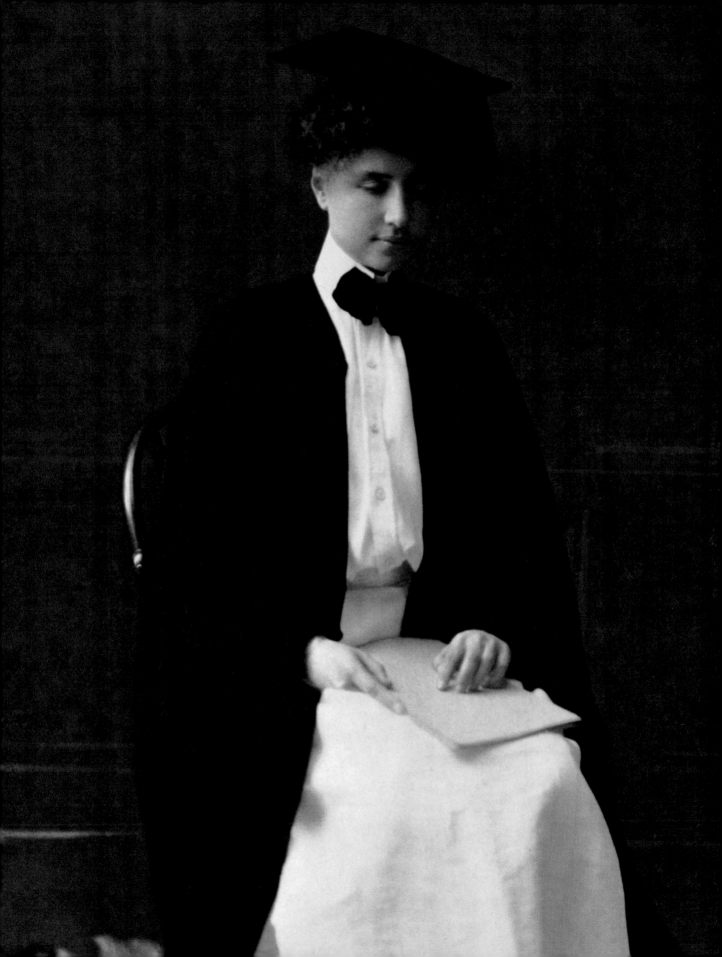

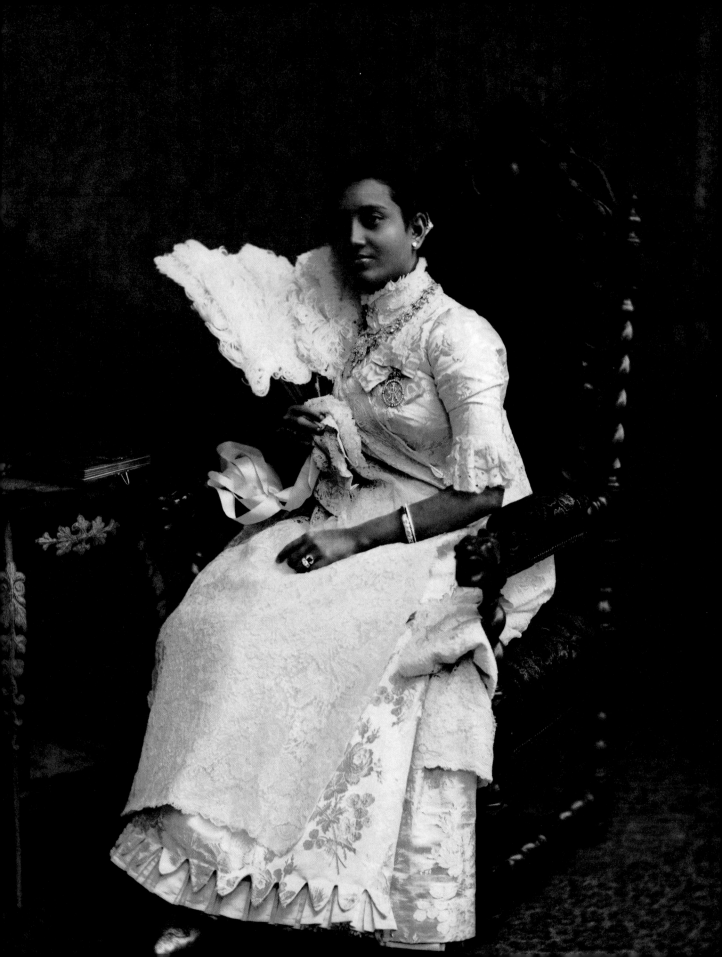

Sunity Devee

Married at 13 to a maharajah and mother of seven children, Sunity Devee, the Maharani of Cooch Behar, was a champion of education for girls and of women's rights in India. Her father was a reformer who established schools, including the first Indian 'normal school', for teacher training. In her autobiography, Devee wrote: 'My father fought for female education… some of my earliest recollections are connected with the female education movement.'

Born in 1864, one of ten children, she went to school from a young age, which was unusual for Indian girls at the time. In 1881, a girls' high school, Suniti College, was established in her home town of Cooch Behar, about 300 miles north of Kolkata, in her name and with her guiding hand and her family's financial backing. This photograph of her is dated circa 1885; two years later she became the first Indian woman to be awarded a CIE (Companion of the Most Eminent Order of the Indian Empire), given her by Queen Victoria.

Devee and her sister Sucharu Devee, also a maharani, funded the Maharani Girls' High School, founded in Darjeeling in 1908. In 1932, she was a co-founder and president of the All Bengal Women's Union, an organization founded to counter the rise in trafficking of women and children. When she died a few months later, in November 1932, Sucharu was elected to succeed her.

Agnes Maitland

In 1889 Agnes Maitland, aged 39, was appointed principal of the women-only Somerville Hall at Oxford University. Somerville had been founded ten years previously, and although the handful of women who stayed there were permitted to study at Oxford, they could not take a degree and were barred from attending lectures at many other colleges.

Maitland shook all this up. When she arrived at Somerville, she was already a well-respected schools examiner and education inspector and the author of several cookery books. She also had a driving passion for improving the standing of women in higher education – and Somerville was an excellent place to put her ideas into action.

This photograph of Maitland at her desk was taken in 1895, the year after Somerville became a college – the first of the women's halls of residence at Oxford to evolve in this way. To match its new status, Maitland had a huge library built, to get around the fact that women were not permitted to work at the university's world-famous Bodleian. She more than doubled the student population of the college, from 35 women to 86. She established the first research fellowship and laid the groundwork for female students to become eligible to receive the full Oxford BA degree.

Although genuine equality for women at Oxford only arrived generations after Maitland's death in 1906, she was one of the most important figures along the way.

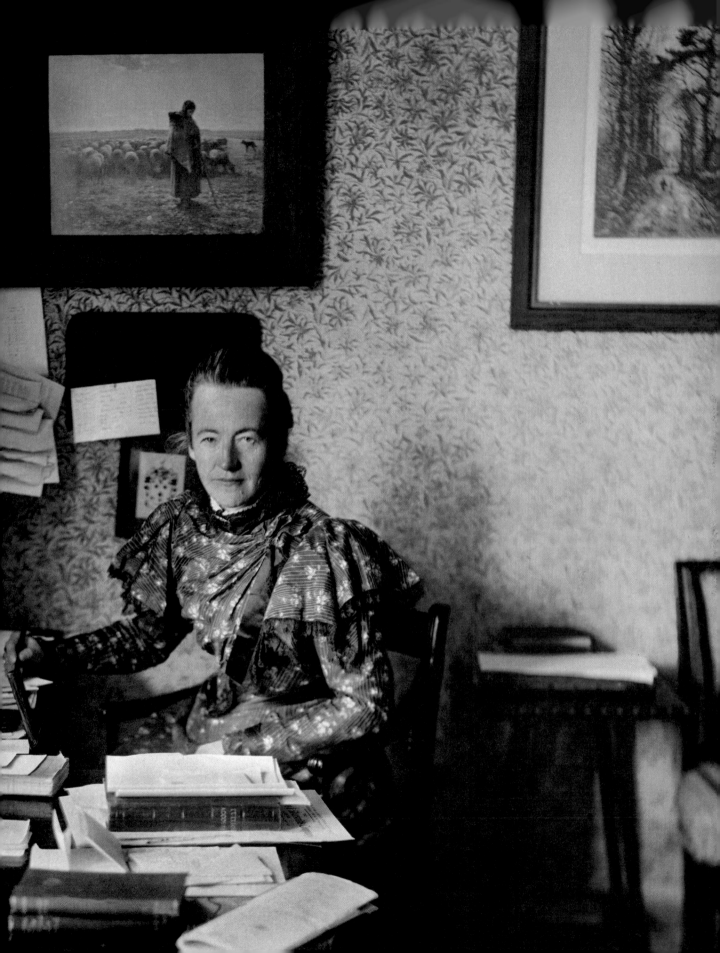

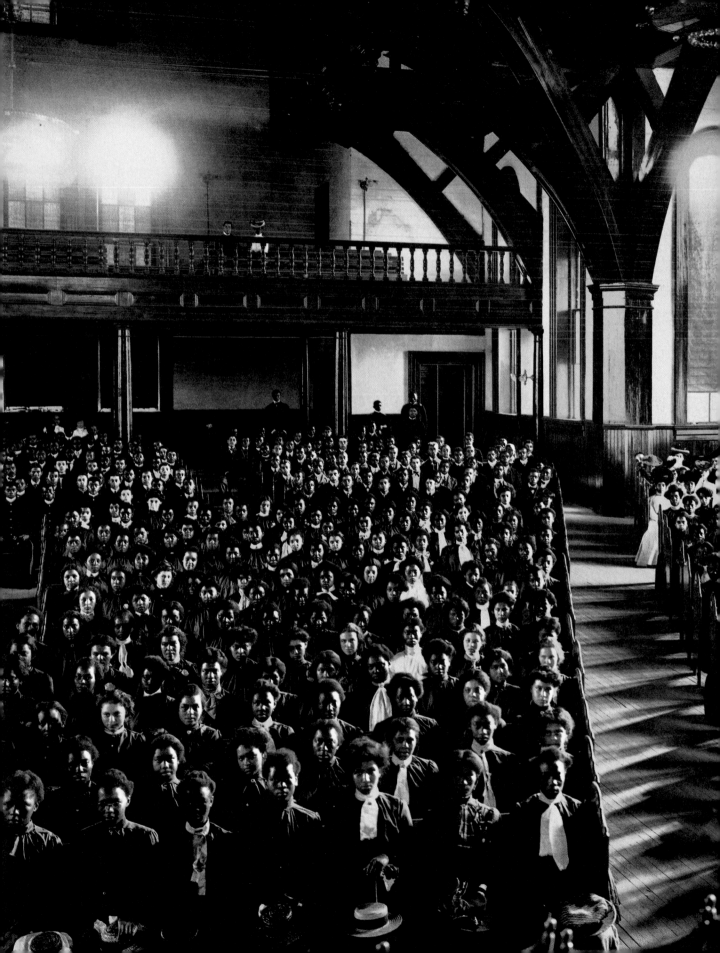

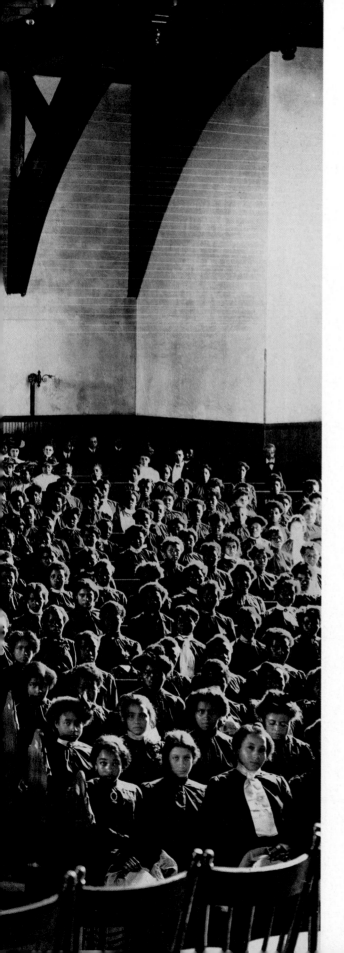

Tuskegee Institute

This extraordinary photograph, showing a sea of women's faces beneath the vaulted roof of the chapel at the Tuskegee Institute in Alabama, was taken in 1902 by the pioneering photographer Frances Benjamin Johnston. It was part of a documentary series of pictures that Johnston was commissioned to take by the institute's principal, Booker T. Washington, the famed educator who was one of the most important Black leaders in America at the turn of the twentieth century.

The Tuskegee Institute was founded in 1881 as a school for Black teachers, and its first buildings were a church and a shanty. But Washington soon purchased several large tracts of land, and students helped construct the campus buildings as part of their studies. Washington's third wife, Margaret Murray, became the school's 'lady principal' and focused on the vocational and domestic education of Black women.

Both Murray and her husband were criticized for their belief in slow, incremental change instead of the direct action and anti-white protests of their fellow campaigners for racial equality. The institute taught Black people practical life skills as well as academic subjects, believing it more important for them to first be self-supporting on an individual and community level, and then to support the fight against discrimination and racism. 'Above all,' said Margaret Murray Washington in an 1898 speech, 'let those of us who have had an opportunity, who have educational advantages… stoop down now and then and lift up others.'

'No place for you maids'

This picture was taken on 21 May 1897 outside Senate House, the eighteenth-century building in the centre of Cambridge that is traditionally where the university senate meets, and where students go at the end of their studies to graduate. The crowd of 20,000 people who gathered there were protesting against women receiving degrees. And the day was significant: a vote was underway to decide whether the university would agree to reverse a policy, then nearly 700 years old, of denying women the chance to graduate.

The banner, to the left of the female figure dangling on a rope, reads: 'Get you to Girton, Beatrice. Get you to Newnham. Here's no place for you maids – Much Ado About Nothing.' Girton and Newnham were the first female-only colleges at Cambridge, both barely 20 years old.

In the days leading up to the vote, letters on the matter printed in *The Times* were mostly Against. If the vote carried For, read one, 'the glorious career of this University as a producer of great men will receive a most serious check'. Another pointed out the special train put on from London that would get potential voters to Cambridge in time to submit their ballot. The motion to award degrees to women was defeated, 1,707 votes to 661. It would be another half-century before, in 1948, Cambridge finally recognized women as full members of the university, eligible to receive the same degrees as men.

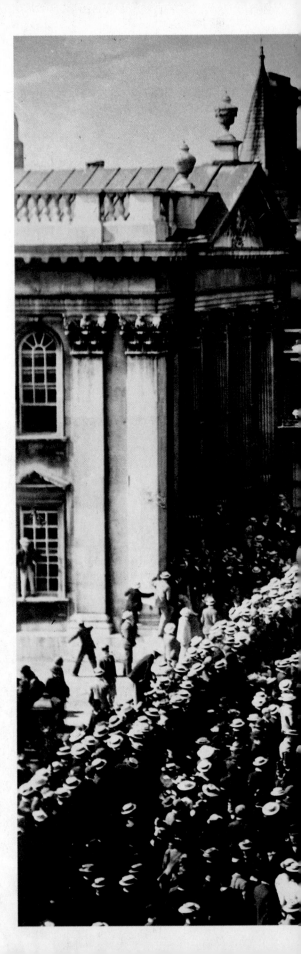

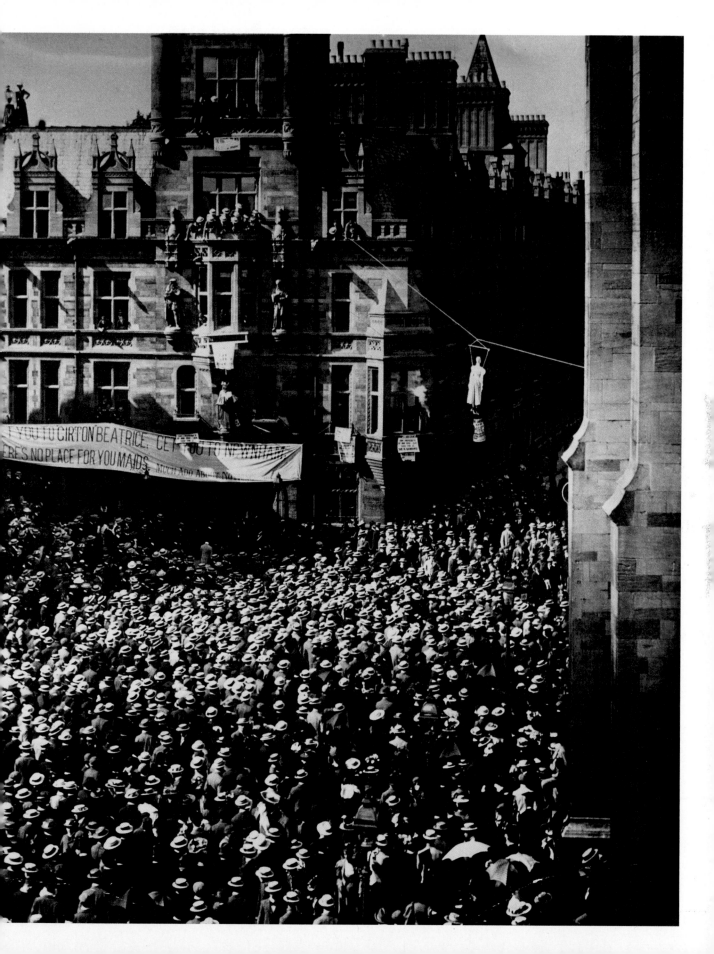

Dr Hü

When she graduated from medical school, Dr Hü King Eng was among very few officially qualified female doctors anywhere in the world. This was all the more remarkable given that when she arrived in the US to study, aged 19, she spoke no English and was only the second ethnic Chinese woman ever to attend an American university.

Hü was born in 1865 in Fuzhou, in Fujian province on China's south-eastern coast, to Methodist parents, who sent her first to boarding school and then to train at the city's hospital for women and children. There, an American missionary and physician spotted her potential and wrote to Hü's father to recommend she study in the US, which the Methodist Episcopal Church agreed to fund. In 1884, she arrived in New York and spent the summer in Philadelphia learning English. After studying medicine in Ohio and Philadelphia for the better part of the next decade, she qualified as a doctor in 1894.

After a year working as a surgeon's assistant, Hü returned to Fuzhou in 1895 to work in the women and children's hospital; a year later she was running it and in 1899 she was made a resident at the Woolston Memorial Hospital in Fuzhou. There she oversaw an increase in annual case numbers from 2,000 patients in her first year to 24,000 in 1910, and also trained students. After performing a double cataract operation on an elderly woman, restoring her sight, Hü became known as 'the Miracle Lady'. She lived to the near-miraculous age of 105.

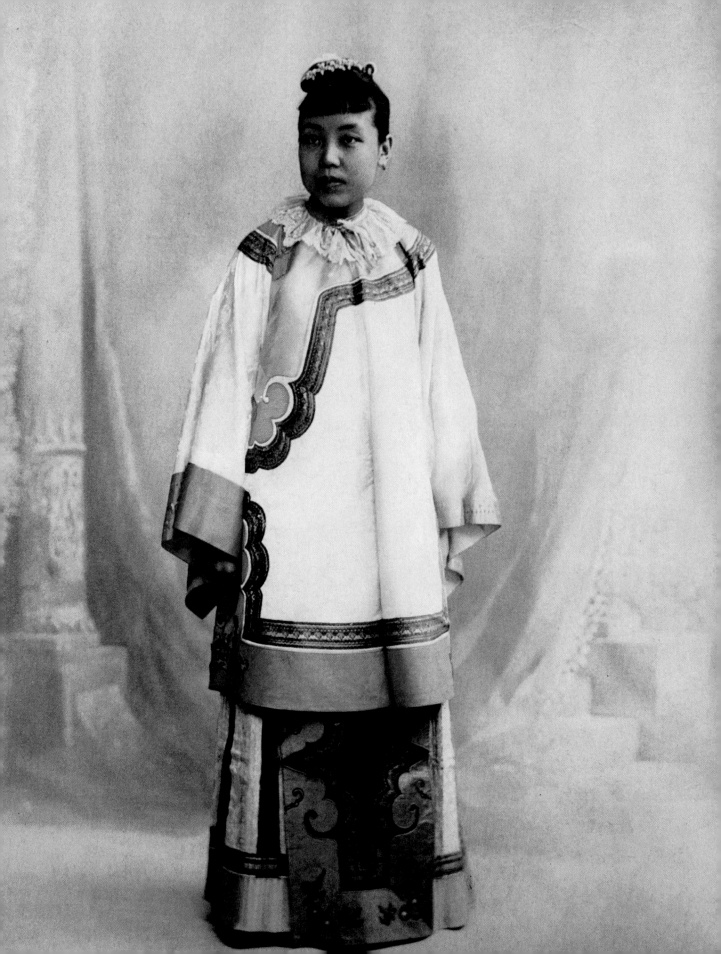

'A Voice from the South'

This image of Anna J. Cooper was taken at the Washington, DC studios named for the famous portrait photographer C. M. Bell. Hundreds of American luminaries had been photographed in that studio, from politicians and church leaders to athletes. By the time Cooper sat for the camera, sometime between 1901 and 1903, Bell was dead, but an appointment there still represented recognition of high achievement and personal prestige.

Cooper was born a slave in Raleigh, North Carolina in 1858. After the American Civil War, she went to school, and stayed there, beginning a 60-year career as a teacher, principal and administrator in schools and universities. She was dazzlingly gifted academically, with a master's degree in mathematics and a particular gift for history and classics; in 1891 she published an essay arguing that Black women ought to be taught the works of the ancient Greeks. The following year she published her best-known book, *A Voice from the South*, which became a foundational text of Black feminism, arguing that educating Black women would benefit the whole African-American community.

Certainly, Cooper practised what she preached. She travelled widely in Europe and in 1925, aged 67, she earned her PhD from the Sorbonne in Paris, defending a thesis on French attitudes to slavery during the revolutionary era. History was in her blood. 'We look back', she wrote, 'not to become inflated with conceit because of the depths from which we have arisen, but that we may learn wisdom from experience.'

Fanny Cochrane Smith

Here we see Fanny Cochrane Smith recording songs in the Tasmanian Aboriginal language onto a wax cylinder phonograph. Smith was the last surviving Tasmanian Aboriginal, and her recordings, spoken and sung, are the only surviving examples of the language being spoken by an indigenous speaker.

In 1834, Fanny was the first child to be born on Flinders Island, 34 miles off the coast of Tasmania, from which indigenous Australians were forcibly removed by the Australian government to be 'civilised and Christianised'. She was given the name Cochrane either by the Aboriginal Protection Board or by the family for whom she worked in service from the age of 12. Another government-mandated initiative, in 1847, moved the Flinders Aboriginals to Oyster Cove, a rural area south of Hobart on the main island. In 1854, Fanny Cochrane married William Smith; they had 11 children. Fanny ran a boarding house in Hobart, held church services in her house and became much loved in her community. She died, aged 70, in 1905.

Cochrane's recordings were made for entertainment, not anthropology. Horace Watson, the phonograph operator in the picture, was a Tasmanian businessman and hobbyist recorder, one of the first Australians to own recording equipment. He saw Smith perform a concert of Aboriginal songs and stories at the Hobart Theatre Royal in 1899 and encouraged her to make recordings later that year and again in 1903, when this photograph was taken.

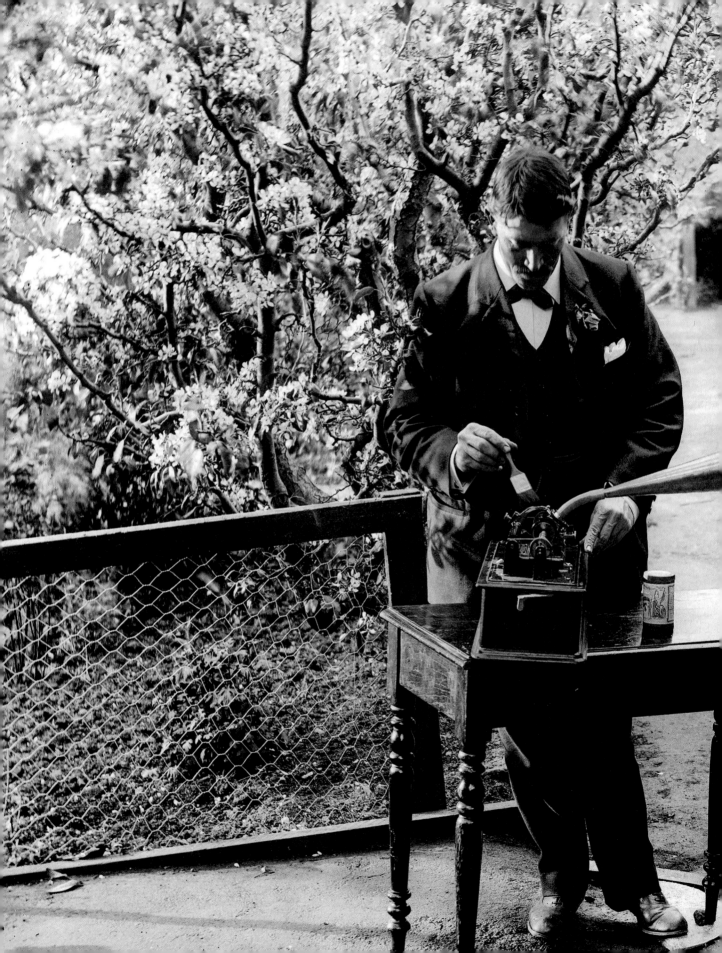

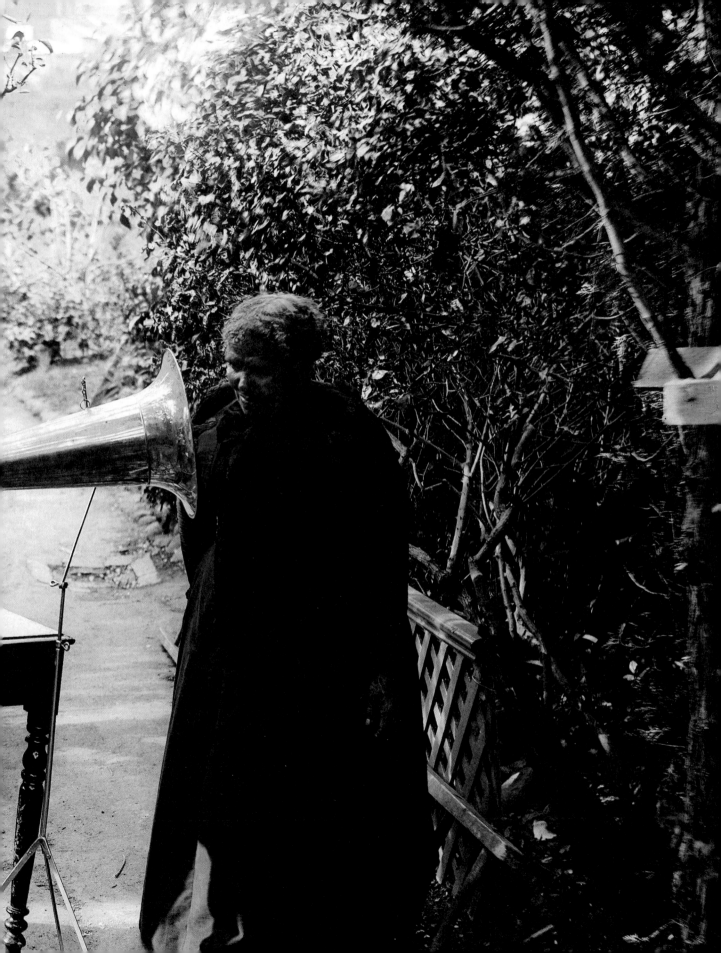

Defending a Thesis

Compared to other universities in the world, Paris's Sorbonne was relatively progressive in its stance on female education. In the last decades of the nineteenth century the university's schools were reorganized and reformed, and women were gradually allowed to take courses and degrees. In 1903 the scientist Marie Curie was awarded her PhD, becoming the first woman in France to receive a doctorate. As we have already seen, in the early twentieth century women began to travel to Paris from countries where restrictions on female higher education could be more stringent.

This picture was taken by the famous Parisian photographer Albert Harlingue, noted for his pictures of French celebrities and political events, and (in wartime) of soldiers and veterans. It shows an unnamed woman defending her thesis at the Sorbonne at some point between 1925 and 1935. The balance between men and women in the room is obvious: there is only one woman visible, other than the candidate. Yet very slowly, things were changing. In 1924 a new law had allowed French public schools to prepare girls for the baccalauréat exams that had been open to boys for more than a century. Three generations after Harlingue captured this scene, in the 1990s, 12 per cent of French women under the age of 35 held degrees – a figure comparable with most other developed nations in the west.

Nature *vs* Nurture

Margaret Mead was one of the most famous scientists in America, a public intellectual who put forward controversial ideas that were later accepted by both the scientific community and the public. At the heart of her work as an anthropologist lay a simple contention: Mead argued consistently that 'nurture' was more important in human behaviour than 'nature'.

Born in Pennsylvania in 1901, as a girl Mead was drawn to scientific study. She joined her mother, a sociologist, on research trips to Italian immigrant communities. Back home, she collated data on garden plants and her siblings' language. After university, she took a job in the American Museum of Natural History in New York, and received her PhD from Columbia University in 1929. In this photograph, taken around 1930, Mead is holding a Samoan mask. It evokes her most famous book, *Coming of Age in Samoa*, which she published during her studies, basing its text on nine months of fieldwork in the country.

Mead was an anthropologist during the discipline's boom time, between the world wars, when much field research took place in cultures Western scholars then considered 'untouched' and 'primitive'.

During the Second World War, Mead campaigned for peace, arguing that, since cultural norms are taught and not innate, it follows that no group of humans is more naturally inclined towards war rather than peace. Controversial at the time, this idea became widely accepted and highly influential, especially in terms of educating and socializing children.

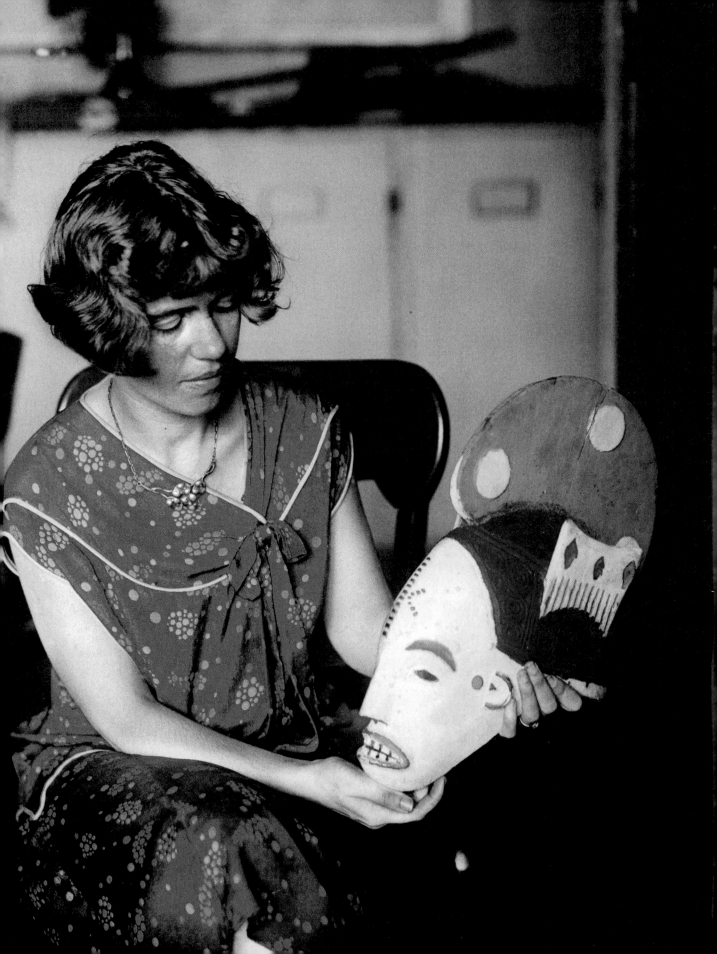

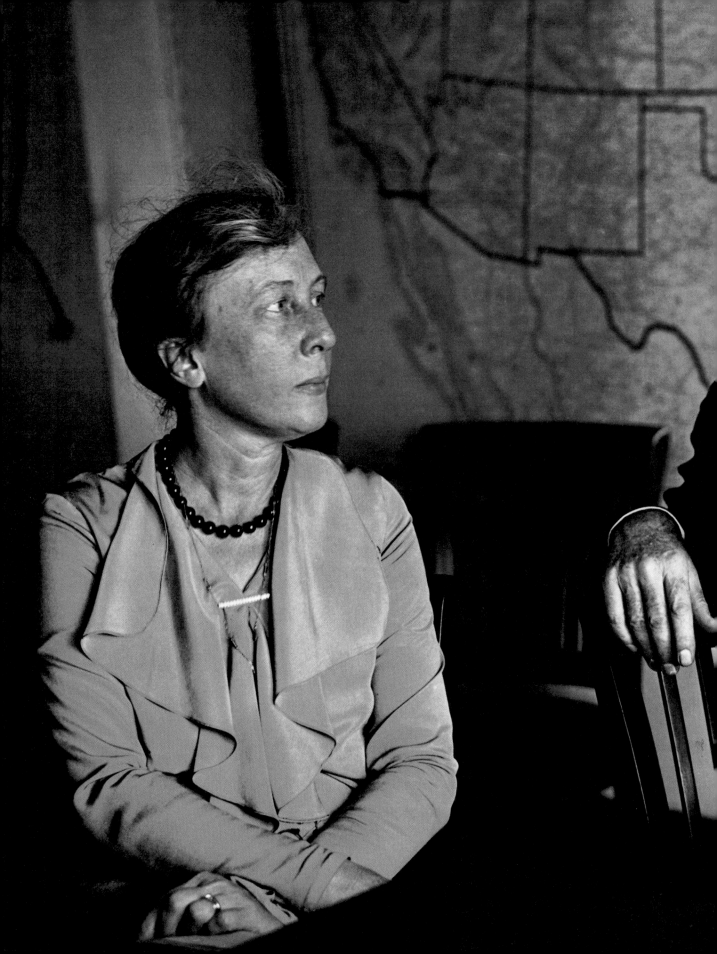

Lillian Gilbreth

An industrial engineer, management psychologist, writer, ergonomist, product designer and lecturer, Lillian Gilbreth was known was the 'Mother of Modern Management' because of her groundbreaking work in time and motion studies in the workplace and the home.

Born Lillian Moller in Oakland, California in 1878, Lillian graduated from university in 1900. Four years later she married Frank Gilbreth. Together they ran an engineering and consultancy firm called Gilbreth, Inc, and co-authored dozens of academic papers, combining theories about psychology, engineering and management. Their findings 'eliminated waste', as Gilbreth termed it, for employers looking for ways to make their staff work faster and harder.

Gilbreth's own time management during her married years was astonishing. She gave birth to 13 children between 1905 and 1922, 11 of whom lived to adulthood. Meanwhile, she continued to study as well as work, and in 1915 she was awarded her PhD. After Frank died in 1924, Gilbreth's professional focus turned to domestic efficiency and the best way to build a kitchen. She once interviewed over 4,000 women to find the correct height for worktops and fittings; she also invented the pedal-operated waste bin and fridge door shelving, including the egg tray.

Gilbreth is pictured here in 1930 alongside Arthur Woods, a colleague on a US unemployment commission set up by President Herbert Hoover. Altogether, she advised five administrations on scientific and industrial matters. One acquaintance thought would have made a fine president herself.

Girton College

When this photograph of Girton College, Cambridge was taken, in 1931, the women who lived and studied there still could not earn a degree from their university studies, unlike their male counterparts (such a thing would not be permitted until 1948). But as the first residential college to offer a university education to women in the UK, and the first college for women established at either Oxford or Cambridge, Girton is central in the story of women's higher education.

The UK university system was one of the last in the world to grant women degrees. Italy's was the most progressive in this regard, with the University of Bologna (the world's oldest) awarding a law degree to Bettisia Gozzadini in 1237; two years later she became the first female university teacher. The first woman to earn a doctorate, Elena Piscopia, was an Italian who graduated from the University of Padua, in 1678 – almost two centuries before Girton was founded, in 1869.

The journalists and suffragists Emily Davies and Barbara Bodichon were the driving force behind Girton. The notion of women learning at the university had little opposition; the main objection was to women living as students alongside the men. Davies in particular railed against the idea of women-only teaching, exams and qualifications of a lower standard than men's. 'It makes me very unhappy', she wrote, 'to see the Ladies' Lectures, Ladies' Educational Associations, etc, spreading. It is an evil principle becoming organized, and gaining the strength which comes from organization.' It would be through her and Bodichon's organizing that equality was eventually achieved.

Mary McLeod Bethune

In its August 1955 issue, the influential magazine *Ebony* published an article by Mary McLeod Bethune titled 'My Last Will and Testament'. Written in her final days, it is a powerful statement of her beliefs and hopes. 'The Freedom Gates are half ajar,' she wrote. 'We must pry them open.' In the struggle to reach that point, Bethune was a central figure, effecting real change by championing the education and empowerment of young African Americans. She has been called the most influential Black woman in American history.

Born in South Carolina in 1875 to former slaves, she was the only one of her parents' 17 children to attend school. She loved learning, became a teacher and, in 1904, opened a schoolroom in Daytona Beach, Florida, teaching five girls and her son, Albert; the pupils used goose-feather pens with 'ink' from squeezed berries. She travelled widely to raise funds, from Black and white trustees, and grew the school to eventually become the Bethune-Cookman College, now a university.

Bethune's networking took her to Washington, DC, where she worked for the US government and lobbied it as a member of organizations including the National Council of Negro Women. From 1939 to 1944, she was director of the Division of Negro Affairs within the New Deal National Youth Administration, which helped young Black people get jobs and vocational training – the first African-American woman to hold high-level US government office. She died, aged 79, in May 1955; a statue of her erected in July 1974 was the first monument to a woman or an African American in Washington, DC.

GIs in Paris

This photograph, dated September 1945, shows a class of US servicewomen (and two men) studying dressmaking at the Sorbonne in Paris. These GIs were among many who stayed behind in Europe at the end of the Second World War. In this case, it was a prestigious posting, as the class was taught practical fashion skills from French couturiers at one of the great European universities.

All American veterans had something in common after the war: they could get their tuition paid, for school or college, thanks to the Servicemen's Readjustment Act of 1944, commonly known as the GI Bill. Only 2 per cent of the 16.1 million US military personnel during the war were women, but that nevertheless meant about 300,000 women presented with new educational opportunities.

There were, of course, conditions and barriers to equality that remained. Harvard Medical School accepted its first female student in 1945, whereas Georgia Tech, one of the world's best universities, did not accept women until 1952. Nevertheless, more women earning degrees and doctorates led to a significant increase in the number of female professors in the 1960s and 1970s throughout the Western world. In the early twenty-first century, Oxford, Cambridge and Harvard appointed female leaders. Today, nearly 70 years since this image was taken, gender equality in terms of numbers has been achieved. Although this took a long time, and many rounds of protest and negotiation, the experience of the wartime generation was a vital step along the way.

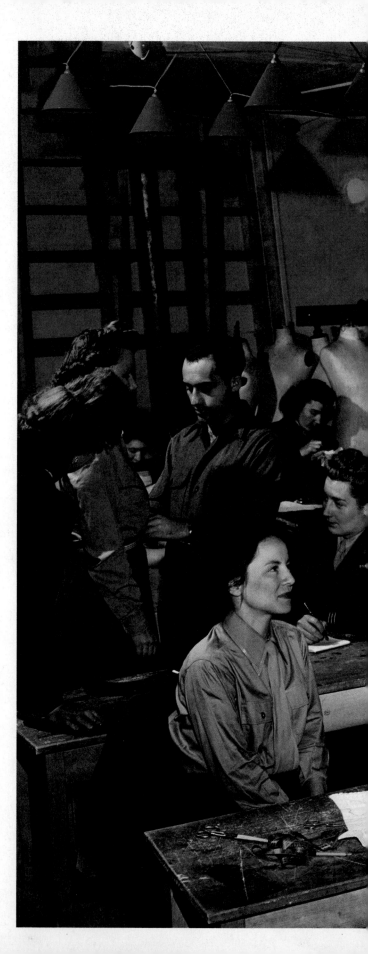

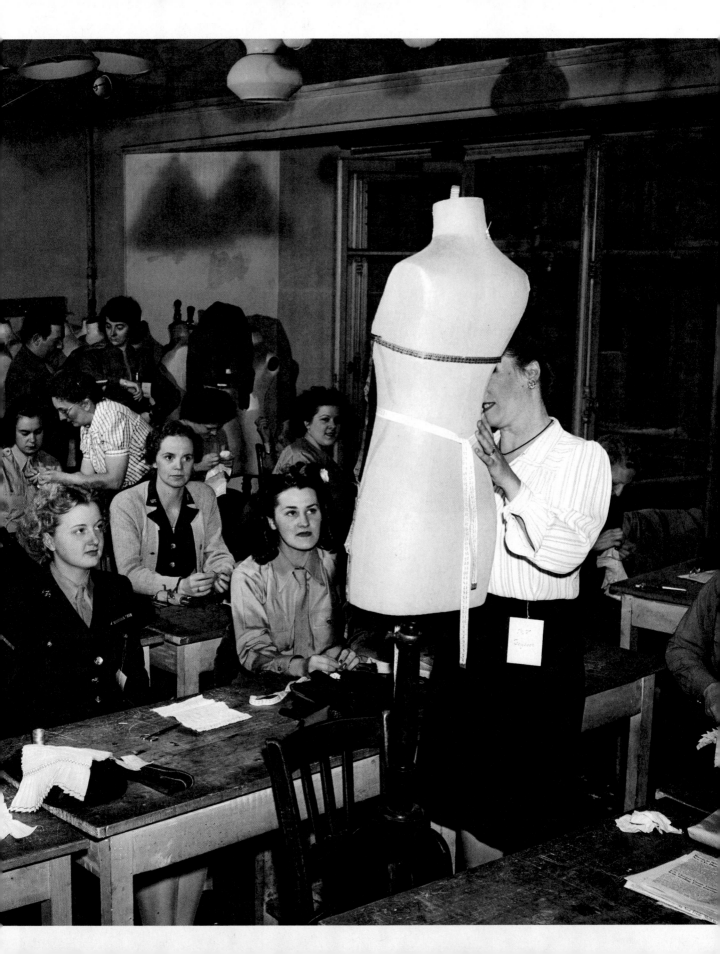

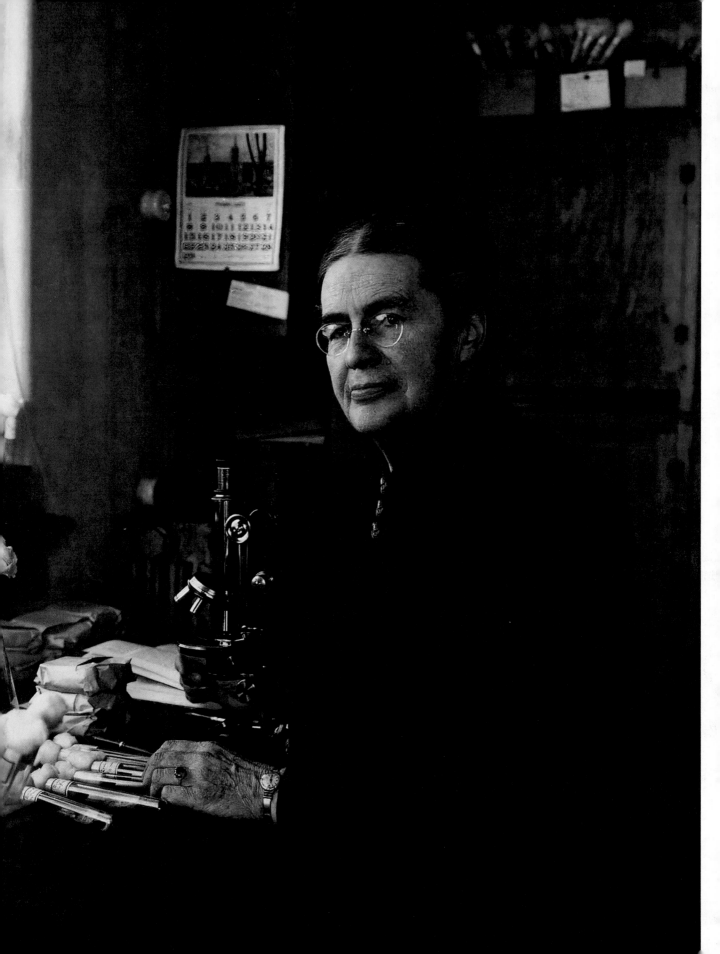

Johanna Westerdijk

When the plant pathologist Johanna Westerdijk gave her last lecture, in 1952, 500 friends, colleagues, students and former students turned up to mark the occasion. During the previous 35 years, after being appointed the Netherlands' first female professor in any subject, she guided 56 students, almost half of them women, to their doctorates, first at the University of Utrecht and, later, at the University of Amsterdam. (Two of her female PhD students were responsible for identifying Dutch elm disease.)

On entering Amsterdam University aged 17, in 1900, Westerdijk had been refused permission to take practical botany classes because she was a girl. But she studied there for a time, then in Munich and in Zurich, where, in 1906, she earned her PhD; later that year she became director of a Dutch laboratory. After research in Indonesia, Japan and the US, she took up her first chair, at Utrecht, in 1917, moving to Amsterdam in 1930.

From 1932 to 1936, Westerdijk was president of the International Federation of University Women. In 1937, the vote of thanks at the association's general assembly in Poland said that Westerdijk 'made the meetings so human and happy'. In obituaries and tributes written on her death, aged 78, in November 1961, her generosity of spirit, in both her academic and personal life, was remembered fondly, along with her scientific achievements and support of women in higher education. On the outside of her laboratory at Amsterdam, she had carved a motto, which translates as 'working and partying shapes beautiful minds'.

Maria Montessori

The Italian educator Maria Montessori is often credited with being the single most influential woman in twentieth-century education: the inventor of 'The Montessori Method', an innovative philosophy of early-childhood teaching, based around children learning through play and self-guided exploration.

Montessori was the first woman to attend and graduate from the University of Rome medical school, and her approach to education was explicitly scientific. She insisted that children have different stages of development requiring different teaching methods. She also argued that older children perform better at school if introduced to learning early in life, and that this was especially important in dealing with economically and socially disadvantaged infants.

In 1907 she opened her first school in a slum district in Rome. Her success there led to her first book, in 1909, which helped spread her ideas rapidly across Europe and into America. However, in the 1920s and 1930s, educational psychologists attacked Montessori's ideas while at the same time fascist governments in Europe cracked down on freethinking, nonconformist institutions. Her schools closed down and Montessori went into exile in Holland.

Yet her methods were not permanently suppressed. In this photograph, she is seen with pupils at a Montessori school in London in 1951. She died the following year, aged 81, as a resurgence in popularity of Montessori teaching, begun in the US, restored her ideas to the educational mainstream. Today, there are about 20,000 Montessori schools worldwide.

Septima Clark

Seen here on the left of the activist Rosa Parks at a Tennessee high school in 1955, Septima Clark was a US civil rights figure as important as Parks or Martin Luther King Jr, who called her the 'Mother of the Movement'. Over the course of half a century as an educator, she was committed to imparting the knowledge, especially to adults, that would improve lives and tackle racial inequality. 'The greatest evil in our country today', she wrote in 1965, 'is not racism but ignorance… we must try harder than ever to reach the great mass of the uninformed, whose basic interests are no different from our own – if they but knew it.'

Born in 1898, she graduated from high school in 1916 and became a schoolteacher. Her fight to earn equal pay for Black teachers took her into the civil rights movement. In the 1940s, earning her degree and masters, she taught illiterate Black soldiers how to read and write and began her journey in adult literacy.

Working for King's SCLC organization in the early 1960s, Clark established 800 citizenship schools, taught mainly by women, at which over 100,000 African-American adults were given literacy lessons, learned their rights as US citizens and gained practical skills that helped them to organize in groups. It was Clark's lifelong belief that action by communities at the local level, not national, was best and necessary for overcoming racial inequality. She died in 1987, aged 89.

Women
at the Wheel

In the middle of January 1939, *Time* magazine published a tiny story at the bottom of an inside page, reporting the judgement of a court in California. The court had decided that Amelia Earhart, described by *Time* as a 'famed aviatrix', was legally dead.

The story was small because the news was not a surprise. Earhart had disappeared over the Pacific Ocean 18 months earlier, in July 1937, near the end of her attempt to circumnavigate the globe in her Lockheed Electra plane, 'the Flying Laboratory'. She had taken off from Lae, in New Guinea, aiming for Howland Island. For Earhart, who had previously flown alone across the Atlantic, and from Hawaii to California, this was far from a challenging journey. Yet on the way she lost radio contact with the ground, and her plane never arrived. Within days of her disappearance, she and her navigator, Fred Noonan, were declared lost at sea.

However, if the California court's judgement merely rubber-stamped what was already known, it did nothing to dampen the fascination and affection that generations of aviation fans would feel towards Earhart. Intrepid, charismatic and photogenic, she smashed records for solo flying, published bestselling books and organized clubs for female aviators. In 1932, she became the first woman to be awarded the US Distinguished Flying Cross medal.

From the day she first sat in a plane – in 1920, when she was 23 – Earhart knew that she wanted to devote the rest of her life to flying. That was what she did, so when she disappeared, it was while doing something she loved.

Public fascination with Earhart and the exact nature of her fate has endured for more than eight decades since the day her radio signals cut out and her plane vanished without trace. In the whole history of aviation, probably only the Wright Brothers and the crew of Apollo 11 are better known. This photograph of Earhart, taken in 1926 for *Life* magazine, is just one of a vast number that helped make her face instantly recognizable.

Yet Earhart's astonishing fame does not mean that she was unique. The era in which she lived – the first four decades of the twentieth century – was something of a golden age for women behind the controls of new and rapidly developing machines like planes, cars and powerboats. Breaking world records took money, determination and a pragmatic acceptance of the risk of injury or death. But everything was possible and the sky – or sea, or open road – was the limit.

Over the following pages, we will meet some of Earhart's contemporaries from this exciting time. Some of these were (and remain) famous. They include Bertha Benz, one of the brains behind the motor car, and Valentina Tereshkova, the first woman to travel to space. But others were not known to the public at all. They were taxi drivers, bus conductors and train drivers – ordinary people doing jobs that, as the twentieth century progressed, made the world go round.

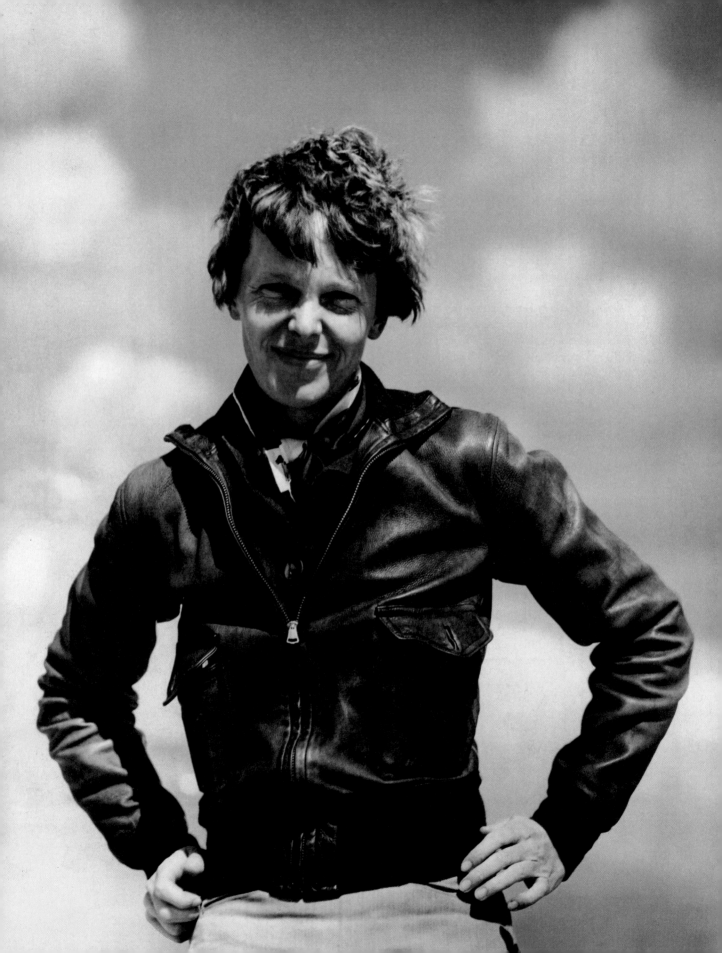

Bertha Benz

Early on 5 August 1888, three people snuck into the Benz factory in Mannheim, Germany. They were Bertha Benz and her two teenage sons, and they had come for a joyride in a three-wheeled Patent-Motorwagen Model III: the world's first motor car, and ancestor of the four-wheeled Benz-Viktoria pictured here in 1893.

Bertha had every right to take the car. Her marriage dowry had underwritten her husband Carl's engineering business, allowing him to develop vehicles in which people could travel far and fast without animal traction. But Bertha was after more than just a road trip. Although the Benz had been patented in 1886, public feeling towards the car was still lukewarm. Bertha was on a mission to convince the world that this was the future.

She took the Model III about 100 kilometres south of Mannheim to Pforzheim, a journey that took most of the day and required three stops at pharmacies to buy ligroin fuel. She also stopped for water to cool the engine, dismounted at the bottom of hills to get out and push (the car only had two gears) and on arrival advised Carl by telegram what she'd been up to.

At one point, Bertha used her hatpin to unblock a fuel line and a garter to insulate worn ignition wire. On the return journey, she stopped so a cobbler could cover the brake shoes with leather, thus inventing brake pads. The world's first long-distance car journey was not easy. But it was a triumph.

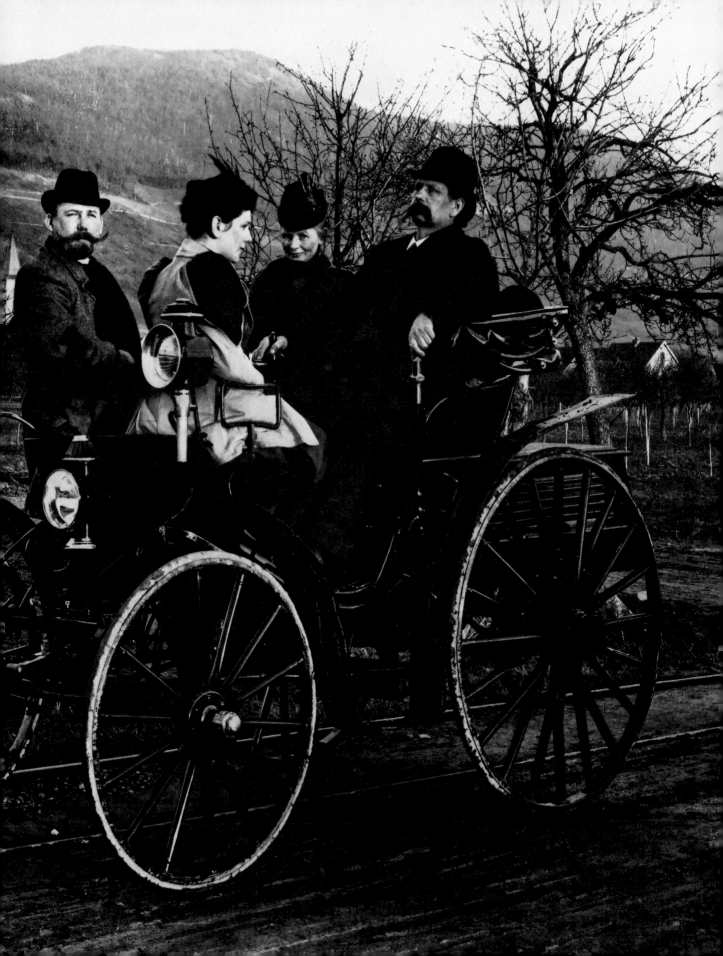

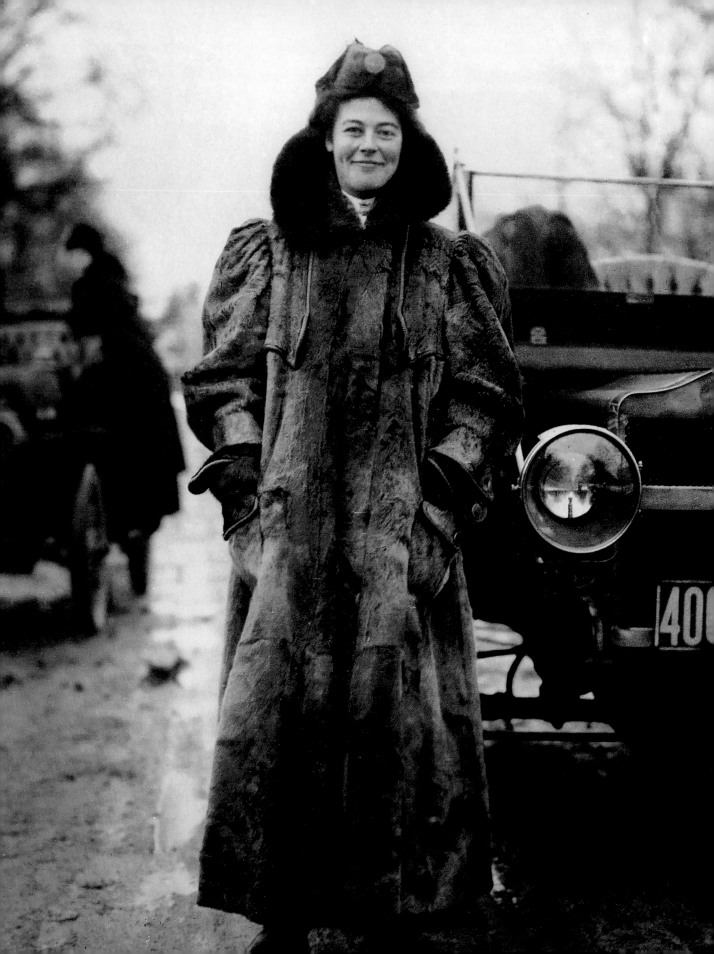

Alice Ramsey

In the early days, motoring could be messy, as this photograph of Alice Ramsey suggests. Only a tiny fraction of the world's roads were surfaced, which meant driving was bumpy in the dry and muddy in the wet. Yet for those who fell in love with cars, the thrills were worth the discomforts.

Ramsey started driving seriously in 1908, when she acquired a new Maxwell car, in which she spent the summer touring around New Jersey, where she lived with her husband, a US congressman. Having covered 6,000 miles in a few months, she decided to strike out further. She agreed with Maxwell to attempt to drive coast-to-coast across the US, from east to west. No woman had made this journey before, but for both parties, that was the appeal. Maxwell wanted to appeal to women customers. Ramsey wanted to drive.

The journey took 59 days, far longer than planned, but on 7 August 1909, Ramsey arrived in San Francisco, California, accompanied by two of her sisters-in-law and another friend. It had been a rough ride from New York: only about 150 miles of the 3,800 they had covered had been surfaced, their top speed was 42mph, and in Nevada they had been surrounded by Native Americans carrying bows and arrows. But the journey was complete; the news was made and Ramsey, who would drive across America 30 more times in her life, was a celebrity. In 1960, the AAA named her female motorist of the century.

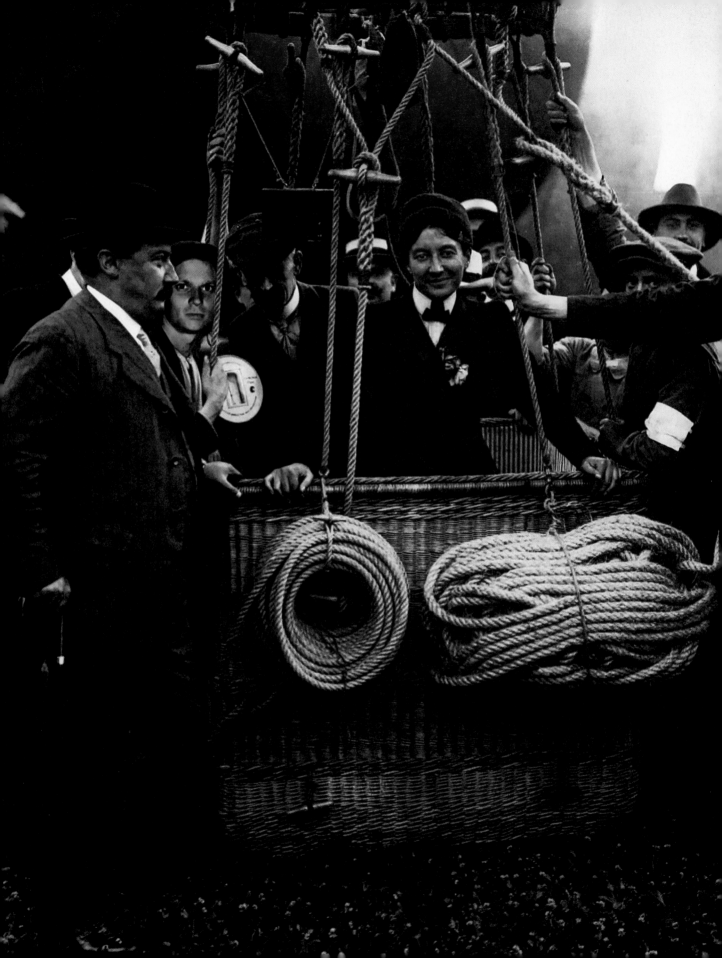

The Fiancée of Danger

This photograph shows Marie Marvingt before the French Aéro Club's Grand Prix balloon race at the Longchamp racecourse in Paris on 26 June 1910. Marvingt was a pioneering balloonist who the year before had become the first person to pilot a balloon across the North Sea from France to England.

She took off from Nancy, in north-east France, a male aeronaut assisting. Winds blew the balloon north over Amsterdam, then west over the water towards England, into a five-hour snowstorm at night, during which the balloon's basket dipped in and out of the sea. 'My overcoat and wool stockings were no help,' she told *Sports Illustrated* magazine in 1961, two years before she died at the age of 88. 'I was freezing. Besides that, we couldn't tell which way we were heading.' They eventually landed, 14 hours and almost 1,000 kilometres after take-off.

Marvingt called it her most memorable achievement. She had many to choose from. Having been barred from the all-male 1908 Tour de France, she followed the men stage by stage, day by day, and completed the course, unlike 78 of 114 male starters. She was the first woman to climb Dent du Géant in the Mont Blanc massif and to drive across the Sahara in a car. She held several pilot's licences, flew bombing raids in the First World War, and was instrumental in the development of the air ambulance, becoming a world authority on the subject and lecturing internationally. 'I became an adventurer', she said, 'because there were things to be conquered.'

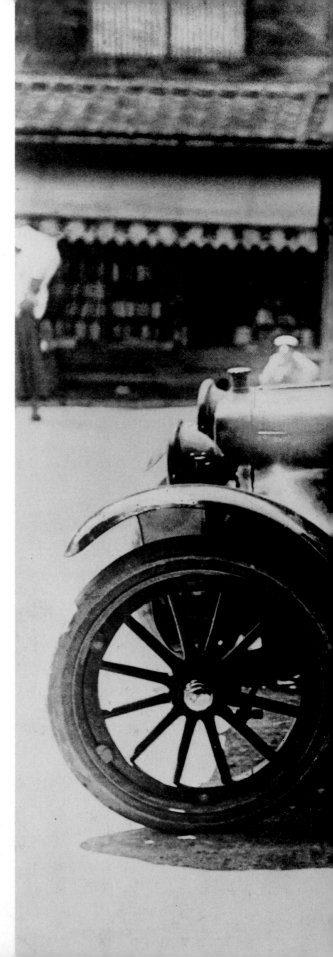

Tokyo Taxis

These two women chauffeurs were probably photographed in Tokyo, Japan, sometime before 1915. But this is by no means a typical image from that time. For one thing, Japanese motoring was in its infancy – the first car made in Japan had only been produced in 1907, and imported vehicles were rare. For another, Japanese women were disappearing from the workplace.

At the turn of the twentieth century, half of workers in Japan were women. Just over a decade later, that figure had fallen to one-third. Women's rights were restricted in general: a 1900 law banned women from all political activity, including attendance at rallies, and female suffrage only arrived in 1945.

Nevertheless, vehicles like the one being driven here *were* starting to become a familiar sight on Japanese streets, as part of a more general public transport revolution. Rickshaws had traditionally been the mainstay of transit, but in 1903 a streetcar service began operating in Tokyo. In 1912 six Model T Ford cars arrived to provide the first taxi fleet. And two years later Tokyo Station opened, as an important hub of the country's inter-city rail network.

Japan's first female taxi driver, Ninagawa Noriko, started work in Kyoto in the 1930s, but it took much longer for women to be accepted in transport roles more generally. The first female driver of a Japanese suburban electric train started work in 1995. Only in 2000 did the high-speed or bullet trains welcome women drivers for the first time.

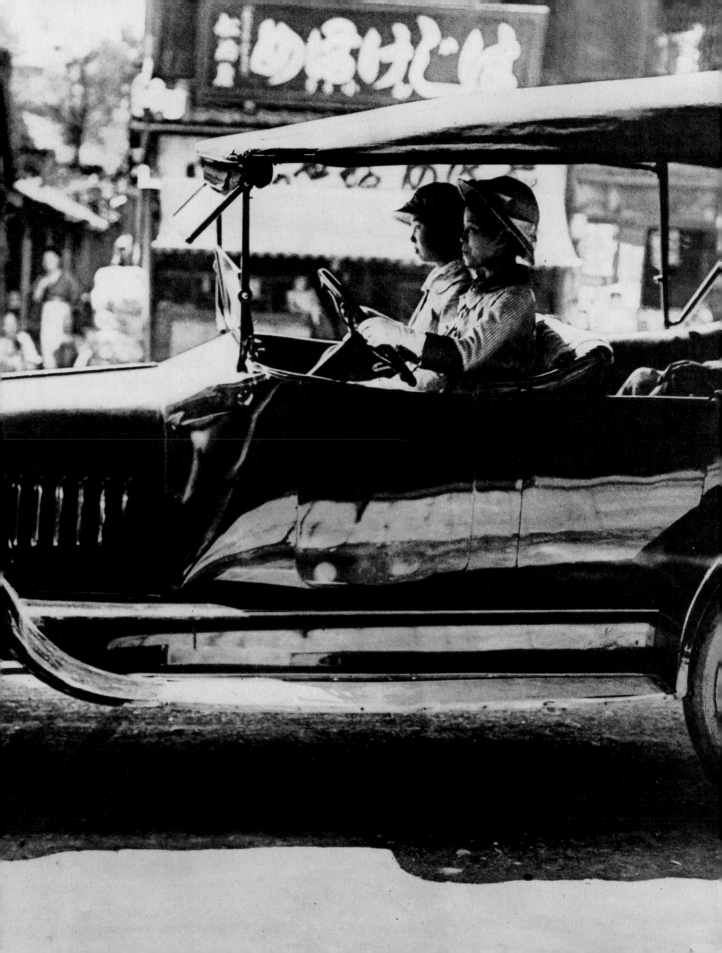

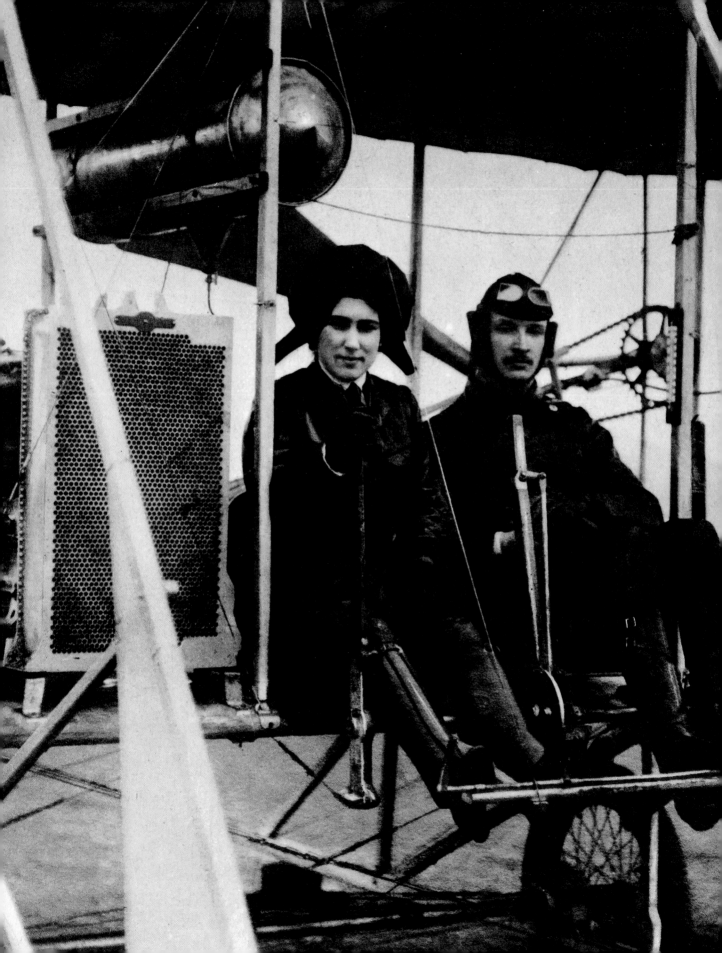

Evgeniya Shakhovskaya

Life and legend swirl together when Russians mention the name of Evgeniya Shakhovskaya, pictured here in an undated photograph by the Bain News Service some time before or during the First World War. Born in 1889, she was a member of the Russian aristocracy: a titled princess and a cousin of Tsar Nicholas II. She was inspired to fly by the French female pilots she saw in the travelling air shows that came to Russia in the very early days of aviation. She learned to fly in Russia and Germany, and was awarded her pilot's licence in the summer of 1912, having been taught by instructors including Wssewolod Abramovitch, with whom she is pictured here.

In April 1913, Shakhovskaya crashed a Wright plane at Johannisthal airfield near Berlin. She suffered only minor injuries but Abramovitch died. The two were said to be lovers, and her grief kept her from flying for a time; but at the outbreak of the First World War she wrote to Nicholas II, asking to join the Imperial Russian Air Service. She flew reconnaissance missions from November 1914 until she was accused of spying for Germany; she was saved from the firing squad by the Tsar and imprisoned in a convent. Freed during the 1917 Russian Revolution, she worked for the secret police for a short time, supposedly as an executioner. Shakhovskaya died around 1920, allegedly in a drunken shoot-out.

'Clippies'

In London during the First World War, women were employed to work on the buses as conductors. They were known informally as 'clippies', since the job involved clipping bus tickets to make sure they were not used twice. This photograph was taken in the winter of 1916; the clippie is wearing the navy-blue uniform of the London General Omnibus Company (LGOC), the city's largest bus operator, which employed more than 4,600 women to replace men who had gone off to fight.

In total, 18,000 women worked on London's bus and train network during the war, although their pay and conditions did not match those enjoyed by their male colleagues, who earned higher wages and a 'war bonus'. Women were also only eligible for employment if they were aged between 21 and 35.

Understandably, this caused some discontent. In August 1918, around 17,000 female tram and bus workers went on strike across the UK, following the example of women at the Willesden bus garage in North London. Their action won them the war bonus, although not equal pay. And later that year, after the Armistice, women in wartime jobs, including public transport, were made redundant; employers had promised servicemen that their old jobs would be available once they were demobbed.

It would take another war to bring women back into the public transport network in large numbers. During the Second World War, more than 20,000 women worked to keep London's buses, trams and Tube trains running.

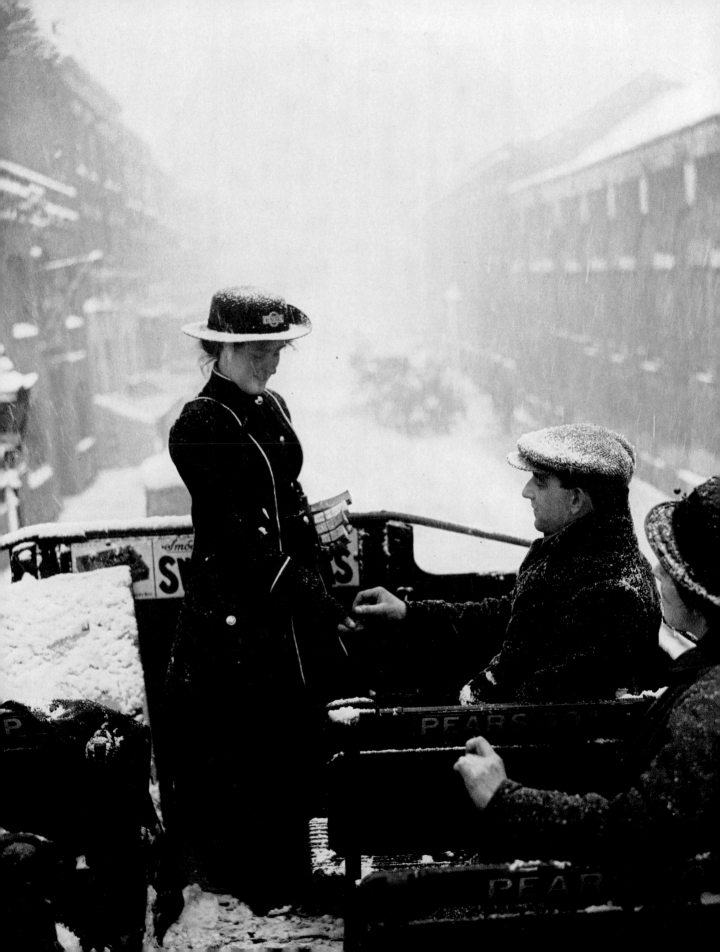

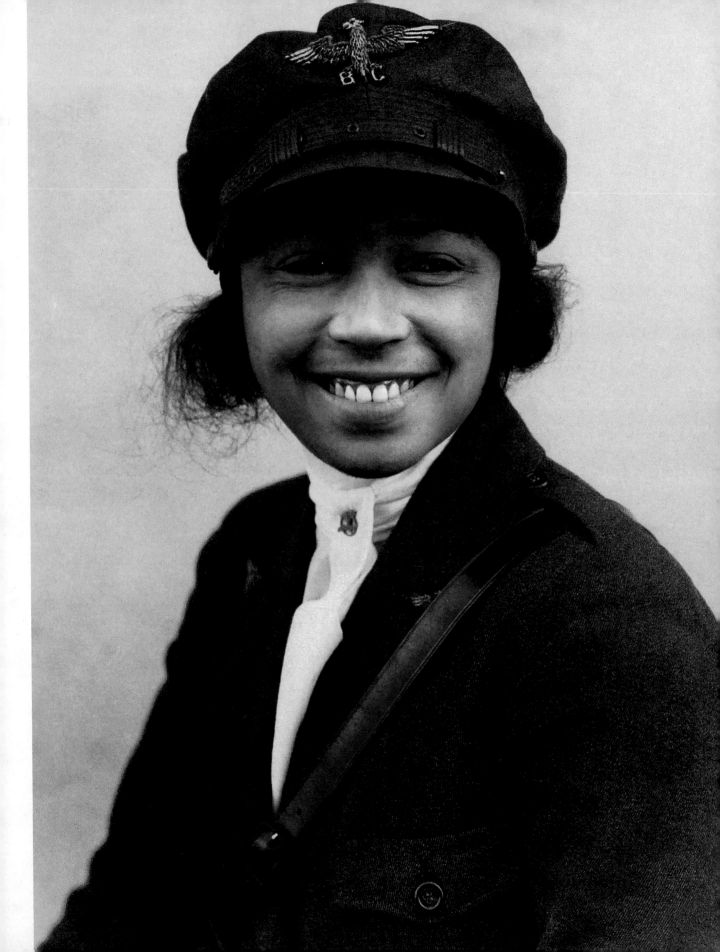

'Queen Bess'

In 1919, Elizabeth 'Bessie' Coleman was working as manicurist in a Chicago barbershop, where she heard clients talking about planes, pilots and aviation. She decided to get involved with the dawning age of flight.

This was easier said than done. Coleman had been born in Texas to parents of mixed Black and Cherokee heritage. That – and the fact she was a woman – barred her from American flying schools. Undeterred, she took a second job and sought financial support from businessmen and newspapers from Chicago's Black community. In 1920 she went to Paris and graduated the following year from the *Fédération Aéronautique Internationale* with an international pilot's licence.

On her return to America, Coleman was hailed by one Chicago newspaper as 'the world's greatest woman flier'. She set out to prove the point, and publicize the cause of Black aviators, by working as a barnstormer: performing stunts, wing-walking and parachuting at air shows, circuses and county fairs. She refused to fly at events that banned Black spectators. 'The air is the only place free from prejudices,' she said.

Flight was dangerous. This photograph was taken in 1923; in February that year, Coleman broke three ribs and her leg in a crash at Santa Monica. In April 1926, a plane in which she was a passenger went into a dive and she was thrown to the ground and killed, aged 34. Before her funeral in Chicago, 10,000 people filed past her coffin.

Maria Avanzo

On 2 April 1922, Maria Avanzo entered the famous
Targa Florio: the world's oldest sports-car race, held
in the mountains of Sicily near Palermo. Her car –
in which she is pictured here – was an Alfa Romeo
20/30 ES, a beefed-up version of a model designed in
1914, with electric lights and a four-cylinder engine
that could produce a top speed of 81mph. This was
the same type of car that another legendary driver,
Enzo Ferrari, drove when he began his career. Indeed,
Ferrari lined up in the same field on the day this
picture was taken.

Ferrari's name is better known today than
Avanzo's, but her career was just as extraordinary.
Born in 1889, she made her debut in competitive
motorsport at the 1920 Giro del Lazio in Rome,
winning her class despite having to replace one of
her tyres mid-race. During her ensuing 19 years as a
racing driver in Europe, Australia and north Africa,
Avanzo was often the only woman in her races.

She competed at least five times in the Mille
Miglia, the thousand-mile Italian endurance road
race that was once considered the world's toughest.
She drove Alfa Romeos, Bugattis and Fiats, and in
1932, was invited to race demonstration laps at the
Indianapolis 500. At one event – a speed trial on a
beach in Denmark – she famously put out her car's
engine fire by driving it into the sea. Avanzo retired
in 1940, having been racing until the age of 51.

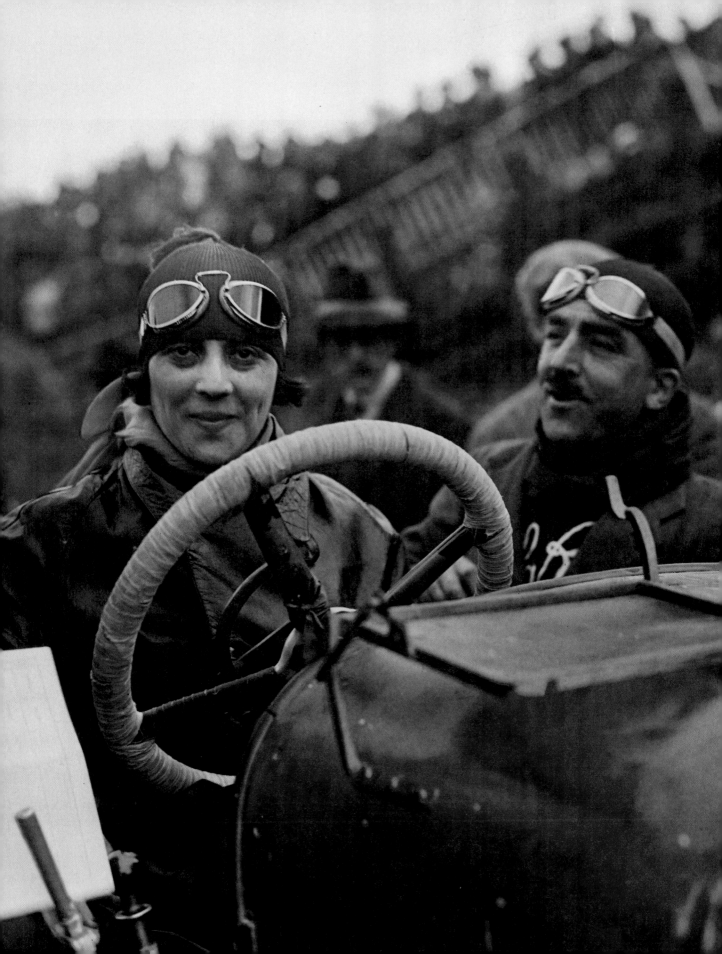

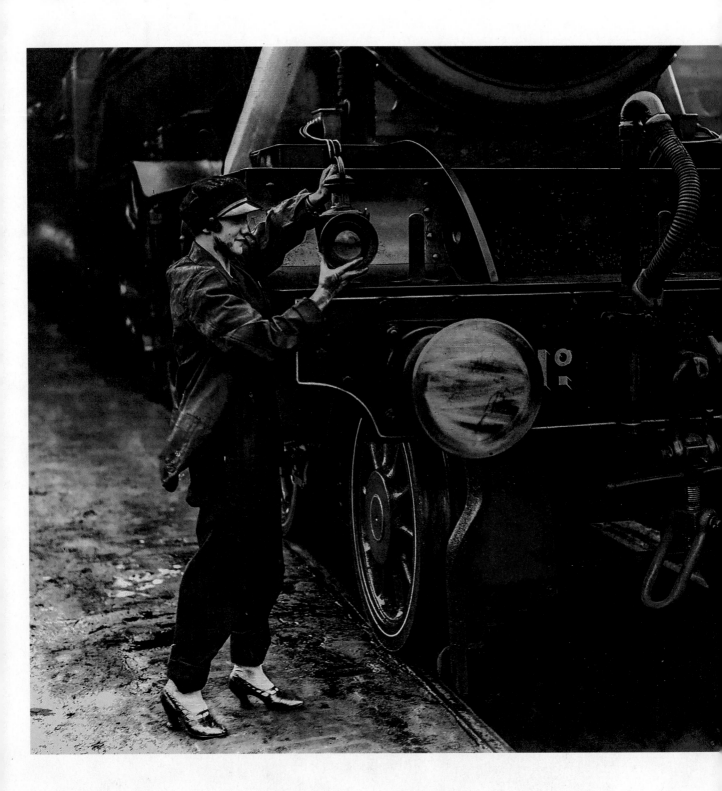

'Pretty Polly'

It is easier to be certain about the railway engine in this famous photograph than it is about the woman fixing the lamp on it. The number '2560' identifies the train as *Pretty Polly*, an LNER Class A3 steam locomotive, built in Doncaster Works in 1925. She could travel at up to 100mph, and in 1992 she was mentioned in the children's cartoon series *Thomas the Tank Engine*, in a story called 'Galloping Sausage'.

But what of the woman? She is often described as a 'lady engine driver' hard at work during the nine-day General Strike of 1926. But this would have been unprecedented for the age, even during the strike, when 1.7 million industrial workers walked out of their jobs. Although hundreds of thousands of civilians volunteered to take over strikers' jobs in an attempt to break the action, putting an untrained driver in an engine cab, whether male or female, would have been wildly risky. More likely, then, this is a posed photograph published by a newspaper as anti-strike propaganda.

What we can say is that a generation after the strike, during the Second World War, 100,000 women worked on Britain's railways, although none are recorded as having driven trains. The UK's first qualified female train driver, Karen Harrison, began her career in the cab in 1978. By that time, *Pretty Polly* had been out of service for a long time: she was removed from the British Rail fleet and scrapped in 1963.

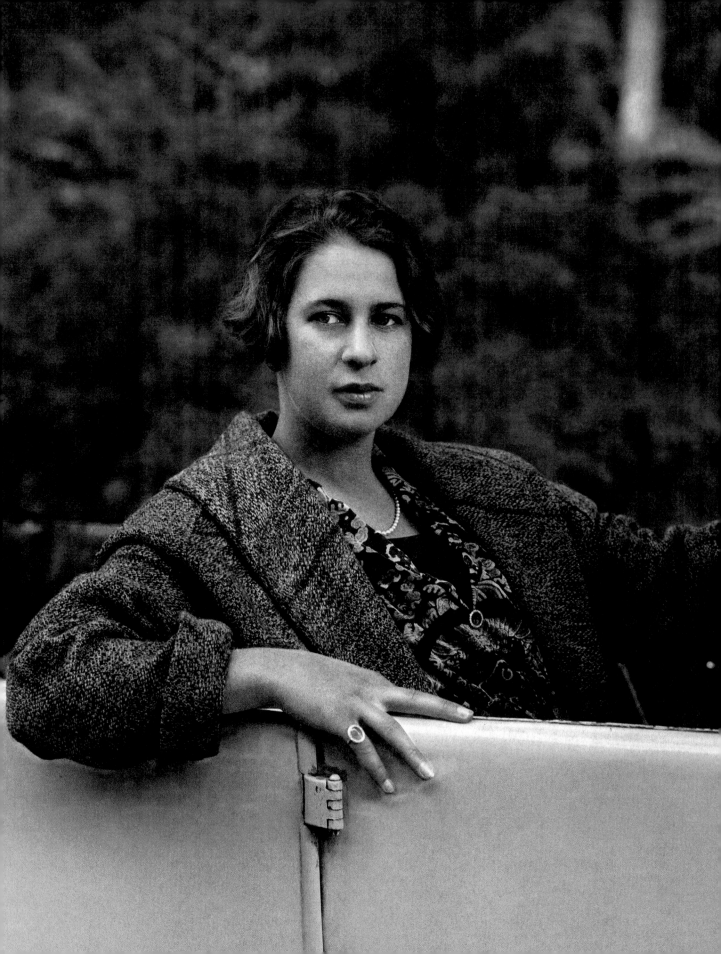

Clärenore Stinnes

This photograph of racing driver Clärenore Stinnes was published in the May 1926 issue of the German art magazine *Der Querschnitt*. It shows her at the wheel of an Aga open-topped car, in which she had stormed to victory in her class at a rally in Soviet Russia the previous year. Stinnes was becoming known as one of Europe's finest drivers, but her greatest adventure lay ahead of her, as in 1927 she set out to become the first European woman to drive around the world.

She began her journey in Berlin on 25 May, driving a German Adler Standard 6 production car, modified with adjustable seat backs. With her was a Swedish cameraman, Carl-Axel Söderström, whom she had met and hired to document the adventure two days before departing. Two mechanics drove an escort truck with supplies and spares, and the trip was funded by German car companies, who saw it as excellent publicity for their industry.

It was an extraordinary journey. From Germany, Stinnes crossed Europe to Turkey, then drove through Iran, Russia, Mongolia, China, Japan and America, before taking a ship back to Europe. In the Gobi desert, she outran armed horsemen. A wooden ferry across the Sura river in Russia had to be reinforced to keep the touring party and the car from sinking.

In all, she drove nearly 50,000 kilometres, returning to Berlin on 24 June 1929. 'She must be made of steel', wrote Söderström, whom she later married, 'because she can endure anything without complaining.'

Trout and Smith

In this photograph, taken in November 1929, a red Sunbeam biplane is refuelled via a hose from a Curtiss Carrier Pigeon biplane above Metropolitan Airport, now Van Nuys Airport, in Los Angeles. Flying the Sunbeam is 18-year-old Elinor Smith, who earned her pilot's licence at 16 and, at 17, demonstrated her skill by flying under the Queensboro, Williamsburg, Manhattan and Brooklyn Bridges in New York City.

Behind her, carrying out the refuelling, is Bobbi Trout, five years Smith's senior and the first woman to set a non-refuelling endurance record with a 12-hour 11-minute flight. Smith and Trout had traded the record for endurance flying regularly in January and February of 1929, but when Trout secured the funding and equipment to make a first female refuelled record attempt, she invited Smith to take part. 'Bobbi and I were planning', Smith wrote in her memoir, *Aviatrix*, 'to stay in the air for a week.' At the time, the men's record for refuelled flight stood at 17 days and 12 hours.

This photograph was taken 32 hours into their attempt. Not long after, at sundown on the second day, the Pigeon's engine cut out during refuelling, leaving Smith and Trout with half the fuel they needed to get through the night ahead. They ran dry before the Pigeon could be repaired and had to land, setting a first refuelling endurance record of 42 hours 30 minutes. 'To me,' wrote Smith, 'it represented a crushing defeat.'

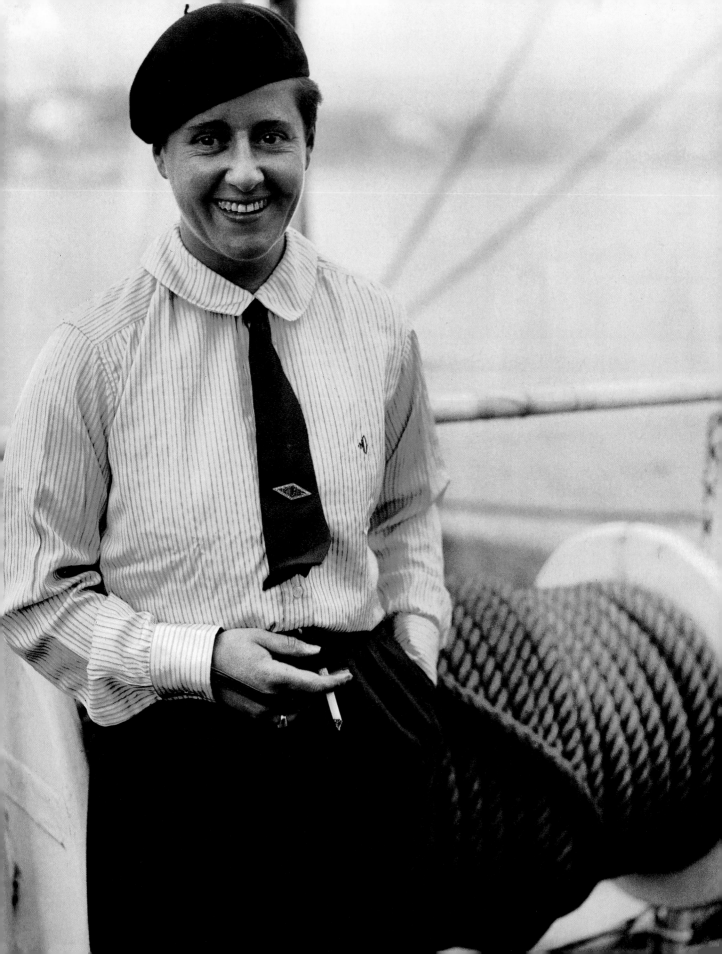

Extraordinary Joe

'You get a better idea of speed than in a car or anything else,' said Joe Carstairs, when asked why she chose to race powerboats. And speed was something Carstairs excelled at. During the First World War, she drove ambulances in France. In 1924, Carstairs inherited a vast family fortune and faster vehicles became available. Already a fine sailor, Carstairs had a powerboat built in 1925 and steered it to fifth place at the Duke of York's Trophy, a 30-mile race on London's River Thames.

This was the beginning of an exciting time on the water. At the 1926 Duke of York's, Carstairs wore the victor's rosette, won four more races during the UK season and set a world speed record in her class. From 1928 to 1930, Carstairs competed in the world's top powerboat race, the Harmsworth Cup, in Detroit, crashing once and suffering mechanical problems twice, before retiring from racing.

Carstairs always cut a striking figure. Born Marion Barbara Carstairs in Mayfair in London in 1900, in childhood she started buying boy's pyjamas using her pocket money. By the mid-1920s, Carstairs was racing in a flannel lounge suit made by a men's tailor on London's Savile Row. She went by the name Joe, and had affairs with numerous women, including the actresses Marlene Dietrich and Greta Garbo. From 1934 to 1975 she lived on her own island, Whale Cay in the Bahamas. The great racing driver Sir Malcolm Campbell called Carstairs 'the greatest sportsman I know'.

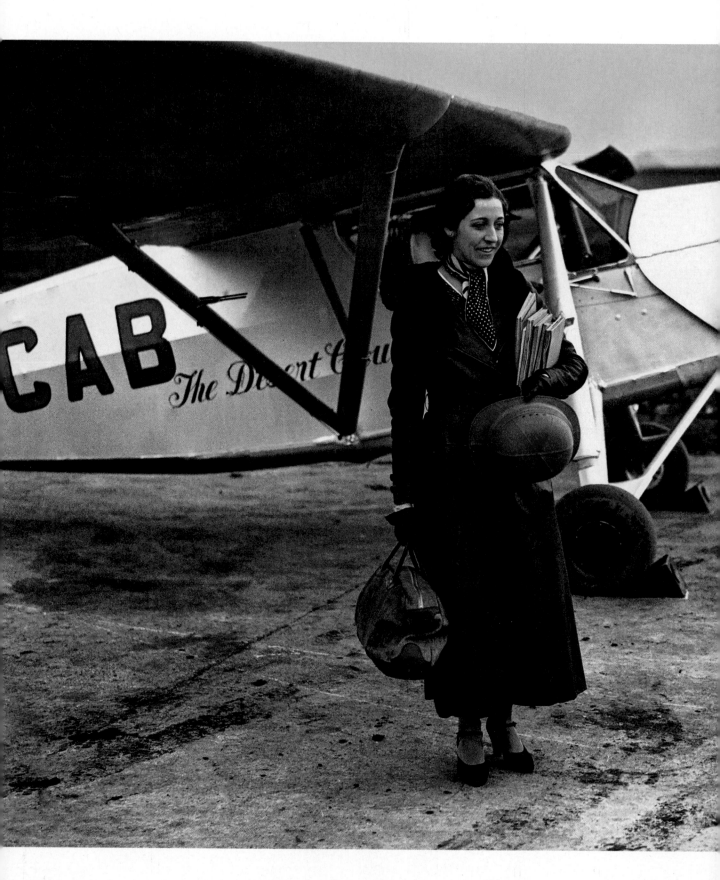

Amy Johnson

The British pilot and engineer Amy Johnson was her country's equivalent of Amelia Earhart: a record-breaking aviator who epitomized a new age of travel and adventure, until her death in a plane crash generated tragedy and mystery, reinforced by multiple retellings of her story.

Johnson took up flying as a hobby in her early twenties, while working as a typist in London. In 1929, she earned her pilot's and ground engineer's licence. In May 1930, aged 26, she became the first woman (and second person) to fly solo from England to Australia, taking 19 days to travel 11,000 miles. She was only prevented from setting a new world record time when she ran into monsoon conditions over Burma (Myanmar).

In 1931, Johnson did set a record flight time: travelling from England to Japan, and on the way setting a new best for London to Moscow. The following year, when this photograph was taken, she married the Scottish pilot Jim Mollison, then promptly broke her new husband's record for the fastest flight from London to Cape Town. Together they set a record flight time from Britain to India in 1934.

During the Second World War, Johnson flew Royal Air Force planes around the UK (see 'Special Delivery', page 141), but on 5 January 1941, off course and possibly out of fuel, she bailed out of her aircraft and into the Thames Estuary. The captain of a nearby Royal Navy ship died of hypothermia trying to rescue her. Johnson's body was never recovered.

Wal and Blenk

In this photograph, the British motorcyclists
Florence Blenkiron, left, and Theresa Wallach are
being waved off by a central London crowd,
including the MP Nancy Astor (wearing a blue hat)
at the start of a long-distance ride to Cape Town.
Wal and Blenk, as they were known to each other,
departed on 11 December 1934. They would be on
the road for eight months and 13,500 miles.

On a 600cc Panther motorbike equipped with
sidecar and trailer, Wal and Blenk rode through
France, Algiers, Niger, Nigeria, Chad, the
Democratic Republic of Congo, Uganda, Kenya,
Tanzania and Zimbabwe before arriving at their
destination in South Africa on 29 July 1935. Wallach
wrote a memoir of the trip, *The Rugged Road*, and
recalled how skimming over Saharan sand dunes was
like 'tackling hazards in a club trials event', while in
Algerian Tuareg country, people would gather round
the bike, marvelling at their first sight of a 'horse-on-
wheels'.

After their trip to South Africa, Wallach returned
home by boat, but Blenkiron rode the return
journey, on a replacement bike, sidecar and trailer,
leaving in September 1935 and arriving in April 1936.
Both women continued to compete in motorcycle
racing and served during the Second World War:
Blenk joined the Mechanised Transport Corps and
Wallach the Auxiliary Territorial Service, the women's
division of the British Army, where she became the
ATS's first-ever female tank mechanic.

'A rendezvous with danger'

'Terry Strong, daredevil' – as she was billed by *Life* magazine in the issue of 13 September 1948 – was one half of a motorcycle stunt duo who performed for 15 hours a day, six days a week with a travelling carnival called World of Mirth.

The travelling show was run by a larger-than-life character called Frank Bergen, whose myriad other attractions included a contortionist, an escapologist, a 'pinhead', rides such as a Ferris wheel and waltzer, and an 'iron-tongued lady' who could pull an adult sitting in a child's buggy with an iron hook stuck through her tongue. Terry Strong's act, which she performed with her male partner, 'Flash' White, was one of the most impressive.

They would ride, in turn and in tandem, around a 'wall of death' type wooden bowl 30 feet in diameter, with walls 15 feet high. The safety cable (visible here above the 'Keep Hands Off' sign) protected the spectators from the possibility of the bikes going out of control, but all that protected Strong and White was their skill in the saddle. The patter given by the World of Mirth's announcer promised that those who paid to see the stunts would witness 'men and women keep a rendezvous with danger. You will see them slip, slide, race, ride – racing motorcycles upside down!' This picture, which suggests this was not too much of an exaggeration, was taken by Cornell Capa, one of *Life*'s most famous photographers.

Ellen Church

Working as a nurse at a hospital in San Francisco, Ellen Church dreamed of becoming the world's first female airline pilot. But though she held a pilot's licence, her application to Boeing Air Transport (later United Airlines) was rejected on the grounds that the company would not allow women in the cockpit. Instead, Church became the world's first air stewardess, having convinced Boeing that a nurse in the cabin might help reassure passengers that air travel was a 'safety first' business.

Having been appointed as the most senior of eight stewardesses, Church flew for the first time on 15 May 1930, attending to 12 passengers on a Boeing 80A during a 20-hour, 13-stop flight from Oakland/San Francisco to Chicago. She continued to work as a stewardess for the next 18 months, until she was injured in a car accident and reverted to nursing. However, during the Second World War she worked aboard hospital planes as a member of the Army Nurse Corps, returning to civilian life on the ground when the war ended.

By that time, the role of air stewardesses was well established. The pay was good and the lifestyle could be glamorous, although flagrantly sexist standards abounded: most airlines insisted that their stewardesses be unmarried, 'conventionally' beautiful and below a certain height and weight. They were also only allowed to work until their early thirties, while their male counterparts could go on until their sixties.

Today, an airfield near Church's hometown of Cresco, Iowa, is named in her honour.

Captain Converse

When she posed with a sextant for the *Denver Post* staff photographer Dave Matthias, on 5 February 1957, Mary Parker Converse was recreating a pose she had adopted tens of thousands of times before. As an amateur yachtswoman, the first woman to attain the rank of captain in United States Merchant Marine and a US Naval educator during the Second World War, she regularly picked up her sextant, 'took a sight' in alignment with the horizon and navigated her ship's course. She taught thousands of others to do the same.

Born in 1872, she married her husband Harry in 1891. He was a keen yachtsman and his new wife soon developed the same passion. When Harry died in 1920, Mary enrolled in the United States Merchant Marine Academy and earned her second-class pilot's licence. To re-licence in 1938, Converse had to spend time at sea, so, aged 66, she sailed on a freighter to Africa as fourth mate, then took three further long voyages to log 33,700 miles at sea before the end of 1940.

That, along with study at the Washington Technical Institute, meant she earned a commission in the US Merchant Marines, the only woman to hold captain's papers in the service. One newspaper report said that by doing so, she had proved 'that woman's place is on the bridge, as well as the galley'. During the Second World War, Converse taught navigation to over 2,500 US Naval reservists. She died aged 89, in 1961, in California.

Women
at War

Modern warfare would be impossible without women. Fighting is often characterized as the ultimate macho pursuit, yet since the dawn of history, stories have been told of women disguising themselves as men to serve in battle. From the American War of Independence in the late eighteenth century, the historical record shows that women went to war in notable numbers. And in the twentieth century, industrial warfare was made possible by the hard, often dangerous work carried out by women: whether fighting on the front line, in nursing, or, on the domestic front, taking up jobs male soldiers left behind.

Lyudmila Pavlichenko, pictured here in a photograph taken in Washington, DC in 1942, was a Russian sniper during the Second World War. Russia had deployed women soldiers since the First World War, and following the Nazi invasion of June 1941, Russian authorities allowed more women into the military. They were deployed as tank drivers, radio operators, pilots, machine gunners and snipers. Pavlichenko herself had 309 confirmed kills. The average number of confirmed kills for other Russian women snipers, of which there were about 2,000, was five.

In June 1941, Pavlichenko, aged 24, a history student with marksmanship certificates from gun clubs and rifle courses run by the Red Army, volunteered for military service, insisting on front-line duties. From August to October 1941, during the defence of Odesa, she shot and killed 187 enemy combatants. She was then posted to Sevastopol, where, in December 1941, she married a fellow sniper, who died after being hit by shrapnel when the couple was out walking together in March

1942. By this time, the Germans knew of Pavlichenko by name, and began broadcasting, via loudspeakers, appeals for her to defect. She had also acquired the nickname 'Lady Death'.

Pavlichenko continued her work, and taught other snipers, until June 1942, when she too was hit by shrapnel. After recovering from her injuries, she was posted to Moscow and never saw active duty again. As part of a delegation that visited the US and Britain in autumn 1942, she became the first Soviet citizen to enter the White House and toured US cities with the first lady, Eleanor Roosevelt. In public, she refused all offers to demonstrate her shooting prowess, feeling she was not a trick-shot act. This stance, and a general suspicion that all public Soviet proclamations were likely to be propaganda, fuelled the theory that she was a fake. Journalists asked her if she wore make-up while on duty, or commented on her uniform and her body shape.

On returning to the Soviet Union, Pavlichenko spent the rest of the war as a sniper instructor, then finished her history degree and worked as a researcher at naval headquarters. She earned Russia's highest honours, including the Order of Lenin twice, and died in 1974, aged 58. Hers is the rare story of a front-line female soldier. But there are many, equally remarkable stories of women without whom wars could not be fought. A few of these stories – concerning South American revolutionaries and Spanish militiawomen to English nurses and Vietnamese guerillas – are collected in the pages that follow.

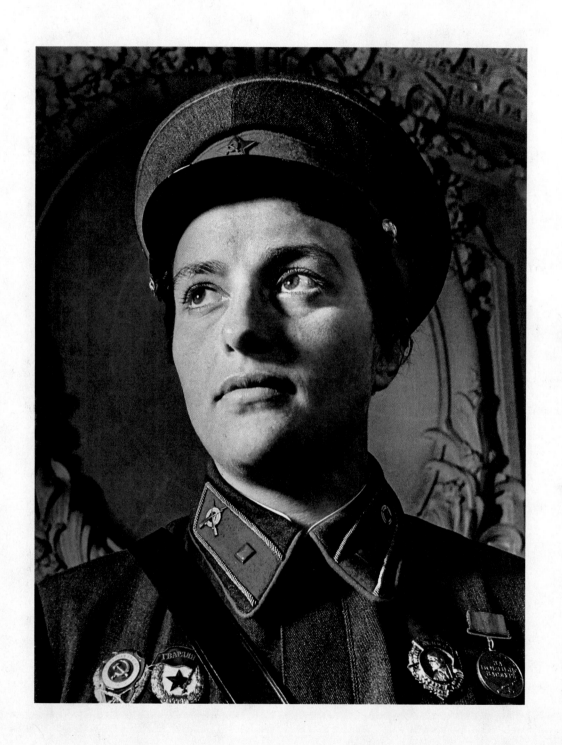

Anita Garibaldi

Anita Garibaldi, seen here in a photograph taken in Rome shortly before her death, fought on the side of revolution on battlefields in South America and Europe. Alongside her husband Giuseppe Garibaldi, she defended two capital cities against invading foreign armies.

Born in 1821 in Brazil, she was 17 when she met Giuseppe, an Italian merchant seaman who had fled a death sentence in his home country after a failed insurrection. In Brazil Giuseppe was fighting for separatist rebels in the Ragamuffin War. Anita joined him and fought in battles at sea and on land. She was captured at the Battle of Curitibanos in January 1840 and erroneously told that her husband had been killed. With permission, she searched the battlefield for his body; during the search she escaped, on foot after her horse was shot, and eventually reunited with Giuseppe, who was very much alive. In July 1840, eight months pregnant, Anita again fought in battle. Subsequently the couple moved to Montevideo, Uruguay, where they had three more children and, in 1847, fought in the defence of the city against Argentine attack.

The following year, in Italy, Anita Garibaldi fought alongside her husband in the First Italian War of Independence and in 1849, again pregnant, in the unsuccessful defence of Rome against the French. She died of malaria in August 1849, aged 27. There are many statues of her in Brazil and Italy, one in a park in Rome depicting her with a baby under one arm and the other high in the air, brandishing a gun.

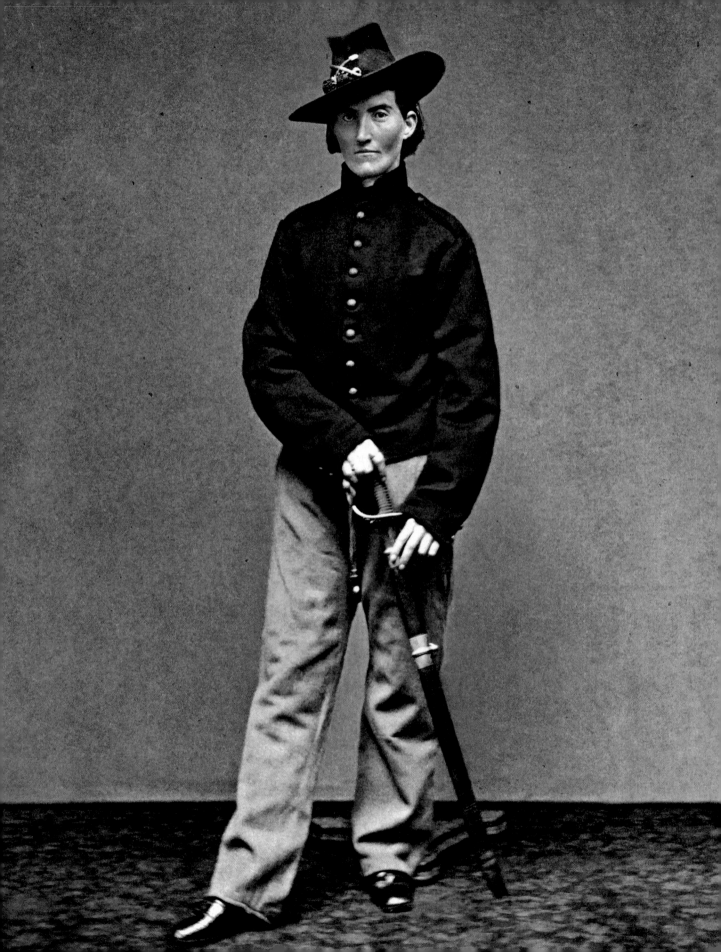

'Jack Williams'

This photograph, taken in a Boston, Massachusetts studio around 1865, shows a female soldier of the American Civil War. In civilian life she was known by her married name of Frances Clayton. But when in uniform she went by Jack Williams. Clayton signed up for the Union Army in Missouri, a Confederate state, in autumn 1861, a few months after war had been declared. As Jack, she served for 22 months, first in heavy artillery and then in the cavalry.

Noted for her abilities on horseback and with a sword, Clayton fought in the Battle of Fort Donelson in February 1862. She was injured during that engagement, but recovered sufficiently to serve in the Battle of Shiloh in April 1862. At the Battle of Stones River, fought between 31 December 1862 and 2 January 1863, her husband was killed; she is reported as striding over his body to continue fighting. Later that year, in Louisville, Kentucky, Clayton was discharged, supposedly after her true identity was discovered. Little is known of her after that.

After Clayton left the army, many newspaper reports were printed about her. However, they contained much conflicting information, giving three different first names for her husband. No military records have been found for her. Nevertheless, the power of this photograph is undeniable, and tells an important story of the Civil War, in which between 500 and 1,000 other women are known to have masqueraded as men in order to enlist and fight.

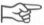

Edith Cavell

Aboard the Royal Navy destroyer HMS *Rowena*, the flower-covered coffin of the British teacher, nurse and war hero Edith Cavell is transported from Ostend to Dover in May 1919.

Born in 1865, Cavell worked as a governess in London and Brussels, then began a career in nursing at the age of 30, working in London, Manchester and, from 1907, a nursing school in Brussels. During the First World War, this became a Red Cross hospital with Cavell in charge. She was also part of a resistance network helping people over the border into neutral Holland. After being betrayed by a French collaborator, she was imprisoned for ten weeks, then court-martialled for treason, during which she admitted her actions. Her death sentence led to international outcry. Appeals for clemency failed.

At dawn on 12 October 1915, Cavell was executed by firing squad. She was 49 years old. Her body, first buried in Brussels, was repatriated after the war. A state funeral was held at Westminster Abbey before her body was laid to rest at Norwich Cathedral, a few miles from where she grew up.

The night before her execution, the British chaplain of a Brussels church visited Cavell in prison. 'To my astonishment', he later wrote, 'I found my friend perfectly calm and resigned... She [said], "I realize that patriotism is not enough. I must have no hatred or bitterness towards any one."' The German chaplain who attended her execution told him, 'she was brave and bright to the last. She died like a heroine.'

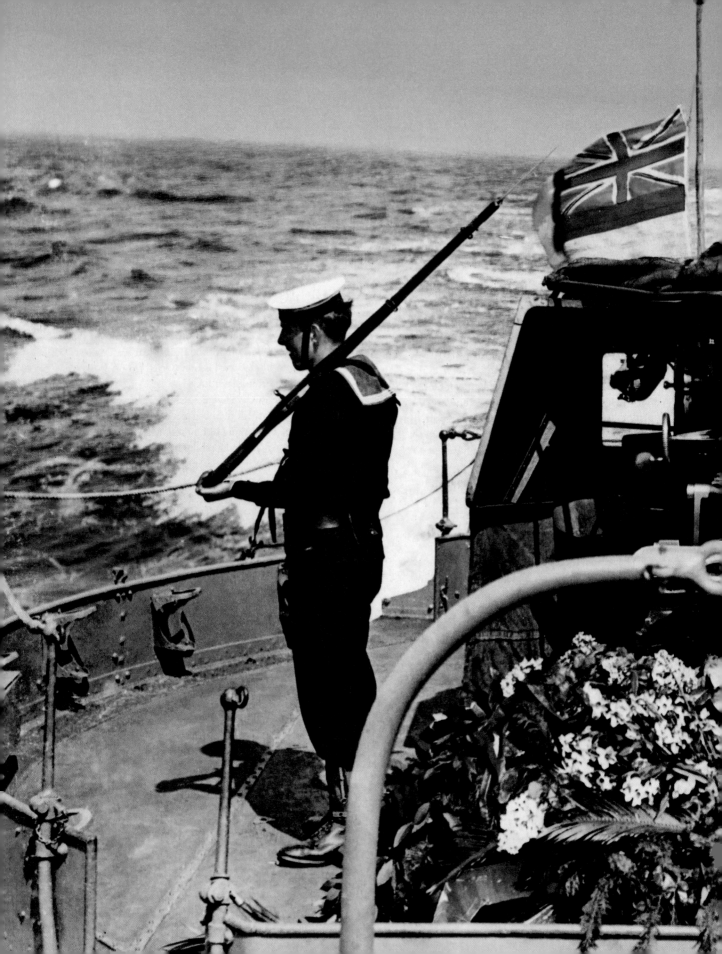

Women's Land Army

The outbreak of the First World War created a labour crisis in British agriculture. In the first year of the war, about 100,000 farm jobs had been left empty by men going off to fight and, although thousands of women stepped up to fill some of those roles, food production levels were dropping. Volunteer organizations such as the Women's National Land Service Corps, an offshoot of the Women's Farm and Garden Union, helped to train more women in farming skills and smooth their path to employment, but it was not enough. In 1916, another 40,000 full-time female farm workers were still needed.

One of the most basic problems was prejudice: many people, in farming and government, felt that women were simply not strong enough for farm labour. To try and dispel this myth, the Board of Agriculture and Fisheries organized country shows, at which women showcased their skills in demonstrations and competitions. Eventually, in March 1917 the Board formed the Women's Land Army, implementing a four-week training period and a minimum wage for the women, known as Land Girls. This photograph, taken in April 1918, shows Land Girls on a recruitment march in London.

By the end of the war the Women's Land Army had 23,000 members, and the total number of women working on the land during the war was estimated to be 300,000. The Women's Land Army was disbanded in May 1919, six months after the war ended, but was re-established in June 1939, as global conflict again became imminent.

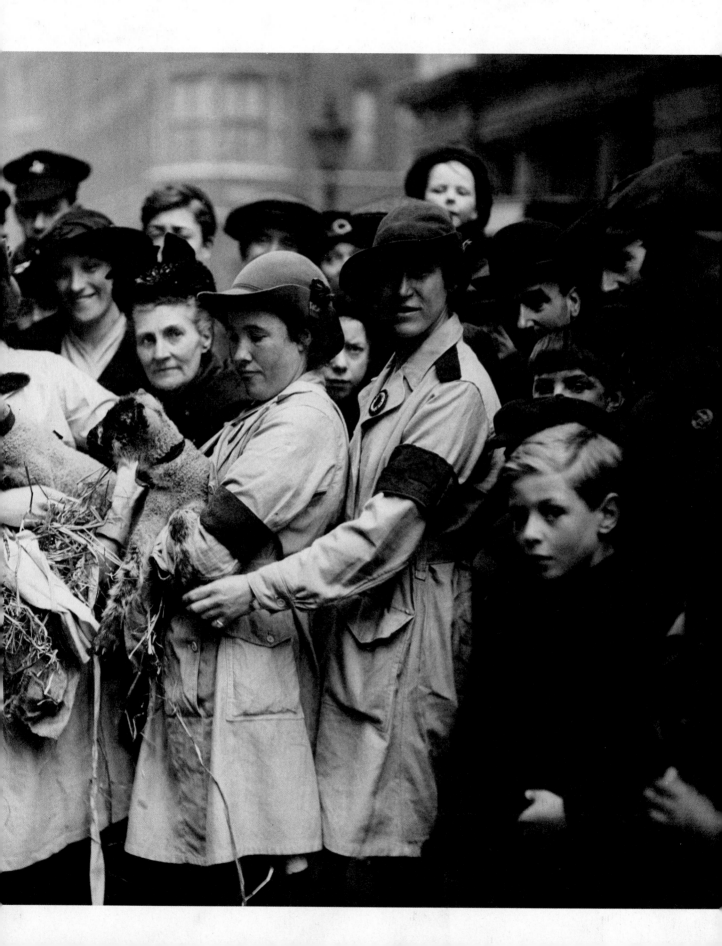

Lena Ashwell

Lena Ashwell, pictured here around the year 1900, was a British actress and theatre manager who had appeared in plays in London and New York before moving into theatre management. Although no soldier, she was a pioneer of a popular form of military entertainment, organizing performances by actors, musicians and comedians to raise the morale of front-line troops.

Early in the First World War Ashwell lobbied to be allowed to take a troupe of entertainers to the western front. The first party went to Le Havre in France in February 1915 and gave 39 concerts in 15 days. The standard line-up included four vocalists, two musicians and an entertainer, typically a comic. Later, one-act plays and scenes from Shakespeare were introduced. Ashwell's final concerts were given in May and June 1919 in Cologne, for the Army of Occupation. Over 400 actors, singers, musicians and entertainers performed, with Ashwell in charge throughout.

Critics scorned the notion that ordinary soldiers would take to theatre, especially Shakespeare, but in her 1922 memoir, *Modern Troubadours*, Ashwell noted that in letters home, soldiers 'wrote at great length and with great enthusiasm about the plays'.

After the war, Ashwell continued to put on shows in new or unfashionable venues, running a London theatre company, the Lena Ashwell Players, which performed in halls and rooms far from the West End. She eventually ran out of money, but the wartime tradition she established continues to this day.

Munitions Factory

In 1915, running low on shells after the opening phase of the First World War, the British government established the Ministry of Munitions, which built and operated a network of factories making bullets, shells and other ordnance. Women were recruited as the primary workforce. This photograph, dated 1917, shows workers at National Filling Factory No. 6 at Chilwell, Nottinghamshire.

The work – machining shell cases, lifting and shifting heavy shells and hazardous chemicals – was hard, noisy and dangerous. A working week was 54 hours. And for women it was underpaid: the government argued against rewarding women in factories at the same rate as men, on the dubious grounds that this would be unfair on working women elsewhere, on lower pay, doing 'women's work'. *The Official History of the Ministry of Munitions*, published by the government in 1922, said a man's wage was for his family, a woman's wage was 'individual'.

By the end of the war there were perhaps a million female factory workers. Some were known as Canary Girls, since their skin turned yellow from exposure to the TNT powder with which they filled shells. And this was far from the only hazard of the job. Workers had to wear wooden clogs to avoid making sparks with metal in their shoes. On 1 July 1918, an explosion at National Filling Factory No. 6 killed 134 people, 102 of whom could not be identified, their bodies buried in a mass grave. Work began again the next day.

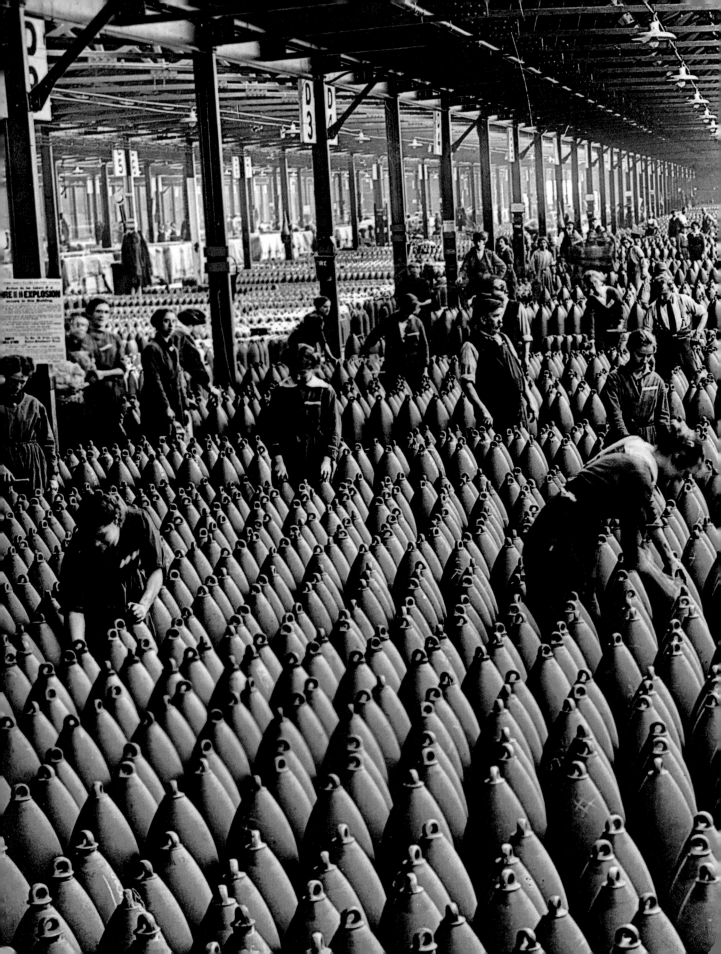

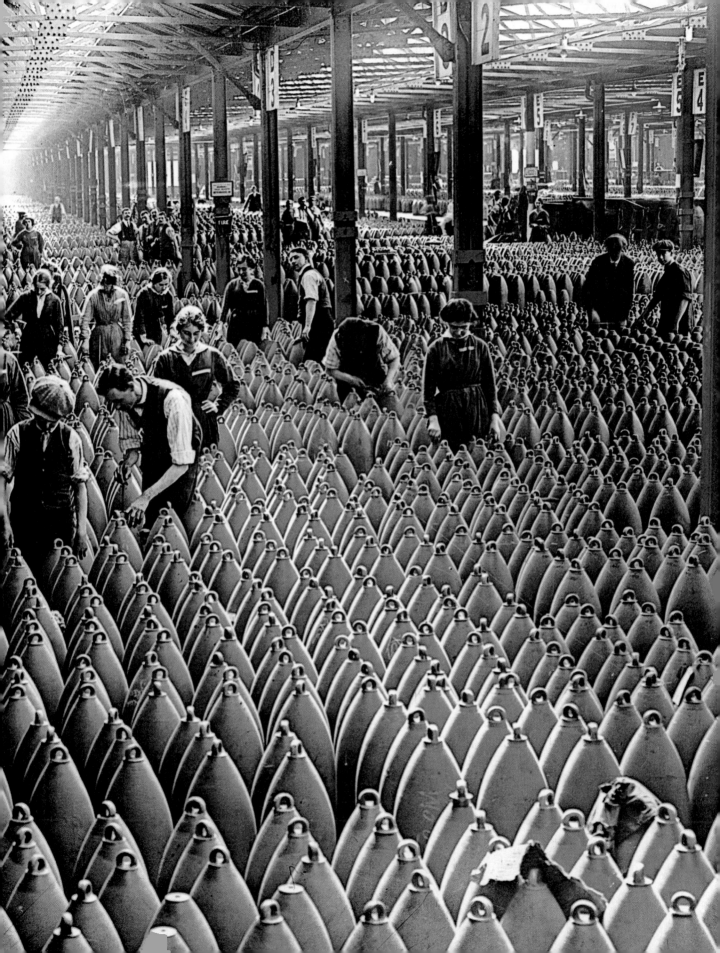

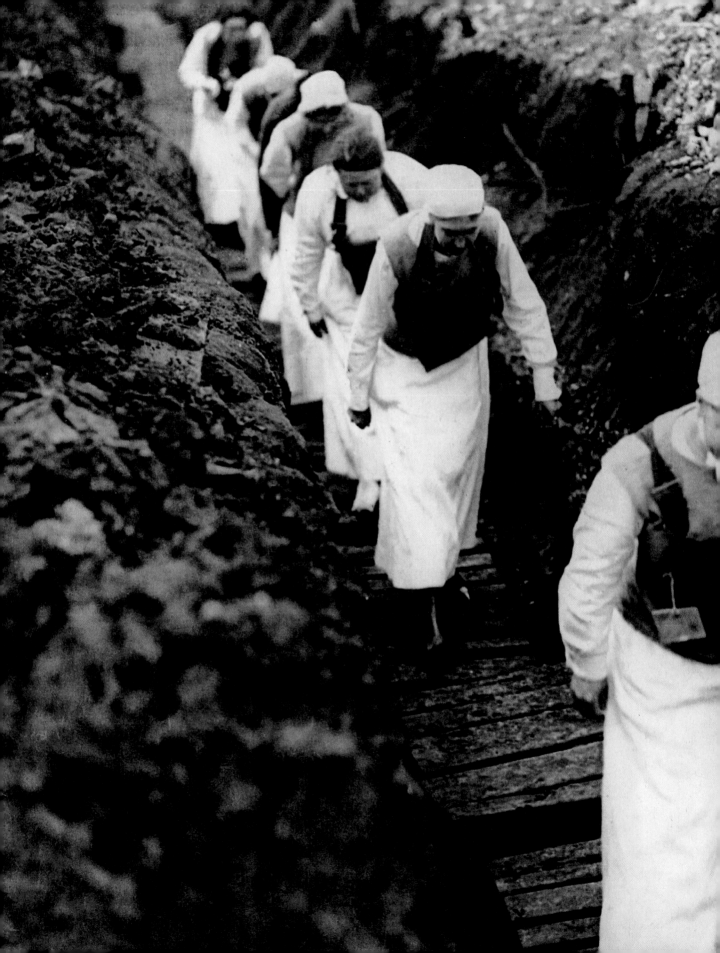

In the Trenches

These American nurses are carrying gas masks as they walk through a First World War trench in France in 1918. American troops engaged the enemy at the European front for the first time in October 1917, but American women had been in action since the outbreak of war in 1914. The volunteer nurses of the American Red Cross gave aid – medical treatment, ambulance rides, hot food and drink – to combatants of all nations before the US's declaration of war; after that, no longer neutral, they provided aid only to the Allied Powers. They also helped and trained the nurses of the United States Army Nurse Corps (ANC), which recruited 20,000 registered nurses, half of whom served on the Western Front, in ambulance companies and field hospitals.

The nurse and writer Ellen La Motte worked in a French field hospital 10 kilometres behind the front line in Belgium between 1915 and 1916. Short essays she wrote about her time there were published in the American magazine *The Atlantic* and, in 1916, collected in a book, *The Backwash of War*, a rare war memoir to appear during the conflict it discussed. La Motte spared no details – of bloody injury, of the effects of poison gas, of dying soldiers begging to be killed, the depressing futility of it all. The book's brutal frankness led the White House to ban it in 1918, in case it damaged American morale.

The 'Battalion of Death'

As we have already seen (see 'Lady Death', page 120), Russia was the only country to send female soldiers to fight at the front during the First World War. Perhaps the most famous group of women in the Army was the 1st Russian Women's Battalion of Death, led by 27-year-old Lieutenant Maria Bochkareva.

Bochkareva was an appropriate person to lead such a battalion. She had enlisted in the Army in 1915, after securing permission via telegram from Tsar Nicholas II. Inside her first two years of service, she had been decorated for bravery, injured twice and saw front-line action at least three times. She pitched the idea for an all-female battalion to her superiors in 1917, at a moment when the Russian military was in turmoil. Bochkareva's hope for the Battalion of Death was that it might shame faltering male troops into giving their all to the war effort.

In July 1917, 300 women of the Women's Battalion of Death took part in the Kerensky Offensive, Russia's last significant military act of the war. They fought fiercely, suffering about 50 deaths and 100 casualties, including Bochkareva, who was knocked unconscious by an exploding shell and carried to a field hospital.

Bochkareva earned a poor reward for her service. After the war was over she was declared an enemy of the working class and sentenced to death following a four-month interrogation by Soviet secret police. She was executed on 16 May 1920.

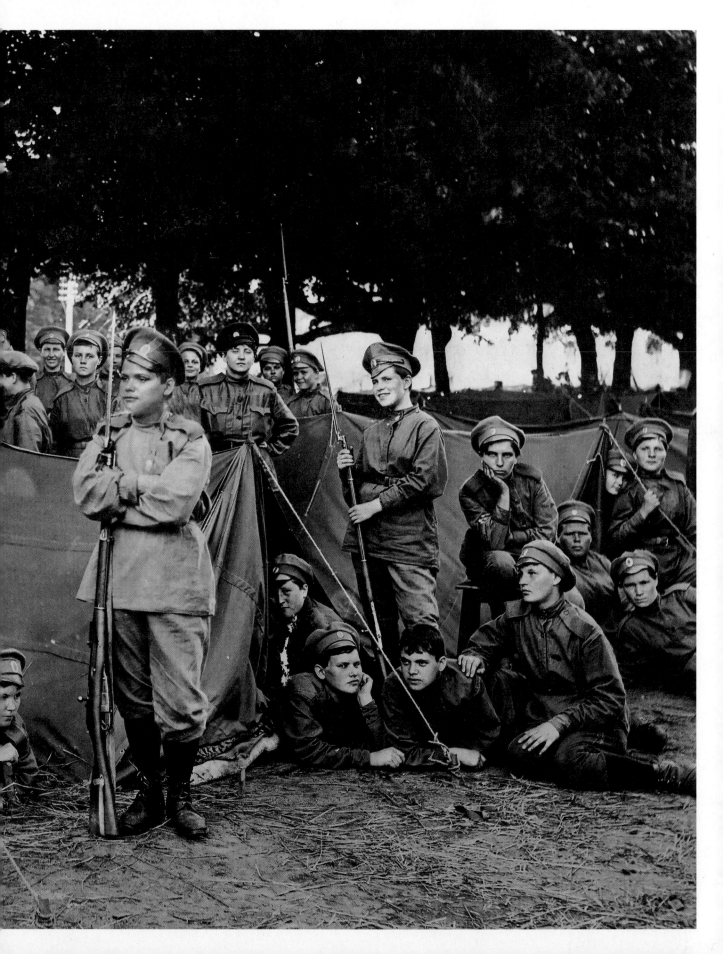

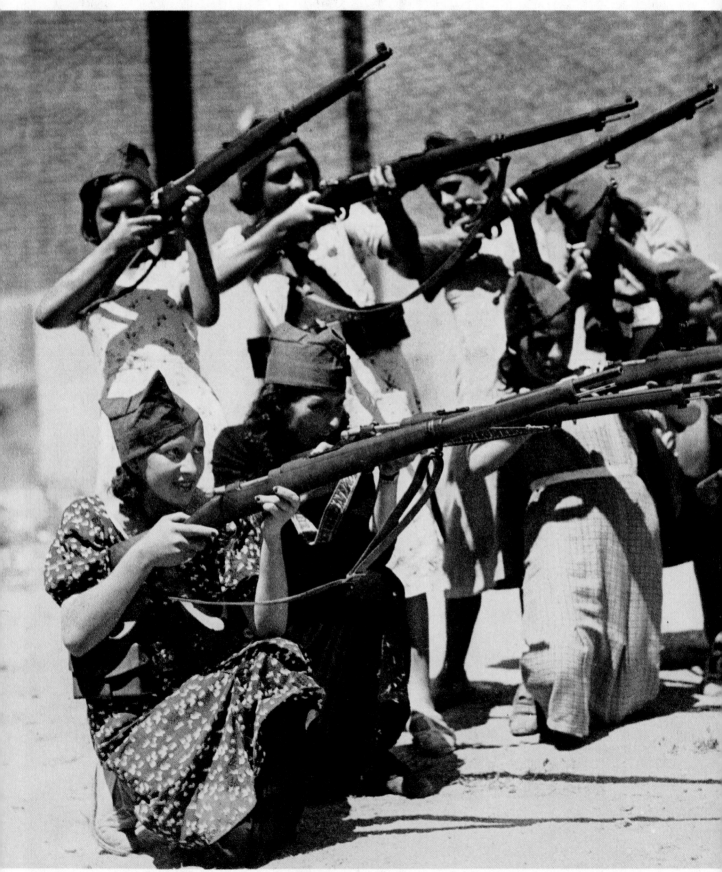

Milicianas

During the Spanish Civil War, fought between July 1936 and March 1939, fascist Falangist insurgents fought and eventually overcame the democratic Republican regime. About a thousand militia women, known as *milicianas*, defended the Republic on the front lines, with several thousand more in the rearguard. Another several hundred women fought in the International Brigades, the communist-backed fighting force comprised of overseas combatants. At the front, women fought alongside men in mixed-gender battalions, with women-only battalions found at the rear.

The risks were mortal. On 14 September 1936, in the ninth week of the war, Lina Odina became the first miliciana to die in battle, when she committed suicide in the face of capture. The stories of Odina and women like her were used as propaganda on both sides: Republicans recounted tales of heroism in the face of right-wing terrorism, while Falangists scoffed at the presence of women on the battlefield.

During the winter of 1936–7, women began to be removed from front-line duties. Male Republicans fighting in the streets had no problem with the women alongside them, but the leadership told women to join the rearguard action or support the fighting in other ways. In May 1937, the new leader of the Republican armed forces stepped up efforts to bring disparate fighting groups together as an army, and women were excluded. Overseas organizations were told to send only men for the International Brigades. The last photograph of miliciana appeared in the Republican press in May 1937.

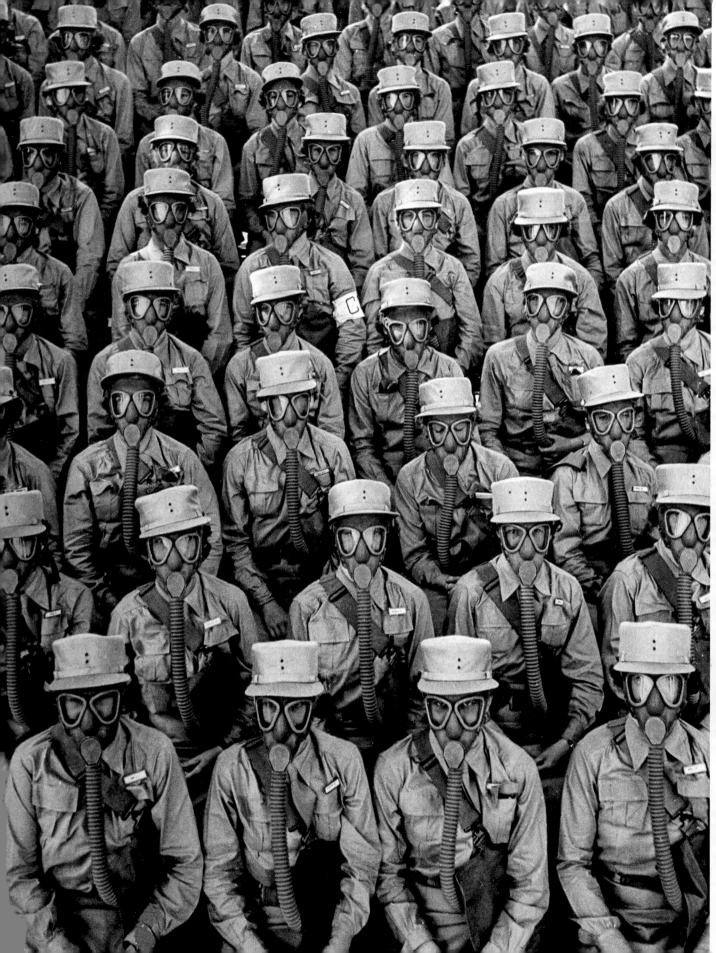

The WAC

This photograph of US Women's Auxiliary Army Corps (WAAC) volunteers wearing gas masks during training drill at Fort Des Moines, Iowa was taken by the photojournalist Marie Hansen and printed in the 7 September 1942 issue of *Life* magazine. It was part of a photo essay of 34 images that gave America its first look at the WAAC.

The WAAC had been founded in May of that year, and had proven popular: 35,000 women applied for about 1,000 places on training courses held at Fort Des Moines in the summer. 'The idea behind [the WAAC] is simply this: Women can do some of the jobs that men are doing in the Army,' *Life*'s editors wrote, to introduce the pictures. 'By taking over these jobs, they can release men for active or combat duty.' Women learned to become weather forecasters, radio mechanics, cryptanalysts, sheet metal workers and surgical technicians, among many other jobs. In July 1943, the WAAC became the WAC, when the corps was converted to 'active duty' status and women received the same rank insignia, pay and allowances as men. In 1944, WAC units went overseas wherever US troops needed support, including to the beaches of Normandy after D-Day.

At the end of the war, General MacArthur, commander of the US Army in the Far East, praised the WAC for working harder, complaining less and being better disciplined than men. They were, he said, 'my best soldiers'.

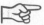

Special Delivery

In Britain during the Second World War, the Air Transport Auxiliary (ATA) was an organization of civilian pilots that flew military aircraft on ferry flights, transporting and repositioning planes around the UK, freeing combat pilots to fly combat missions. Ferrying in wartime could mean taking a brand-new plane from the factory to an air base, an almost-finished plane to a maintenance unit to have guns installed, a damaged plane to a repair shop, or a terminal specimen to the scrap yard. ATA pilots flew over 309,000 ferry flights between early 1939 and late 1945.

This was difficult work. For security, radio silence was mandatory, so ATA pilots had to fly in sight of the ground. Wartime skies contained barrage balloons as well as the threat of enemy aircraft. ATA flights, by civilian law, could not have loaded guns. And pilots often flew aircraft they'd never flown before, using printed notes to guide them in the air.

Eight women pilots joined the ATA's ranks in January 1940; this picture shows Joan Hughes, of that initial group of eight women, on ATA work in a Lockheed Hudson bomber in September 1944. Later that year, Britain's most famous female pilot, Amy Johnson (see Transport, page 109) joined the ATA. Johnson was killed during a flight in 1941, one of 15 women pilots who died in the course of their duties. From 1943, the ATA's women pilots were paid the same as men of equal rank – the first time such a measure had been mandated in any British government organization.

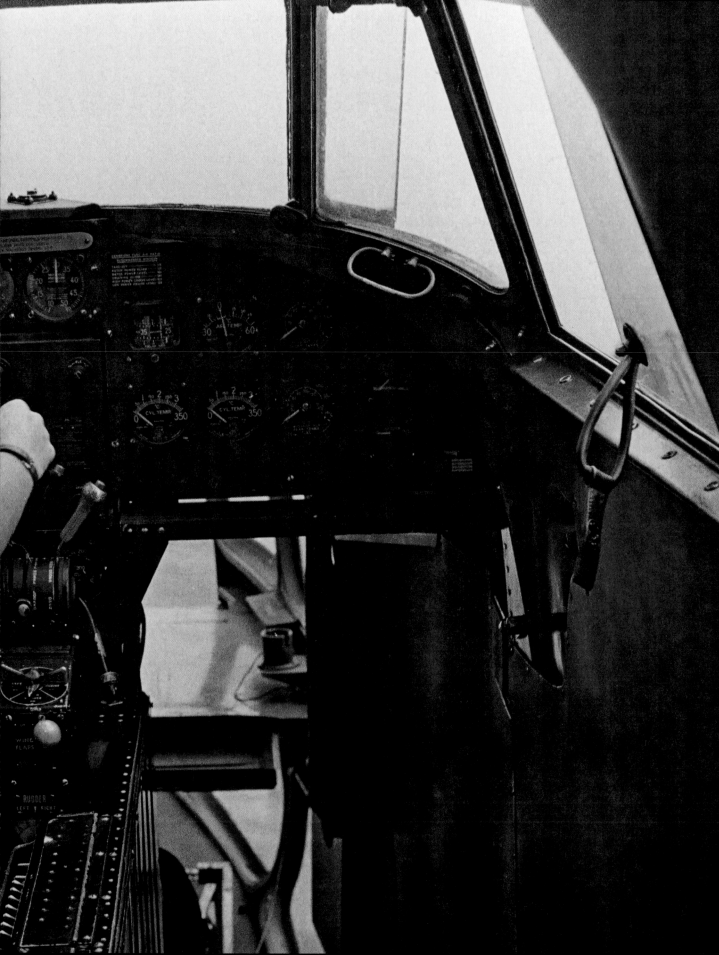

Josephine Baker

The American singer, dancer and civil rights activist Josephine Baker was famous for wearing a skirt made of artificial bananas and a string of pearls on the stages of Paris. During the Second World War she performed in concerts at Allied military camps in North Africa. However, she was more than just a morale-boosting entertainer. Early in the war she worked as a spy, gathering and couriering information for French military intelligence.

When the war began in 1939, Baker volunteered her services to her adopted country in gratitude for the life it had given her. (She is photographed here wearing the uniform of the French women's naval auxiliary.) As a spy, her fame was her cover. At embassy functions in Paris, generals and diplomats overshared with her and she made notes of their indiscretions. She smuggled documents when touring overseas and sheltered members of the Resistance in her chateau. In 1941 and 1942, she was the hub of an information network in Casablanca, despite spending 18 months in hospital after a near-fatal bout of peritonitis.

After the war, Baker performed again in Paris, at the Folies Bergère, and in America, where she insisted on playing to integrated audiences and became a figurehead in the civil rights movement. In 1961, her wartime work was revealed when she received the Legion of Honour, France's highest order of merit. She died in Paris in 1975 aged 68 and was given a state funeral with full military honours.

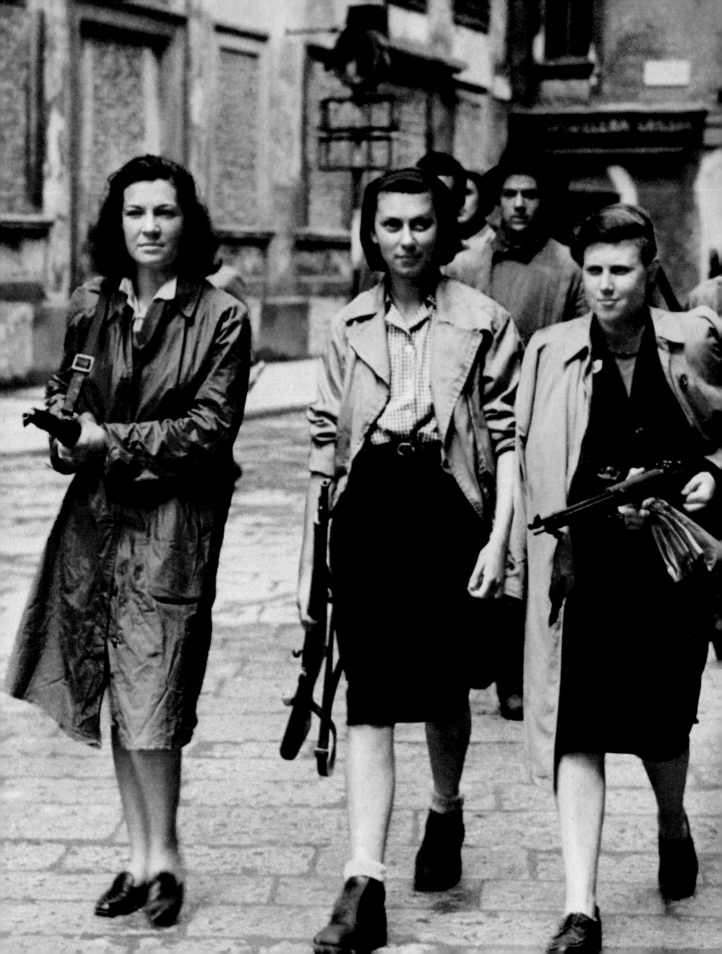

Italian Resistance

These Italian anti-fascist partisans took to the streets of Milan when the Italian city was liberated in April 1945. Italian women played a vital role in the resistance that fought the ruling Fascists in the Italian Civil War, from September 1943 to April 1945. The resistance was also then fighting the occupying German army, especially in the north and centre of the country, as Allied troops made their way up from the south.

Women had suffered greatly under Mussolini's Fascist government, which had taken power in 1922. Mussolini said the main role of women was to be mothers, and this attitude was reflected in his economic policies: men who fathered six or more children did not have to pay tax, while women were prevented from working in certain occupations and, when they did work, received lower wages than men. So when the opportunity came to fight back, against first Mussolini and then the Nazis, women stepped up in great numbers. About 35,000 Italian women took up arms in partisan brigades.

Many more served as 'staffettas' in a countrywide supply and communication network operating when the postal and telephone networks were limited and unsafe. Staffettas smuggled arms, supplies and equipment in fake pregnant bellies and prams, or disguised as Red Cross nurses. They were crucial to the success of the resistance movement, which triumphed in April 1945 with the liberation of the largest cities in the north: Bologna, Genoa, Turin and Milan.

Hoa Hao

In July 1948, when the photographer Jack Birns took this photograph of a group of women from the Hoa Hao religious movement undergoing jungle warfare training in French Indochina, the country was at war. A communist-backed united front, Viet Minh, was fighting to shake off French colonial control and restore a free Vietnam. Viet Minh was a coalition of groups seeking independence, in which the Hoa Hao briefly participated, until a disagreement led them to take funding from the French. The Hoa Hao's militant nationalist beliefs would set them against all sides in the complex political and military struggles to come, not least after Vietnam was divided in two, leading to the Vietnam War from 1955 to 1975.

During that war, several million women served in guerrilla groups, militias and the military in North and South Vietnam, especially in the Liberation Army of South Vietnam (LASV), the armed wing of the North-controlled Viet Cong. The Vietnamese People's Army, the North's primary state military force, had a female general who commanded men and women and also led a women-only unit of spies. For the South, the People's Self-Defence Force, a rural militia, had about a million women signed up, 100,000 of whom were combatants. The South's failure to recruit as many women into its military as the North became powerful propaganda for the latter, which some believe contributed to its winning the war.

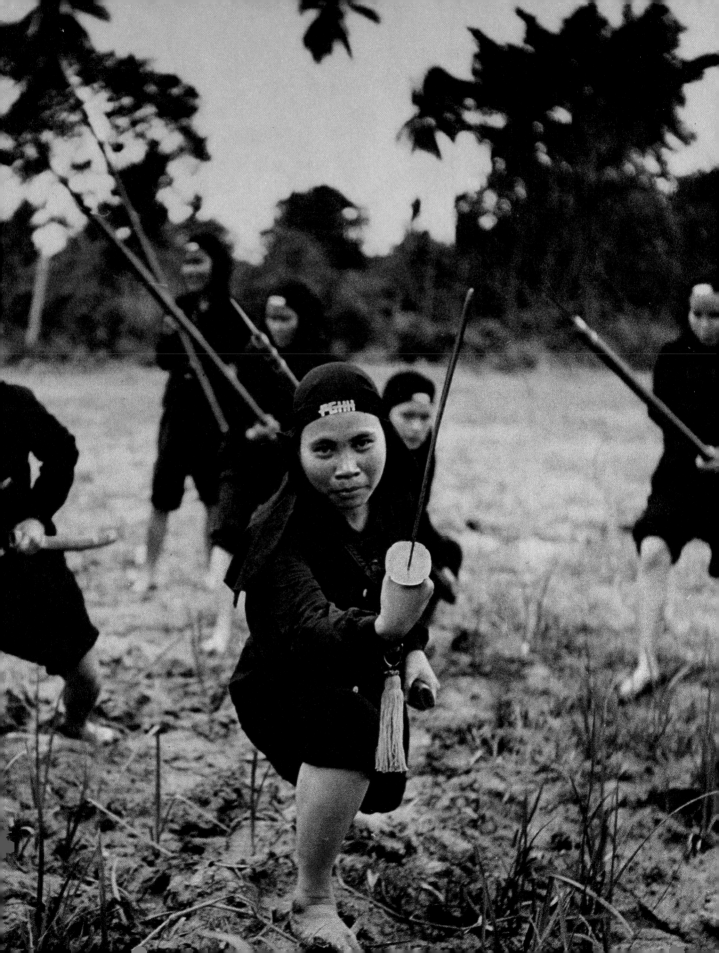

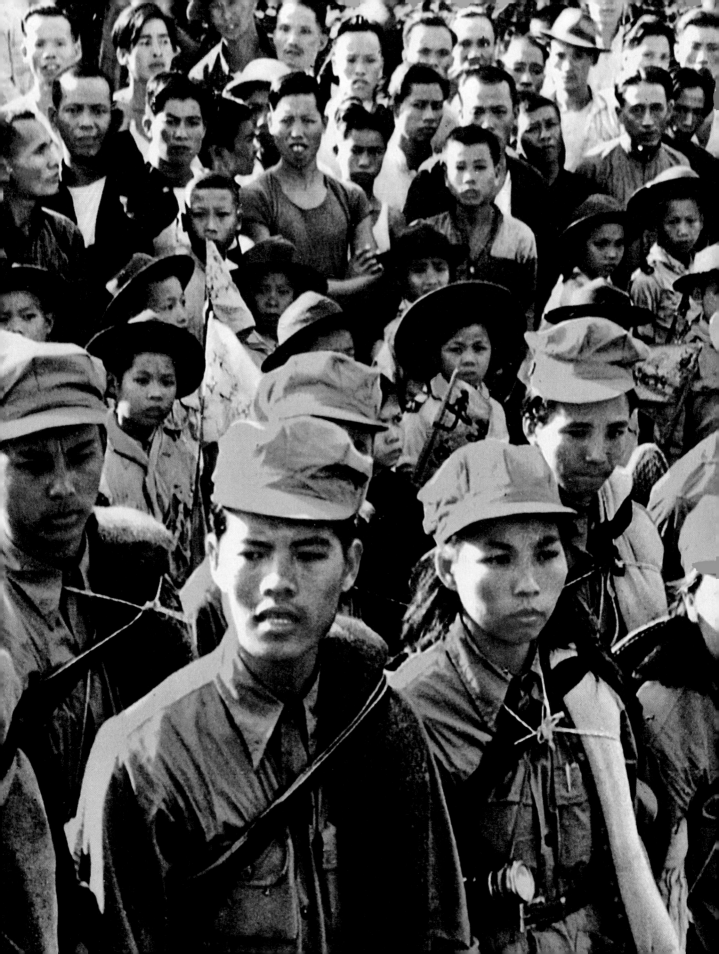

The People's Army

When Mao Zedong proclaimed the People's Republic of China on 1 October 1949, the women of China had good reason to be hopeful. Mao promised several new policies favourable to women, based on successful measures that had already been implemented locally in communist strongholds before he took power of the whole country.

These included: giving women the right to own land; changing the divorce law so only one party needed to agree, not both; and encouraging women into the workplace. But all these measures backfired: men divorced older wives, who then found it hard to claim back their own land from that combined by marriage, and women were mostly given low-paid menial jobs with few or no benefits. For the women who fought and worked in support of the revolution, these blows were especially severe.

This photograph, dated 24 October 1949, shows soldiers from the East River unit of the People's Liberation Army (PLA) glorifying Mao in song. The PLA marched and sang in displays of communist strength and unity throughout the country. Women were not permitted to fight, but in their thousands they performed combat support roles such as nursing and ferrying supplies. They also worked to build roads and bridges, and as guards and instructors in prisoner-of-war camps. Female militias also formed, mostly away from large urban centres. The future freedoms for which those women put their lives on the line would never materialize.

A Lone Gunwoman

Guatemala in the 1950s was a turbulent country, bubbling with revolutionary tension stirred up by the US Central Intelligence Agency, who saw it as an important theatre in the Cold War. In 1951 the nation had elected as its president Jacobo Árbenz Guzmán, who instituted a series of radical land reforms, which seemed to bring communism to the Americas, while threatening the interests of US multinational corporations like United Fruit. The CIA launched a campaign to overthrow the president, sponsoring and training a rebel army led by Colonel Carlos Castillo Armas. The woman pictured here wielding a submachine gun is Maria Trinidad Cruz, reputed to be the only woman in the rebel ranks.

Latin American women had been called to revolution before Trinidad Cruz, among them Anita Garibaldi (see above, page 123) and Simon Bolivar's lieutenant-lover 'Manuelita' Sáenz. CIA propaganda sought to cast Trinidad Cruz in this tradition. American news outlets who carried her image reported that she had been widowed and ruined by the president's regime: her husband shot dead by 'Reds' and her business interests destroyed. She had therefore joined a rebel training camp in Tegucigalpa, Honduras, and been part of the rebel invasion of Guatemala in June 1954. This photograph was taken on 4 July, and shows Trinidad Cruz guarding Armas' headquarters in the city of Chiquimula. Days after it was taken Árbenz was deposed and Armas declared president in his place. This began a cycle of violence that became the Guatemalan civil war, which raged between 1960 and 1996 and left 200,000 people dead or missing.

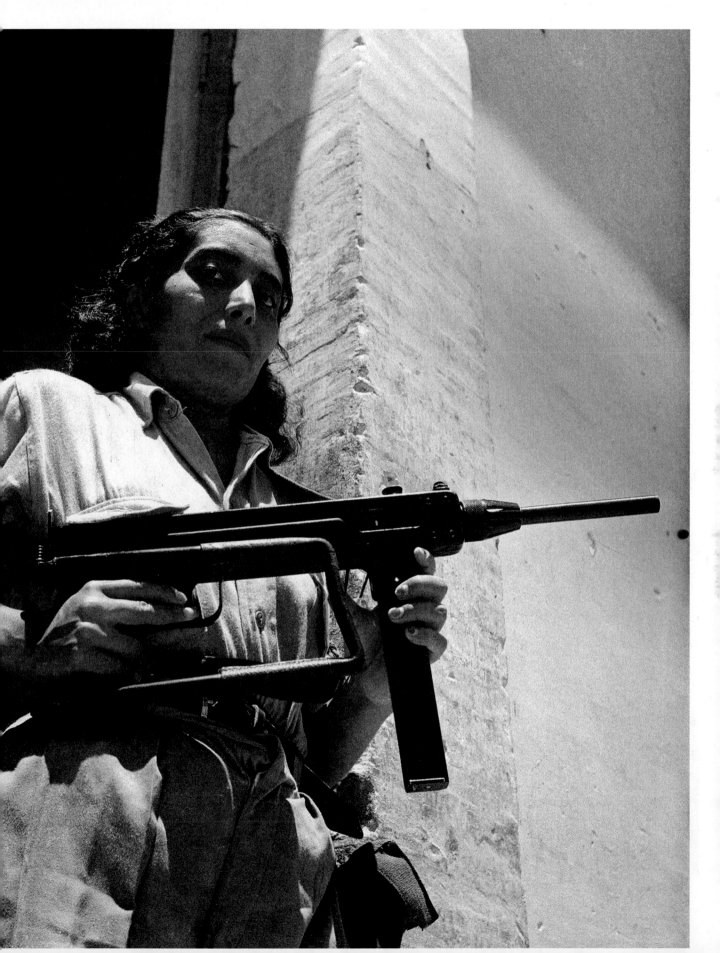

Mau Mau

The Mau Mau Rebellion in Kenya from 1952 to 1960 was a brutal, unsuccessful uprising. But it set the east African nation on a path to independence from Britain.

The British first laid claim to Kenya in 1895 and declared it a colony in 1920. But there were frequent revolts against London's highhanded and faraway rule. In the summer of 1952, the Kenyan Land and Freedom Army (KLFA), colloquially known as Mau Mau, launched a series of fierce attacks on the colonial powers and Kenyan loyalists. The following year, the British retaliated in kind.

This image was taken by the photographer Bert Hardy in 1952, for a photo-essay in the British magazine *Picture Post*. It shows a Kenyan policeman, under British authority, hauling a Mau Mau suspect out of her bed. Few women fought in the KLFA, but a large number were successfully deployed in supply and communication networks, and they were targeted by the authorities as a result.

Between 8,000 and 20,000 Mau Mau women were detained in two detention camps, one of which was reserved for 'hardcore' women who were said to be of 'unsound' mind. In both camps, women were tortured, raped and murdered. A further one million people from the Kikuyu ethnic group to which most Mau Mau belonged were forcibly resettled and starved in 800 villages similar to prisoner-of-war camps, with barbed-wire fences and watchtowers. By 1956, Mau Mau had been crushed. In the course of the struggle at least 25,000 and perhaps as many as 300,000 Kenyans were killed.

The Invincible People

On 1 January 1959, Fidel Castro's Red Army marched into Havana to signal the end of the Cuban Revolution, after five years, five months and six days of armed insurgency. This photograph was taken in Havana on the same day, in the lobby of the Hilton Hotel. In the city that day, Castro said: 'We organized units of women which showed that women can fight. And when a people has men who fight and women who can fight, that people is invincible.'

Historically, socialist, communist and anti-fascist fighting forces in uprisings had more women in front-line and combat roles than their opponents. Leftist values of equality, social progressivism and civil rights appealed to women who lived under regimes where they were actively – and sometimes legally required to be – second-class citizens. In 1958 there were about 150 female soldiers out of a Red Army total of 3,000: 5 per cent of the insurgent fighting force.

In August 1960, the Cuban Women's Federation was founded with the express purpose of educating and training women to be part of the new workforce and economy of Cuba. On the eve of the revolution, two-thirds of Cuban women were housewives, and of those who worked, 70 per cent were in domestic service. In the 1960s and 1970s women in Cuba gained access to better education and more varied jobs. However, they did so under a communist dictatorship, where basic rights were repressed.

Women
in Charge

Taytu Betul was Empress of Ethiopia from 1889 to 1913, as wife of Emperor Menelik II. Given the consort title 'itege', she was more than just the leader's spouse: she was a key advisor to the emperor, played an active role in national affairs and led troops into battle in defence of Ethiopia's independence. Among her many other political achievements, she launched banks and hotels, promoted secular education and founded churches and nunneries. One church she funded, Entoto Maryam, was built on a hill overlooking Addis Ababa, a city founded under Menelik's authority but located on a site chosen by Taytu, who also gave Ethiopia's capital its name, which in English means New Flower.

Taytu was born around 1850 into an elite family in northwest Ethiopia and was unusually fortunate to be educated as a child: by her teens she could write poetry and play music in classic national style, and was literate in Ge'ez, an ancient Ethiopian language. She was married for the first time at the age of ten. Menelik – whom she wed in 1883 when he was King of Shoa, in central Ethiopia – was her sixth husband, and the couple struck up a fruitful political partnership. In 1889 Menelik proclaimed himself Ethiopian Emperor, succeeding Yohannes IV; Taytu was now the most powerful woman in the Empire.

As empress, Taytu was a traditionalist, who believed that the country's future strength and continued independence from colonial rule was dependent on maintaining the cultural and religious ways of its past. She took a hands-on interest in government, and was active in placing her own relatives in powerful political positions throughout the Empire, until some observers reckoned she held half of Ethiopia under her command.

This private political network operated alongside her own private army, more than 5,000 strong, with its own artillery unit. Her troops proved particularly useful during the First Italo-Ethiopian War of 1895–6. At the Battle of Adwa (March 1896), her troops played a decisive role in the Ethiopian victory. Taytu was on the battlefield during the fighting, leading a group of female nurses, cooks and stretcher-bearers and assisting in surgeries at a field hospital.

Menelik suffered a cerebral haemorrhage in 1906, from which he never fully recovered. After he had a stroke in 1909, Taytu became de facto head of state. However, since she and Menelik had never had children, her rise to supreme power made her a target as other political players contested the imperial succession. In March 1910 a plot to push her aside succeeded, after which she was only allowed in the imperial palace to nurse her husband. Following Menelik's death in December 1913, Taytu retired to live in the church at Entoto Maryam, where she died in 1918.

Compared to more famous contemporary female rulers – such as Britain's Queen-Empress Victoria – Taytu wielded an extraordinary degree of political agency. She also paved the way for female rule in Ethiopia. In 1916 Menelik's granddaughter Zewditu became empress in her own right, albeit with the future emperor Haile Selassie as regent. (The first female president of Ethiopia, Sahle-Work Zewde, took office in 2018.) In that sense, Taytu Betul was a woman of her time – an age where women's right to exercise royal, political and religious power was slowly beginning to gain worldwide acceptance.

'The Traditional Queen'

Queen Isabella II of Spain's reign officially began in the autumn of 1833, shortly before her third birthday. Her father had changed the nation's constitution in order to allow her to succeed him, setting aside French-derived Salic law, which prohibited women from taking royal power.

However, having ascended the throne as a child monarch, Isabella II never enjoyed much peace. Her right to rule was bitterly contested throughout her life by other (male) claimants, in a series of dynastic conflicts known as the Carlist Wars. She often relied on strongman ministers to shore up her rule – one was unsubtly nicknamed 'the Big Sword'. Isabella married her first cousin, Francisco di Asís, gave birth a dozen times to children who may or may not have all have been his, endured an assassination attempt outside a church and was eventually forced out of her country in Spain's so-called Glorious Revolution of 1868. Two years later she abdicated, and her son Alfonso XII was eventually installed as her heir, in 1874. She returned to Spain occasionally during his reign but was in Paris when she died in 1904.

This was a reign whose dynastic drama smacked of a bygone age, so it was fitting that Isabella was nicknamed 'The Traditional Queen'. This picture of her was originally taken in the 1860s. During this decade, photographs of European monarchs became particularly popular and were often sold, swapped and collected as 'cartes-de-visite', in a craze known as 'cardomania'.

'Queen of the Poor'

Angela Burdett-Coutts, pictured here, was not a monarch, but she was almost as rich as one. She was friendly with the French emperor Napoleon III and her jewellery collection included a tiara once worn by Marie Antoinette. In the opinion of the future Edward VII, she was 'the most remarkable woman in the country' after his mother, Queen Victoria, herself.

From her father, a politician, Angela inherited a fine brain, progressive views, powerful contacts and great oratorical skill. Through her mother she inherited a vast amount of money and the banker's surname Coutts. She spent her life using her wealth, and the influence it bought her, for good causes. She built and endowed churches and founded schools. She patronized artists and funded scientific research. She toiled and spent large sums trying to alleviate poverty in East London, working closely with the novelist Charles Dickens. A keen animal-lover, she served as president of the Ladies' Committee of the RSPCA.

Burdett-Coutts gave away millions of pounds in her life and lost more than half her fortune when she married a much younger American man – breaching the terms of her original inheritance. She was nicknamed 'Queen of the Poor', and 30,000 people paid their respects when she died in 1906, aged 92.

This photograph was taken in 1882 by Francis Henry Hart, a photographer associated with the London studio Elliott & Fry. This studio did a booming business during the nineteenth century producing and distributing images of Victorian England's best-known figures.

Mary Baker Eddy

Mary Baker Eddy did more than just rule: she founded a religion. Born into a strictly Protestant family in New Hampshire, US, in 1821, Eddy spent much of the first half of her life dirt-poor, ill or in pain. But in 1866, she hurt her spine in a fall on ice and experienced healing while reading an account of Christ's miracles. This, combined with a growing interest in homeopathic, 'mesmeric' medicine, influenced her as she set about establishing the movement that became known as Christian Science.

In 1875 Eddy published a book called *Science and Health with Key to the Scriptures*, which became the foundational text of Christian Science. At the root of her theology was the idea that matter was illusory, that the human senses were deceptive, that only the spirit truly existed. In the decades that followed, she continued to write and publish at an extraordinary rate.

A physical church was founded in Boston, Massachusetts; Eddy defined the structure of the movement at large in another book, entitled *Manual of the Mother Church* (she used the term Mother-Father God to refer to the supreme deity). Despite fallings-out with her early acolytes, and criticism from famous figures including Mark Twain, the church thrived and attracted followers in significant numbers. By the time of Eddy's death in 1910, Christian Science was an established and successful, if somewhat controversial, religious movement – one of the very few in human history to have been founded by a woman.

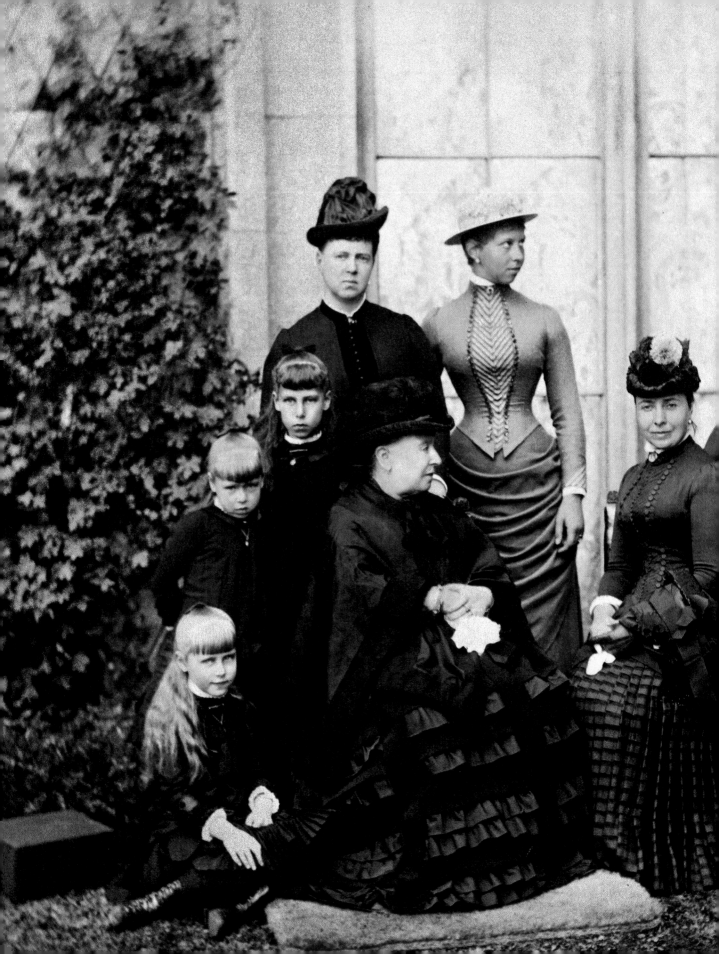

'Grandmother of Europe'

Queen Victoria gave her name to a famous era of Western history, and her reign was characterized by her extraordinary personal longevity and political circumspection.

After a rather dull and cosseted childhood, Victoria succeeded her uncle, William IV, in 1837, when she was aged 18. She ruled as queen of the United Kingdom and the dominions of the British Empire for the rest of the century; from 1876 she was Empress of India. In that time, Britain grew to become the world's leading industrial power, with much of that power built on the exploitation of other lands and people.

The Victorian age to which the queen-empress lent her name is today associated with revolutionary advances in transport, communication, scientific enquiry and manufacturing, as well as with reforms in politics, education and public health. Some of this was sponsored directly by Victoria and her beloved consort, Prince Albert.

Although Albert died aged 42 in 1861, Victoria had nine children with him, and their marriages into the great European royal houses lent her the nickname 'Grandmother of Europe'.

This photograph, from a family album, shows the queen surrounded with a few of her offspring, relatives and descendants. The young grandchildren (left) are Princesses Marie, Alexandra and Victoria Melita of Edinburgh. Beside them is their mother, the Duchess of Edinburgh. Also standing are an older granddaughter, Princess Victoria of Prussia, and Victoria's youngest child, Beatrice. Seated is the Princess Royal, another Victoria.

Death of a Dowager

When Victoria died in 1901, her funeral was an extraordinary affair, attended by Europe's greatest rulers. But it was nothing compared to the mourning that took place seven years later in China after the death of the Empress Dowager Cixi. She had been regent and the power behind the throne for nearly half a century, directing affairs in the name of her son, the Tongzhi emperor, and, later, her nephew, the Guangxu emperor – both of the Qing dynasty.

Cixi had lived a luxurious life in the Forbidden City, surrounded by eunuchs and pets, having more than 100 dishes served at each meal, dressing in exquisite silks and adorning herself with precious metals and rare jewels. Her death rites were of a fittingly grand standard. This photograph shows Cixi's body being transported to the Qing mausoleum at Zunhua, 125 kilometres from Beijing. In another ceremony, at the Forbidden City, a funeral boat and set of wooden pavilions were burned, along with an army of life-size papier-mâché servants and courtiers dressed in fine robes and model soldiers riding fake horses. Cixi was entombed with a huge pearl in her mouth, which was believed to stop her body rotting. This was stolen when the tomb was looted in 1928.

Cixi's passing was not only spectacular, it marked the end of an era. The Guangxu emperor was poisoned with arsenic the day before she died, and power passed to a toddler, Puyi, who would be the last Qing emperor.

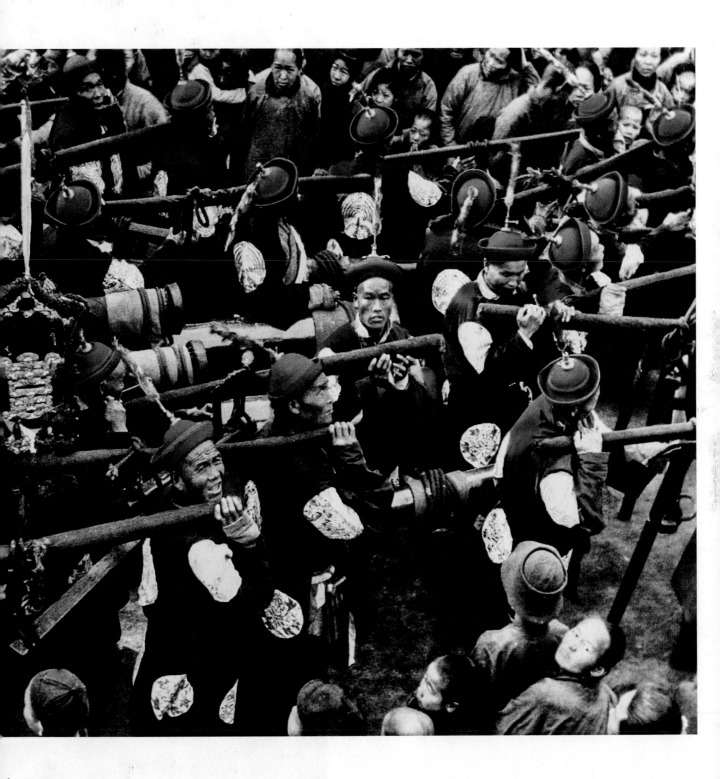

Queen Alexandra

The finery of the extraordinary costume worn here
by Alexandra, queen consort of the British king
Edward VII, would not have been out of place in
Cixi's Forbidden Palace. But the extravagance was
understandable. Alexandra was photographed in 1902
as she prepared for a joint coronation with her
husband – a moment for which she had been waiting
nearly 40 years.

'Alix' had been born to a minor and relatively
impoverished branch of the Danish royal family in
Copenhagen in 1844. But around her 16th birthday
she was headhunted to marry Queen Victoria's eldest
son; their wedding took place in Windsor in 1863. In
many ways, Alexandra was a dutiful and diligent
member of the British royal family: she performed
public duties, endured her husband's flagrant
infidelity and produced a brood of children
(including the future king George V).

Yet she also attempted to sway British policy,
particularly on the foreign stage, where she lobbied
for the interests of her brother, who had become
King George I of Greece, and her sister, who had
become the Empress of Russia as wife of Tsar
Alexander III. After her coronation, she was blocked
by ministers from involvement in foreign affairs –
misguidedly, as it transpired. She harboured a deep
distrust and dislike of Kaiser Wilhelm II of Germany
and warned repeatedly of the threat of German
aggression. She had more success in using her
position and popularity with the British public for
charitable work, urban improvement and helping
wounded war veterans.

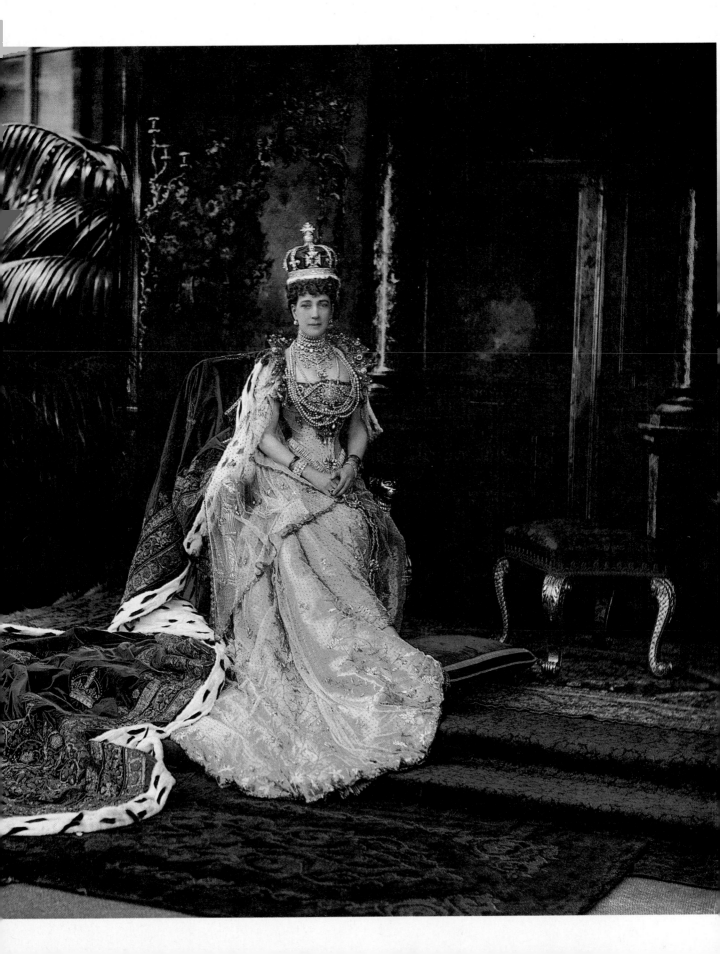

Isabel of Brazil

The only woman to exercise power as head of state in Latin America during the nineteenth century was the one pictured here with a small boy on her lap. She was Princess Isabel of Brazil, who was raised and educated as heir to her father, King Pedro II, and served as his regent three times between 1871 and the royal family's deposition in Brazil's revolution of 1889.

Isabel was groomed as her father's successor and lieutenant by default, after her two brothers died young. She was given a superb education, absorbing lessons in the sciences, literature, classics and the arts. She spoke at least four languages, and by her teenage years was trusted to welcome dignitaries on the king's behalf.

Isabel first served as her father's regent in 1871–2 and used her time in power to historic end, passing the Law of Free Birth, which put an end to hereditary slavery in Brazil. Later, during her third time as regent, she went further. In 1888 she signed the 'Golden Law', which brought about the complete abolition of slavery. For this, Isabel became known as 'the Redemptress'.

After the Brazilian monarchy was abolished, Isabel went into exile in France, along with her French husband, Gaston, Count of Eu. The boy on her lap is one of her grandsons – either Prince Pedro or Prince Louis-Gaston – whose descendants today dispute their right to be the head of Brazil's defunct royal dynasty.

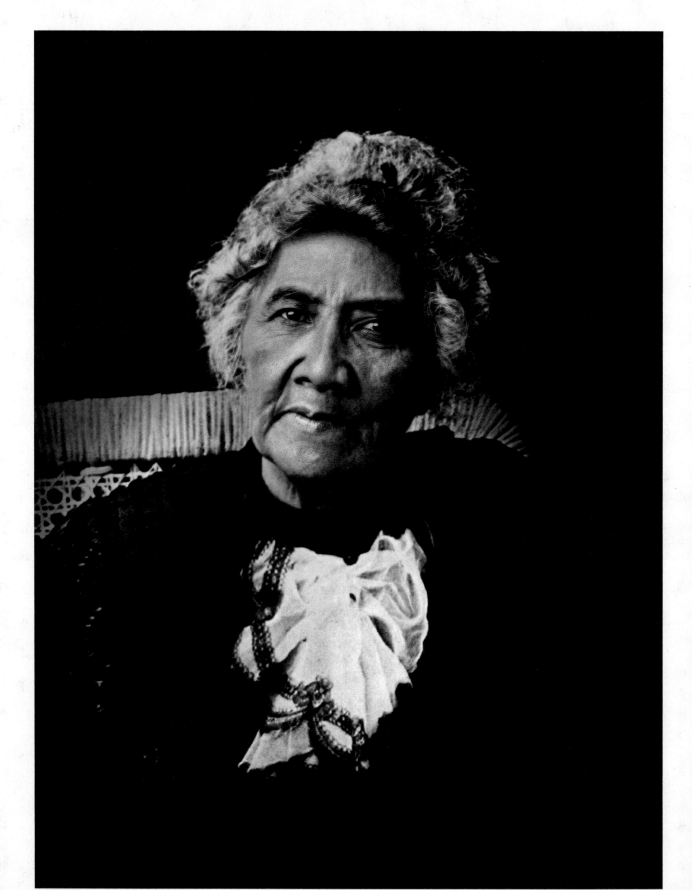

Last Queen of Hawaii

By the time this photograph was taken, in the 1910s, Liliuokalani was no longer Queen of Hawaii. But for several years she had been the first and only woman to rule there, until the Hawaiian monarchy was overthrown and the islands were annexed to the US, eventually to become the fiftieth state.

In 1891 Liliuokalani had inherited the throne from her brother Kalakaua. However, almost immediately after she took power, Hawaii was gripped by political turbulence and constitutional crisis. Much of this was prompted directly by Liliuokalani herself as she tried to pass a new Hawaiian constitution that would restore lost powers to the monarchy, giving the Queen power of veto on all laws and over meetings of the legislature. This sparked widespread disorder and protest, and in January 1893 a coup was launched by rebels, abetted by US Marines, which ended with Liliuokalani's deposition.

After attempts to restore her to the throne failed, it became clear that this was the end for the Hawaiian monarchy. After a period of house arrest, Liliuokalani was freed and allowed to live as a regular citizen. She wrote her memoirs and, an accomplished musician, composed many songs, including the famous 'Aloha 'Oe'. But she could do nothing to prevent the formal annexation of Hawaii in 1898. She spent the rest of her life in her Honolulu residence, known as Washington Place, and died in 1917. She was buried in the royal mausoleum.

Constance Markievicz

After the Easter Rising in Ireland in 1916, Constance Markievicz was sentenced to death. Her life was spared on the grounds that it was unseemly to kill a woman, but she was nevertheless a prisoner in Holloway gaol in 1918 when she was elected as a Westminster MP, representing the constituency of Dublin St Patrick's. She was the first woman ever to be elected.

Markievicz never took her seat in the House of Commons, partly because she was a prisoner, and partly because it was the policy of Sinn Féin MPs not to do so. Instead, she became a member, and later a cabinet minister in the Dáil Éireann: the legislative assembly of the revolutionary Irish Republic, which stood against British rule in Ireland.

Markievicz was born into the aristocratic Anglo-Irish Gore-Booth family in 1868. She trained as an artist and also married one: the Polish count Casimir Markievicz. She became active in revolutionary politics around the time of her 40th birthday in 1908 and remained so for the rest of her life, during the War of Independence and the Irish Civil War that followed (this photograph of her was taken in 1922, during the latter conflict). She was arrested and imprisoned many times, and spent most of her wealth on supporting the revolutionary cause and poor workers' families. When she died after a bout of appendicitis in 1927, the streets of Dublin were lined with thousands of mourners.

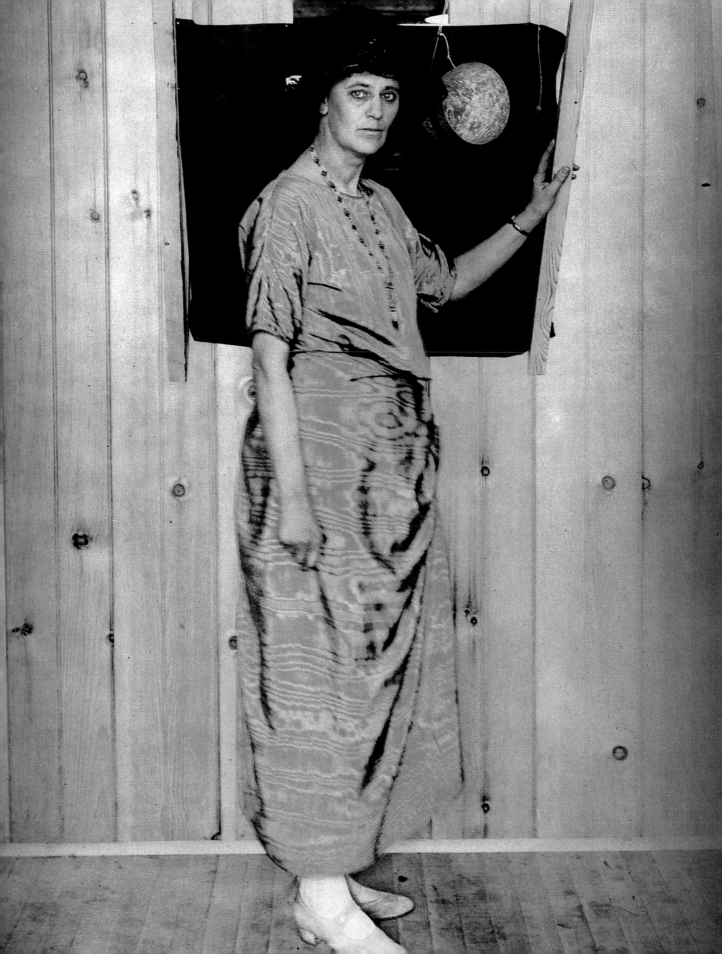

Lady Astor

While Constance Markievicz was the first woman elected to the UK House of Commons, the first to actually take her seat there was Nancy Astor, pictured here in 1923 on campaign in Plymouth, surrounded by local children.

Born and raised in post-bellum Virginia, the daughter of a Civil War veteran who had grown wealthy building railways, Nancy Langhorne moved to England in 1905. She took as her second husband Waldorf Astor, the son of a millionaire. She enjoyed a position as an English society hostess, holding parties at the stunning Buckinghamshire house Cliveden and at the Astor home in central London. Known for her ready wit and often abrasive personal style, Astor was said once to have told Winston Churchill that if she were married to him, she would put poison in his coffee. (Churchill supposedly replied: 'If I were married to you, Nancy, I'd drink it.')

Churchill and Nancy Astor had plenty of opportunities to cross paths, for in 1919 Waldorf inherited his father's peerage and Nancy took his place as Conservative candidate for Plymouth Sutton. She was returned to parliament and served until the 1945 election. Her reputation was battered in the 1930s by press attacks on the 'Cliveden set', characterized as wealthy, unduly influential and pro-appeasement with the Nazis; however, her patriotism during the Second World War restored some of her popularity, at least in Plymouth. She died in 1964.

The Ambassador

Alexandra Kollontai was in her early sixties in 1934 when she was photographed in her office in Sweden by Alfred Eisenstaedt, one of the most prominent photojournalists of the age. She was a high-ranking diplomat who had previously represented her homeland, the USSR, in embassies in Mexico and Norway. Sweden would be her longest posting; she worked there from 1930 to 1945, reaching the rank of ambassador by the time she retired at the end of the Second World War.

During her long career, Kollontai knew all Russia's leading communist revolutionaries. As a young woman she had been fascinated by history and political theory; she gravitated towards Marxism, met Lenin in 1899 and threw in her lot with the Bolsheviks in 1917. Her loyalty was rewarded when Lenin appointed her as a minister in his first government: she held the office of People's Commissar for Social Welfare. In 1919 Kollontai set up the Zhenotdel, which represented women's rights within the Communist Party; among its achievements were successfully lobbying for Russia to become the first country in the world to legalize abortion (1920). Kollontai believed communism could usher in a new age in women's freedom and promote 'free love', in which the rights of both sexes were far more level. However, her influence in Russia waned sharply in 1921–2 when she was sidelined within the party following a factional dispute and sent to see out her career working as a diplomat overseas.

'Silent Hattie'

The first woman to be elected to the US Senate was Hattie Wyatt Caraway, photographed here around 1936. By this time, Caraway had been a senator for five years. She first inherited the post when her husband, Thaddeus, died in office in 1931, but subsequently won an election that gave her the right to represent her home state, Arkansas, in the highest house of the American legislature.

According to Washington, DC folklore, Caraway's first exclamation on entering the Senate in December 1931 was: 'The windows need washing!' Later, she was nicknamed 'Silent Hattie', since she barely ever spoke on the Senate floor. Yet Caraway was a steely and determined politician who set many new precedents during her 14 years in office. She was the first woman ever to chair a Senate committee and to preside over the Senate.

Caraway was a strong supporter of US president Franklin D. Roosevelt's New Deal – the programme of government-funded reforms and works programmes aimed at getting the American people through the worst of the Great Depression. However, as a Southern Democrat, some of her voting choices were less than progressive – particularly on race; in 1938 she helped to block the passage of a law that would have outlawed lynching.

Caraway served the Senate until 1945, when she lost a Democratic primary in Arkansas, where the political establishment had never fully warmed to her. On the day she left the Senate, she was seen out with a standing ovation.

'Goodnight, children'

Princesses Elizabeth (right) and Margaret (left), pictured in 1940, were the daughters of the British king George VI. When the Second World War broke out, they were assigned particular royal duties, which included keeping up the morale of their father's subjects in the UK and elsewhere in the world.

The princesses gave their first radio broadcast on 13 October 1940. It was led by the 14-year-old Elizabeth, who addressed the nation during what was known as Children's Hour, and spoke to young people who had been evacuated for their own safety, forced 'to leave your homes and be separated from your fathers and mothers'.

She continued: 'To you, living in new surroundings, we send a message of true sympathy and at the same time we would like to thank the kind people who have welcomed you to their homes in the country.' Towards the end of the short broadcast, ten-year-old Margaret chipped in with: 'Goodnight, children.'

Elizabeth would go on to inherit the crown from her father on his death in 1952 and become the longest-reigning British monarch in history. Although she has devoted her life to public service, as monarch she has addressed the nation in her own words relatively rarely, other than with her annual Christmas message. She tends to speak most often at times of private grief or public crisis, such as after the death of Diana, Princess of Wales in 1997 and the outbreak of the coronavirus pandemic in 2020.

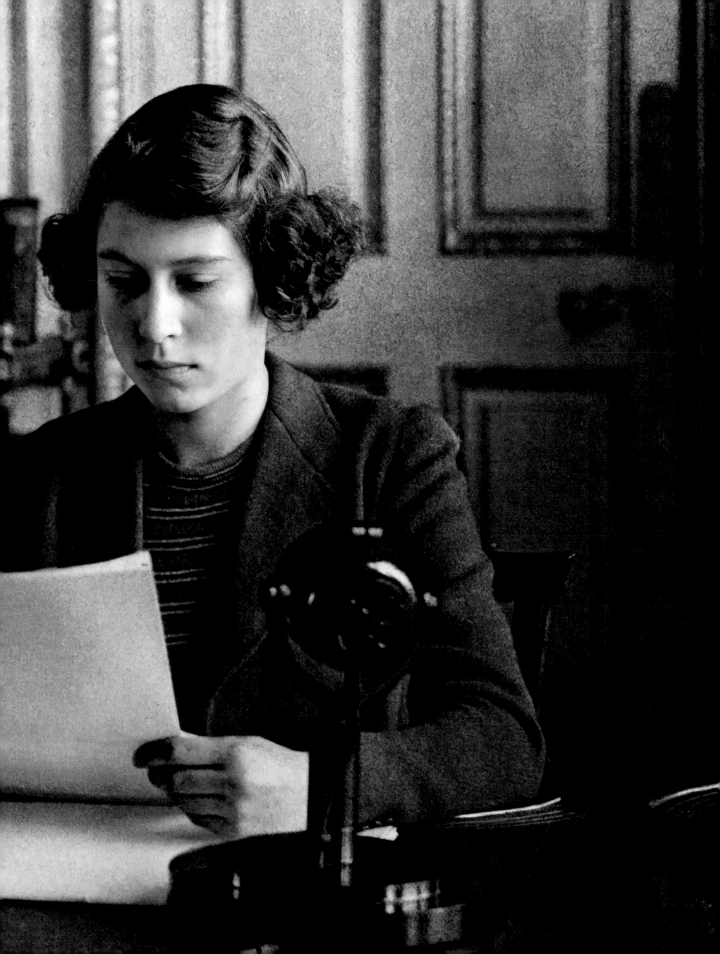

Lone Voices

Although by the 1940s it was possible for women to hold high political office and ministerial posts in many countries, this photograph shows just how male-dominated politics remained. This image was captured in Washington, DC on 11 December 1941, as the US House of Representatives voted to declare war on Germany. More than 400 people had been elected members of the House at the 77th Congress. Only nine of them were women.

Of these, the best known and most controversial was 61-year-old Jeannette Pickering Rankin of Montana. She had been America's first ever congresswoman, when in 1916 she was elected on a platform that included female suffrage and US neutrality in foreign wars. After serving only four days of that term, she had cast her vote against American involvement in the First World War, a decision that earned her such notoriety that she left Congress in 1919. In 1941 she was back, once more having won election by arguing that the US would do better to concentrate on social reform than foreign wars.

Three days before this picture was taken, Rankin had been the only member of the House to vote against the resolution to declare war on Japan in retaliation for the bombing of Pearl Harbor. 'As a woman I can't go to war,' she said, 'and I refuse to send anyone else.' On 11 December, she abstained from the vote to attack Germany. She finished her term in Congress, left once more, and devoted the rest of her life to the (as she saw them) intertwined causes of feminism and pacifism.

Evita

This photograph of Eva Perón and her husband, Juan Perón, was taken on 4 June 1952 during a rally in the streets of Buenos Aires, held to celebrate Juan's re-election for his second term as president of Argentina. At this moment, they were probably the most famous political couple in the world. A huge part of Juan's popularity stemmed from the devotion Eva inspired.

Originally an actor and a performer, Eva met Juan at a gala to raise money for earthquake victims in 1944; they married the following year and Eva proved an invaluable campaigner during his first bid for the presidency in 1946. She was a tireless advocate for women's rights and poverty relief, which won her enormous fame and adoration from ordinary Argentines.

In 1947, 'Evita', as she was nicknamed, became internationally famous during her 'Rainbow Tour' to Spain, the Vatican and France, where she met heads of state, and was featured on the cover of *Time* magazine.

By the time this picture was taken, however, she was grievously ill with cervical cancer. Evita was just 33 years old but so weakened by illness that she had been forced to abandon plans to stand for election as her husband's vice-president. She was also unable to stand – she is only upright here thanks to a metal frame hidden beneath her large fur coat. She died less than two months later, on 26 July, and was mourned by her official title of Spiritual Leader of the Nation.

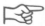

Eleanor Roosevelt

Like Eva Perón, Eleanor Roosevelt was a remarkable woman who used her position as the spouse of a president as a powerful political office in its own right. In 1905 Eleanor married her distant cousin Franklin D. Roosevelt, who in 1933 became president of the US and served until his death during his fourth term in 1945.

As first lady, Eleanor broke with American convention and used her role as a platform to pursue her interests in politics and business. She hosted a weekly radio show, wrote regular columns for newspapers and magazines, gave lectures, advocated for civil rights and worked on a troubled project to build a resettlement town for homeless miners in West Virginia. At times, her political stances inconvenienced her husband, not least when she spoke out against mistreatment of Japanese Americans following the Pearl Harbor attacks of 1941; but she rarely backed down.

After FDR's death, Eleanor was appointed as a delegate to the UN General Assembly. She was the first chair of the UN Commission on Human Rights, which in 1948 produced the Universal Declaration of Human Rights. Eleanor called it 'a Magna Carta for all mankind'. This photograph shows her holding the Spanish language edition.

Eleanor wrote, lectured and maintained an active political career in the US and abroad until the end of her life. After her death in 1962, she was commemorated with a bronze statue in Washington, DC – the only US first lady to be honoured in such a way.

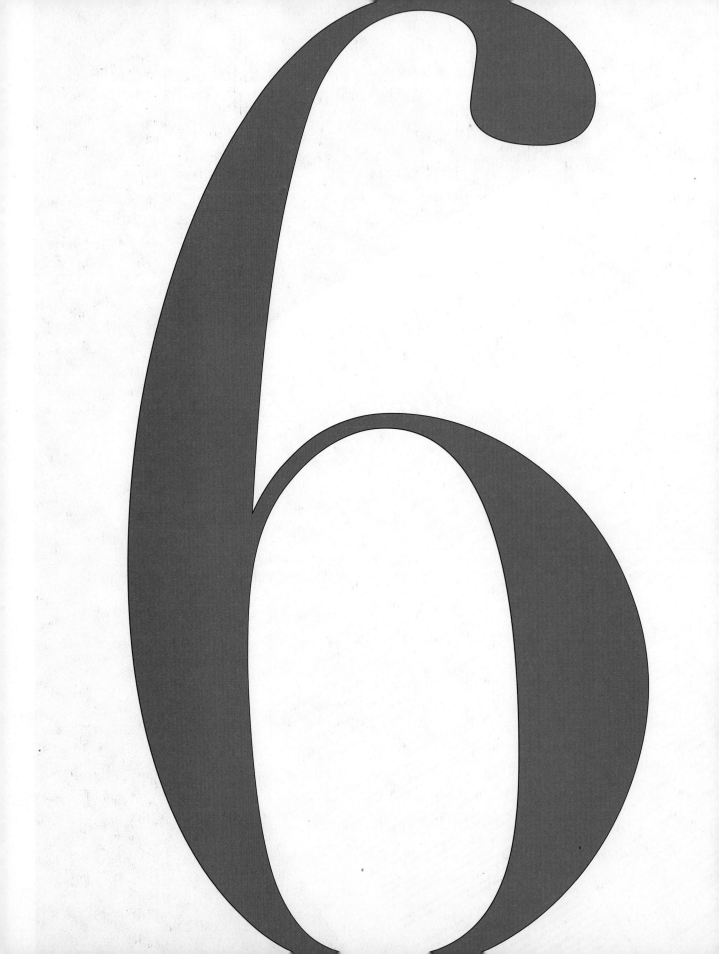

Women
in the Arts

During her lifetime, Virginia Oldoïni, Countess of Castiglione, was first feted by high society and the press for her beauty and fashion sense, then ostracized by both for her love affairs and her vanity. Throughout, she remained fascinated by her own appearance, and from 1856 to 1898, directed the photographer Pierre-Louis Pierson to take hundreds of portraits and close-ups of her in his Paris studio, many of which recreated earlier moments in her life. This image, 'Scherzo di Follia' ('joke madness'), dates from the first decade of the project, circa 1863 to 1866.

As a study of a female body not viewed through the male gaze – Oldoïni did everything to create the photographs except stand behind the camera and press the shutter button. Some critics hated her work, diving no serious artistic intent in the photographs, but rather seeing them as the vanities of a rich, eccentric woman trying hard to relive her own former glories. A kinder view is that Oldoïni's work was unprecedented in the history of photography, pre-empting by more than a century the style of self-portraiture for which the artist Cindy Sherman became world-renowned in the 1980s.

Born in Florence in 1837, into minor nobility, Oldoïni married the Count of Castiglione at the age of 17. In 1856, she and her husband went to Paris, where, as an envoy of the Italian government, she met with Napoleon III to discuss his support for the reunification of Italy. After this she became Napoleon's mistress, an affair which prompted the breakdown of her marriage; in the same year she also began her collaboration with Pierson, already known for producing portraits of French aristocracy and celebrities. In their work together Oldoïni devised the poses, art-directed the shots and the retouching, provided the costumes, and wrote titles and scenarios. Pierson provided technical expertise. The two kept their work discreet, not least because some of it, featuring close-ups of her bare legs and feet, would have been considered close to pornographic.

In the last 20 years of her life, Oldoïni retreated from society, only leaving her home at night, and putting her self-portraiture project on hold for several years until restarting it in the 1890s. In 1899, while working on an exhibition of the photographs, intended for the Paris Exposition of 1900, she died, aged 62. Her photographs were preserved for posterity by her biographer, the poet Robert de Montesquiou; they are today in the collection of the New York Metropolitan Museum of Art.

Women have been making art for thousands of years – the oldest surviving novel, *The Tale of Genji*, was written in the eleventh century by a Japanese noblewoman. Yet the history of art tends more often to characterize women as muses and models rather than creators. To be sure, in the period covered by this book, would-be female artists faced institutional and financial hurdles: formal training and academy membership were generally available only to men, and an artistic vocation tended to depend on a woman's access to private funds or a forward-thinking husband. Nevertheless, the writers, musicians, painters, photographers and designers featured in the following pages show us what was possible, given a little opportunity.

Clara Schumann

When Clara Schumann gave her final concert in March 1891, aged 71, she had been delighting European audiences with her piano-playing for over six decades. 'An artist of that sort', wrote George Bernard Shaw, 'is the Holy Grail of the critic's quest.' She was also considered, along with Franz Liszt, to be the leading piano teacher of her generation. And though she was the great champion of the work of her husband, the composer Robert Schumann, her own works became an essential component of the Romantic music canon.

Clara was born in Leipzig in 1819 to parents who were both pianists. After her parents separated, her father, Friedrich Wieck, taught her to play the instrument. She first performed a few weeks after her ninth birthday, and gave her first solo concert, which included one of her own works, aged 11. By the time she married Robert Schumann, ten years later, she was already internationally famous. He, meanwhile, was a promising composer, and his subsequent success owed a great deal to her support in private and patronage in concert.

The couple had eight children, but motherhood barely dented Clara's touring schedule, which she organized herself. After Robert's death in 1856, she supported her family singlehandedly with her performance and teaching. When she died, at the age of 76, in 1896, her obituarist in *The Times* repeated another critic's judgement that 'she was one of the greatest pianoforte players the world has ever heard'.

Frances Benjamin Johnston

This photograph was taken in 1896 by Frances Benjamin Johnston in her Washington, DC studio. It shows the artist herself, smoking a cigarette, nursing a beer and showing off her ankles. Its title, 'Self Portrait (as New Woman)', spoke to Johnston's conception of a feminist term for women who challenged the buttoned-up pieties of nineteenth-century polite society. For Johnston, this was more than a simple studio pose. It summed up a lifelong worldview that brought her great personal and professional success.

Born in West Virginia in 1864, Johnston studied art in Paris before returning to the US to work as a commercial illustrator. In 1888 George Eastman, the founder of Kodak and a family friend, gave her a camera, and she subsequently worked in the photography department of the Smithsonian in Washington. Later she was an unofficial White House photographer for five presidents and shot reportage, photojournalism, documentary, art and architectural work. She was commissioned by magazines such as *Vogue* and *House & Garden* and employed privately by aristocrats and celebrities.

The great project of Johnston's later life was a series of photographs documenting buildings in nine southern US states during the 1930s and 1940s. Throughout her career, she encouraged women to take up photography: giving speeches, writing how-to articles and curating female-only exhibitions. She died in 1952, aged 88, in the New Orleans town house where she took pictures and told stories to the last.

Nampeyo

The Hopi potter Nampeyo is an important figure in Native American art. Her distinct style was derived from two major inspirations: the pot shapes of her ancestors in the Hopi-Tewa group and designs inspired by excavated potsherds she saw at archaeological digs near where she lived. By combining the two, she created original, sought-after work in what became known as the Sikyatki Revival style.

Born in 1859 or 1860, Nampeyo lived on the Hopi Reservation in Arizona and learned pottery from her grandmother, making mostly jars and storage vessels by hand in the traditional Hopi style: without a wheel, fired in the open on dung and wood fires and decorated with plant-based paint using yucca leaf brushes. By the time she was 20, sales of her work at a nearby trading post were earning her a steady income. She first exhibited her work in Chicago in 1898; this portrait of her was taken around 1900 by the photographer Edward Curtis, who took over 40,000 photographs of Native North Americans during a four-decade-long project. Curtis's work became nationally known; through the photographs and regular pottery demonstrations, Nampeyo and her pots became icons of Hopi culture.

Nampeyo died in 1942. For the last 15 years of her life, poor eyesight meant her pots were painted by her husband and children, complicating matters for collectors and museums trying to authenticate her work, already a hard task with an artist who never signed it. Two of her daughters became potters, as did members of her family in three further generations.

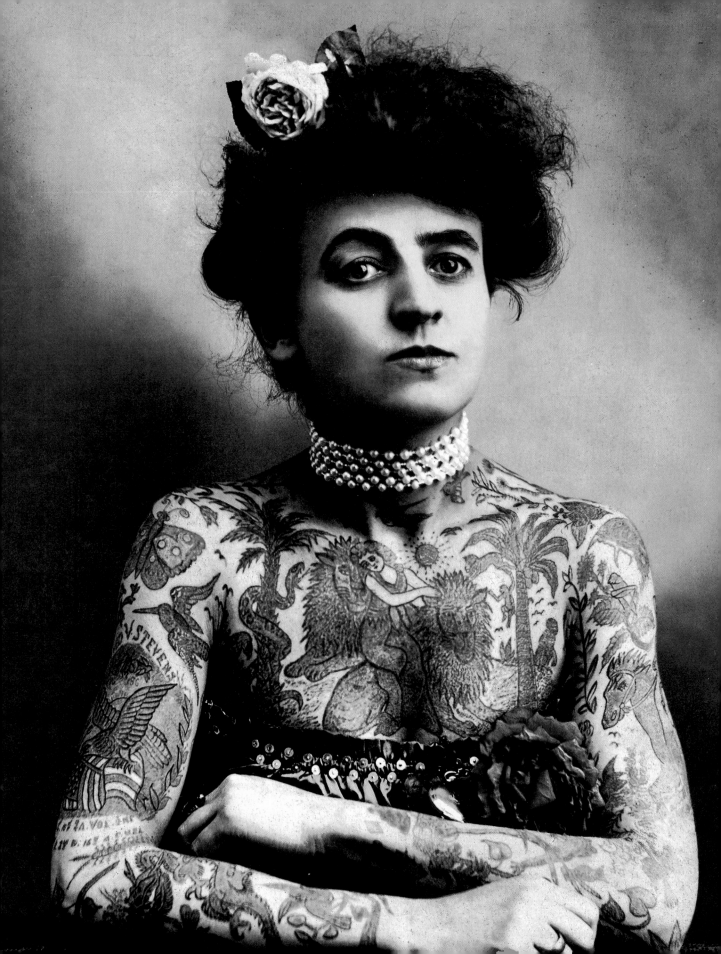

Maud Wagner

Born in Kansas in 1877, Maud Stevens was an accomplished trapeze artist and contortionist when she met Gus Wagner at the St Louis World's Fair in 1904. On their first date, at her insistence, Gus demonstrated the art of tattooing on his assistant and Wagner herself. Later that year she and Gus married. By 1907, Maud had hundreds of tattoos, and was known as 'The Tattooed Lady', star of the sideshow the couple staged at carnivals, circuses, amusement arcades and fairs for the next three decades. These were the tattoo parlours of their era, and Wagner was recognized as the first female tattooist in America, practising the hand-pricking method of tattooing, using ink and needles, which Gus had learned from indigenous people in south-east Asia during his time in the merchant navy.

Tattooing was considered subversive, even deviant, by many in the West during the early part of the twentieth century. The thrill of the taboo meant that tattooed people – women, especially – were popular carnival attractions, and photograph souvenirs sold just as well as tickets.

Maud's neck-to-toe decoration included birds, palm trees, butterflies, monkeys, lions, horses, women, a tiger's head, a cowboy on a steer and a snake climbing a tree. According to her daughter Lotteva, also a tattoo artist, Wagner also 'sat on two baby elephants'. Wagner lived to see her groundbreaking work acknowledged by the growing tattoo community and was hand-pricking tattoos up until her death, aged 83, in 1961.

'La Comradessa'

The Italian modernist photographer and political activist Tina Modotti lived in eight countries, carried out secret missions for Soviet Russia, starred in a Hollywood movie, befriended Frida Kahlo and was expelled from Mexico for plotting to kill the president, only to die there years later under a false name.

Born in 1896 in Udine, Italy, to working-class socialist parents, Modotti was nine when her father emigrated to America to provide for his family, and 16 when she joined him in San Francisco. She worked as a theatre actress and artist's model, moving to Los Angeles in 1918, where she won roles in silent films, including the lead in *The Tiger's Coat* (1920), from which this image is taken. With the photographer Edward Weston, she moved to Mexico City, ran his studio and began her own photographic career, documenting the life of working Mexicans and the murals of Kahlo's husband, Diego Rivera.

In 1927, Modotti joined the Mexican Communist Party and in 1929 she was out walking with the exiled Cuban activist Julio Antonio Mella when he was shot and killed. The fallout from this murder, during which a presidential assassination plot was blamed on her, led to her expulsion from Mexico in 1930. She subsequently lived and worked in Moscow, Berlin, Paris and Spain, working for the communist cause both overtly and covertly, but never taking photographs – she had given away her camera in 1932. She returned to Mexico, illegally, in 1939 and died of a heart attack in the back of a Mexico City cab in 1942.

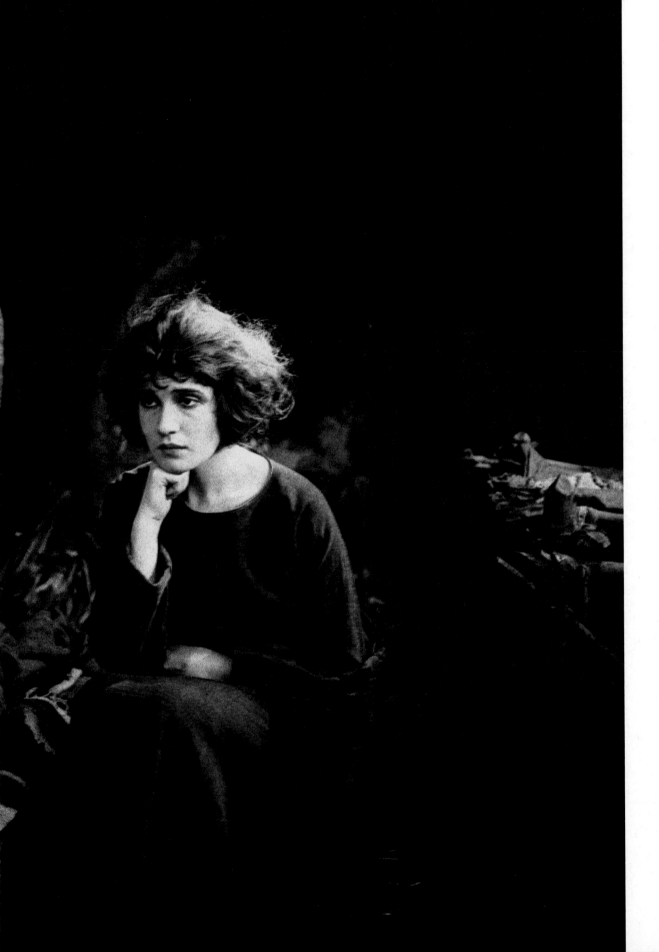

Suzanne Valadon

Before she became the first female painter to be granted membership of the prestigious *Société Nationale des Beaux-Arts* – Suzanne Valadon appeared in the works of Renoir, Toulouse-Lautrec and others. In high demand as a muse and model in Montmartre, the artists' quarter of Paris, she used her time in studios to learn the techniques of the great painters of the day, so that one day she might join them.

Born into poverty in 1865, Valadon left school aged 11 and in her mid-teens took a job performing as an acrobat in a circus. Within her first year, however, she fell from the trapeze and suffered a career-ending injury. At this point she took up modelling and working for artists, befriending many of the leading French painters of her time, and becoming for a time Toulouse-Lautrec's lover. All the while she was developing her own drawing and painting; among her first patrons was Edgar Degas, who bought her pieces and urged her to keep working.

Valadon typically painted female nudes of what much later would be called 'real women' in real poses; her repertoire included self-portraits well into her sixties. Few artists of her time, female or otherwise, painted women in this candid and vanity-free way, and Valadon was both praised and scorned for doing so. Her personal life – an unmarried mother at 18, she later left her husband for one of her son's friends 20 years her junior – was pored over as much as her art, but never eclipsed it. She died in Paris, of a stroke, aged 72, in 1938.

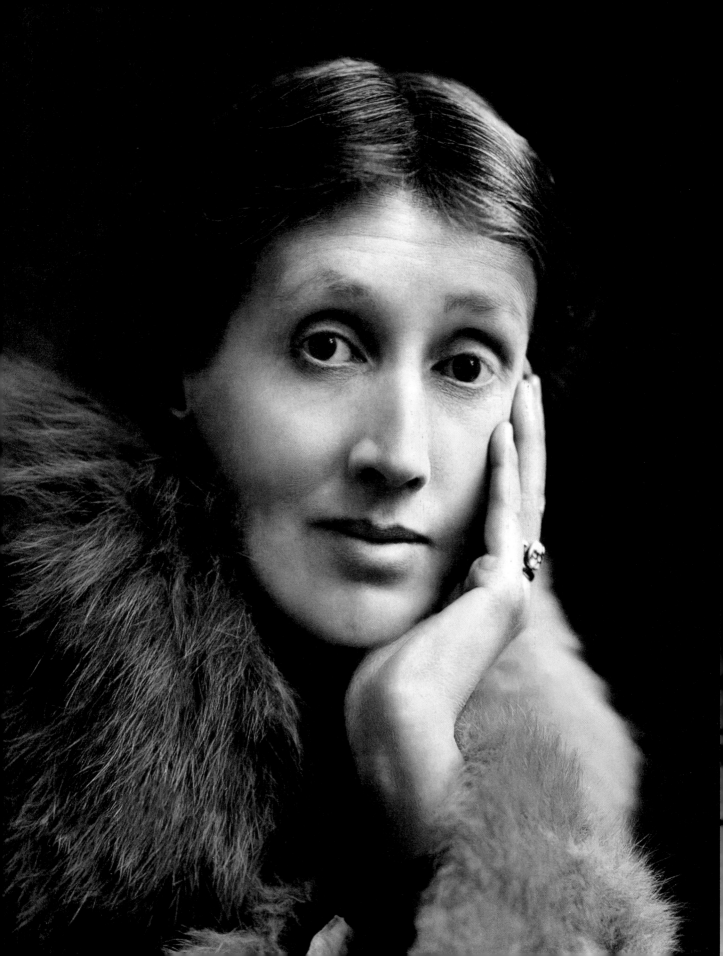

Virginia Woolf

Aged five, Virginia Bell was telling her father a story every night before bed, and aged nine she began writing, with her sister, the painter Vanessa Bell, a newspaper about their family and home life that ran for at least 70 issues. Her professional literary output – nine novels, 46 short stories, 400 essays, 4,000 letters – made her as central to the Western literary canon as the leather-bound classics she devoured from her father's home library.

Woolf's first novel, *The Voyage Out*, was published in 1915, when she was 33. Two years later, she and her husband, Leonard Woolf, started Hogarth Press with a hand-printing press in their basement. They published their own works as well as those of T. S. Eliot, E. M. Forster and Vita Sackville-West, with whom Woolf had a ten-year affair and on whom the gender-fluid, centuries-old title character of Woolf's novel *Orlando: A Biography* (1928) is based. Other major novels include *Mrs Dalloway* (1925), *To the Lighthouse* (1927, the year this photograph was taken) and *The Waves* (1931). Among her non-fiction, *A Room of One's Own* (1929) is a key work both in and about the history of women's writing.

Woolf's life and work are often viewed through the prism of her traumas and mental health problems and her suicide in 1941, at the age of 59. Critics once dismissed her as a minor novelist who suffered major tragedy. Her rediscovery in the 1970s, not least by second-wave feminists, turned that characterization on its head, revealing one of the great modern English writers, who triumphed despite her suffering.

A Woman Called John

This photograph, taken in 1927, shows the author
Radclyffe Hall, in her signature male dress, and her
partner, Lady Una Trowbridge. The year before it was
taken, Hall's novel *Adam's Breed* had been a prize-
winning bestseller. The year after it was taken, her
next novel, *The Well of Loneliness*, was ruled obscene
in the UK and banned, which of course led to greater
fame and success for its author.

Born Marguerite Antonia Radclyffe Hall in 1880,
she dropped her given names for her authorial
pseudonym, although she was known as 'John' by
those close to her. (The name was given by her first
lover, the singer Mabel 'Ladye' Batten, who is the
figure in the John Singer Sargent painting on the wall
here.) Hall was an 'out' lesbian who did not set out
to provoke by her appearance or lifestyle, although
people took offence all the same. She won a lawsuit
for slander when an acquaintance of Lady Una's
husband called her a 'grossly immoral woman'. In her
twenties and thirties, she wrote poetry, some of
which was adapted into popular songs, before the
publication of her first novel, *The Forge*, in 1924 when
she was 44.

During the legal proceedings that led to *The Well
of Loneliness* being banned, the novel was deemed
'gravely detrimental to the public interest', despite
being resolutely un-erotic; other novels dealing with
lesbianism were published without controversy in the
same year. After the ban, an English-language edition
published in France became an underground hit, and
when Hall died in 1943, aged 63, a million copies had
been sold.

Genius of the South

The writer and folklorist Zora Neale Hurston is considered one of the most important figures in African-American culture, but when she died, aged 69, in 1960, none of her books were in print, a collection was needed to pay for her funeral and she was buried in an unmarked grave.

After becoming the first Black person to graduate from Columbia University's prestigious Barnard College, with a degree in anthropology, she began years of research, collecting stories of and told by 'very regular people' in the Black rural South. She was criticized for ignoring racial suppression and not concerning herself with civil rights, but her belief that Black people were undiminished, and could and should be proud of their heritage and culture outside of any white influence, even negative, is what made her work, especially *Mules and Men* (1935), unique and valuable. She also wrote short stories, essays and novels. Her work *Their Eyes Were Watching God* (1937), in which a Black woman recounts her three marriages in unselfconscious and vibrant detail, was unsuccessful in its day but now makes all-time bestseller lists.

By the 1950s, Hurston had to work as a supply teacher and a maid to supplement her earnings as an essayist. A week after she died, a policeman responding to an unauthorized fire found a man burning papers while clearing out Hurston's rented home. The officer, who had met Hurston as a student, recognized what remained of her archive and manuscripts and saved them from destruction.

Amrita Sher-Gil

Amrita Sher-Gil was twentieth-century India's first great modern artist. Born in 1913 in Budapest, her father was a Sikh aristocrat and experimental photographer, her mother a Hungarian musician, her uncle an author, and all three encouraged Sher-Gil in her creative endeavours. By the time the family moved to India, when she was seven, she was painting the servants, whom she roped in to model for her. As a teenager she painted her first female nude; having been expelled from convent school for atheism, she went to study art in Paris aged 16.

After seven years in Europe, she moved back to India, where a visit to the ancient wall paintings at Ajanta gave her a new lease of artistic life, and classic Indian motifs merged with her European-influenced style. She died aged 28, in 1941, in Lahore, the cause of death unknown. (Later biographers suggested she died as the result of a botched abortion performed by her husband, a doctor.)

Sher-Gil mainly painted women, capturing the power, as well as the contradictions and connections, displayed in their labour and their eroticism. 'All art, not excluding religious art, has come into being because of sensuality,' she wrote, in one of the few letters not burned by her parents, who were scandalized by their daughter's frankness and bisexuality. Sher-Gil's example of female creative autonomy, especially rare in India, was welcomed in Indian society during her lifetime, as was her fusion of Eastern and Western artistic sensibilities.

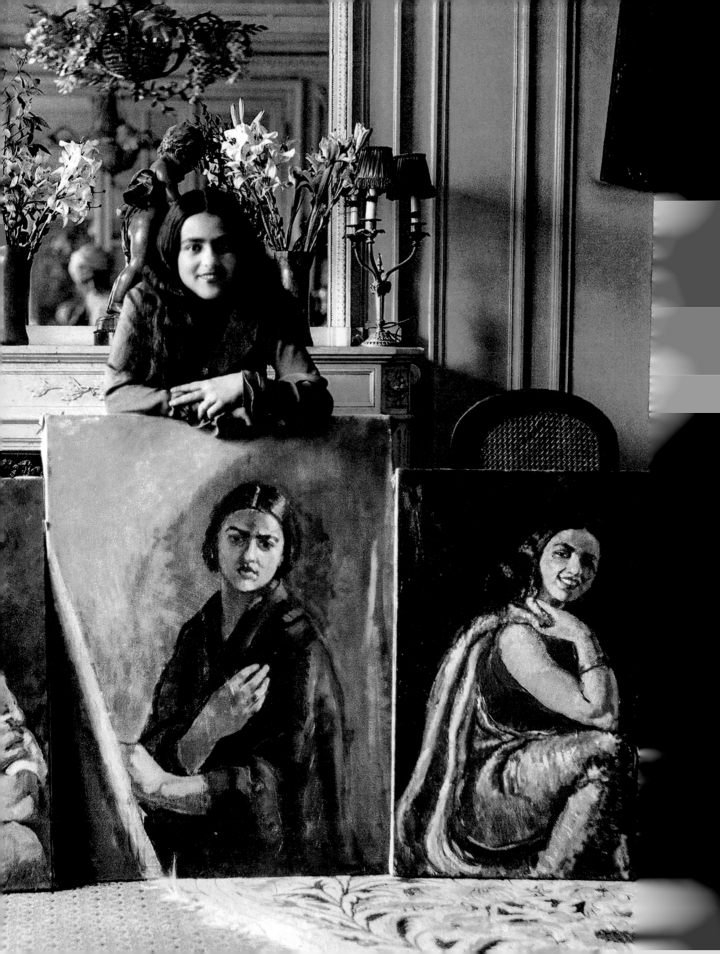

Coco Chanel

This picture of Coco Chanel, wearing a three-quarter-length coat and hat of her own design, was taken in 1937 by the fashion and society photographer Horst P. Horst. At this point, 25 years into her career as a designer, most of the world's stylish women had worn something of Chanel's: a little black dress, a bag, a dab of Chanel No. 5 perfume, a cardigan suit. She championed less formal, unpretentious style and radically altered the way women dressed and thought about their clothes and their bodies.

Born Gabrielle Bonheur Chanel in Saumur, France in 1883, she learned to sew at the convent orphanage to which her widowed father sent her and her two sisters. The nickname Coco stuck in her early twenties, from a song she sang in cabaret, a means of supplementing her income as a seamstress. She opened her fashion house in Paris in 1918, and launched the perfume Chanel No. 5 in 1921. This was the first perfume marketed with a designer's name; the No. 5 referred to the fifth vial of fragrance Coco chose from a selection at the perfumer's. Her share of profits in its sale made her one of the world's richest women.

Chanel closed her fashion house at the start of the Second World War, and during the conflict her relationship with a German aristocrat led her, as later biographers discovered, to undertake secret work for the Nazis. She re-emerged with new designs in 1954 and was preparing her final spring/summer collection when she died, aged 87, in January 1971. It is impossible to overstate her influence on style and fashion.

Margaret Bourke-White

The mid-1930s to mid-1950s was the heyday of photojournalism, published to huge audiences in magazines such as *Life*, *Paris Match* and *Picture Post*. Margaret Bourke-White, pictured here around 1943, was among the very best photojournalists. Her work, first in industrial and architectural photography, then later as a war photographer, was truly groundbreaking.

Born in 1904, Bourke-White learned photography from her father, kept it up as a hobby while she was a student, and from 1928 made it her business. In 1930 she became the first Western photographer allowed to shoot Soviet Russian industry, after requesting a visa every day for six weeks at the Russian embassy in Berlin, where she was on assignment for *Fortune*. In 1936 she joined *Life*, covering architecture, the social upheaval of the Dust Bowl and political unrest in central Europe.

In 1941, she took spectacular shots of the Nazi bombing of Moscow, the only foreign photographer in the city. Two years later, while sailing to Algiers to cover the North African campaign of the Second World War, her ship was torpedoed and she spent eight hours in a lifeboat. She was with General George S. Patton in Germany at the end of the war and photographed the liberation of Buchenwald.

Bourke-White's nickname at *Life* was Maggie the Indestructible. But she suffered from Parkinson's disease during the last two decades of her life, which forced her into retirement from 1957. She died, aged 67, in August 1971.

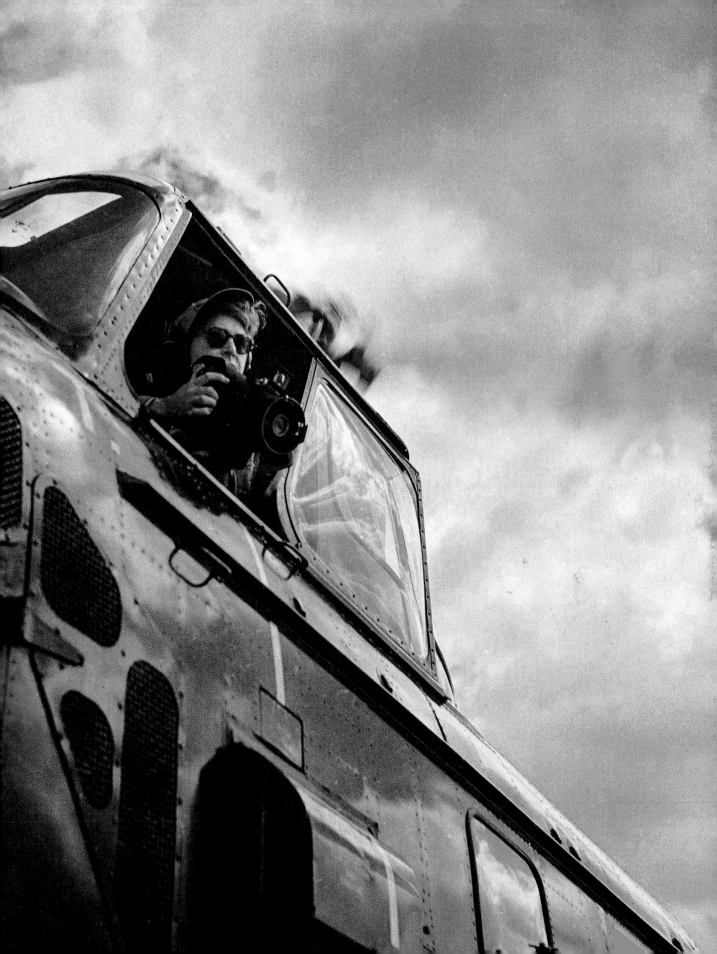

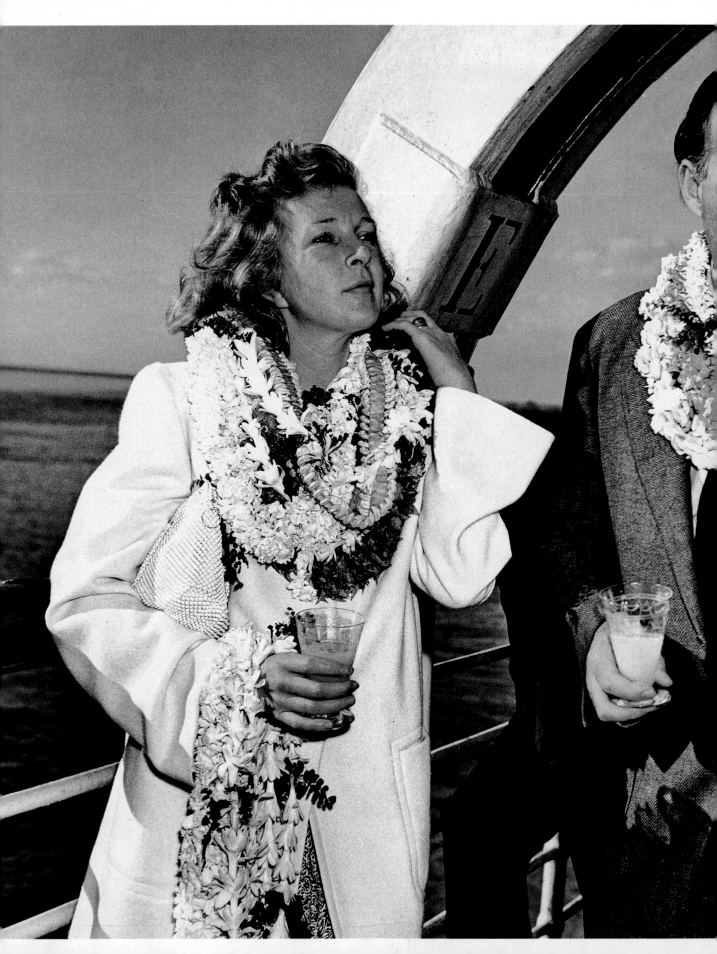

Martha Gellhorn

The only woman to land on the Normandy beaches on D-Day, 6 June 1944 was Martha Gellhorn, the American novelist and journalist whose six-decade career spanned some of the most momentous events of the twentieth century, many of which she reported on in person. Gellhorn is pictured here with her first husband, Ernest Hemingway, to whom she was married for five years during the Second World War. The marriage was not entirely happy and Gellhorn justifiably resented other journalists' interest in it. 'Why should I merely be a footnote in his life?' she asked.

Why, indeed. Gellhorn was a considerably more inquisitive and intrepid reporter than Hemingway. She began her career on the crime beat in St Louis before writing about fashion on the staff of *Vogue Paris*. From the mid-1930s until 1990 she documented historical events, from the Spanish Civil War to the Great Depression in the US and the rise of Nazism in Europe. Gellhorn's presence at D-Day was typical of the resourcefulness and bravery her assignments demanded. Refused journalistic accreditation, she hid aboard a Red Cross ship then worked as a stretcher-bearer on the beaches.

Gellhorn often wrote from the point of view of her subjects: 'the view from the ground', as she called it. Reflecting on her reports from Dachau concentration camp when it was liberated at the end of the Second World War, she said, 'What was there to be objective about? It was a total and absolute horror and all I did was report it as it was.'

Frida Kahlo

The Mexican painter Frida Kahlo was photographed here in March 1939 when she arrived in New York aboard the huge, fast and extravagantly luxurious transatlantic liner SS *Normandie*. She was then 32 years old and an established artist with a reputation in Europe and the Americas. However, she had not yet achieved the status that she holds today – as one of the most important and honest painters of the twentieth century. Indeed, she was more commonly referred to as simply the wife of the well-known mural painter Diego Rivera.

For Kahlo, painting was a process bound up with pain. When she was 18 she suffered severe injuries when a bus she was travelling on collided with a tram. She taught herself to paint while she was recuperating, experimenting with what would become her most reliable subject matter: the self-portrait. 'I paint myself', she said, 'because I am so often alone.'

By this time Kahlo had met Rivera – both were involved in Mexican communism – and the two were married in 1929. From this point Kahlo's work began to incorporate more obvious elements of Mexican folk art, while exploring themes of physical and psychological pain: in *In Henry Ford Hospital* (1932) she painted herself haemorrhaging on a hospital bed after a miscarriage.

Kahlo's marriage to Rivera was fraught and full of infidelity on both sides, and they briefly divorced in 1939–40. Kahlo achieved fair success in her lifetime, but on her death in 1954, aged 47, the *New York Times* predictably referred to her as 'Frida Kahlo, Artist, Diego Rivera's Wife'. However, from the mid-1970s her posthumous reputation began to grow, and in 2021, her painting *Diego And I* sold at auction for $34.9m (£25m).

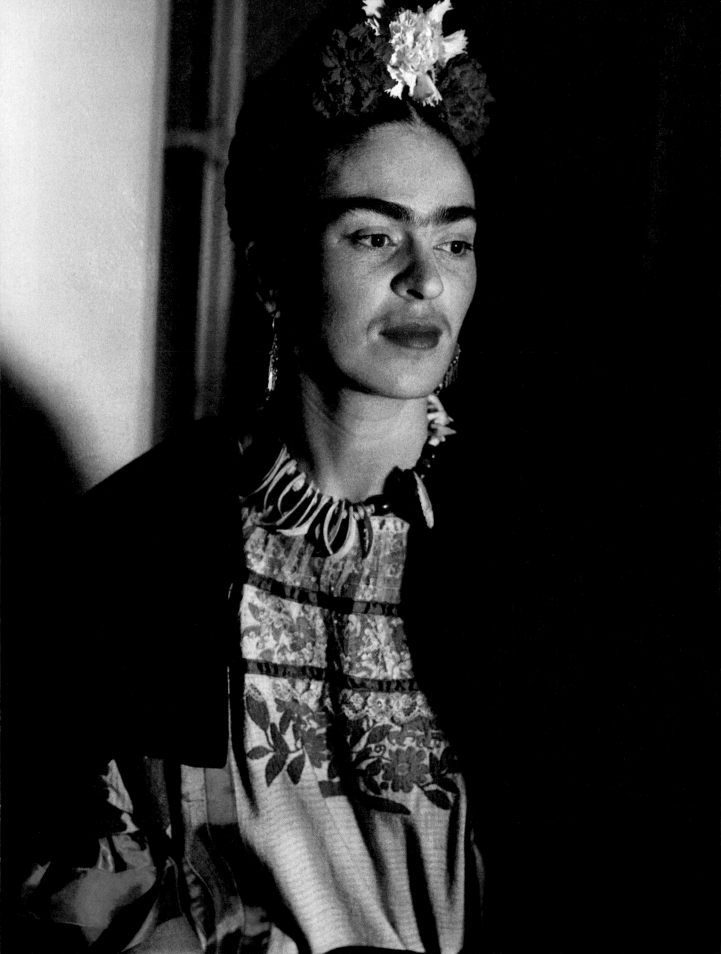

Agatha Christie

Only the Bible and William Shakespeare have more readers than the crime novelist Agatha Christie, whose books have sold over two billion copies in almost 50 languages. Half of her 66 novels feature the detective Hercule Poirot, who solved the country-house murder of a wealthy old woman in her first book, *The Mysterious Affair at Styles* (1920), and the last book published in her lifetime, *Curtain* (1975). Another dozen are cases for Miss Marple; the two sleuths star in several of Christie's 165 short stories.

Born in 1890, Christie had an idyllic childhood and grew into a shy teen who loved reading and wrote poetry before being challenged by her sister to write a detective story. During the First World War, she worked in a dispensary, where she became fascinated by poisons; over 80 of her subsequent murderers slipped something fatal into their victim's drink, nasal spray or breakfast marmalade. Her tightly plotted stories represent the essence of modern crime fiction: a murder occurs, there are multiple suspects, clues and cues play on readers' assumptions and a final twist defies them, while still making logical sense.

Christie herself starred in a true-crime mystery that remains unsolved: in 1926 she disappeared for 11 days, which was variously explained as a publicity stunt, the result of a breakdown or an attempt to frame her husband, who was leaving her, as her murderer. She didn't discuss it publicly or in her autobiography – her longest book, published the year after her death in 1976, aged 85.

Eva Jessye

The American conductor and choirmaster Eva Jessye
was central to the story of African-American music
in the twentieth century. In particular, she had a
passion for spirituals, the songs created and sung by
slaves while they worked, and from which gospel and
blues directly descended.

Born in rural Kansas in 1895, Jessye was barred on
racial grounds from attending her local high school.
Despite this, she started university at 13, graduated at
19 and taught in schools and colleges until 1926,
when she went to New York to find work as a
performer and arranger. That year she joined a group,
later named the Eva Jessye Choir, which had huge
success on radio, then the most popular medium for
music, and which she directed for almost 30 years.

Jessye was the choral director on *Hallelujah*
(1927), the first movie musical with an all-Black cast;
on Gertrude Stein's *Four Saints in Three Acts* (1934),
the first Broadway musical to use Black performers in
a story not specific to Black life, and, most famously,
on George Gershwin's opera *Porgy and Bess* (1935),
from its first US performance to its inaugural world
tour, on which she and her choir were the chorus.
She became a much-consulted expert on the opera,
and in this photograph from 1965 is showing its score
to the Broadway performer Irving Barnes and four
children. After her choir disbanded in the 1970s, she
moved into academia and established an important
African-American music archive. She died in
February 1992, aged 97.

Women
in the Streets

'I see immense advantages in being gagged,' wrote Margaret Sanger in 1929. 'It silences me but it makes millions of others talk about me and the cause in which I live.' Her cause, for which she was silenced, prosecuted and jailed, was birth control. She coined the term, wrote and published the first advice pamphlets when they were considered obscene publications, opened America's first family planning clinic and campaigned for a woman to be, as she put it, 'the absolute mistress of her own body' in the face of fierce legal and moral challenges.

Born in 1879, Sanger trained as a nurse but gave up her career to get married and raise her three children. In 1910, she and her family moved to New York City, where she took up nursing again and became active in socialist politics and women's groups. At work, she saw first-hand how working-class women in particular suffered where the alternative to unwanted pregnancy was illegal abortion. Her professional and political lives fused: it was her ardent belief that women could be freed from the tyranny of frequent childbirth with the supply of information and contraceptives.

In 1914, Sanger published a short-lived journal of her own publication, known as *The Woman Rebel*, which featured articles on subjects ranging from practical advice about puberty, birth control, motherhood and contraception to poems and historical articles on iconic women such as Cleopatra. In 1916 she opened America's first birth control clinic, for which she was fined, and in 1917 jailed for 30 days. Incarcerated in a workhouse, she went on hunger strike and was force-fed. Although she lost a legal appeal against her conviction, the law changed to allow doctors to prescribe contraception on medical grounds.

On her release, Sanger took the birth control movement across America, then into Europe and Asia, and in 1952 co-founded the International Planned Parenthood Federation. When money was needed to continue the development of the contraceptive pill, Sanger raised most of it from private investors. The pill was made available to women in the early 1960s, shortly before Sanger died, aged 86, in 1966.

This photograph shows Sanger being symbolically and theatrically silenced in 1929. Having been banned from speaking in Boston, Massachusetts, she nevertheless arranged a lecture at the city's Ford Hall Forum, walked on stage in front of 800 people while gagged and gave her notes to a colleague to read. She knew the value of good publicity, and her tireless campaigning improved the lives of millions of women around the world.

In the rest of this chapter are more remarkable individuals who stood up, spoke out or even took up arms for what they believed in. They fought variously against imperialism, oppression and apartheid to claim better rights for women, workers and marginalized people. They changed hearts, minds and laws, often at great personal cost.

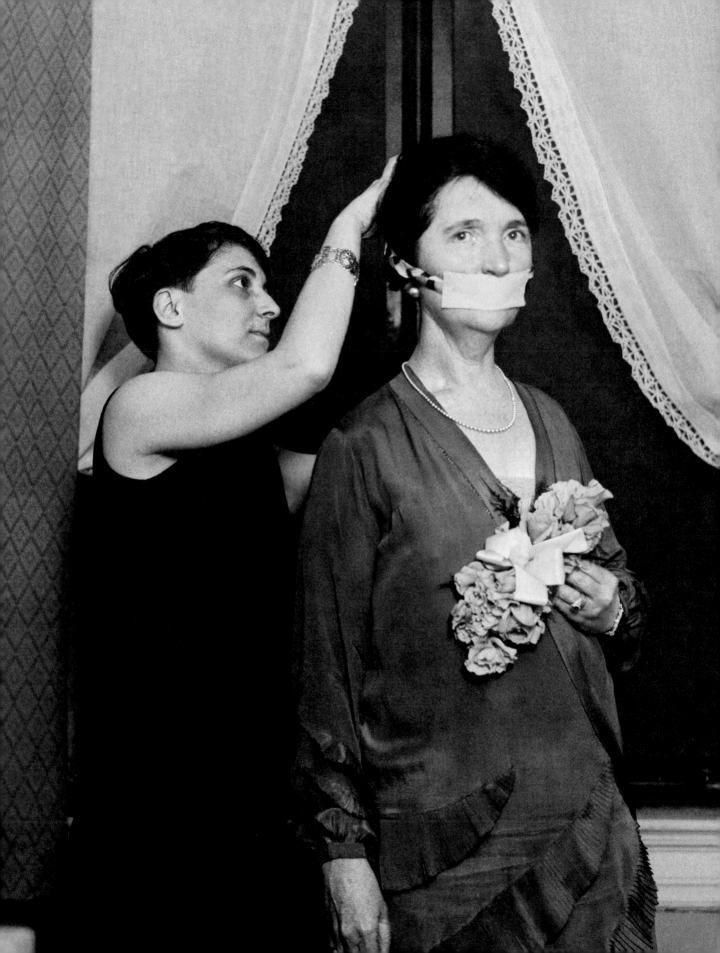

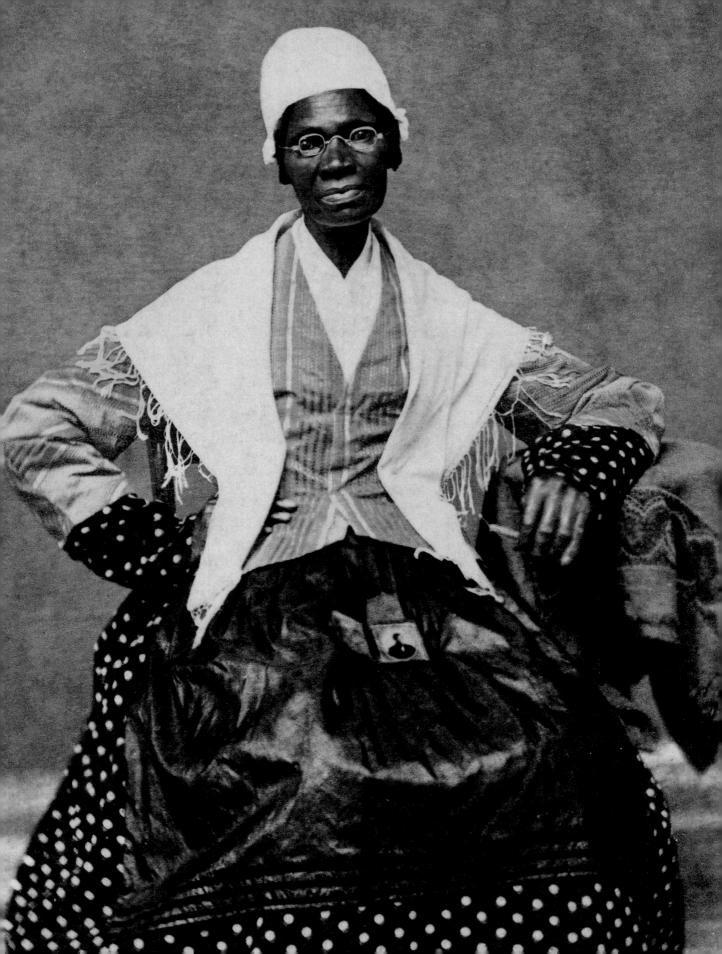

Sojourner Truth

On 29 May 1851, when Sojourner Truth stood up to speak at the Women's Rights Convention at Akron, Ohio, the crowd hushed. Truth was six feet tall and physically strong, the legacy of two decades spent working as a slave on farms in New York State. She was also a compelling orator, and her powerful speech, later circulated in writing as the 'Ain't I A Woman?' speech, was a turning point in American social justice. It brought Black and white women, then almost entirely separate in society, closer together to better fight their causes.

Truth was not afraid of standing up for what she felt was right. She was born into slavery in 1797, escaped in 1826 and became a Methodist preacher. All her speeches were off the cuff – she could not read or write. In 1828 she went to court to fight to be reunited with her son, who had twice been sold illegally into slavery. After a long legal battle, she won one of the first victories of a Black woman over a white man in an American court, and she and her son were reunited.

After the publication of her ghostwritten memoir in 1850, Truth was in great demand as a public speaker. She used her platform to campaign for better employment rights and abolition, and met President Abraham Lincoln in the White House in 1864, the year before slavery was abolished in the US.

Susan B. Anthony

In 1873, the reformer and activist Susan B. Anthony was convicted of the crime of voting. She and fourteen other women had cast ballots in the US Presidential election the previous November. None believed their votes would count; but Anthony's purpose in persuading election officials to let her break the law had been to force a legal reckoning. In court, she hoped to show that denying women the vote violated the Fourteenth Amendment, which guaranteed the privileges of US citizens. Her attempt failed – she was fined but the case was dropped before it could go to the Supreme Court. Yet this was a prime example of the direct action that characterized Anthony's lifelong quest for social justice.

Born in 1820 in Massachusetts to a Quaker farmer, Anthony was a teacher and farmer during early adulthood. But around the age of thirty she met the reformer Elizabeth Cady Stanton, who became a great friend and collaborator. Anthony (photographed here around 1868) threw herself into campaigning issues, beginning with temperance: an important part of the women's movement, since married women's rights were so subordinate to their husbands' that a drunken spouse could spell a lifetime of misery and abuse. She also campaigned for equal pay and women's rights, and against slavery.

A tireless, talented speaker, Anthony toured the US and Europe, giving lectures and speeches that helped to unite disparate factions in the women's movement. She died in 1906 aged 86. Fourteen years later the Nineteenth Amendment – nicknamed the Susan B. Anthony Amendment – granted American women the vote.

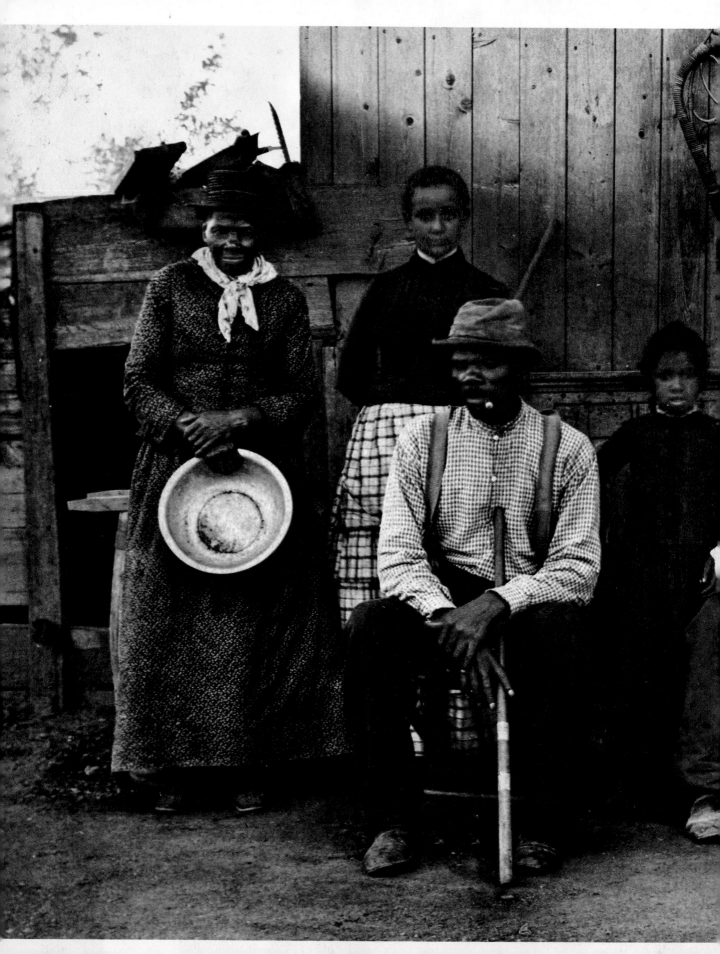

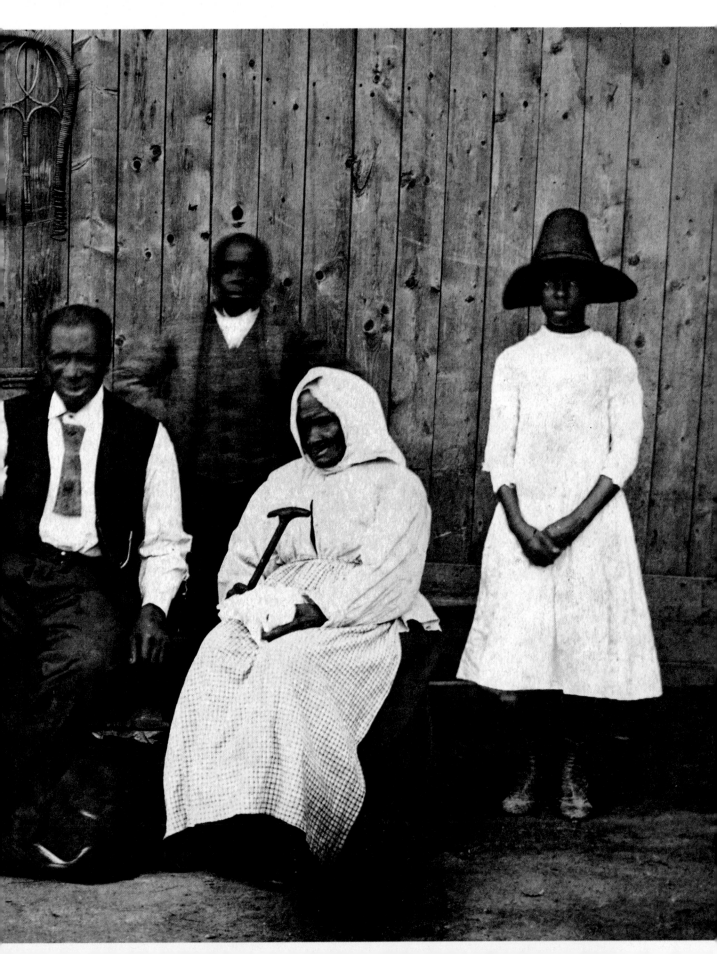

Harriet Tubman

Among operatives of the Underground Railroad, the secret network of volunteers who risked their lives to free slaves in America in the nineteenth century, Harriet Tubman was considered a special asset. She was both a 'conductor', leading parties along escape routes between safe houses, and an 'abductor', raiding plantations and farms to free slaves. Her efforts made her a folk hero, and a large bounty was offered for her capture. She led so many people to freedom that she was nicknamed Moses.

Tubman was born into slavery in Maryland in 1822, where she was beaten and abused, suffering head injuries that may have prompted religious visions she experienced later in life. She escaped via the Underground Railroad in 1849 then joined its ranks to free members of her family and then hundreds of others from enslavement. In 1861, when the US Civil War broke out, she volunteered as a nurse, before working as a scout and spy for the Union Army. In 1863, she led a regiment of Black soldiers in an armed raid at Combahee Ferry in South Carolina that freed over 700 slaves.

Tubman retired from the Army in 1865 and settled in New York, campaigning for reform with the women's suffrage movement and for her own soldier's pension, which she finally received in 1899. She died in 1913 at home in Auburn, New York, where this photograph was taken in 1887. Tubman is on the far left of a group of her family and friends.

Madeleine Pelletier

'It must be left to each woman to decide if and when she wants to be a mother,' wrote Madeleine Pelletier in 1911. The French doctor and political activist was considered extremely radical for her uncompromising beliefs. She promoted ideas that would become central tenets of women's rights, such as contraception and abortion. She also attacked unfairness in her professional life. As one of the first female doctors in France, she instigated a newspaper campaign to overturn a rule preventing women studying psychiatry, the subject in which she then became the first French woman to earn a doctorate.

In Pelletier's books, pamphlets and newspaper articles, she used examples from everyday life in her arguments, an approach dismissed by many academics, including some in the women's movement, who preferred a more theoretical approach. She sought to examine sexual behaviour as a social science: a provocative stance at a time when the discussion of sex was taboo.

This photograph of Pelletier was taken in April 1910, when she was a socialist candidate in the French parliamentary elections. She often wore male dress, kept her hair cut short and advocated celibacy. This, along with her involvement in freemasonry, communism and anarchism all contributed to her controversial public image. In 1937, she was left part paralysed by a stroke; in 1939, she was convicted of offering illegal abortions and died later that year, aged 65, in an asylum.

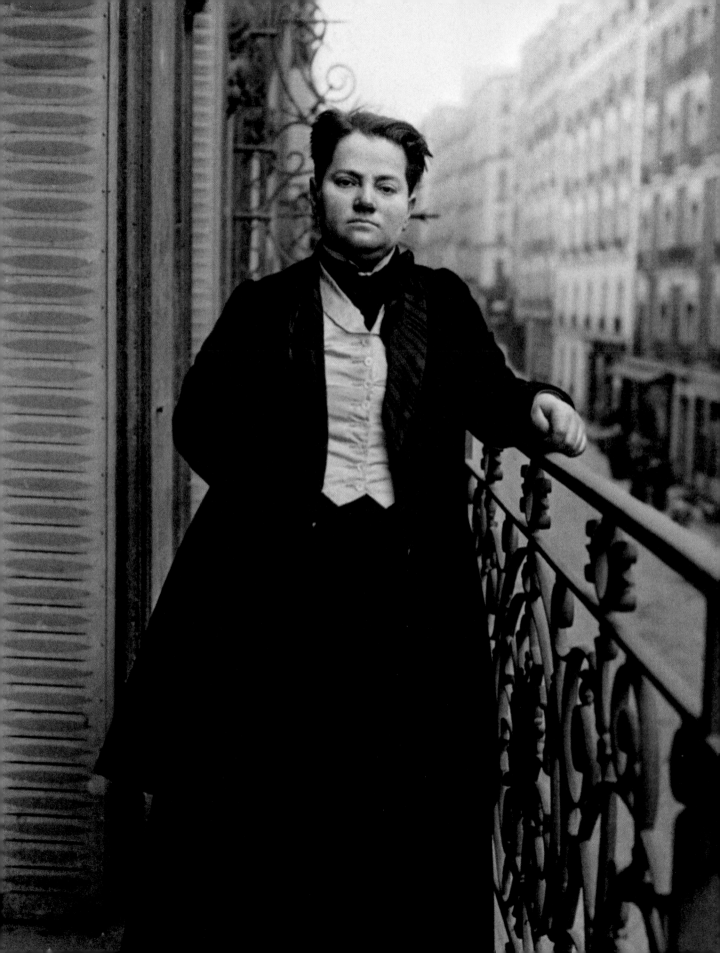

Coronation Procession

These Indian suffragettes were taking part in the Women's Coronation Procession in London on 17 June 1911. Groups across the full spectrum of the suffragist movement came together to form the largest women's suffrage march ever held in Britain, involving as many as 60,000 attendees. The timing of the march, five days before the coronation of King George V, was significant. Women's leaders wanted to put on the 'most imposing peaceful demonstration' possible for the new king and his queen consort, Mary: monarchs they felt might be sympathetic to their cause.

In the early evening, the march progressed from Charing Cross embankment to the Royal Albert Hall, where a meeting took place. The streets en route were lined with onlookers whose cheers competed with the sounds of 75 bands among the marchers. Newspapers reported 'the most beautiful demonstration ever seen in the streets of London', saying that 'it must have impressed even the most rabid and reactionary "antis" with some idea of the driving force behind suffrage agitation'.

Inside a packed Royal Albert Hall, banners from the march were draped over the sides of the boxes. Collection plates filled with cash, pledges and jewellery. A resolution was passed to use 'any and every means necessary' to hold prime minister H. H. Asquith's government to its pledge to change legislation and allow women to vote. And eventually change came. In 1928, 17 years after the biggest demonstration for suffrage in UK history, women were finally enfranchised equally with men.

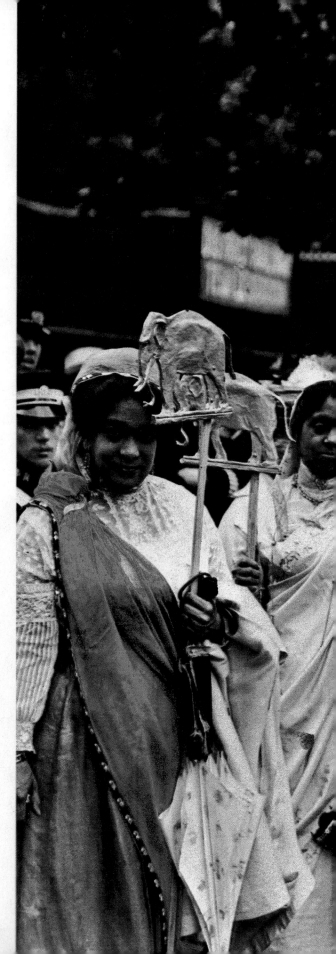

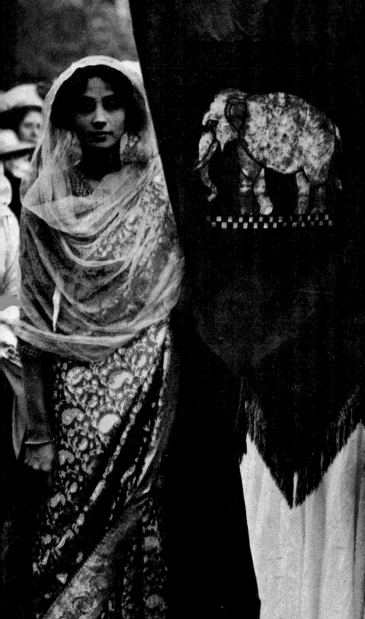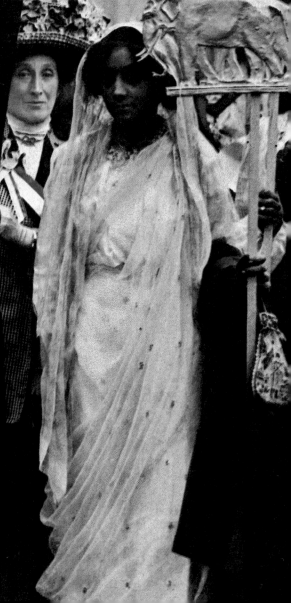

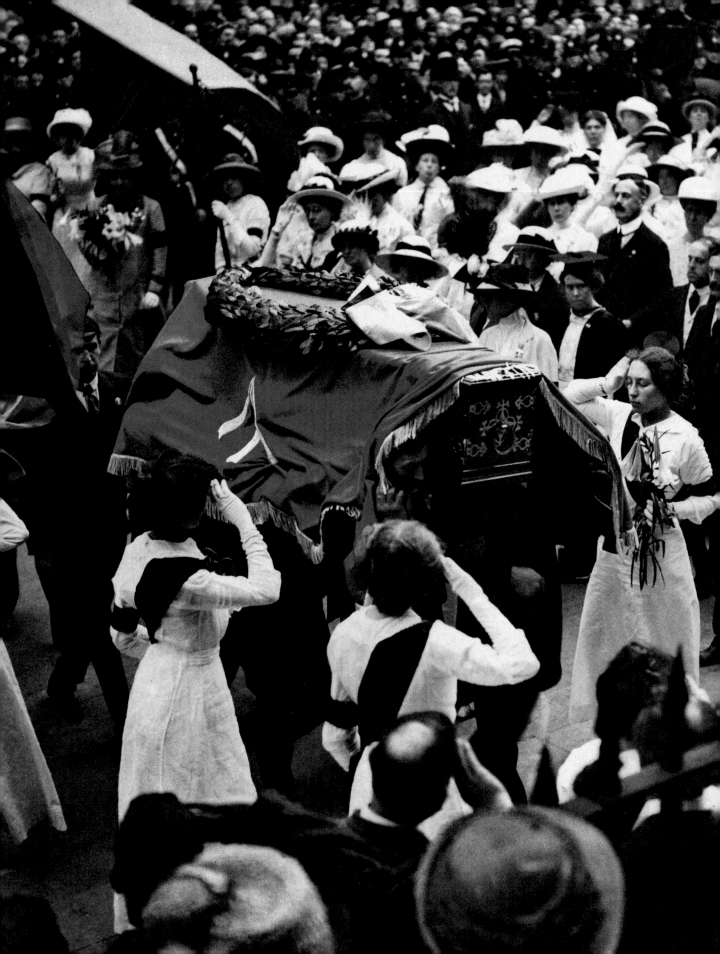

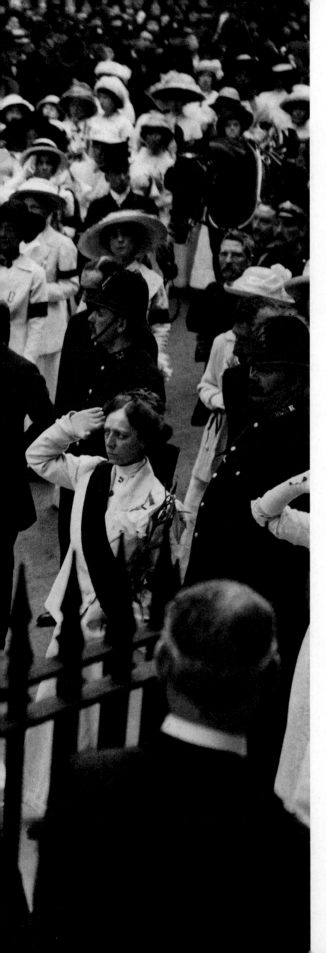

'She fought the good fight'

On 14 June 1913 , 6,000 people, mostly women, formed a funeral procession through London for Emily Davison, who died from her injuries after she stepped on to the track at that year's Epsom Derby and was struck by the king's horse. Whether Davison meant to give her life for the cause of women's suffrage, or was trying to attach a suffragette flag to the king's horse as a publicity stunt, remains unclear to this day.

Davison, who was 40 when she died, was a committed suffragette who had been arrested and imprisoned several times for her activism. In prison she had gone on hunger strike and been force-fed, as had many of her fellow protesters, jailed for their part in an arson and bombing campaign targeting mainly empty public buildings, churches and postboxes.

The London Society for Women's Suffrage stayed away from the funeral, held 10 days after the Derby. Its secretary wrote: 'We deplore her actions. We have to realise that such an occurrence does great harm to our cause.' However, the wider movement claimed her as a martyr.

Either way, world events soon paused the struggle for women's rights. British party politics were put on hold with the outbreak of the First World War, and the suffragettes committed to the war effort. A month after the war ended, however, at the 1918 General Election, women over 30 who met certain property-owning criteria were given the vote.

Inez Milholland

'No suffrage parade was complete without Inez Milholland,' stated the *New York Sun*, remarking on the ubiquity of the woman pictured here in 1915 in American protests demanding women's rights. Born in 1886 to a well-to-do, highly educated New York family, Milholland was schooled in London, New York and Germany, and qualified as a lawyer in 1912. Around the same time she was also throwing herself into the suffrage movement, the cause of prison reform and child labour, along with the broader struggles for world peace and equal rights.

One of Milholland's most famous public appearances came in March 1913 at the Woman Suffrage Procession that took place in Washington, DC on the day before the inauguration of President Woodrow Wilson. Riding a white horse and dressed in flowing robes, she stood out among 10,000 marchers and a partially hostile crowd numbering around a quarter of a million: her dazzling appearance earned her the nickname 'the American Joan of Arc'.

At the start of the First World War, Milholland went to Europe to work as a war correspondent, but was thrown out of Italy for her pacifist views. In 1916, the year after this photograph was taken, she was on a 12-state speaking tour representing the National Women's Party when she collapsed during a speech in Los Angeles and died in hospital some weeks later, from complications arising from anaemia. She was 30 years old.

Jeannette Rankin

Here the first female member of the US Congress, Jeannette Rankin, is presented with the Stars and Stripes that was flying at the House of Representatives when the US government gave women the vote.

Rankin was born in Montana in 1880. Her family was well-educated and ambitious, but she knew what hard work was, having laboured on the family ranch. That experience convinced her that if men and women could toil together, they deserved equal standing in politics and before the law.

In her late 20s Rankin worked in social care and became involved in pacifism and the suffrage movement. She stood for Congress in the 1916 elections – and after a campaign that generated widespread national interest she achieved her goal. 'I am deeply conscious of the weight of responsibility resting on me,' she said, when victory was confirmed.

She was not idle in office. In 1917 she stuck to her pacifist principles by voting against American entry into the First World War. The next year she opened the debate on a Constitutional amendment to allow women's suffrage; this became the Nineteenth Amendment. By the time it was passed she had left Congress, but she returned for a second term in 1941–3, where she again voted against American involvement in a World War. When she died in May 1973, aged 92, she was remembered as a pacifist – though she said she would have preferred to be known as 'the only woman who ever voted to give women the right to vote'.

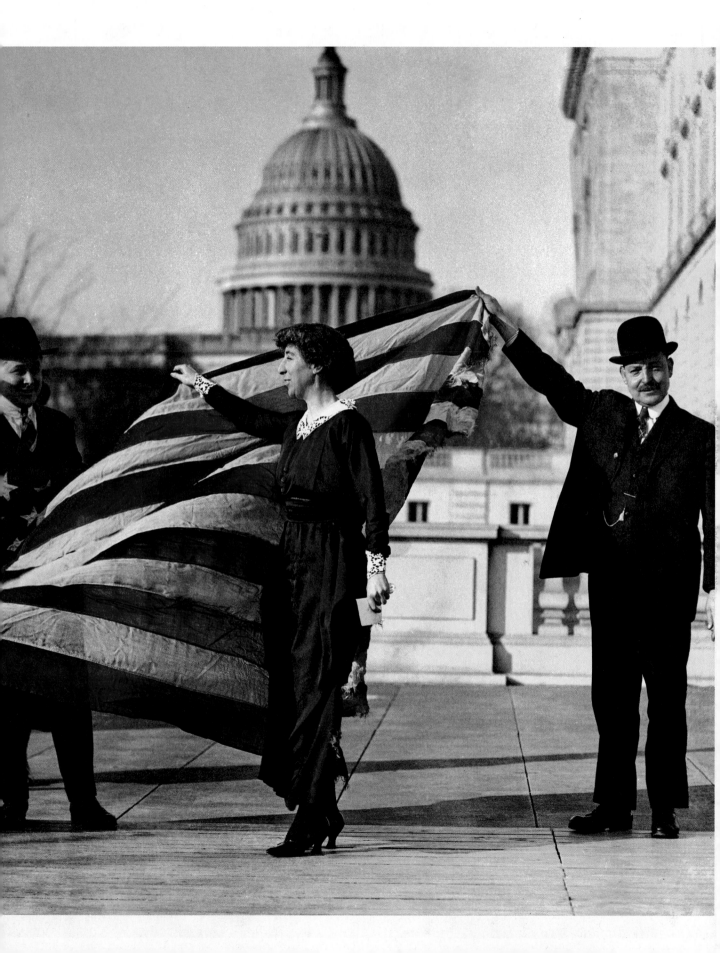

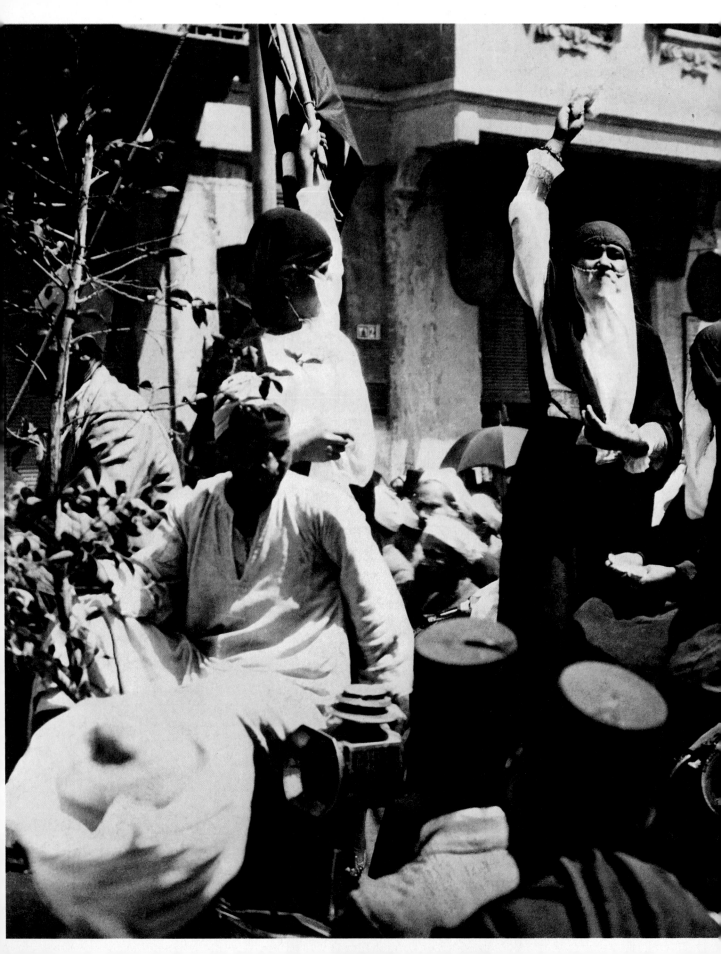

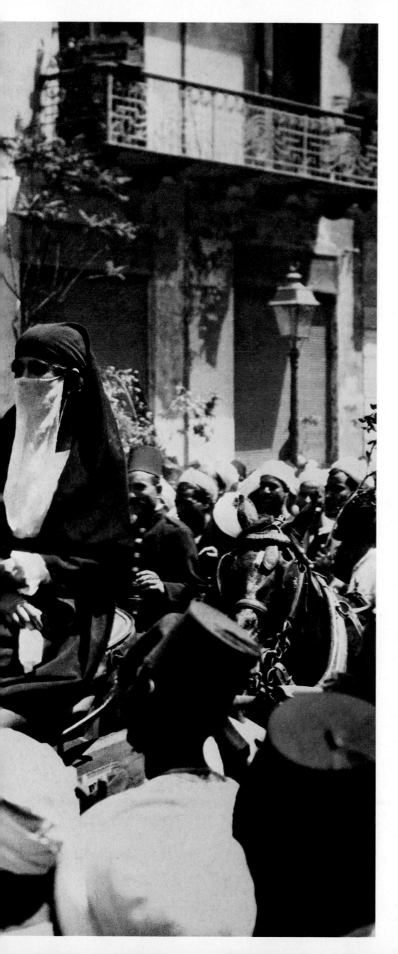

Revolution in Cairo

These women addressing a crowd in Cairo in 1919 were speaking freely in an Egypt they might hardly have dreamed of. At the time, the country was still under martial law, imposed by the occupying British at the start of the First World War, and in the midst of revolution, following the exile by the British of Saad Zaghlul, a popular nationalist leader. Internal and external conflicts raged, but the promise of new beginnings brought by the end of the war gave Egyptians hope.

The nationalist revolutionaries were liberals, who believed that Egypt could only change for the better if the status of Egyptian women was improved. When strikes, boycotts and demonstrations against the British followed Zaghlul's exile, women not only took to the streets but were, for the first time in Egyptian history, among the organizers of direct political action.

In the spring and summer of 1919, gender (and religious) barriers that reinforced Egyptian society were forgotten as mass civil disobedience measures targeted British military and civilian institutions and individuals. During the repression of the revolt by the Egyptian Expeditionary Force of the British Army, 800 Egyptians were killed and 1,600 wounded. Egypt became a sovereign state in 1922, but with significant British influence and military presence until 1956. That year, Egyptian women were given the constitutional right to vote, but only if they satisfied literacy criteria that did not apply to Egyptian men.

Marching Against Peace

The First World War did not officially end in 1918. The armistice of 11 November that year stopped the fighting, but six months of negotiations were required at the Paris Peace Conference before Germany and the Allied Powers signed a treaty of peace on 28 June 1919. The German delegation was not allowed to take part in the drawing up of the treaty, only to raise objections and agree final terms in the six weeks before it was signed.

Later that year, when this photograph was taken, German women and children took to the streets to demonstrate against the terms of the treaty. Most objectionable to the German people was Article 231, which said Germany must take sole blame and responsibility for the loss and damage caused by the war. Further clauses redrew Germany's borders, with a loss of 10 per cent of its population, dividing families across lines on a map. Vast reparations were also imposed.

Four more peace treaties, between the Allies and the other defeated Central Powers (Austria, Bulgaria, Hungary and the Ottoman Empire) were signed during the year-long conference, which ended in January 1920 with the formation of the League of Nations. The failure to maintain world peace of that organization, which the US first proposed then refused to join, along with the Great Depression and the rise of nationalism in Europe in the 1930s, set the world at war again less than 20 years later.

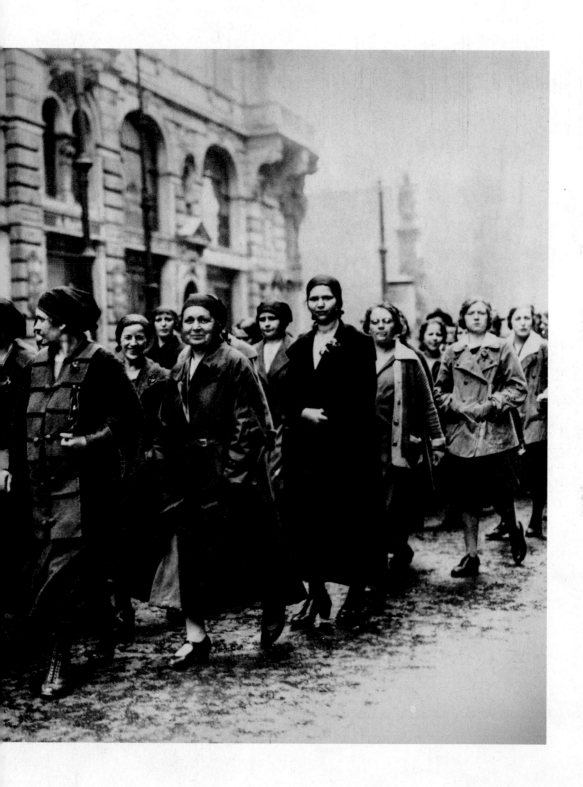

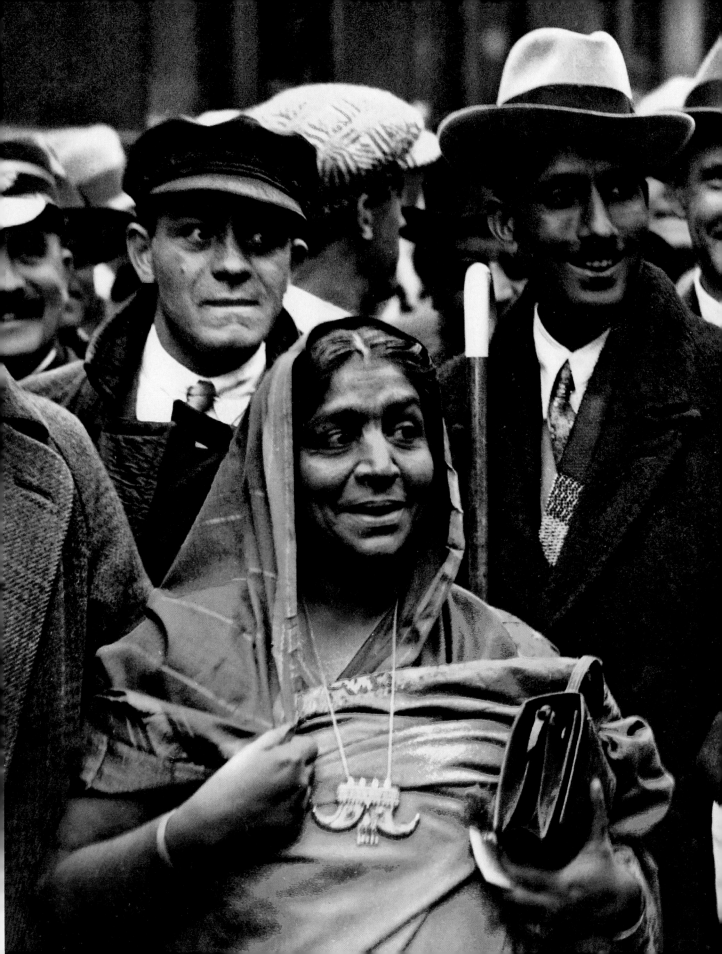

'Nightingale of India'

A poet and civil rights activist, Sarojini Naidu championed women's education and women's suffrage in India in the inter-war years. A close political ally of Mahatma Gandhi, she was a leading figure in his non-violent movement opposing British rule in India.

In 1930, when Gandhi organized the Salt March to protest the British monopoly of salt manufacture and sale, he said it was too arduous for women. However, Naidu insisted on joining. When Gandhi was arresting for making salt, thus breaking the law, Naidu led the continuing civil disobedience, until she too was arrested. She was jailed twice for protesting, non-violently, against British rule.

Gandhi gave Naidu the nickname 'Nightingale of India', in reference to the lyrical beauty of her poetry. Her first book of verse was published in 1895, when she was 16 and studying at Girton College, Cambridge (see page 71). In this photograph, taken in September 1931 at Boulogne station in France, they are part of the Indian delegation travelling to England for talks with the British government regarding the constitutional reform of India and the country's possible future self-rule.

In 1925, Naidu had succeeded Gandhi as president of the Indian National Congress, one of the country's two main political parties, which led the fight for independence. She was the first woman to hold that office and later became the country's first regional governor. India finally gained independence from the British Empire in 1947. Naidu died in office in March 1949, aged 70.

Charlotte Despard

This photograph shows Charlotte Despard channelling the spirit of the lion nearby at a communist rally at Trafalgar Square in London on 11 June 1933, four days before her 89th birthday. A veteran of the suffrage movement, Despard also campaigned for world peace, Indian independence and child welfare. In London, she founded a health clinic and a soup kitchen. In Dublin, she was president of a prison reform charity and her home was a hub of radical Irish republican activity.

Despard came to activism at the age of 46, after she was widowed and friends suggested charity work as something to do. She went to live in a poverty-stricken area of South London, the condition of which became her first cause. Her work caught the attention of the suffragette movement, and she became an enthusiastic and active member of several organizations, including the Women's Freedom League, of which she was a co-founder. She was jailed four times for her activism, and imprisoned alongside Sylvia Pankhurst. During the First World War, she identified as a pacifist – a triumph of politics over personal loyalty, since her beloved brother Sir John French was leading troops in Europe as the head of the British Army.

At the 1918 General Election, the first in which women over 30 could vote, Despard stood for Parliament, but her anti-war views did not win over voters. After the war she moved to Ireland, where the government later put her on a watch list because of her anti-establishment views and where she died, aged 95, in 1939. Her portrait is on a suffragette memorial in Trafalgar Square.

Blanca Canales

On 30 October 1950, Blanca Canales went to the stockpile of weapons and ammunition in her house in a suburb of Jayuya, about 60 miles south of San Juan in the mountainous central region of Puerto Rico, and began arming the 20 men who had arrived at her home in a bus and a car earlier that day. Once everyone, Canales included, was armed, she led her nationalist revolutionary comrades into town.

Under her command, they stormed the police station, the town hall and the post office and took control of the phone lines. In the town square, they raised the Puerto Rican flag – an illegal act – and, from a second-floor hotel balcony, Canales declared the Republic of Puerto Rico.

In at least six other towns in Puerto Rico that day, including the capital San Juan, armed insurrectionists followed suit but were immediately overpowered by the authorities. The Jayuya Uprising lasted for three days, in the face of heavy bombing and artillery fire from the Puerto Rican National Guard, a branch of the US military.

Canales, then 44, a social worker and 20-year veteran of Puerto Rican National Party activism, was arrested in the aftermath of the uprising: this photo shows her being taken into custody on 5 November. She was eventually given a life sentence for fatally shooting a policeman, a charge she denied, and 11 years for the federal offence of post office arson. She served 17 years in prison, but remained a passionate advocate of Puerto Rican independence until her death in 1996, aged 90.

Strike at Loray Mill

On 1 April 1929, 1,800 workers, about half of them women, walked out of the Loray Mill in Gastonia, North Carolina in protest over pay and working conditions. The National Union of Textile Workers called the strike, one of several large industrial actions in the US textile industry in the late 1920s. In response, management evicted workers from company-owned homes, and amid the disruption the state governor called in the National Guard. About 250 armed troops arrived on 3 April and immediately clashed with protesters. This photograph was taken the following day, and shows strikers trying to disarm a trooper.

This was only the beginning. In the early hours of 18 April in Gastonia, a wooden shack rented by the union for its headquarters was destroyed, along with its contents and the contents of the strikers' food store next door, by a masked mob armed with axes and sledgehammers. A tent city for union officials and homeless strikers, including a new union HQ, was built on the outskirts of the town, patrolled by a 24-hour armed guard. But on 7 June, the Gastonia police chief was shot and killed in a gun battle there.

The strike continued throughout the summer of 1929, with repeated flare-ups of violence, leading to a clash on 14 September in which the union organizer Ella May Wiggins was shot and killed.

The strike largely failed in its aims, but it inspired other strikes, raised the profile of the labor movement in the American South and entered working-class lore, memorialized in literature and folk music.

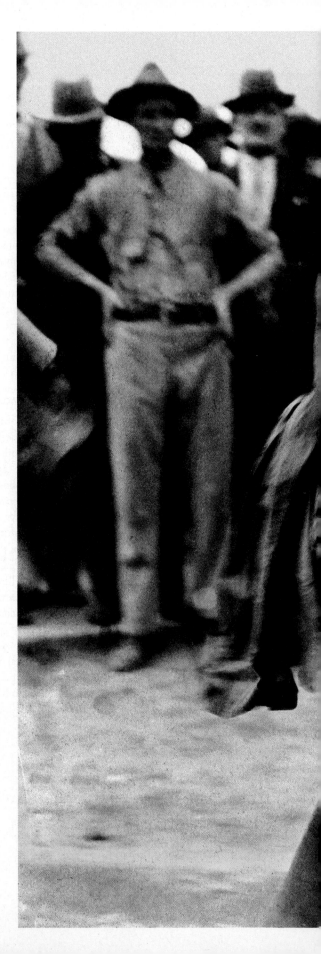

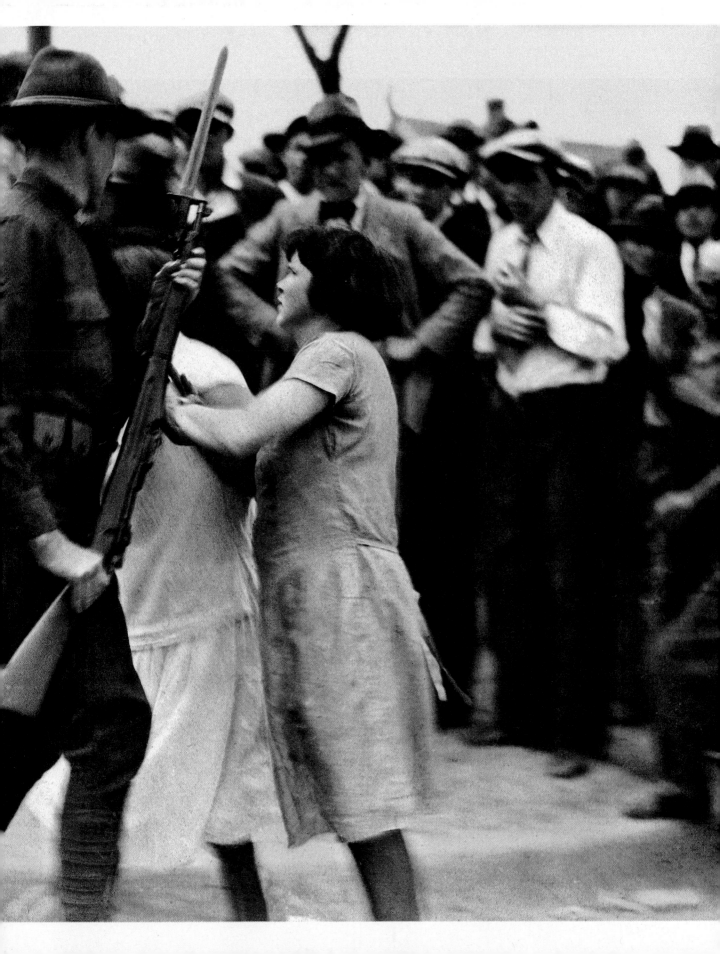

Apartheid

In 1948 the National Party came to power in South Africa, and immediately began introducing the system of apartheid, segregating life on racial lines. Three years later the party stripped non-whites of the right to vote. Apartheid had prompted immediate opposition led by the African National Congress (ANC), and this organization accordingly amended its stance of non-violent opposition to include more disruptive militant acts. The Defiance Campaign of 1952 would be the ANC's boldest move to date: a mass civil disobedience programme they hoped would undermine functions of government.

Beginning on 26 June, Black and Indian South Africans began a campaign of deliberate law-breaking. They walked into bus and train stations and other public buildings using the whites-only entrances or, like the woman in this photograph, sat in white-only train carriages. These were minor offences worthy of fines or short jail sentences. Many of those arrested chose to be jailed, in an attempt to overwhelm the prison system; there were more than 8,000 arrests in the second half of 1952. The following year, the National Party brought in new laws making penalties for protest more severe.

Many women were involved in the fight against apartheid, and figures such as Ida Mntwana, Amina Cachalia, Annie Silinga and Winnie Mandela are all remembered today in South Africa for the important parts they played – marching, organizing, protesting and resisting – during the long walk to freedom.

The Little Rock Nine

Elizabeth Eckford knew there would be trouble on the way to school on 4 September 1957. She and eight other Black children were going to Little Rock Central High, the first Black students in the country to attend what had been an all-white school after the US Supreme Court declared educational segregation to be unconstitutional.

The Eckford family didn't get a message about a last-minute change of plans for the first day's entrance, so Elizabeth went to school alone. The school board had advised the parents of the Little Rock Nine to stay away, in case their presence incited a mob.

Between a crowd of people and the school stood a line of National Guards, who Elizabeth thought would protect her. But the state governor had ordered them not to let the Black students pass. The mob chanted as she made her way to the school building: 'Two, four, six, eight. We ain't gonna integrate!' 'Lynch her, lynch her!' As she tried to walk in behind some white students, a guard raised his bayonet to her.

Elizabeth walked to a nearby bus stop and sat on a bench. Some of the crowd followed, still threatening to hang her. Eventually, a white woman helped her on to a bus. Three weeks later, with the National Guard under federal control, US troops walked the Little Rock Nine into school for the first time. Elizabeth became a teacher and social worker and spent five years in the US Army. She lived in Little Rock as an adult, the only one of the Nine to do so.

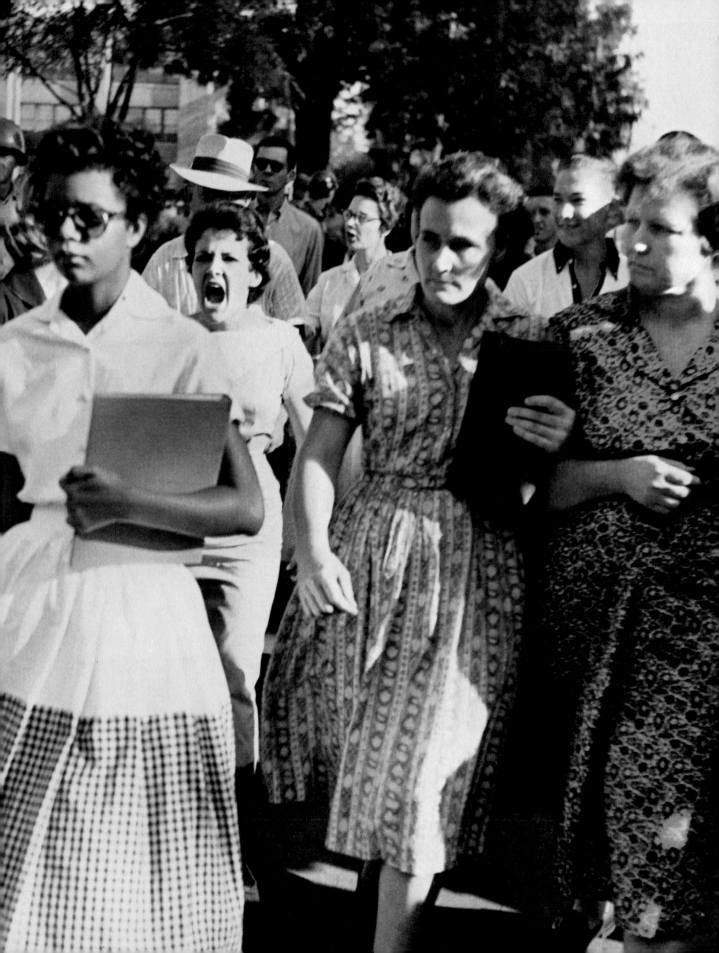

Anti-American Chinese

This photograph, showing a female Chinese student and her male colleagues plastering up anti-American slogans, was taken in July 1946. The Second World War had ended nearly a year before, but it had not brought peace to China, where fighting had been going on intermittently since the outbreak of civil war in 1927. That domestic conflict was now underway once more, with the emerging postwar superpowers – the USSR and US – backing opposing sides.

As a result, anti-American sentiment was not unusual. In 1946, there were about 12,000 US military personnel in China to oversee the repatriation of Japanese soldiers. The Chinese press reported criminal behaviour by US troops who, under American military jurisdiction, did not face Chinese justice. One Shanghai paper said one Chinese person every day was being killed, and compared the senseless, often drunken attacks with the behaviour of the occupying Japanese.

By summer that year, groups like the students in this photograph were organizing anti-American protests. These stepped up a gear in December 1946 after a Beijing student was allegedly raped by two US Marines. The Chinese Communist Party (CCP) said this represented the rape of the Chinese nation. In 1948, Japanese repatriation complete and focusing its post-war fight against communism in Europe, the US withdrew its final troops and support for Chinese nationalists. The communists won the Civil War in 1949.

Rosa Parks

This photograph shows the American civil rights activist Rosa Parks being arrested for the second time in her life, in February 1956. Her first, more famous arrest, had occurred around three months previously, in Montgomery, Alabama, when she refused to give up her seat on a bus for a white man, as she was legally required to. When the bus driver said he would call the police and have her arrested, she replied politely, 'You may do that.'

After Parks was convicted and fined for disorderly conduct and local code violations, the Women's Political Council, a civil rights group, flooded Montgomery with leaflets telling Black people to boycott the buses. The boycott lasted more than a year and contributed to a Supreme Court ruling against bus segregation. It was a tipping point in the civil rights struggle and showed the power of one person's dignified non-violent protest to spark change.

Before she shot to fame, Parks was more or less an ordinary Black American. She was 42 years old, a seamstress who worked in a department store and served as secretary of the Montgomery branch of the National Association for the Advancement of Colored People (NAACP). In other words, she was a committed behind-the-scenes activist but not an obvious candidate to become the figurehead for the national civil rights movement and one of the most recognizable women in America.

Nevertheless, that was how her life turned out. Parks's second arrest, shown here, came in a sweep of boycott organizers and figureheads; the charges were dropped. She spent the next 35 years giving speeches and working for civil rights and educational groups. She died in 2005, aged 92.

Women
on Stage

In the spring of 1953, the 26-year-old actress Marilyn Monroe received a visitor to her Hollywood home. It was the photographer Alfred Eisenstaedt, on assignment for *Life*, the world's most famous picture-led magazine.

In his time working for *Life*, Eisenstaedt, then aged 54, had photographed some of the most famous (and notorious) people in twentieth-century history. He had covered the first meeting between Adolf Hitler and Benito Mussolini in Venice in 1934. He took portraits of Winston Churchill and Ernest Hemingway. His photograph of a woman kissing a sailor in Times Square on VE Day was perhaps the best-known image of his age.

Yet few of Eisenstaedt's subjects had anything like the sheer star power of Marilyn Monroe. Weeks before this photograph was taken, she had appeared in the Technicolor film *Niagara*, playing a *femme fatale* hell-bent on murdering her husband. A few months afterwards, *Gentlemen Prefer Blondes* would be released. Between them, those two films established her not only as a bona fide Hollywood star, but as an icon whose innocent but knowing command of her sexuality and sex appeal would long outlast her spectacular – if short, and not always happy – life.

Marilyn Monroe was not, of course, her real name. Like many film stars before and after her, she used a pseudonym as part of a carefully curated image designed to tantalize ticket-paying moviegoers worldwide. She was born Norma Jean Mortensen in 1926, and grew up both close to and a million miles away from the spotlight: although she was a child of Los Angeles, fast becoming the film capital of the world, she spent much of her youth in foster homes and orphanages.

Yet in her late teens, Norma Jean, having already married the first of her three husbands (police officer James Dougherty; the second and third were baseball legend Joe DiMaggio and playwright Arthur Miller), embarked on a pin-up modelling career. This soon led to bit parts in movies, which from 1950 developed into ever-bigger roles. So it was that in 1953, when Eisenstaedt met her, she was transforming from a bankable actress into a megastar.

Although this was a promising time, it is impossible to tell the story of Marilyn Monroe without acknowledging the unhappiness that enveloped her as her career progressed. While at work she made films that were commercially acclaimed and/or classics, including *Seven Year Itch* (1955), *Some Like It Hot* (1959) and *The Misfits* (1961), her marriages to DiMaggio and Miller were not happy, and she was plagued by anxiety and insomnia, which led her in turn to drug abuse and addiction. In early August 1962 she was found dead in bed by her housekeeper at the age of 36. Her death was the result of a barbiturate overdose, although many since have doubted the coroner's verdict of suicide.

Marilyn Monroe lived a singular life. Yet her experience – of wild fame and highs interspersed with personal struggle and tragedy – was one that became generally associated with Hollywood stars over the ages. Many of the women in this chapter would have recognized her journey. But all of them – be they ballerinas or vaudeville stars, actors, producers or directors – would be remembered for the joy and entertainment they brought to audiences worldwide.

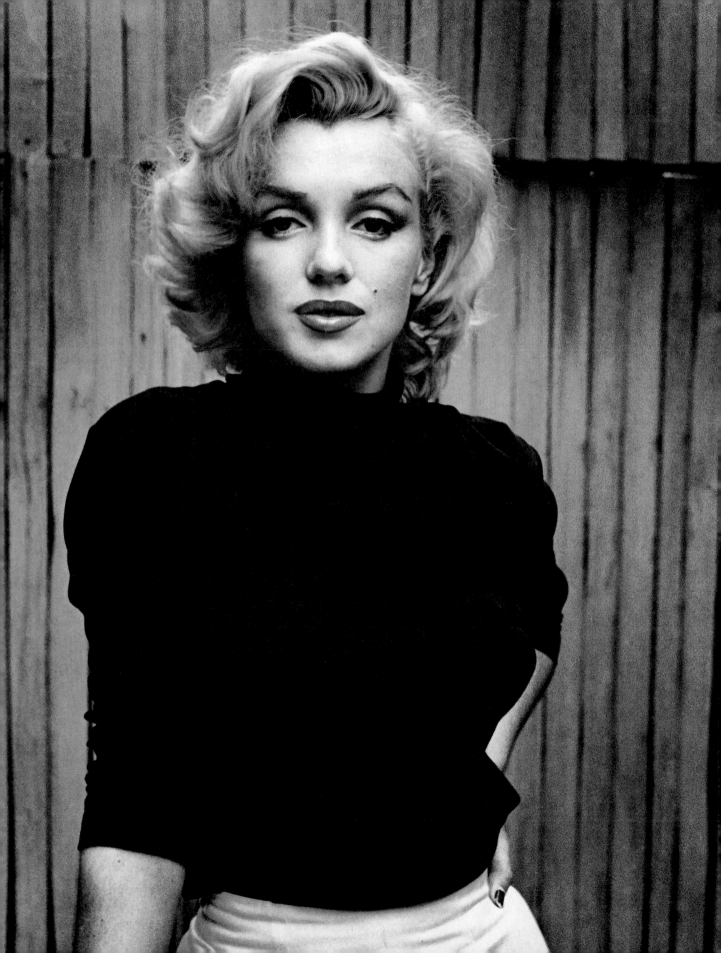

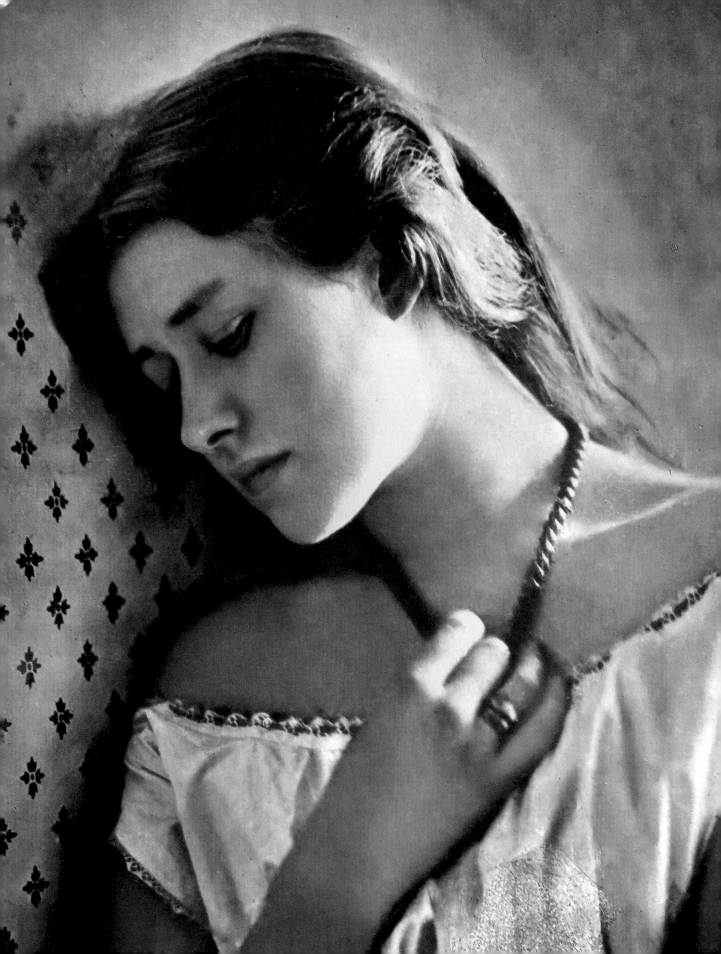

Ellen Terry

The British actress Ellen Terry was the child of a prestigious theatrical dynasty. Born in 1847, she and several of her siblings were coached for the stage by their parents. Terry performed her first Shakespearean role aged nine. Here, in a picture taken by the great Victorian conceptual portrait photographer Julia Margaret Cameron, she is 16, already a seasoned professional and married to her first husband – the painter and sculptor G. F. Watts, who was 30 years older than her.

During the next seven decades, Terry became a national treasure. She had a graceful, almost ethereal stage presence and a musical voice; she was cheerful and charming. Although not the greatest talent of her generation (that honour belonged to Sarah Bernhardt or Eleonora Duse), she was adored by the public.

The golden period of her career came between 1878 and the turn of the twentieth century, when she worked under her friend and confidant Henry Irving at the Lyceum Theatre, excelling in Shakespeare as well as more modern productions such as *The Cup*, *Faust* and *Olivia*. She acted until 1925, when she was 78 years old. That year she was made a Dame, the second actress ever to receive such an honour (after May Whitty). When she died in 1928, an obituary declared her a 'genius… of the spirit and of the heart… On the stage or off she was like the daffodils that set the poet's heart dancing.'

'The Incomparable One'

The American essayist and wit Mark Twain wrote
that there were five types of actress: 'bad actresses,
fair actresses, good actresses, great actresses, and
Sarah Bernhardt'. Born in Paris in 1844, Bernhardt
conquered the French stage, travelled the world and
lived long enough to perform in silent film. She was
an international superstar in an age when that was
a rare accolade.

The daughter of a courtesan, Bernhardt trained
for the stage as a teenager and made her name with
the prestigious Comédie-Française company. She was
admired by society figures, writers like Victor Hugo
and the emperor Napoleon III. By her late twenties
she was famous – for her enchanting voice, her
dazzling command of lead roles in plays like *Hamlet*
and Racine's *Phèdre* and her opulent eccentricity
(her habits included sleeping in a satin-lined coffin).
This photograph of Bernhardt was taken in her
apartments on the boulevard Pereire by the
celebrated French photographer, journalist and
hot-air-balloonist Gaspard-Félix Tournachon, better
known by his pseudonym 'Nadar', who had first
taken her picture in 1864, when she was 20 years old.

Bernhardt's phenomenal fame did not wane even
when she was in her seventies and had been forced to
have her right leg amputated following an injury she
sustained while acting in Victorien Sardou's play *La
Tosca*. She was making silent films up until her death
in 1923, when tens of thousands of Parisians flocked
to the streets to mourn her.

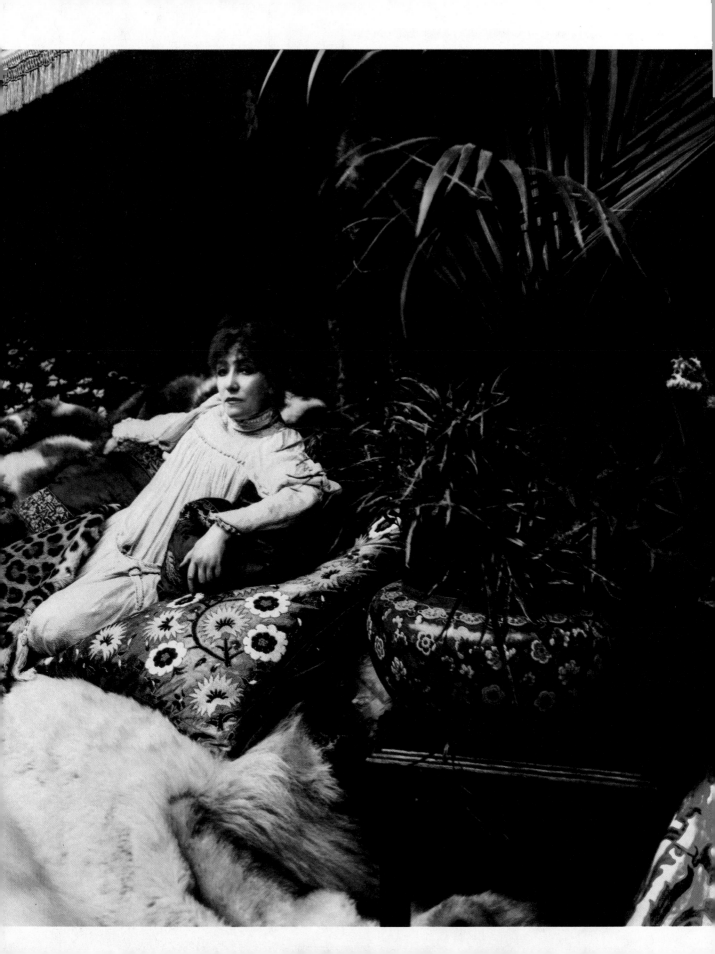

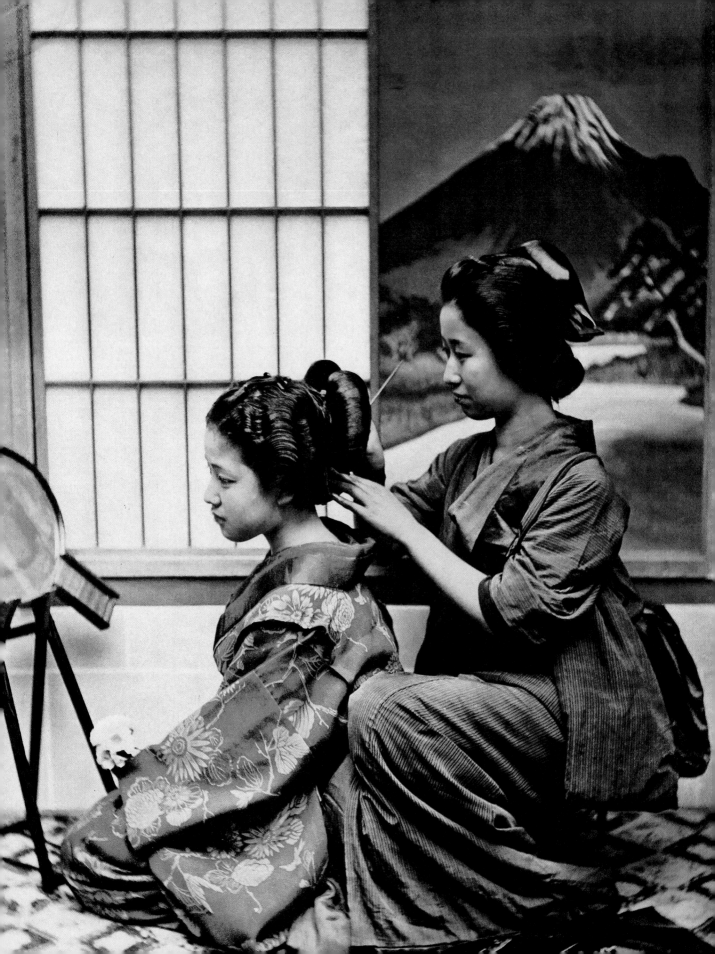

Geisha

This image, taken around the year 1890, shows two Japanese geisha styling their hair, perhaps in preparation for a performance. The profession of geisha had existed in Japan since the Middle Ages, becoming an almost exclusively female occupation in the eighteenth century. The word literally translated as 'artist', for geisha were highly trained performers, typically adept at dancing, singing and playing music, as well as the refined arts of hostessing, making witty conversation and presiding over tea ceremonies. Geisha dressed in flowing kimonos and wore heavy white make-up and nihongami, a traditional form of Japanese hairstyle.

Geisha performances were specifically designed to please wealthy men at parties, often at 'geisha houses' grouped together in specific districts of cities, which has made them ambiguous characters in Japanese culture – at least to outsiders. A common mistake is to confuse geisha with prostitutes – a conflation that owes much to the late stage of the Second World War, when some Japanese sex workers advertised themselves to occupying US troops as 'geisha girls'. Although historically some geisha slept with their clients, and the profession could be extremely exploitative, this was not what characterized their work.

Photographs of geisha like this one became popular outside Japan from the mid-nineteenth century, when Japan opened its borders to foreigners during the so-called Meiji Restoration. Photographic postcards showing geisha were sold across the US and Europe, often with the black-and-white images hand-coloured in vivid hues to emphasize the visual splendour of geisha culture.

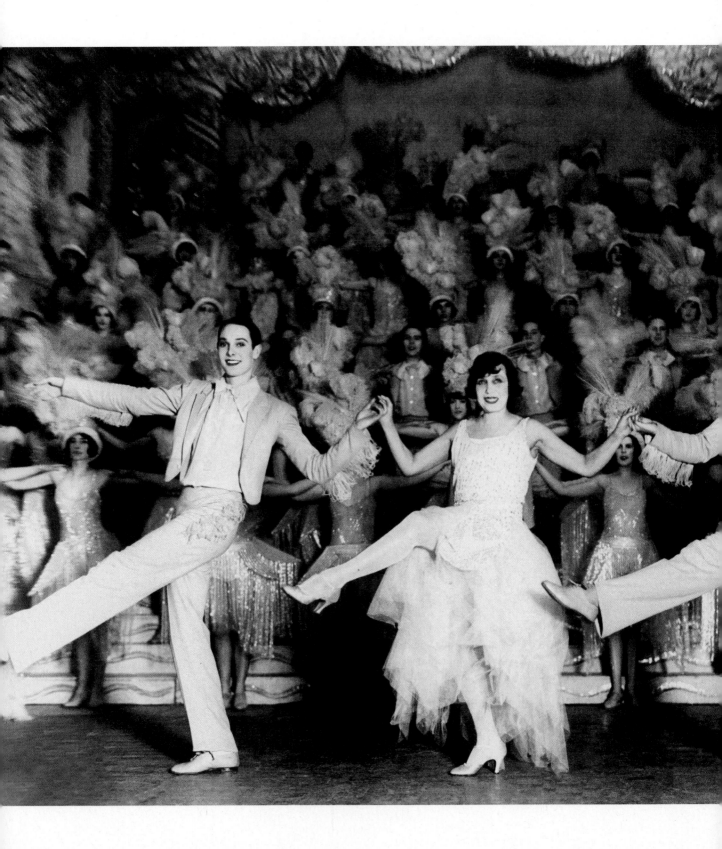

Mistinguett

For the three decades before the outbreak of the Second World War, Mistinguett – pictured here in a white dress – was the most popular performer in France. A singer, dancer and comedic actress, she appeared in almost 50 silent films and dozens of plays and sketches, but it was her headlining years in music hall revues that made her truly famous. She helped devise and starred in hit dance shows at the Moulin Rouge and the Folies Bergère, the latter in partnership with Maurice Chevalier, one of her lovers. She was known simply as 'Miss' throughout France, where everyone loved her, the glamorous queen of Paris nightlife who never lost the common touch, a true woman of the people.

Born Jeanne Florentine Bourgeois in a small town just north of Paris in 1875, as a teen she took music and singing lessons in the capital, squeezing in a show at a music hall or café before catching the train home. Hanging around those places got her a manager and first jobs as a stagehand. She made her debut as solo performer at the Casino de Paris in 1893, her stage name adapted from 'guinguette', the sort of rowdy music hall in which she learned how to move on stage and grab hold of an audience. After years in comic plays at the Eldorado, in 1908 she moved to the Moulin Rouge, co-creating a sensational waltz routine that propelled her to stardom. When she died, aged 82, in 1956, her body lay in state in Paris.

'The Black Patti'

Sissieretta Jones was one of the most famous American sopranos of her age. Known across the world, she performed for numerous US presidents and European royalty, and was nicknamed 'The Black Patti', a favourable comparison with Adelina Patti, the Italian opera singer who was her contemporary (and whom Verdi considered the greatest ever born).

She was born Matilda Sissieretta Joyner in 1869, to a mother who was a washerwoman and a father who was a freed slave turned minister. (She married her husband, David Jones, when she was 14.) Sissieretta trained to sing in Rhode Island and made her debut on the New York stage in 1888, when she was 19. Four years later she was becoming famous, performing at Carnegie Hall, Madison Square Garden and the White House – where she was made to enter the building by the back door on account of the racism entrenched in American society at that time. Her nickname had also been coined, although she was not wildly enthusiastic about it, since she considered herself just as good a singer as Adelina Patti, and not merely her Black equivalent.

By 1895 Jones was the highest-paid Black artist in America and in demand to tour internationally, yet she was also held back by racial discrimination in her home country. She took control of her own career when she founded the Black Patti Musical Comedy Company, which sustained her until she retired from performance to look after her ailing mother in 1915.

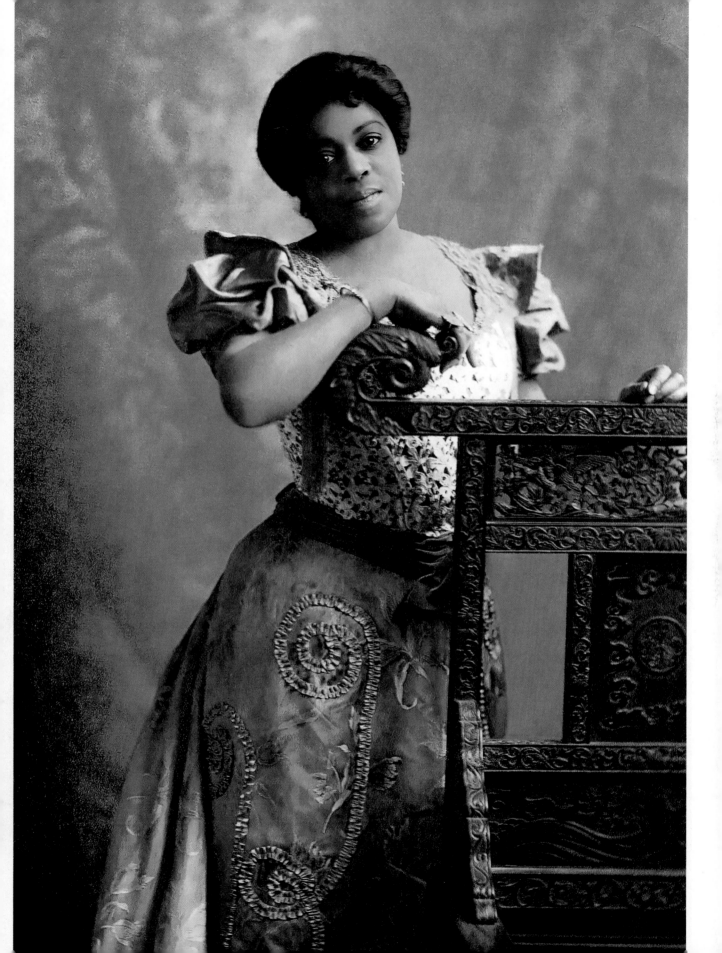

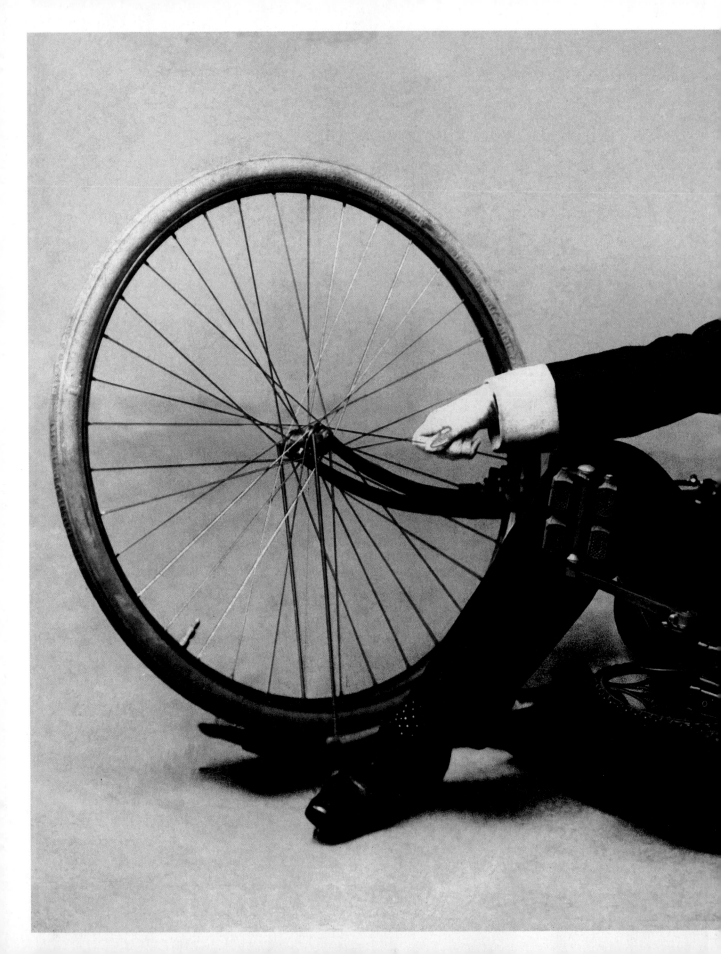

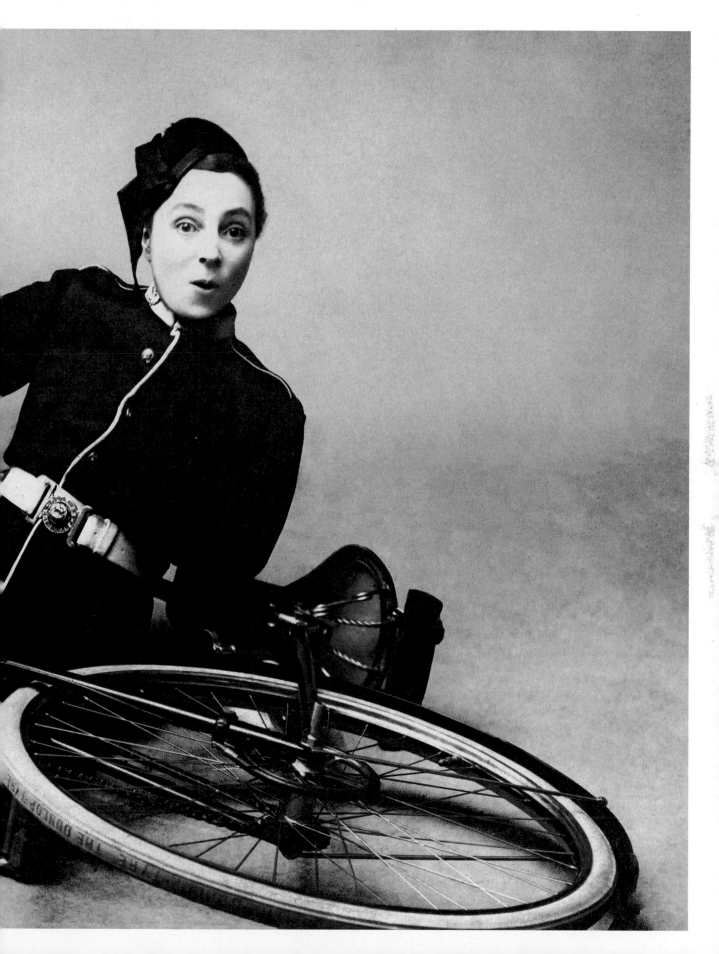

Vesta Tilley

During the 1890s Vesta Tilley was the highest-earning woman in Britain: a singing, dancing, cross-dressing phenomenon whose songs were familiar to an entire generation.

Born Matilda Powles in 1864, she was first called 'Vesta' by her father, a theatre manager who introduced her to the stage when she was five. The nickname was borrowed from Swan Vesta matches, which were advertised with the slogan 'bright as a spark'.

The music halls that boomed in late nineteenth-century Britain were the perfect environment for her talents, and a great backdrop for her range of drag characters: light-hearted, family-friendly stock types like policemen, vicars and a London dandy known as Burlington Bertie. She also played male leads in pantomime to enormous acclaim. Her marriage in 1890 to an enterprising theatre owner called Walter de Frece gave her access to a chain of first-rate venues; she also toured the US, commanding large fees to perform.

In 1912 Tilley performed before Queen Mary, and during the First World War she and de Frece threw themselves into military recruitment and charity work to entertain wounded soldiers. She sang (and recorded) patriotic songs with titles such as 'Jolly Good Luck to the Girl Who Loves a Soldier'. After the war, de Frece was knighted and elected to Parliament, and Tilley had to quit the stage. At her retirement performance, Ellen Terry presented her with a message of thanks signed by two million Britons – fitting tribute from one national treasure to another.

The Dying Swan

This photograph of the Russian ballerina Anna Pavlova shows her around the year 1914, in her most famous role, known as 'The Dying Swan'. A solo of only around four minutes, set to music by Cyril Saint-Saëns, she created it in 1905 in collaboration with the great choreographer Mikhail Fokine. During the course of her career, Pavlova performed the piece thousands of times, preserving her version of it in a silent film recorded in 1925. Fokine later reflected that the dance was 'of the whole body and not of the limbs only; it appeals not merely to the eye but to the emotions and the imagination'.

Born in 1881, Pavlova trained at the Imperial School of Ballet in St Petersburg, initially struggling due to the extremely curved arches of her feet and earning unkind nicknames from her classmates, including 'the little savage'. But she worked hard and graduated aged 18. Seven years later she was named prima ballerina; her fans in St Petersburg, enchanted by her frail and delicate style, called themselves the Pavlovatzi.

After working briefly for Sergei Diaghilev's avant-garde Ballets Russes, in 1912 Pavlova set up her own company, making her home in London as she toured the world for the following two decades. An animal lover, she kept many swans as pets. It is said that when she lay dying of pleurisy in a hotel in The Hague, aged just 49, her last words were: 'Get me my swan costume.'

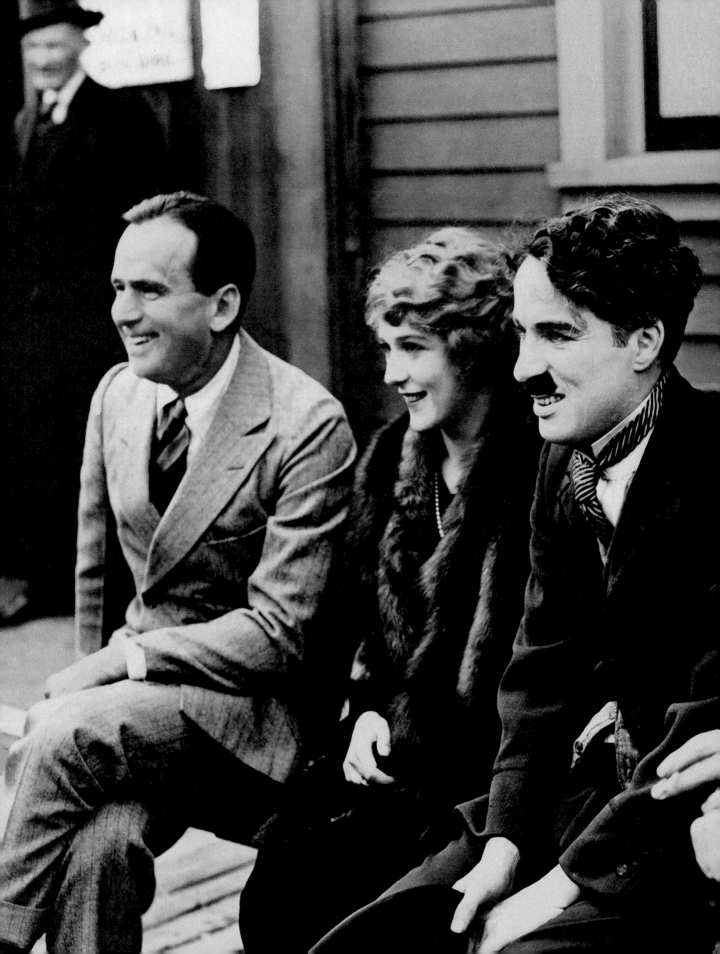

Queen of the Movies

Mary Pickford was one of the brightest stars of the Hollywood movie business as it emerged in the 1910s and 1920s. She cut her teeth as a child actress touring the US under her real name, Gladys Marie Smith, but in 1909 was headhunted to appear in motion pictures. By then she had acquired the pseudonym by which she would be known for the rest of her career.

Ten years later, Mary Pickford was a household name – an actor so popular that her presence could sell tickets to a silent movie. She was commanding big fees for her work. However, like several other major stars of her age, she felt that artists ought to have more control over their work, rather than being bidden to do as the studios decided. In 1919 Pickford therefore became one of the founder members of United Artists. In this photograph, she sits with her three co-founders: Douglas Fairbanks, Charlie Chaplin and D. W. Griffith.

At the time United Artists was set up, Pickford was having an affair with Fairbanks. She married him in 1920 after divorcing her first husband. The celebrity couple were feted worldwide as the King and Queen of the Movies, and held court at their Beverly Hills mansion, known as Pickfair.

Pickford won the second-ever Academy Award for best actress in 1930 but quit acting in 1933, divorced Fairbanks in 1936 and lived out a long, alcoholic and reclusive retirement at Pickfair, until her death in 1979.

'Daughter of the Dragon'

Wong Liu Tsong – better known as Anna May Wong – was one of eight children born to parents who owned a laundrette in Los Angeles' Chinatown in the first decade of the twentieth century. Fascinated by the booming movie business, she dropped out of high school to make her way in silent film. Her first break came in 1922 in *The Toll of the Sea*, one of the first colour movies ever produced. Soon after, she appeared in Douglas Fairbanks' *The Thief of Bagdad*, then one of the most expensive films ever produced.

This photograph of Wong was taken in 1931, when she was cast as Princess Ling Moy in *Daughter of the Dragon*, a story heavily derived from the book *Daughter of Fu-Manchu* by the English novelist Sax Rohmer. In many ways, this was a stereotypical role for a Chinese-American actress of that time. Although Wong was a superb actress and renowned around the world as a fashion icon, Hollywood offered her little other than typecast oriental villains; anti-miscegenation laws ruled that she couldn't kiss a white actor on screen, so many leading Asian roles were played by white actors in 'yellowface'.

Wong spent part of her career in Europe, and toured China, although her popularity there was tempered by suspicions that her work had helped spread negative stereotypes of the Chinese people. She died in 1961 aged 56, and today is recognized as a pioneering Asian-American film star.

The Blonde Bombshell

Few careers were as spectacular, or as tragically short-lived, as that of Harlean Harlow Carpenter, nicknamed Baby by her family and known to the public by her mother's maiden name of Jean Harlow. She is photographed here in 1929 with comic duo Stan Laurel and Oliver Hardy, on the set of the MGM short *Double Whoopee*.

In 1928, Harlow had been talent-spotted while driving to drop off an actress friend at a studio. Soon after, she was recruited by director Howard Hughes to appear in *Hell's Angels*, a film that was a huge international success. Although Harlow was neither a trained nor a particularly capable actress, she was astonishingly beautiful, and known for her 'platinum blonde' hair, supposedly natural, although almost certainly chemically enhanced. In 1932 MGM bought her contract from Hughes and she became one of the biggest stars on that studio's roster, leading comic and romantic pictures such as *Red Dust*, *Dinner at Eight* and *Suzy*.

Harlow's private life was complicated. She divorced her wealthy first husband after two years of marriage; her second husband, Paul Bern, was found dead in their home of a mysterious gunshot wound, and her third marriage was a sham arranged by MGM to cover up her affair with heavyweight boxing champion Max Baer. She died suddenly in 1937, aged just 26, when she fell ill during filming of *Saratoga*. The film was completed with body doubles and became her highest-grossing hit.

'Queenie'

Merle Oberon's first film role, pictured here, was as the doomed Tudor consort Anne Boleyn in the 1933 film *The Private Life of Henry VIII*. This was an appropriate launch pad for her career. When she was spotted by the film's director (and her future first husband), Alexander Korda, she had been working as a nightclub hostess, using the name Queenie O'Brien.

This was not her real name. And Oberon was always cagey about her identity. Her mother, Constance, had been 12 when she gave birth, so Oberon was raised as the 'daughter' of her grandmother. What was more, she was born in Mumbai, and her heritage was a mixture of English, Sri Lankan and Maori. All her life, she did her best to cover up these facts, claiming that she had been born in Australia, but her birth records had been lost in a fire.

Murky as that life of deception was, Oberon enjoyed a successful film career. After her turn as Anne Boleyn, she appeared in *The Scarlet Pimpernel*, starred opposite Laurence Olivier in *Wuthering Heights*, and earned an Oscar nomination for her performance in *The Dark Angel*. Her years in front of the camera spanned five decades, despite the fact that a serious car accident in the mid-1930s left her with scars on her face that required surgery, chemical treatment and bespoke lighting to conceal them on film. She died in 1979, aged 68, taking many of the secrets about her identity to her grave.

Gracie Fields

On 17 June 1937, 39-year-old Gracie Fields, the highest-paid film star in the world, laid the foundation stone for the new Prince of Wales Theatre on Coventry Street in London's West End. A theatre had stood there since the 1880s, but it had been largely demolished and a new art-deco building, designed by Robert Cromie, was now underway.

Fields, photographed here singing to some of the workers on that day, was world-famous. She had been born in 1898 above a fish-and-chip shop in Lancashire, trained for the stage part-time while working in a cotton mill, and by the age of 16 was starring in revue shows, along with her manager and future first husband, the showman Archie Pitt. Her film debut came in 1931 in *Sally in Our Alley*, and her fee per film was a record £50,000.

In 1939 her marriage dissolved; that year, she also underwent surgery for cancer. She took up residence in California and Capri, but still spent part of the Second World War entertaining British troops. After the war she was a star of TV entertainment and drama shows – she was the first actress to play Agatha Christie's Miss Marple. She was also a popular recording artist and received much acclaim for her charity work, which included opening an orphanage in Sussex for the children of dead or impoverished entertainment artists. She died aged 81 in 1979, shortly after having been dubbed a Dame by Queen Elizabeth II.

'Come up and see me'

The actress and writer Mae West challenged, and broke, boundaries of censorship on stage and on film with her comedies and musicals. A star of vaudeville and on Broadway, at the height of her fame in the 1930s she was the highest-earning star in Hollywood and an icon of female sexuality. She wrote all of her hit stage shows and most of her movies. Her one-liners and double entendres still hit the mark a hundred years after she first delivered them.

As was the case with that other female pioneer of American humour, Lucille Ball, West's comic persona and the real person who played it became impossible to separate, not least because West wanted it that way. She never gave an interview or spoke in public without making wisecracks. Journalists who sat down with West, especially the male ones, thought they were sparring with her; her impeccable, impenetrable character act left them in the dust.

Her frank and open discussion of sex, and how much fun it could be, was genuinely groundbreaking. One drama critic called her 'the Statue of Libido'. In February 1927, New York police stopped a performance of her play *Sex*, in which she starred as a prostitute, and she, the cast and producers were arrested; she was convicted of 'corrupting morals' and sentenced to ten days in the workhouse. The play had been a huge hit. 'When one can please the masses,' she wrote in 1929, 'one must essentially be right.' In 1943, rich and happy, she went into semi-retirement aged 50, and died, aged 87, in 1980.

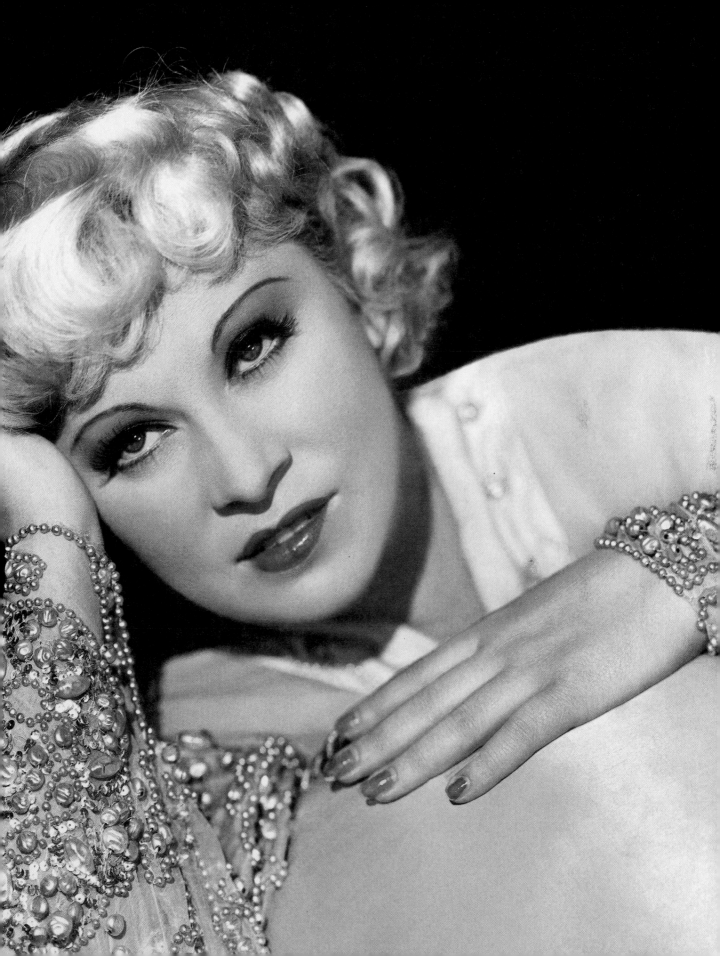

Dorothy Arzner

In front of the camera was a fine place for a woman to be during the golden age of American cinema. It was considerably harder to carve out a place behind the lens. That made Dorothy Arzner – pictured here on set in 1937 – quite exceptional. She was a director, and for her entire career she was the only woman to do that job in all of Hollywood.

Arzner rose and succeeded as a director because she was exceptionally good at her job, and because she understood the whole business of filmmaking like few others. She learned the craft working as an editor, and first tried her hand at capturing footage when she oversaw the shooting of bullfighting scenes in the 1922 movie *Blood and Sand*, starring Rudolph Valentino. She then struck up a fruitful working partnership with the prolific director James Cruze, which gave her enough credibility and leverage with the studios of the day that in 1927 she was given the first of her own directing jobs.

Over the next 16 years, Arzner directed 20 films, several of which had pronounced feminist themes. She worked with rising and established stars including Clara Bow, Katharine Hepburn and Maureen O'Hara. And she lived as an openly gay woman with her partner Marion Morgan, in an age that did not always make that easy. Arzner retired in 1943 to consult to businesses and teach filmmaking; her students included such Hollywood greats as Francis Ford Coppola.

Carmen Miranda

When this photograph was taken, in New York City around the year 1940, Carmen Miranda, 31, was famous around the world. She was known for wearing elaborate arrangements of tropical fruit on her head. But her cheerful trademark headgear obscured the fact that Miranda was one of the most talented dancers, singers and actresses of her age, and a performer who knew how to turn her popularity into profit.

Born in 1909 in Portugal, but raised from infancy in Brazil, Miranda was named by an opera-loving father after the eponymous gypsy girl of the opera *Carmen*. Appropriately, she found success as a singer, signing her first record deal in 1930. She was wildly popular on the radio, and soon in demand as a film performer too.

In 1939 Miranda moved to the US, and it was at this point that she began wearing her fruit hats, part of a costume supposed to evoke the styles popular with poor Black girls in the Brazilian state of Bahia. She was a hit in Hollywood, and by 1945 was the highest-paid woman in the US.

Miranda was almost single-handedly responsible for introducing samba and the 'carnival' aspects of Brazilian culture to a worldwide audience. And though this was a mixed legacy – many thought she presented the Western world with parody and stereotype rather than an accurate portrayal – there was no denying the mark she made on a world that might otherwise have given Brazilian culture no thought at all.

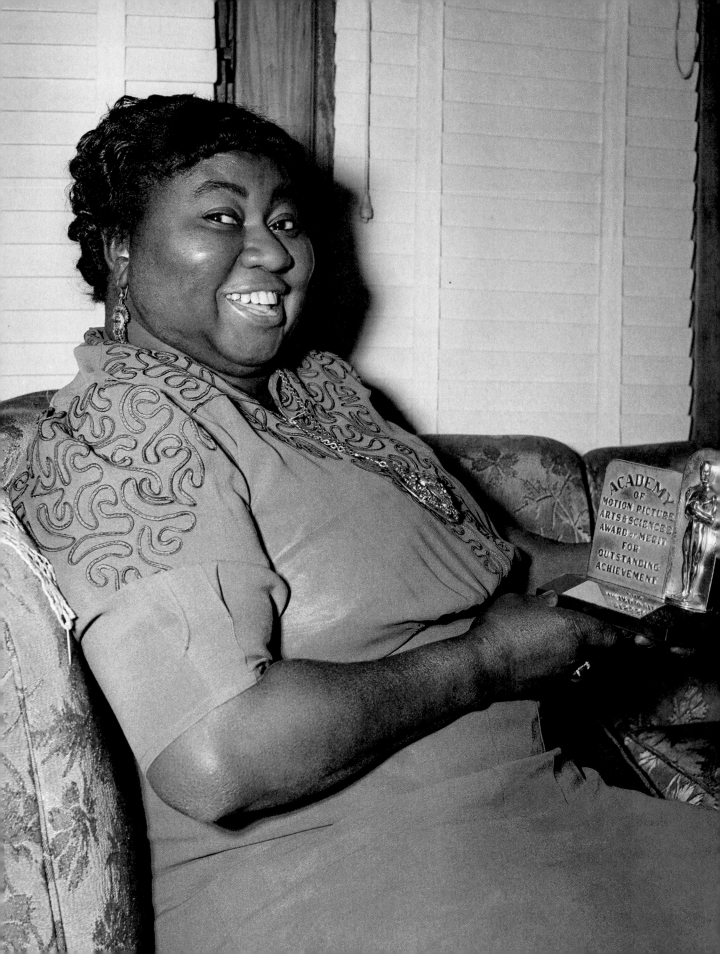

Hattie McDaniel

On 29 February 1940 Hattie McDaniel achieved something no Black American woman had done before: she won an Oscar. The award – which she holds in this photograph, taken two days later - was for best supporting actress. It recognized her performance as Mammy in *Gone With The Wind*, which won Best Picture.

If this was a significant achievement, however, it also showed how unequal the US remained. McDaniel had not been allowed to attend the premiere of *Gone With The Wind*, which played in a whites-only theatre in Atlanta. And at the Oscar ceremony, which was segregated, she had to sit on a table separate from her colleagues.

Despite the obstacles presented by racism, McDaniel was a successful and popular screen star throughout the 1930s and 1940s. It is, of course, arguable that her success and popularity stemmed from her willingness to accept the status quo and her general refusal to enter the fray of the civil rights movement. On screen she was best known for playing an uppity maid or house-servant; this drew criticism from those who thought that she was perpetuating negative stereotypes. It was said that she often responded to criticism by arguing that she would rather be paid $700 for playing a maid than $7 for working as one. However, when she died, after a highly successful career, in 1952, she was mourned as a Hollywood great – although she was still refused burial in the Hollywood Cemetery, which didn't accept Black people.

☞

'Katherine the Great'

Katherine Dunham, pictured second from left here, was one of the greatest dancers and choreographers of the mid-twentieth century, as well as an anthropologist, activist and writer. Born in 1909, she was a student of ballet, but soon began to fuse a variety of traditions to form a style all of her own, which she performed with her own company, taught in her own dance school and codified with an entire system of dance training known as the Dunham Technique.

This photograph was taken in Paris in 1953, when Dunham, 44, was performing her show *Tropical Revue* at the Théâtre des Champs Elysées. The show had been conceived and first performed on Broadway in New York ten years earlier. It was already considered a landmark in modern dance history, by bringing African and Caribbean dance themes together in a way that was authentic, rather than exploitative or comedic.

Dunham was able to create a show like *Tropical Revue* because she was a highly trained anthropologist, having studied the subject at the University of Chicago, earning a master's degree and a doctorate. She had travelled and done extensive fieldwork in Jamaica and Haiti. She knew exactly what she was choreographing, and why.

During her long life – she lived until just before her 97th birthday – Dunham also pursued many other interests and causes. Besides teaching dance, she was involved in anti-racist activism in both the US and abroad: a protest she organized in Brazil helped make racial discrimination in public life a felony.

Billie Holiday

Born in 1915, the jazz singer Billie Holiday
(nicknamed Lady Day, but whose real name was
Eleanora Fagan) was one of the most important
singers of the twentieth century. Her performances
of songs such as 'Strange Fruit' and 'What a Little
Moonlight Can Do' are today considered classic
recordings.

Holiday had a turbulent childhood: her father,
Clarence, abandoned her to become a jazz musician,
and she saw little of her mother. She dropped out of
school aged 11. However, as a teenager she began
singing in jazz clubs in Harlem, New York, where she
was scouted by the producer John Hammond. She
started recording at the age of 18, and was soon
making hits.

By the end of the 1940s, Holiday was a major star
– but she was addicted to heroin. In 1947 she was
arrested on a drugs charge and imprisoned for almost
a year. She played a comeback concert at New York's
Carnegie Hall on her release but could no longer
appear at venues that served alcohol – a problem for
any jazz performer.

In 1956 Holiday released an autobiography and
album, both called *Lady Sings the Blues*. This
photograph was taken in December the following
year on the CBS show *The Seven Lively Arts*. Within
two years, Holiday was dead, of liver cirrhosis. She
was aged 44 and broke, and died while under arrest
once more for heroin possession. It was a sad end
– but her music remains as compelling to audiences
today as ever.

Women
in the Wild

Nellie Bly was a successful journalist in the highly competitive New York newspaper market. In 1887 she sparked a craze for 'stunt girl' reporters – undercover journalism by women – by faking insanity to be committed to an asylum, then writing an exposé of conditions there. The 'Ten Days in a Mad-House' articles, later a book, took her name into the headlines of her stories. To keep it there, she needed a sensational follow-up.

Bly liked to spend Sundays thinking of ideas to pitch her editor at the *New York World* in Monday meetings. At a loss one weekend, she wished she was half the world away on holiday. So she decided that she would aim to beat the record set by Jules Verne's fictional globetrotter Phileas Fogg in *Around the World in 80 Days*. With a plan constructed from steamship timetables, she pitched her boss. He said they'd thought of it before; what was more, as a woman, she would need 'a protector' to chaperone her and have too much luggage for swift transfers. Bly told them to send a man, and she'd do the trip for another paper. A year later, she was summoned into the editor's office, and he asked, 'Can you start around the world the day after tomorrow?'

On 14 November 1889, Bly boarded the luxury liner *Augusta Victoria* at Hoboken, New Jersey for the seven-day journey to Southampton, England. She had with her one large handbag, containing underwear, slippers, her toiletries, pens, pencils, paper and a few other essentials, and only the clothes she was wearing. The Atlantic crossing was rough, but she put up with the seasickness, arrived in England, then went to France and interviewed Jules Verne in Paris. Next she visited Italy, then went through the Suez Canal to Sri Lanka, Singapore, Hong Kong, China and Japan. She sent short reports back via telegraph and longer insights via the post. Rough weather on the Pacific crossing from Yokohama meant she arrived in San Francisco two days behind schedule, but the *Miss Nellie Bly Special*, a train chartered by her paper, broke speed records on its journey to Chicago. Bly eventually arrived back in New Jersey on 25 January 1890: 72 days, 6 hours and 11 minutes after she left.

Bly – her real name was Elizabeth Jane Cochrane – quit reporting after the global adventure to write serialized novels for the papers and, later, to run her late husband's engineering firm. She returned to journalism after the firm went bankrupt, sending back dispatches from the Eastern Front in the First World War, before dying of pneumonia in January 1922, aged 57. By then her circumnavigation record had been broken, but in setting it she took her place at the forefront of an important movement in the nineteenth and early twentieth centuries. Among the adventurers, explorers, travellers and writers who dreamed big and made the world smaller are the women in this chapter. Some struck out to the edge of the Arctic in search of gold. Others plodded around Arabia and North Africa on camel-back. Others still explored the ocean floor or soared high above the Earth in dirigibles. All did remarkable things on their extraordinary journeys.

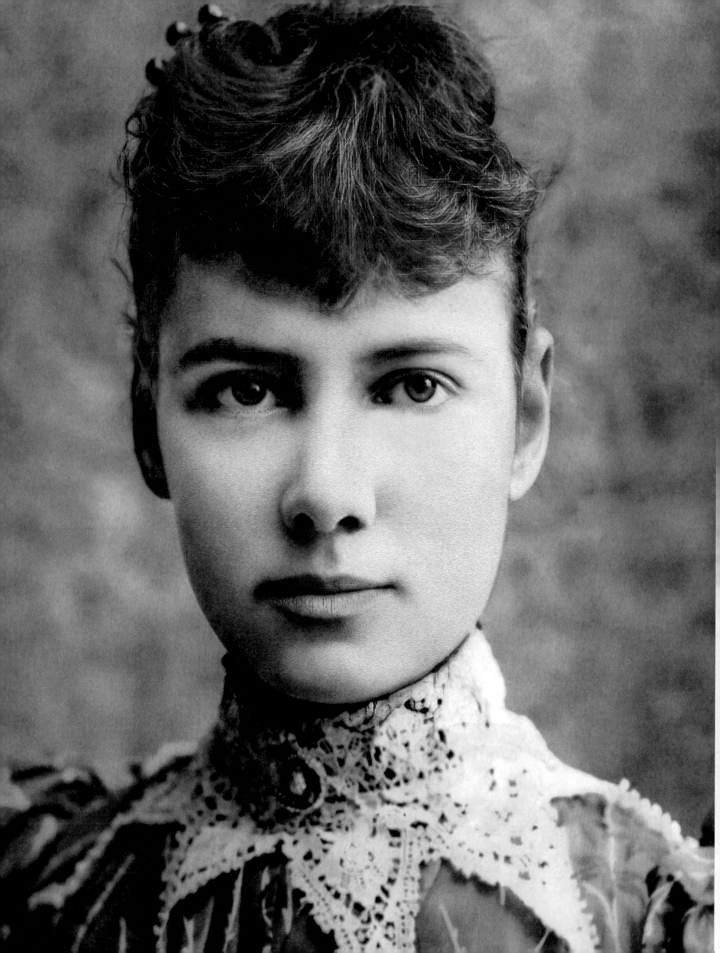

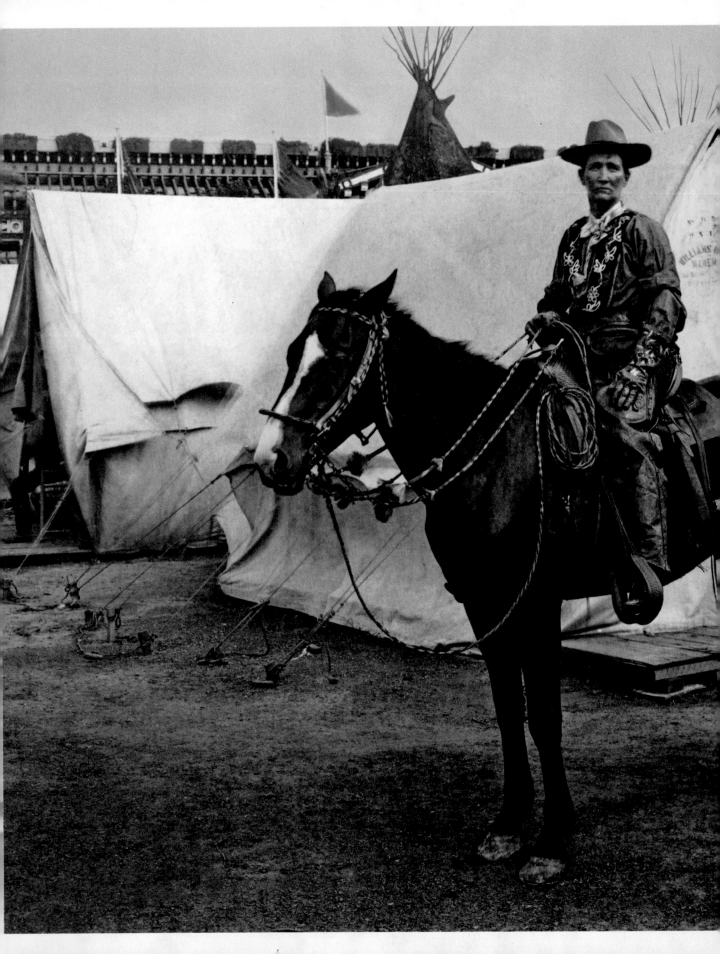

'Calamity Jane'

This photograph of Calamity Jane was taken at the 1901 Pan-American Exposition in Buffalo, New York. The organizers of the event, a World's Fair in all but name, wanted marquee attractions. But they had to hire a journalist to track Jane down. At the beginning of the end of the Wild West, its leading lady had all-but disappeared from public view.

Calamity Jane was literally a legend in her own lifetime, an infamous frontierswoman about whom everyone had a story, and the heroine of several pulp novels. Anecdotes from those books later showed up in her autobiography, and to what degree life imitates art in the tale of Calamity Jane has never been fully resolved. After her death in 1903, her legend only grew, especially with the 1953 film musical *Calamity Jane*, starring Doris Day.

Yet she was a real person: Martha Jane Canary, born in Missouri, most likely in 1856. In her mid-teens, she was left in charge of her five younger siblings by parents who had either died or abandoned the family as they journeyed west by wagon train. As an adult, she moved around the Midwest, settling for a while in Deadwood, South Dakota. Friends with Wild Bill Hickok, she was an enemy of the law and decent sensibilities alike. She was also a hard drinker; she lasted about a month at the Exposition before being arrested drunk at the showgrounds. Two years later, she died from complications arising from alcoholism, and was buried next to Wild Bill in Deadwood.

Ida Pfeiffer

When Ida Pfeiffer was a girl growing up in Vienna at the dawn of the nineteenth century, she would stare at passing carriages with tears in her eyes, envious of the possibilities open to the travellers inside them. As a child she was taken to Palestine and Egypt, but once she became a wife and mother her opportunities to travel very far were limited. However, once she was widowed and her sons left home, her wanderlust returned. In 1842, aged 44, she travelled alone to Egypt, via Greece, Turkey, Lebanon and Palestine, then returned home via Rome. 'As I came home again in perfect safety, I trusted I had not acted presumptuously,' she wrote, 'and I determined to see a little more yet of the world.'

And indeed, Pfeiffer saw as much as was possible to see at the time, covering more than a quarter of a million kilometres by land and sea, most of it on two round-the-world journeys, from 1846 to 1848 and 1851 to 1855. She always travelled alone, and funded her adventures by writing books about them, which were hugely successful and published in several languages. She was the first European in many of the places she went to. Having learned how to take specimens of plants and animals and make daguerreotypes, the first photographic method available to the public, her journeys also proved scientifically valuable. Pfeiffer took her final trip, to Madagascar, in 1857, but was expelled from the country after becoming caught up in a political coup, and died on her return home, possibly from malaria.

During the Gold Rush

After local miners struck gold in the Klondike region of the Yukon territory in August 1896, around 100,000 people joined the gold rush to Canada's north-west corner. Most were male prospectors from the west coast of America, mesmerized by the lure of life-changing wealth. But a few thousand were women. Most, like the woman in this photograph, were wives supporting families uprooted by the promise of fortune and glory. They made homes in what was, and still is, Canada's least populated region, on the border with Alaska.

Other women went to the Klondike to make money in the secondary industries that show up in gold-rush country. (The population of Dawson City, a town at the heart of the gold fields, grew from 500 to almost 20,000 in the space of a year.) They nursed, taught, cooked, sewed and did laundry, offered religious solace and provided entertainment, both in private and on stage. One famous example of this trend was Kitty Rockwell, a vaudeville dancer in Dawson City and the Yukon capital Whitehorse, better known in American folklore as Klondike Kate.

Only a few hundred people are estimated to have got rich in the Klondike Gold Rush, and there is no record of a woman prospector among them. In September 1898, three years after that first lucky strike, gold was found in Alaska, the Klondike emptied, and dreams were chased 750 miles further west on the Nome Gold Rush.

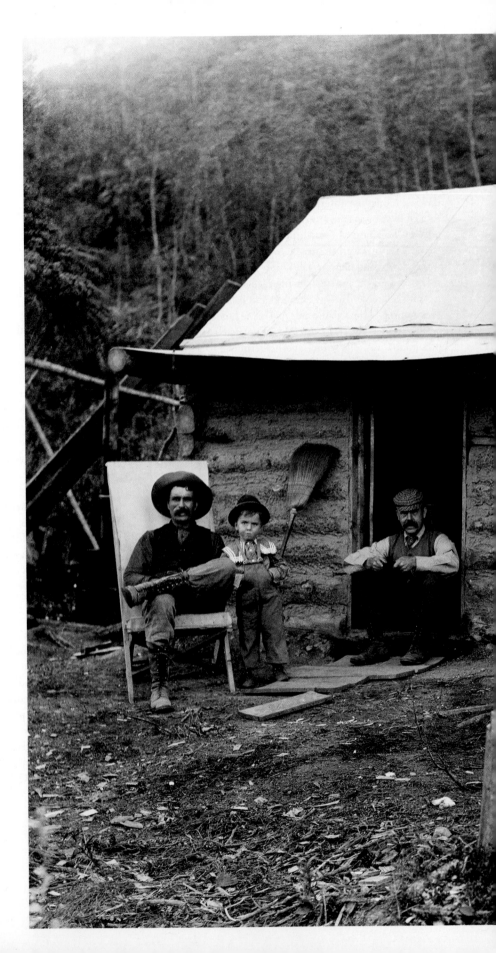

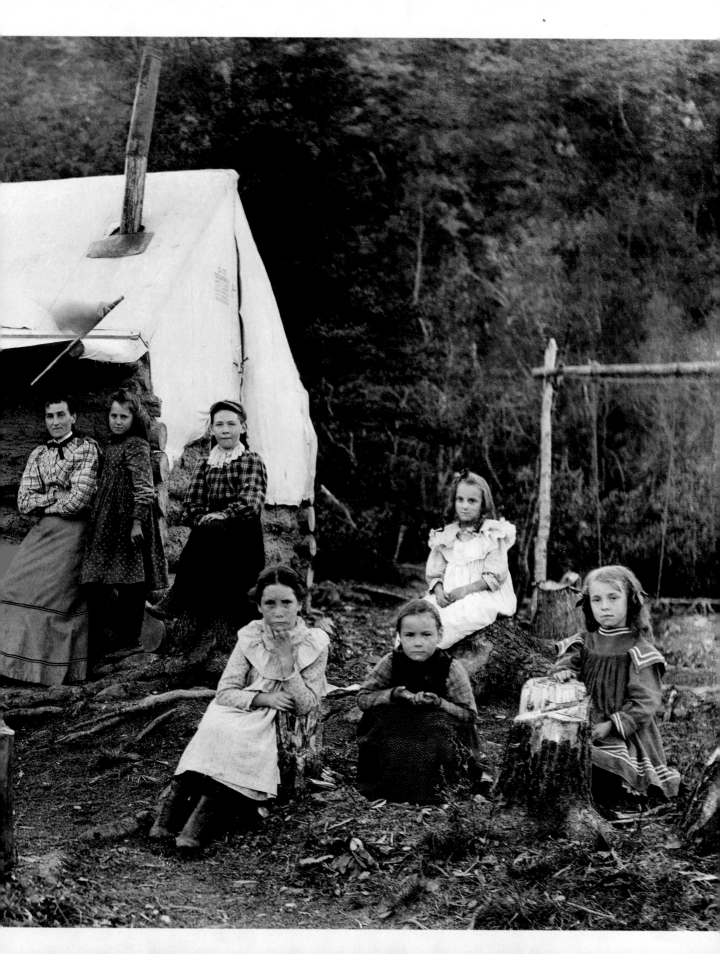

Jane Dieulafoy

In 1881 Jane Dieulafoy and her husband, Marcel, set sail from Marseilles to Istanbul and then rode on horseback for 3,700 miles, across the Caucasus, arriving in Iran the following year. They were searching for the ancient Persian city of Susa, and Jane's work in excavating and documenting the city made her one of the leading archaeologists and travel writers of the age.

This was only one highlight of an exciting life. In 1870, aged 19 and newly married, Jane had accompanied Marcel to the front line of the Franco-Prussian war where, instead of working in the canteen as women volunteers were only permitted to, she disguised herself as a man and fought alongside him. Her lifelong preference was for men's clothing and short hair. In practical terms, trousers and shirts were better suited to digs and travelling than petticoats; it also meant that when the couple travelled and worked the Middle East, they were able more easily to gain access to locations where women were not welcome. Back in Paris, where women were only permitted to wear trousers if they were riding a bike or a horse, Jane received special dispensation to dress as she pleased, in recognition of her finds at Susa.

After three trips to Persia, Jane and Marcel travelled extensively in Morocco and Spain. She wrote journalism and two novels, including one set in ancient Susa. In 1915, leading the excavation of a mosque in Rabat, she contracted dysentery and returned to France, where she died in May 1916, aged 64.

Osa Johnson

In 1952, two years before the first series of David Attenborough's *Zoo Quest*, the TV show often credited as the first about animals in the wild, *Osa's Big Game Hunt* was broadcast in America. Its presenter, Osa Johnson, was for some years as famous in the US as Attenborough would become in the UK. She and her husband, Martin, were pioneers of the wildlife documentary who, on a dozen expeditions to the South Pacific islands, Southeast Asia and Africa between 1917 and 1936, shot footage for films that introduced millions of people to previously unseen parts of life on Earth.

Prior to TV, the Johnsons made over 50 films for the cinema and lecture circuit. Some, like the feature-length documentary *Trailing African Wild Animals* (1923), were box-office successes. In 1937 Martin died in a plane crash; Osa was badly injured but, once she recovered, she continued to travel and lecture alone. Her 1940 autobiography *I Married Adventure* was a huge bestseller. Fans could also buy Osa Johnson branded clothes and toy animals. Her fame faded, but she was planning a big expedition when she died, aged 58, in 1953, the year after her TV show premiered.

The treatment of indigenous people in the Johnsons' work now seems hopelessly patronizing and old-fashioned, but in their time, the couple created a valuable filmed record of wildlife in its habitat that showed, for the first time to a mass audience, the spectacular range and beauty of life on Earth.

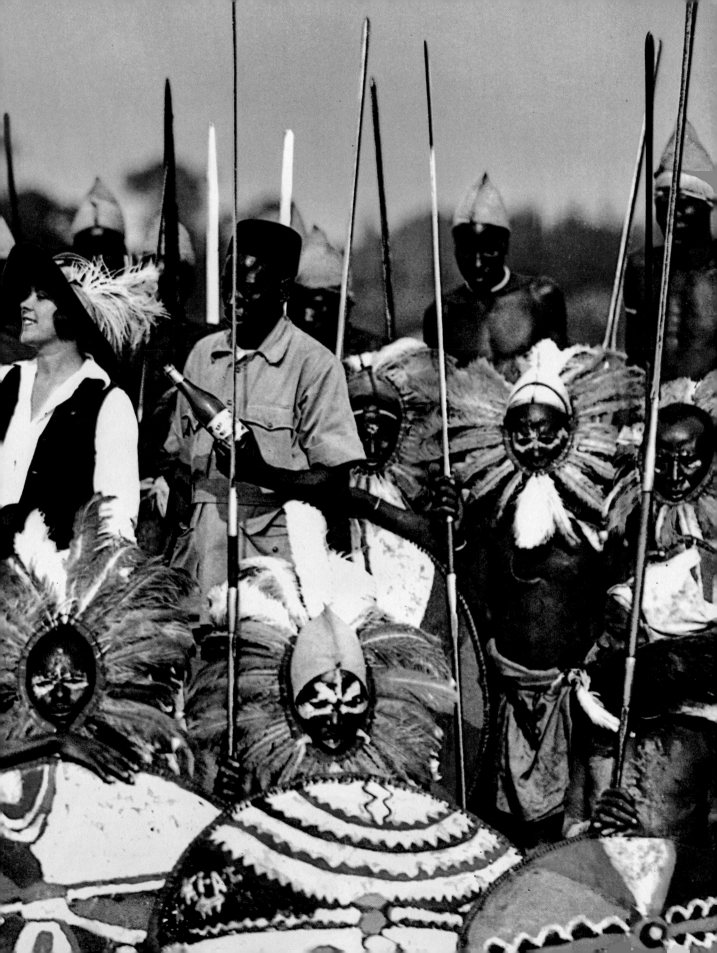

Queen of Bohemia

Aimée Crocker's unbridled passion for life and travel took her to China, India, Japan, Borneo and beyond at a time when her fellow American society women were only just getting acquainted with Paris. She returned home each time with something shocking and new, for which journalists and freethinkers loved her: tattoos, a passion for Buddhism, large snakes, another husband. She married five times or, as she liked to say, 12 times 'if I include in my matrimonial list seven Oriental husbands'.

Heiress to a railroad fortune, Crocker was made a princess and given an island by the king of Hawaii, sailed from Hong Kong to Shanghai with a Chinese feudal lord and was thrown to the ground by volcanic earthquakes on Java in Indonesia. Her exploits abroad and at home made headlines for four decades; a true Bohemian, she defined that lifestyle for Americans, who were shocked and allured by her in equal measure.

'If I could live it again, this very long life of mine,' she wrote in her 1936 memoir, *And I'd Do It Again*, published five years before her death at the age of 77, 'I would love to do so. And the only difference would be that I would try to crowd in still more… more places, more things, more women, more men, more love, more excitement.'

Gertrude Bell

In March 1921, Winston Churchill, then British Secretary of State for the Colonies, called a meeting in Cairo of experts and officials to address the issue of foreign and indigenous rule in the Middle East. The only woman among the 'Forty Thieves', as Churchill referred to them, was Gertrude Bell. She knew more about the region and its people than any other foreigner, fellow attendee T. E. Lawrence (aka Lawrence of Arabia) included.

Aged 19, Bell had earned first class honours in modern history from Oxford and began travelling with family and friends. A brilliant mountain climber, she recorded several first ascents in the Swiss and French Alps. She first visited the Middle East in 1892; her first book, *Persian Pictures*, followed in 1894.

At the time of the meeting pictured here, Bell had spent most of the previous 15 years in the Arab world. During the First World War, her deep connections to local people and society made her an invaluable diplomat and fixer for the British Army, its only female political officer. Her passion was archaeology and after the Cairo Conference she began the work that led her to become the first director of Iraq's new national museum, in June 1926. But she never had the chance to spend much time in the role. A few weeks later, on 12 July, she died in Baghdad after overdosing on sleeping pills.

The Accidental Pioneer

Jackie Ronne did not intend to be the first woman
to work on an Antarctic expedition. In late 1946 she
was going to spend two weeks in Texas with her
Norwegian polar explorer husband, Finn, before he
led his 21-man team on a ship via South America, to
the frozen continent. However, at each stop, Finn
persuaded her to come to the next, before finally
revealing his true intentions. His English wasn't good
enough to write the reports a news agency was
paying him for – the fees vital for the trip – so he
wanted her to be the official expedition historian
and correspondent.

Ronne's cold-weather experience was limited to
skiing on honeymoon in Aspen, and she had a desk
job at the US State Department. All she had with
her in Chile, she said, was 'a good suit, a good dress,
nylon stockings and high-heeled shoes'. But after
loading up on supplies, she joined the team, and
became the first woman ever to set foot in Antarctica.

During the year they were in Antarctica, as well
as writing news releases and a daily journal, Ronne
worked with a geophysicist to record seismic and
tidal activity. After returning to America in 1948, she
lectured and wrote on polar matters for the rest of
her life. She made several more visits to Antarctica
as the star guest on tourist cruises and served as
president of the Society of Women Geographers.
She died in 2009, aged 89.

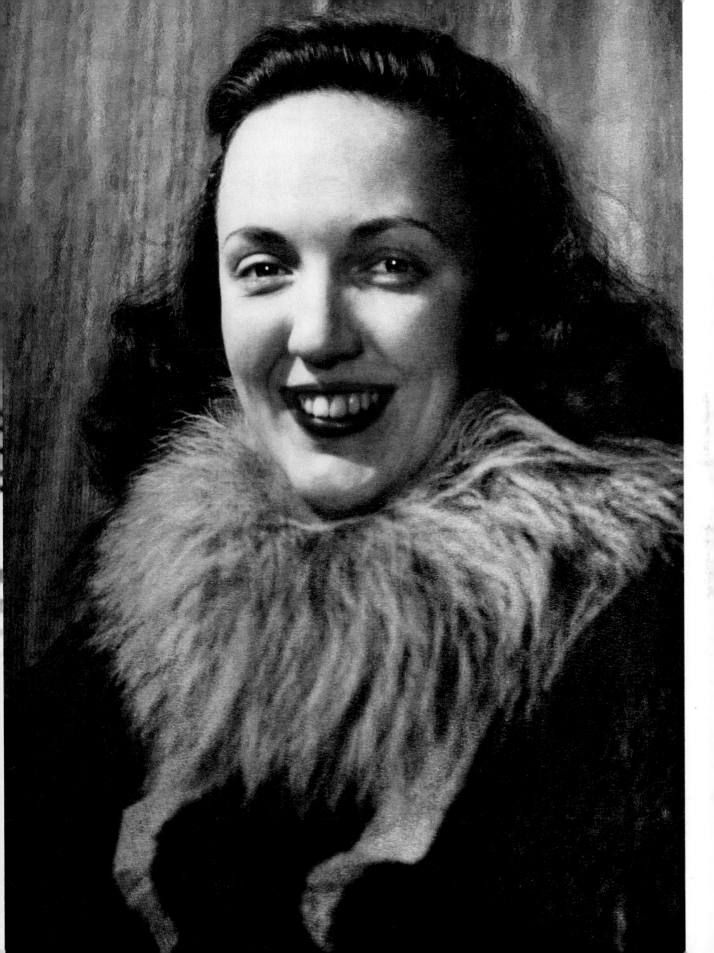

Margaret Naylor

At the bottom of Tobermory Bay on the Isle of Mull off the west coast of Scotland was said to lie the *Florida*, a Spanish Armada treasure galleon supposedly sunk in 1588 with 30 million gold ducats and a crown for the king of Spain's coronation as ruler of England in the wake of Spanish victory. Britain's first female deep-sea diver, photographed here in 1924, was tempted beneath the waves in search of this lost treasure.

Five years earlier, in 1919, Margaret Naylor had begun working as a secretary to the head of a crew that had been diving to the wreck for a decade, one of a long line of salvage attempts since the ship sank in 1588. Within a year, she had learned how to dive and was in the water herself.

'Divers usually practise in tanks first of all,' Naylor told the *Westminster Gazette* in 1922, 'but I was keen on the adventure and went straight into the sea.' A diving suit and helmet of the sort shown here weighed 170lb (77kg) with an air-pipe and lifeline running up to the surface. The *Gazette* described her as 'a young woman of prepossessing manner and strong physique, who looks quite capable of overcoming practical difficulties above water or below it'.

Naylor stopped diving to the *Florida* some time in 1924, after a near-fatal accident. And it was just as well. Research some decades later showed there never was a *Florida*. The wreck was the *San Juan de Sicilia*, a typical Armada vessel, unburdened by gold.

'A checkered life'

In this photograph, dated 1925, Marguerite Harrison is eating with the Bakhtiari tribe of Persia during the making of *Grass*, one of the first ethnographic documentaries, on which she worked both on and off camera. That same year, Harrison co-founded the Society of Women Geographers. Her travelling, as a writer, filmmaker and spy, was fed by her curiosity for a changing world.

As a journalist on the *Baltimore Sun*, Harrison had written women's contribution to the First World War, working in a steel plant and as a trolley conductor to get close to her subjects, before looking to Europe in search of war stories. Unable to secure a post as a war correspondent, she volunteered for US military intelligence. Under cover as a *Sun* reporter, she spied for America in post-war Germany and then in post-revolution Russia. She was imprisoned in the notorious Lubyanka jail, before an aid-for-prisoners deal secured her release in July 1921. A year later, she was in China, where she was arrested, sent to Moscow and eventually returned to the US in March 1923.

After making *Grass*, Harrison married the actor Arthur Blake and lived in Hollywood for 20 years, then resettled in Baltimore. She claimed to have talked her way across the border from West to East Berlin while in her eighties. It would not have been surprising if she did.

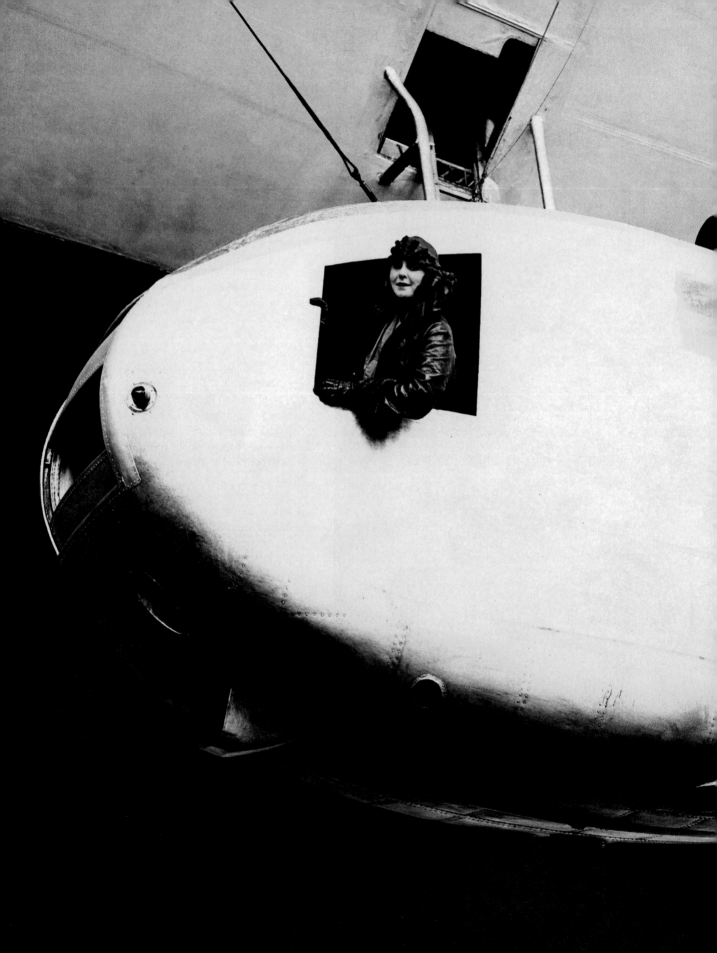

The Journeying Journalist

Grace Lethbridge, better known by her married style of Lady Hay Drummond-Hay, was a British journalist who made her name with first-hand accounts of long-distance air travel. During the Golden Age of Flight in the 1920s and 1930s, there was huge public appetite for stories about airborne adventures. Via her extensive contacts with American newspapers, Lady Hay Drummond-Hay satisfied that demand.

She was aboard the *Graf Zeppelin* on the first airship passenger flight across the Atlantic, in October 1928. In August 1929 she was the only female passenger on the same aircraft on the first airship flight around the world.

This photograph of Lady Hay Drummond-Hay was taken in March 1929, in the engine car of the *Graf Zeppelin*, as it flew from Germany to Palestine. She later flew on the second international flight of the *Hindenburg*, from Germany to New Jersey, in May 1936, almost a year to the day before it crashed and put an end to the airship era.

As well as writing stories in peacetime, Lady Hay Drummond-Hay worked as a war reporter, filing stories from conflicts in Ethiopia and Manchuria during the 1930s, and charming dignitaries such as the Ethiopian emperor Haile Selassie. During the Second World War she was taken prisoner in Manila during the Japanese invasion of the Philippines in 1942. She was released the following year and went to New York, but her health was poor and she died in 1946.

Aloha Wanderwell

In 1922 Idris Hall, a 16-year-old Canadian living in France, left school in Nice and headed for Paris. There she found a job as the filmmaker and mechanic on an endurance motor race around the world, contested between two teams driving Ford Model Ts. One team was led by a Polish man who had changed his name to Walter Wanderwell; the other by his wife. Idris Hall joined Walter's team, claiming to be Aloha Wanderwell, Walter's adopted sister. In 1925, in America and about halfway through their almost eight-year journey, Walter divorced his wife, and he and Aloha married.

During their epic journey, Aloha shot footage and edited it at night in hotel rooms, rewinding film reels with pencils, to make an ever-changing documentary, *With Car and Camera Around the World*, which was screened at stops en route. The ticket sales and product endorsements during Aloha's accompanying talks provided the funds that kept the adventure on the road.

In 1932, about to embark on a filmmaking trip by boat, Walter was murdered. Aloha is seen here in a mourning veil before his burial at sea. The following year, Aloha married Walter Baker, with whom she also explored the world, making about a dozen more documentaries. In 1982, in full expedition costume as usual, she showed her films for the final time, in Los Angeles. 'The World's Most Widely Travelled Girl', as her lecture posters billed her, died in 1996, aged 89.

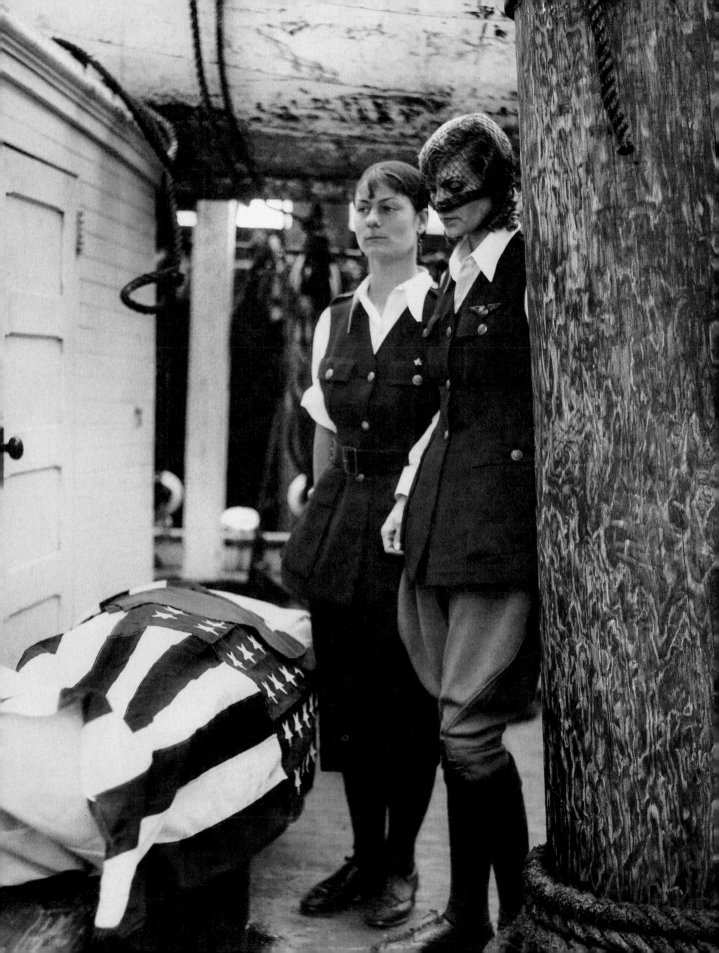

'The Lady and the Panda'

During the 1920s and 1930s there was a craze among rich, brash Westerners for travelling to far-flung parts of the world and either killing or capturing exotic animals such as komodo dragons and mountain gorillas. High on the 'most-wanted list' was the giant panda – a seldom-seen bear-like creature that roamed the mountains of China and Tibet. Catching a panda was the burning ambition of William Harkness, a wealthy Harvard alumnus with a thirst for travel and fame. When Harkness died of throat cancer in 1936, during a panda-catching expedition, his widow, Ruth Harkness (née McCombs) decided to complete the task for him.

Harkness was not an obvious zoologist. A fashion designer and New York party girl, she once said she wouldn't walk a block in Manhattan if she could take a cab. But by the autumn of 1936 she was in panda country, walking with a guide for up to 30 miles a day, dressed in her late husband's retailored mountain gear. On 9 November she found a baby panda in a rotten, hollowed-out tree. She named it Su-Lin and took it back to America, to Chicago's Brookfield Zoo, where it caused a news sensation, dubbed 'Panda-monium'. And in 1937 Harkness repeated the trick. This photograph shows her introducing Su-Lin to another baby, Mei-Mei.

Harkness wrote a book about her adventures, entitled *The Lady and the Panda*, after which she attempted to become a full-time travel writer. But she never enjoyed such success again and died alone in a hotel bathroom, aged 46, in 1947.

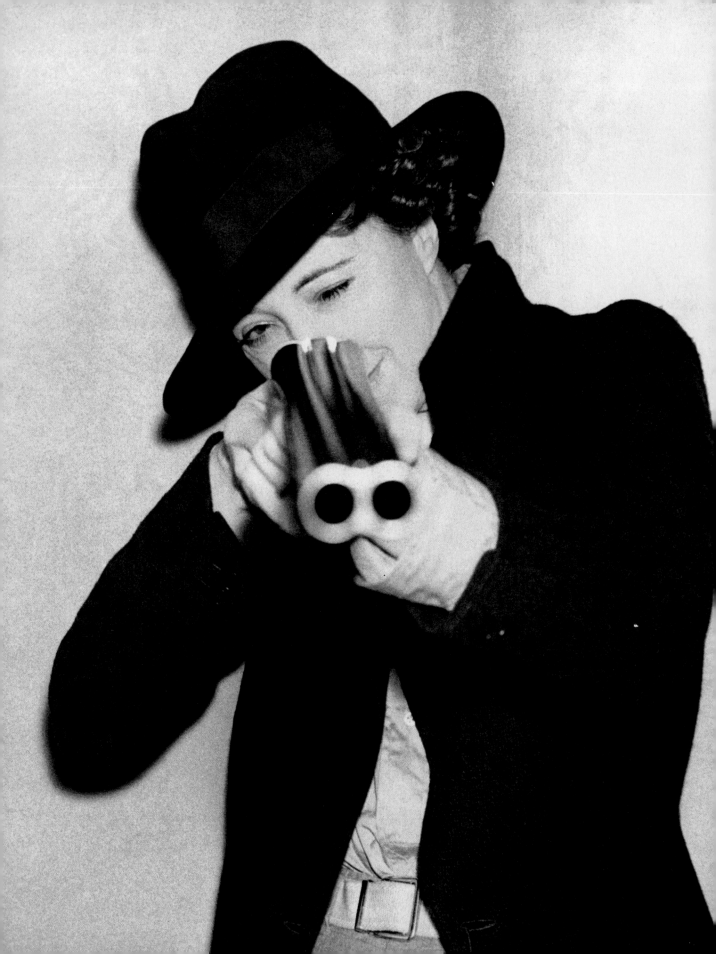

Rosita Forbes

The English explorer Rosita Forbes was a master of disguise, as she needed to be, in order to travel where Westerners were forbidden. Born to an upper-middle class family in Lincolnshire, she was decorated as an ambulance driver in the First World War, before deciding to become a travel writer and adventurer. She roamed across North Africa and Central Asia, funding her travels by writing books and lecturing. Along the way Forbes acquired fake passports, blamed her imperfect Arabic on Eastern European heritage and wore traditional Arab women's dress 'under which', she wrote, 'were hidden my revolvers'.

After the First World War, Forbes travelled east to Asia with a female friend, and wrote a book called *Unconducted Wanderers*. Her first great coup came in the winter of 1920–21, when she crossed Libya and became the first non-Muslim woman to visit the Kufra Oasis, at that time under Ottoman control. She wrote up her story in *The Secret of the Sahara*, and in her account recalled one episode when she was forced to flee on a camel in the middle of the night from robber gangs looking for a 'rich Christian woman'.

Subsequent travels took Forbes around Egypt and Ethiopia, the Balkans and Central Asia. She was criticized for meeting Adolf Hitler and Benito Mussolini in the 1930s, though she claimed only to be reporting on their politics, and not endorsing them. Known for her easy manner with strangers and her ability to mix with all cultures, Forbes supplemented her writing and lecturing work by hosting private parties on tours and safaris; it was in this context that this 1937 promotional photograph was taken. She retired to Bermuda, where she died, in 1967, aged 77.

Women
on the
Shop Floor

Before there was the Wolf of Wall Street, there was the Witch. Hetty Green, seen here in a photograph circa 1897, was an incredibly successful investor in late nineteenth- and early twentieth-century America. She earned her nickname because she dressed in black, was legendarily strict about unnecessary spending, and was not considered as warm in her demeanour as other female public figures of the time.

In 1865, when Green was 30, she inherited twice: from her father, $1 million in cash and a $4 million trust fund; and from her aunt, a $1 million trust fund. Three years later, a court awarded her another $600,000 from her aunt's estate, after Green contested a forged will. She turned these large fortunes into a vast one, first by speculating on the US dollar from London, where she lived for six years (to avoid more legal action arising from the contested will decision) then by investing in property, mortgages and railway company stock.

But unlike many of her contemporaries who made and lost fortunes during the Gilded Age of American wealth accumulation, Green understood the true value of money and its relationship to hard work and physical endurance.

Green was born in 1834, in Massachusetts. Her family were Quakers, and the religion's testimony of simplicity, which frowned on luxury and promoted spiritual gain over material, meant they lived frugally, despite owning a successful whaling fleet and having many other investments. As a child she spent a lot of time with her father, reading the paper to him when his eyesight began to fail and learning business at his elbow. He took her to his warehouses and counting houses and gave her, as a teenager, the job of family bookkeeper.

As Green, and her fortune, became famous, so the legends of her miserliness grew, and rumours circulated that she refused to use hot water or heating, owned a single dress which she only replaced when it was completely threadbare, that she skimped on food expenses by eating cheap, 15-cent pies, and that she neglected to wash in order to save money on soap. It was true that she was extraordinarily thrifty; yet at the root of many criticisms lay a combination of misogyny and snobbery, and a failure to understand how a very rich person could abstain from the lavish appurtenances of wealth. In private Green was a generous philanthropist, who was also willing to loan large sums of money to New York City to keep its government afloat.

Green left her fortune to her two children when she died, aged 81, in 1916. Estimates of its size range from $100 million to $200 million, which certainly made her the richest woman in America, and likely the world.

Yet if Green was uniquely wealthy, she was by no means alone. As the following pages show, women in her age could take the business world by storm, registering patents and disrupting whole industries; running nightclub empires or multinational corporations. Today's board rooms remain stacked with men, but history makes it plain that this is far from sensible business practice.

'Ferreirinha'

The Portuguese businesswoman and viticulturist Antonia 'Ferreirinha' Ferreira was a major player in the port wine industry in the middle of the nineteenth century. Her achievement was a matter of national pride in Portugal, where her name is today synonymous with famous port vintages.

She was born in Godim, in the Douro Valley, a well-known wine-making region, on 4 July 1811. Her family were port producers and exporters. In 1834, she was married to her cousin, a spendthrift who preferred high living to serious business. On his death in 1844, Ferreira, aged 33, became head of the family business and oversaw its expansion. She went on to be the largest landowner in the Douro Valley, owning about 25 vineyards, and also created new estates in northern Portugal.

Ferreira's success in developing her business and amassing a fortune occasionally brought trouble: in 1854, Portugal's president proposed marrying his son to Ferreira's 11-year old daughter. Ferreira refused and felt obliged to move with her daughter to London for two years. And this was not the only challenge she faced. In the 1860s a wine blight known as phylloxera ripped through European vineyards, threatening to destroy entire estates. Ferreira took the problem seriously, eventually replanting her estates with blight-resistant American vines. She also funded hospitals, paid for roads and railways to be built and supported local charitable causes, which earned her the nickname 'mother of the poor'.

Margarete Steiff

In 1900, Germany was the world centre of toy production and one of its most successful companies was Margarete Steiff GmbH. Its founder, Margarete Steiff, was unusual not only because she was a female business leader at the turn of the twentieth century, but also because she ran an internationally successful company from a wheelchair. After contracting polio as a toddler, Steiff was paralysed in both legs and had limited use of her right arm.

As a child, she learned to use a sewing machine that ran backwards, so she could operate it with her left hand. By 1862, the year she turned 15, she was working part-time in her sisters' dressmaking shop in their home town of Giengen an der Brenz, in southern Germany. In 1877, she opened her own shop, selling ready-to-wear clothes and household fabric items, mostly in felt. In 1880, she began making elephant-shaped pincushions as gifts for friends and family; their children co-opted them as toys. The elephants became part of the shop's stock, then other animals. By 1893, sales of toys were double those of clothing. Steiff's first toy factory opened in 1899. Within 10 years, sales were doubling year-on-year helped by brisk exports, and the firm had 40 employees.

In 1902, Magarete's nephew Richard Steiff created the stuffed bear that would make the company world-famous. The millionth Steiff teddy was made in 1907, two years before Margarete died, aged 61. Still handmade in Germany 120 years later, they remain among the world's most sought-after toys.

Emilie Flöge

This photograph from 1910 shows the Austrian
fashion designer Emilie Flöge and the Austrian
symbolist painter Gustav Klimt wearing loose-fitting
clothes in the dress reform style for which Flöge was
renowned. Often described as Klimt's muse, Flöge
was the artist's partner for 21 years and on occasion
modelled for him, though they did not marry or live
together, nor was Flöge mother of any of the 14
children who claimed inheritance when Klimt died
in 1918.

Born in Vienna in 1874, Flöge became a
seamstress and worked in couture houses before
founding the Schwestern Flöge atelier in the city
with her two elder sisters in 1904. All three women
designed and cut clothes, which were very popular
with Viennese society women. Klimt may or may not
have contributed designs. He and Flöge thrived on
each other's creative energy, and he encouraged her
to paint on his canvases.

Flöge also managed the business, which at one
time employed 80 dressmakers, and made regular
visits to London and Paris for professional
inspiration. Running a successful regional bespoke
house during the rise of mass-produced ready-to-
wear fashion was no small task. Her salon only closed
in 1938, when the annexation of Austria by Nazi
Germany sent Vienna's rich either underground or
to safer, unoccupied countries. Flöge remained in
Austria, working from her home, and surviving the
war, although a fire in 1945 destroyed her house,
including many of the clothes she had created over
the course of her career.

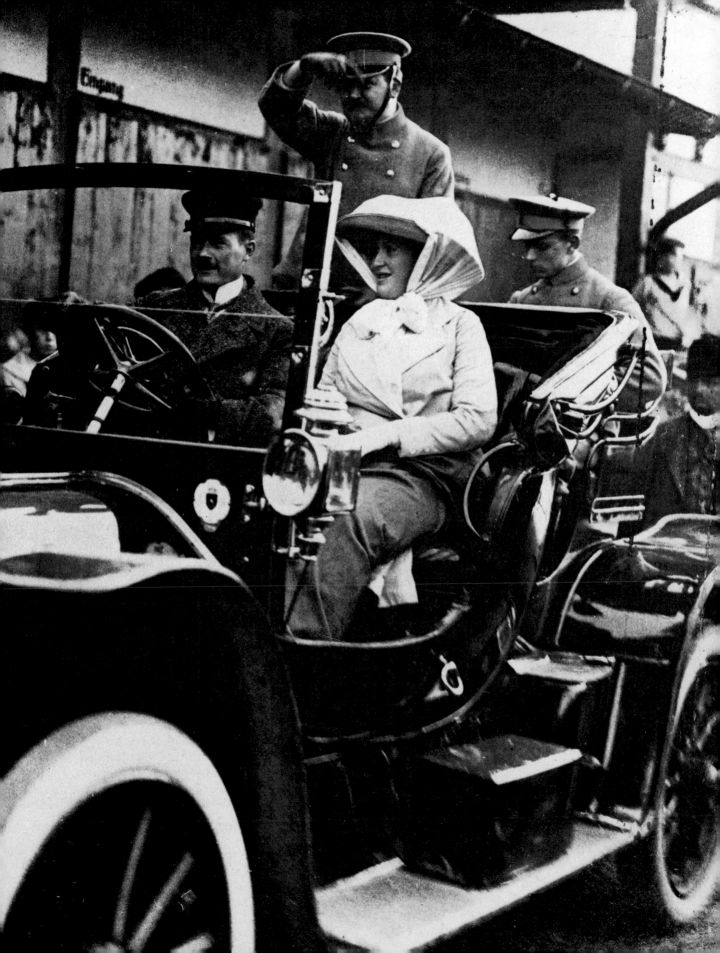

Big Bertha

Bertha Krupp was 16 in 1902 when her father died and she inherited control of one of the largest companies in the world. However, it was decided that the Krupp steel, coal and arms empire could not be run by a woman. So, with German state input, she had a husband chosen for her: Gustav von Bohlen und Halbach, who on marrying Bertha in 1907 was given special dispensation to take his wife's name, so he could take her place as chairman of the company.

When this photograph of Bertha and Gustav (at the wheel) was taken in 1913, the company was Europe's biggest and about to expand dramatically, making arms for Germany in the First World War. German artillerymen nicknamed one of Krupps' largest siege howitzers 'Big Bertha': it had a 42cm calibre barrel and a range of nearly 10km. This moniker was picked up by Allied soldiers and loosely used to describe all massive German guns, including Krupps' 'Paris Gun', which could fire shells 75 miles.

Bertha never played an official role in the family firm, and in 1941 Hitler forcibly transferred all her company shares to her son Alfried. Thereafter the Krupps became notorious for their involvement in the Nazi German war machine, and after the Second World War a special trial at Nuremburg found 11 Krupp directors guilty of war crimes, including using tens of thousands of slave labourers at places including a forced labour camp named Berthawerk.

Maggie Lena Walker

Maggie Lena Walker was founding president of the St Luke Penny Savings Bank in Richmond, Virginia in 1903 – at the height of the Jim Crow laws enforcing segregation in the American South. She was the first African American to run a bank. Most of the very few white women that preceded her had inherited their presidencies from their husbands. Walker was not from money. 'I was born not with a silver spoon in my mouth,' she said in 1904, 'but with a laundry basket practically on my head.' Her stepfather was a waiter and her mother, a former slave, was a washerwoman for whom Walker, as a child, delivered clothes.

Born in Richmond in 1864, Walker graduated from normal school, for teacher training, in 1883 and began teaching at a local school. State law stipulated that only unmarried women could teach so Walker had to quit when she married in 1886. She increased her volunteer work for a local benevolent and mutual society, the Independent Order of St Luke (IOSL). Begun to help Black women with funeral costs, Walker expanded its scope and size to work with young people, offer loans and educate women. By 1890, she held its highest volunteer position. In 1899 she became its Right Grand Worthy Secretary, or what would now be called CEO.

Under her guidance, ISOL and the bank flourished. In 1931, during the Great Depression, when hundreds of American banks failed, she merged the bank with two others, becoming chairman of the new bank's board of directors. She died in 1934, aged 70.

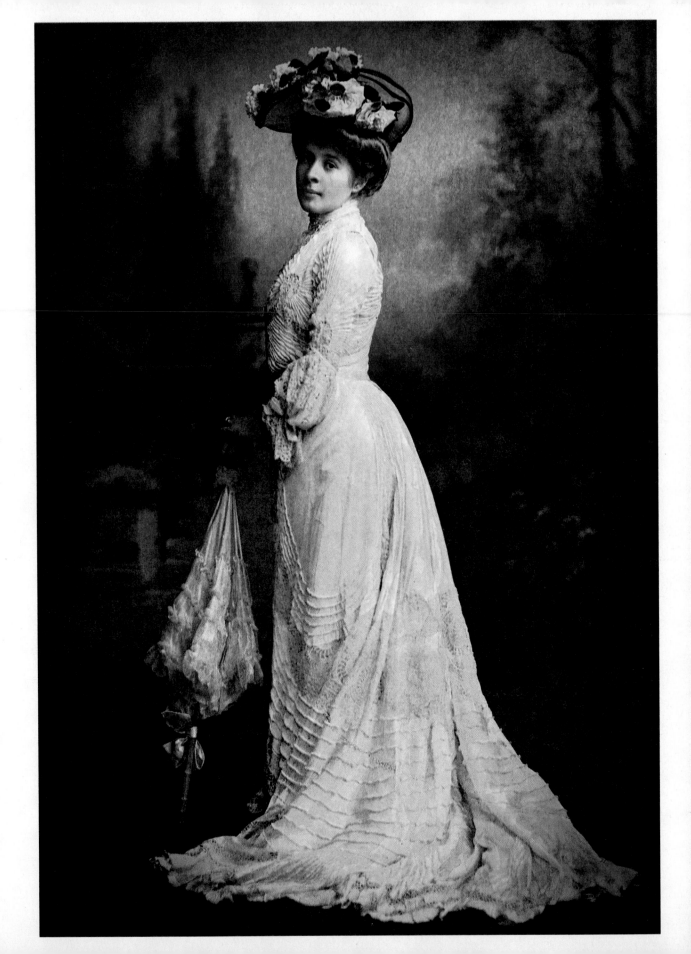

The Homemaker

The interior designer Syrie Maugham was in high demand during the inter-war years, when a group of British and American creatives contributed greatly to the development of interior design as a profession. At its peak, her practice had 70 employees and shops in London, Chicago and New York. She reschemed hundreds of homes for clients that included Hollywood stars, a Rockefeller and the Duke and Duchess of Windsor.

Born in London in 1879, in 1901 she married the pharmaceutical industry executive Henry Wellcome. She was inspired to become an interior designer when the house she moved to in 1913, after splitting from Wellcome, was decorated by Ernest Thornton-Smith, also a noted antiques dealer. She became his unofficial apprentice and opened her first shop in London in 1922.

Maugham designed her own furniture and fittings, restored and repurposed vintage items and had a network of dealers from whom she bought new pieces and finds from Paris flea markets. Her business acumen was sharp and her prices were high. She understood, correctly, that her eye and taste were worth a great deal.

In April 1927, at a party at the house she shared with her second husband, the writer W. Somerset Maugham, in London's King's Road, she unveiled an all-white room, sparking a craze for colour-free colour schemes among the high-society guests with whom she regularly socialized. Her work slowed after she contracted tuberculosis in 1946, and she died, aged 76, in 1955 at her Park Lane flat in London.

Hilda Hewitt

After watching a plane in flight at Britain's first official air show at Blackpool in 1909, Hilda Hewitt (centre) knew she must fly one herself as soon as possible. A year later she co-founded Britain's first flying school and qualified as a pilot there. Yet in 1912, she put an end to her flying career and threw herself into building planes instead. 'I wish', she told a British newspaper reporter, 'to go in entirely for construction.'

She and her flying school partner Gustav Blondeau started an aircraft works in 1912. Operating from an old ice-skating rink in South London, they soon did brisk business. Hewitt was a hands-on manager who knew how to build and maintain every element of a plane.

The First World War was good business for Hewitt & Blondeau. In new larger premises outside London, the company made 124 planes for the British war effort in 1916, 300 in 1917 and 450 in 1918. Staff numbers peaked around 700, building 10 different types of plane. Hewitt set up a three-month training scheme for women who came in to replace male employees who had left to fight in the war. This was so successful that the government co-opted it to train staff for manufacturing plants across Britain. The firm did not survive in peacetime. Hewitt moved to New Zealand where she was president of her local aero club when she died in 1943.

'The Joy Goddess'

As the only child of the entrepreneur Madam C. J.
Walker, A'Lelia Walker inherited both the business
and the mantle of America's leading Black female
entrepreneur. Madam C. J.'s beauty products
company had made her rich and famous. A'Lelia,
shown here getting a manicure circa 1920, became
president of the company on her mother's death in
1919, but as the 'hair care heiress', she was often
thought to be more concerned with her social
calendar than a profit and loss ledger.

Yet A'Leila was a key figure in the growth of the
firm, and had been her mother's close professional
collaborator long before the Madam C. J. Walker
Manufacturing Company was incorporated in 1910.
In 1906, when A'Leila was 20, she was running the
mail order department and overseeing production of
Walker's Wonderful Hair Grower, a pomade that was
the company's first bestseller. It was A'Lelia who
insisted that her mother expand company operations
to the East Coast, and she who ran them.

During her time in charge of the firm, she
devised successful marketing campaigns that chimed
with the mass consumption age and modernized
production operations in a huge factory that opened
in 1927. The following year, the Great Depression hit
and sales fell. After she died in 1931, her daughter
Mae became president.

A'Lelia was a generous arts patron who also
hosted 'mixed' parties for Black and white guests,
often the artists, writers and musicians of the Harlem
Renaissance cultural movement. The writer Langston
Hughes, a regular invitee, called her 'the joy goddess
of Harlem's 1920s'.

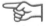

Rachel Parsons

The engineer, women's rights campaigner and racehorse owner Rachel Parsons jointly founded both the Women's Engineering Society (WES), the first organization founded in the UK expressly for the promotion of professional women, and Atalanta Ltd, an engineering company that employed women laid off to make way for men returning home at the end of the First World War.

She was born in 1885, into a family of scientists and innovators. Her grandfather was a president of the Royal Society and built the world's largest telescope, her grandmother a pioneer of early wax-paper negative photography. Her father invented the steam turbine and her mother, Katherine, Lady Parsons, was an engineer who co-founded WES and Atalanta with her daughter.

In 1910, Rachel was the first woman to study mechanical scienes at Cambridge, during the age when women were not awarded degrees. In 1914, she became director of her father's engineering works, replacing her war-bound brother, and worked alongside her mother to integrate women into the workforce. By 1918, 90 per cent of British munitions workers were female. Atalanta was founded in 1920 so that some of those workers, once peace rendered them unemployed, could use their skills. It was wound up in 1928. Rachel was elected to the London County Council but twice failed to become an MP, then became a stud farm owner. After she was attacked and killed by one of her stable lads in 1956, at the age of 71, newspaper reports barely made mention of her scientific career.

Betsy Kiek-Wolffers

Born in Rotterdam in 1891, Wolffers trained as an actress in Amsterdam and performed with theatre companies. In 1914, she married a watch retailer and took over the administration of the business while continuing to act in plays that toured the Netherlands. The Dutch portrait photographer Jacob Merkelbach, whose Amsterdam studio was favoured by Dutch high society, took this photograph of her in 1927.

In 1940, Wolffers fled the German occupation of Holland with her husband and son and went to London. There she met Caroline Haslett, who had been the first secretary of the Women's Engineering Society and was then chairing the International Women's Service Group (IWSG), a wartime association supporting business and professional women in Nazi-occupied countries. Wolffers was appointed the IWSG's Netherlands' representative by the Dutch minister of social affairs. She and her family returned to Amsterdam after the liberation of the Netherlands in May 1945.

In 1951, she took sole charge of the watch business after her husband's death and joined the Dutch Union of Female Managers; by 1959, she was its president. She was a champion of women's workplace rights, of smoothing the path of married women into the workforce and improving vocational education for women and girls in economic and technical matters. She took the union into international partnerships, winning Dutch and French high honours in the process.

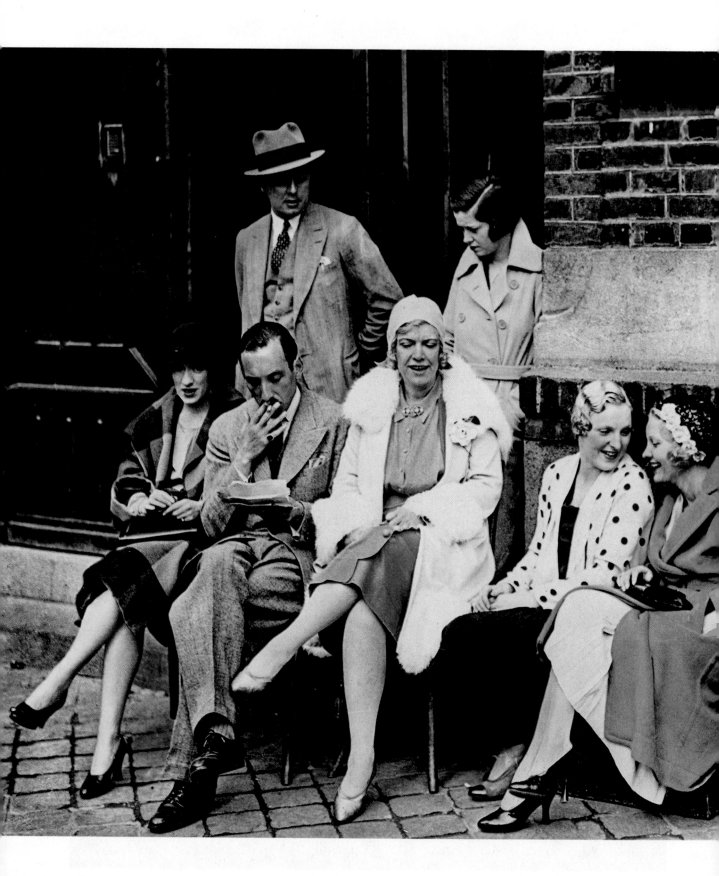

Texas Guinan

From January 1920 to December 1933 – known as the Prohibition era – alcohol was outlawed across the US. Paradoxically, this made many American cities more drunken than ever. Before Prohibition, there were 15,000 places to get a drink in New York City; by its end, there were at least double and possibly five times that number of illegal drinking dens, known as speakeasies. These ranged from one-room dive bars in private homes to palatial nightclubs with dancing and live music. Mary 'Texas' Guinan, a teetotal vaudeville star and silent film actress, was the main attraction and business partner in six lavish Manhattan speakeasies and one in Miami.

A canny business operator as well as a natural show-woman, Guinan made deals with club owners for a substantial cut of their profits. In December 1927, she told a New York newspaper that she teamed with one owner who guaranteed to double her previous salary of $50,000. 'After a girl gets her first $100,000,' she said, 'she doesn't think so much about money – she doesn't have to.' (The average American salary that year was just under $5,500.)

In June 1928, Guinan was arrested when police raided illegal Manhattan clubs, but she was acquitted at trial. This photograph was taken in 1931 (Guinan is seated, wearing a pink hat), during an American touring show called *Too Hot for Paris* – a name that spoke to the fact that Guinan was banned from performing in France. On the Vancouver stop, where the show broke house records, she collapsed backstage before a performance and died the following day, 5 November 1933. She was 49 years old. Thirty days later, US Prohibition ended.

'Queen of the Night Clubs'

On 10 December 1928, this photograph of the
nightclub hostess Kate Meyrick was taken as she
made her way to Bow Street Magistrates' Court in
central London. She knew the route well. Meyrick
ran nightclubs in London in the inter-war years,
almost all of which were raided or closed down for
serving alcohol outside the terms of her licence. She
was fined several times and served four prison
sentences – but this only added to her reputation as
what the newspapers called 'Queen of the Night
Clubs'.

This was a little strange, as in 1919, when she was
44, Meyrick had never been in a nightclub, let alone
run one. But that year, separated from her husband
and in need of a job to support her eight children,
she answered an advert in a paper 'for a partnership
to run tea dances'. This was the start of her career in
London's racy night-scene, frequented by celebrities,
musicians, royals and writers, thirsty for
entertainment and drinks at any hour.

'I admit that first and foremost I was a business
woman,' Meyrick wrote in a memoir in 1933, 'but I
was also a woman thrown on the world with eight
children to be given a decent start in life and very
little means wherewith to do it. It became clear to me
that there was money to be made ministering to the
unfailing demand for amusement, and I made my
mind up to have my share.'

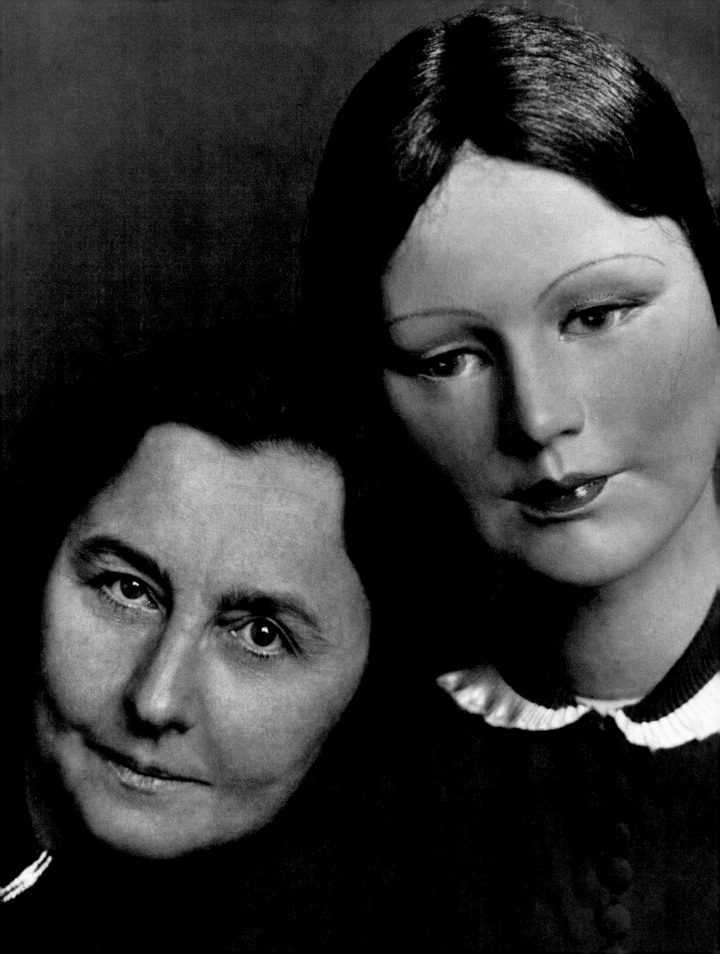

Käthe Kruse

Käthe Kruse was a German businesswoman and toymaker whose internationally successful business began when she made a one-off, handmade gift for her daughter. At Christmas in 1905, Kruse's husband refused to buy a doll for their eldest child, saying Kruse could do better making one. She rose to the challenge, making a doll with a sand-filled towel for a body and a wrapped potato for a head. Unlike the stiff china and bisque dolls then sold in German shops, this doll was soft and cuddly: 'safe and warm', as Kruse put it.

She developed her design so that later dolls had cloth faces and were stuffed with reindeer hair. In 1910, she entered one in a Berlin department store exhibition of home-made toys. Her doll was spotted by a representative of the New York toy store FAO Schwartz, who placed an order for 150, and then a much larger order soon after. In 1912 Kruse opened a factory in Bad Kösen, expanding her range of dolls and selling them across Europe and the US.

By the 1930s, Kruse had 100 employees and was exporting dolls all over the world. This photograph of Kruse with one of her creations was taken in 1934. The firm slowed to a halt in the Second World War, but survived and moved to West Germany following the end of the war in 1945. Kruse died in 1968, but the dolls are still made to her standards today.

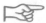

Elizabeth Arden

The Canadian-American CEO and beauty industry entrepreneur Elizabeth Arden was a rare female presence in corporate America during the first half of the twentieth century. With skincare products of her own invention, initially developed at home while working other jobs, she didn't so much break into the beauty industry as define it, in tandem with the rival firm of Helena Rubinstein (see page 374). Arden's products and marketing changed the idea of make-up as something cheap, in both senses, to an aspirational pleasure for stylish women that was just expensive or just affordable enough, depending on the buyer's budget.

The first Arden beauty salon in New York opened in 1910, when she was 28. In 1912 she researched beauty treatments in Paris; by the end of the decade her products were on sale in Europe. Sales doubled between 1925 and 1929, the first year of the Great Depression, during which Arden expanded her company, believing, correctly, that hard times would not stop women from caring about their appearance.

Arden's other great passion was horseracing. She owned several champion horses, including a Kentucky Derby winner. In this photograph, from December 1954, Arden is at the Newmarket horse sales on the day she paid a record price for a foal, almost tripling the previous mark.

Arden owned every share of stock in her company, and its successful direction can be almost entirely attributed to her skill and fortitude. In 1966, the year she died, aged 84, the company was generating annual sales of $60 million via 17 different corporations, its best ever performance.

'Shocking' Schiaparelli

During the 1930s, the Italian-French fashion designer Elsa Schiaparelli was as successful and influential as Coco Chanel. Both the Schiaparelli and Chanel houses sold Modernist designs to great acclaim and profit. Chanel's sales were greater, but Schiaparelli's designs were more daring and original. Both exerted considerable power over what women wore.

That influence went beyond high couture. Thanks to cheaper manufacturing and the growing power of fashion magazines and advertising, catwalk collections had begun to influence the designs of clothes made for ordinary women. Schiaparelli's high-fashion ideas, such as the split skirt and the bold use of colour, inspired mass-market knock-offs. And she embraced the democratization of fashion, selling patterns via mail-order ads in magazines and her clothes in department stores.

Born in Rome in 1890, Schiaparelli lived in London, New York and in several French cities before settling in Paris. Her breakthrough came in 1927, when, after years of making clothes for friends and for herself, one of her creations was featured in *Vogue*: a trompe-l'oeil bow-scarf sweater, with an image of the accessory knitted into the garment. By the end of that year, the House of Schiaparelli was established in Paris and American distribution was in place. In 1935, Schiaparelli opened a ready-to-wear boutique in Paris, the first branded shop of its kind from a couture house. Her influence went beyond fashion into the realm of everyday aesthetics: the colour 'shocking pink' is named after the packaging for Shocking, one of Schiaparelli's many successful fragrances, which survived the closure of her fashion house in 1954.

Helena Rubinstein

Along with Elizabeth Arden (see page 369), Helena Rubinstein was a pioneer of the early luxury beauty industry, which sprung up in America after the First World War. Rubinstein's rivalry with Arden, personal and professional, was inflated by gossip columnists and by comparisons of their sales figures in the business press. 'With her packaging and my product,' Rubinstein said, 'we could have ruled the world.'

Born in 1872, Rubinstein first made her name in Melbourne, Australia, where she moved from Poland in 1896, bringing with her supplies of a face cream used by her family at home. First she began to sell it, then she read chemistry books to understand how and why it worked. This research produced her first great idea: creating different skin creams for different 'problem' skin types. Each purchase in her Melbourne shop came with a personal consultation from Rubinstein; later she trained others to give consultations in her Sydney, London, Paris and New York branches. Selling products along with lessons in how to use them was central to the success of Helena Rubinstein Inc.

In 1928, operating at 50 per cent profit margins, the business was sold to Lehman Brothers. After the 1929 Wall Street Crash, Rubinstein bought back all the shares using just 20 per cent of the Lehman money. Never afraid of raising prices or using pseudoscience to promote products, she never really retired, and died aged 92 in 1965.

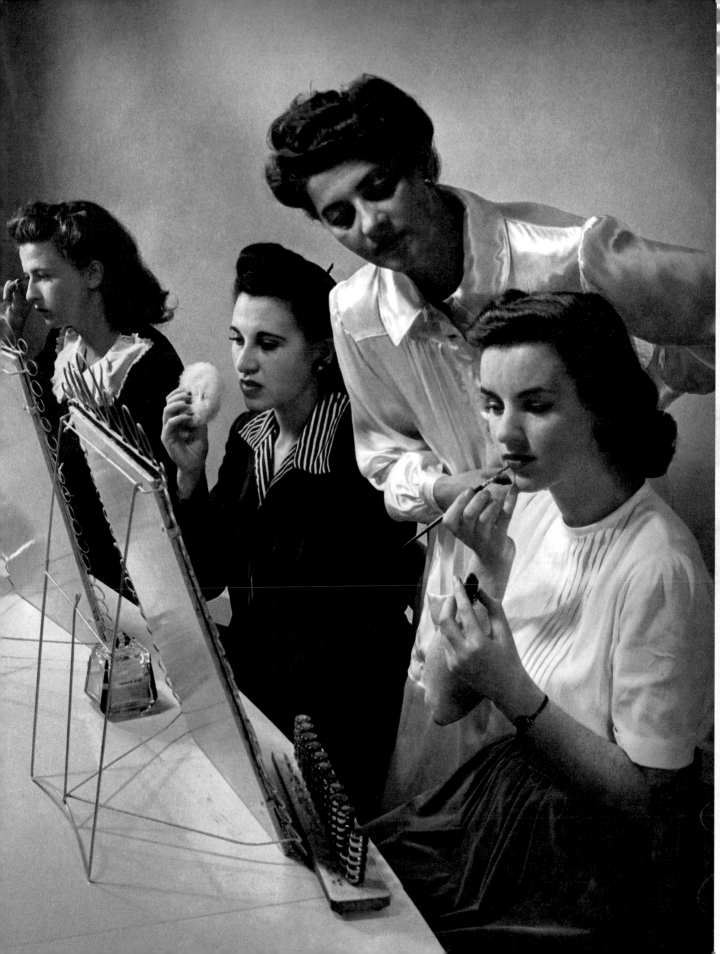

The High-Flyer

'It is a woman's duty to be as presentable as her circumstances of time and purse permit,' the American aviator and cosmetics entrepreneur Jacqueline Cochran wrote in her autobiography. 'But looking good is so emotionally satisfying that you shouldn't ever take it lightly. I didn't.'

Born in 1906 in Florida, Cochran worked in hair and beauty salons in Florida and New York, and founded Jacqueline Cochran Cosmetics in 1935; she is shown here, left, at her desk in 1941. After earning her pilot's licence in 1932, she also pursued a stellar career in the skies: she was a racing pilot during the Golden Age of flying in the 1930s, ran the women's ferry flight service for the US Air Force in the Second World War and was the first woman to break the sound barrier, during her years as a test pilot. She won numerous military and civilian medals for her service, while also winning many awards for her business achievements, including the Associated Press 'Woman of the Year in Business' award in 1953 and 1954.

Cochran's cosmetics were influenced by flying. Long, high-altitude flights were hard on her hands; since existing moisturizers left made her palms and fingers too greasy for the controls, she developed a non-greasy product. Her Perk-Up Stick was a lipstick-sized tube with five sections, each containing a cream or powder, ideal for air travel.

This photograph was taken in 1941 by Bernard Hoffman, a staff photographer on *Life* magazine, in Cochran's office at 1260 Avenue of the Americas, New York.

Lilly Daché

In 1937, a nine-storey Modernist building was built at 78 East 56th Street, three blocks from Central Park in Manhattan, New York City. It housed the penthouse home and business premises of the milliner Lilly Daché. She had the two previous buildings on the site demolished, and spared no cost in building their replacement. This was quite an achievement, considering that a little over a decade earlier, aged 32, she had emigrated from France to America with $13 in her pocket.

Daché had trained as a milliner in Paris before coming to America. She found a job in a small hat shop, which she bought with a co-worker; Daché became the sole owner within a year. Her glamorous designs were an important selling point, as was her personal hand in the making of each creation. And she charged for her expertise: around $30 a hat, at a time when the average price was closer to $3.

In the 1940s Daché's business expanded across the US, and she sold wholesale hat designs to department stores. When the market for ladies' hats cooled in the 1950s, Daché diversified into dresses, accessories, fragrance and menswear.

This photograph, shot for *Life* magazine by Leonard McCombe in September 1945, shows Daché as a multitasker and though it may not be documentary, the idea is true. She was president of the corporation that ran her businesses, as well as its chief designer and famous public face until she sold her last hat in 1969.

Women in White Coats

Marie Skłodowska Curie was the most brilliant scientist of her generation. She won two Nobel prizes, pioneered research into radioactivity and, in the laboratory she shared with her husband, Pierre Curie, discovered two new atoms. Perhaps only Albert Einstein (born twelve years after Curie) could rival her claim to be the most important scientist of the twentieth century.

Curie was born in Warsaw, in 1867, at a time when Poland was partitioned between Russia, Austria and Prussia. Her father was a maths and physics teacher who home-schooled his children in the sciences, which had at that time been removed from the Polish school syllabus by the ruling Russian imperial authorities. Women were not permitted to study science at university in Poland, so Curie instead studied at the Flying University, an underground higher education institution established to teach traditional Polish subjects that were marginalized or banned under Russian rule. In 1891, she went to the Univeristy of Paris, where her elder sister was reading medicine, and continued her studies in maths, chemistry and science. During her studies in Paris she met Pierre, and began sharing a lab with him. They married in 1895 and became scientific collaborators for the rest of their marriage.

In 1898 the Curies announced that they had discovered two new atoms: polonium (named after Poland) and radium (after the Latin word for ray). To describe the rays emanating from radium, Curie coined the term radioactivity. A paper Marie and Pierre published noted that radium radiation killed tumour-forming cells faster than healthy cells. Curie liked to carry bottles of both elements with her, and to sleep with a glowing sample of radium in a jar at her bedside. As a result of these discoveries Marie was awarded her first Nobel Prize (in physics), which she received jointly with her husband and Henri Becquerel, who supervised Marie's PhD.

In 1906 Pierre Curie was struck by a horse-drawn carriage and killed. Marie inherited his professorial seat at the University of Paris and opened a lab known as the Radium Insitute, where she continued working on atomic science and studying radioactivity. She isolated radium in 1910, for which she was awarded her second Nobel Prize (in chemistry). When the First World War broke out in 1914 she worked for the Red Cross, using radiology in the field in the form of mobile X-ray units for wounded soldiers.

During much of her career Marie Curie was sneered at in France for being a woman, a foreigner and a suspected Jew. Towards the end of her life, however, her achievements were rightly recognized and she was lauded as the supremely gifted scientist she was. She died in 1934, probably of radiation poisoning.

In the nineteenth and early twentieth centuries, advances in mass communication and international travel had made the world a smaller place and created a hunger for new information. The solar system and the subatomic world came into view. More people wanted to know where the next frontiers for humankind would lie, and the stories of those who might take us there were front-page news. Against that backdrop there were opportunities for women to study, practice and discover. The following pages pay tribute to doctors and nurses, food scientists and computer programmers. Curie was far from the only woman whose scientific work changed the world.

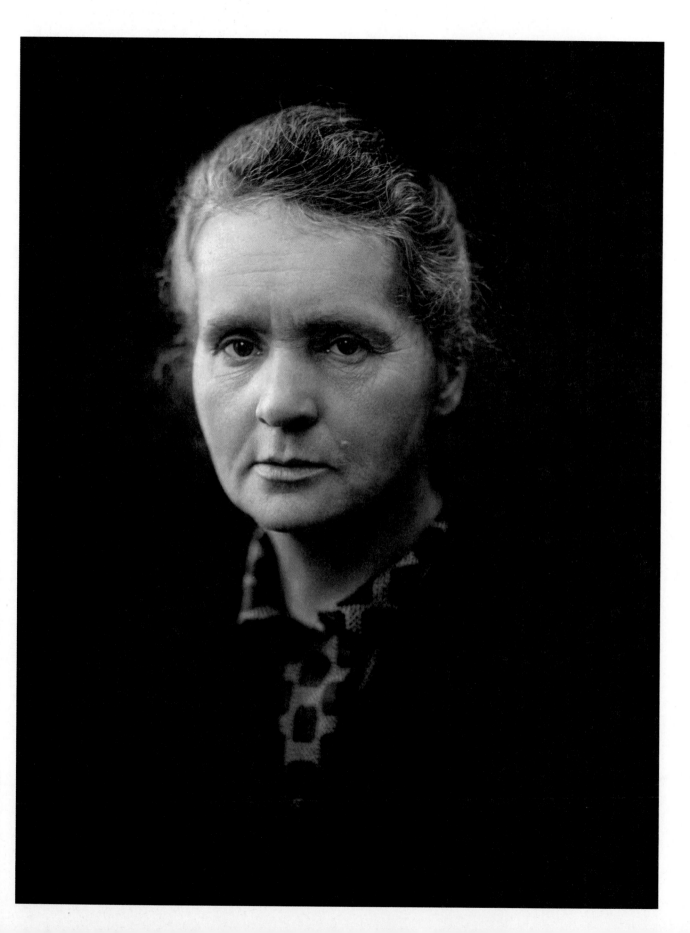

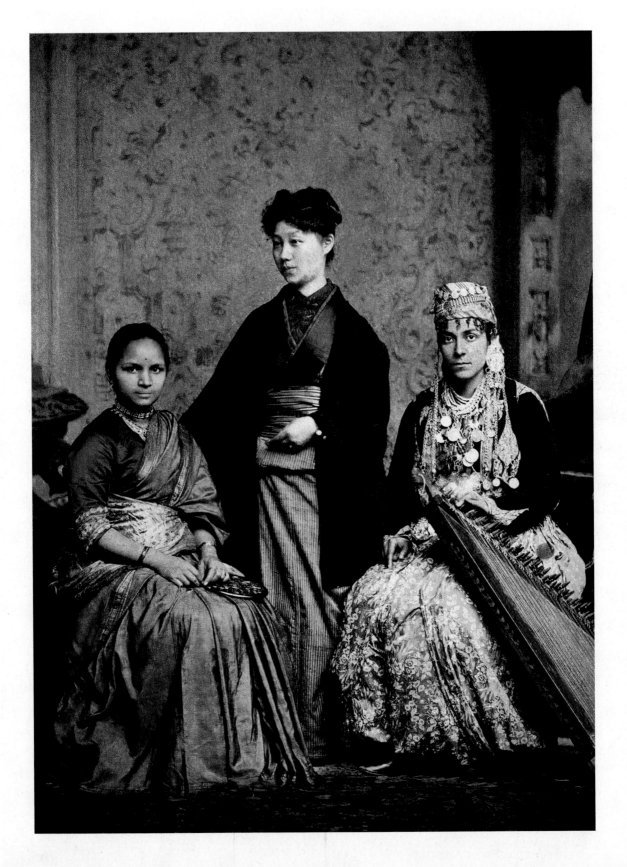

Doctors International

This photograph, taken on 10 October 1885 at a Dean's reception at the Women's Medical College of Pennsylvania, shows three women who were the first from their respective countries to earn a degree in medicine from a Western university. Anandibai Joshee from India, Kei Okami from Japan and Sabat Islambouli from Syria graduated from the college between 1886 and 1890, when women still faced barriers to entry at most universities and medical schools.

At this point in the history of education and female entry to the professions, graduating in medicine was a significant achievement, since women's suffrage, which helped open possibilities in further education, was a generation away. The Women's Medical College of Pennsylvania was the second of several women-only schools founded in response to the lack of opportunity in the US, the UK and China.

The first woman anywhere to become a doctor of medicine was Dorothea Erxleben, who had to prove to three doctors that she was not a quack before getting her medical degree from the University of Halle in Germany in 1754. The second recorded female doctor was Margaret Ann Bulkley, who disguised herself as a man, James Barry, to get an MD from the University of Edinburgh Medical School in 1812. She passed the Royal College of Surgeons' exam in 1813 and spent 46 years in military medicine with the British Army, most of it as a surgeon.

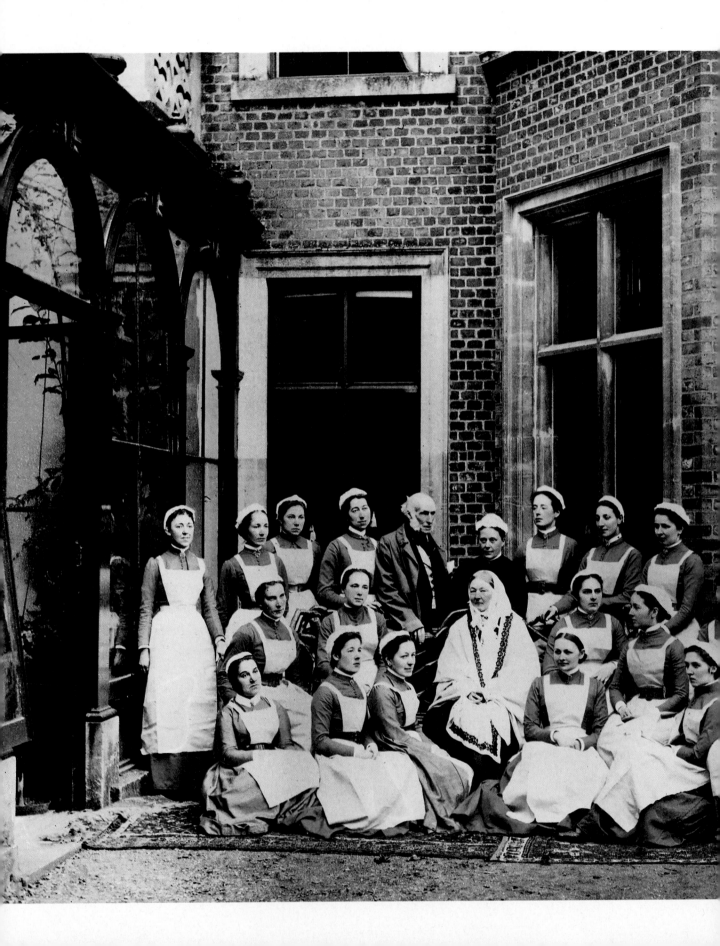

The Lady with the Lamp

Few people have had a greater individual effect on healthcare than Florence Nightingale, whose reforms of British military nursing and hospitals were later incorporated into civilian healthcare. Alongside Queen Victoria, she was one of the most famous women in the world during her lifetime.

Nightingale was born in 1820 to a wealthy English family in the Italian city after which she was named. Despite her family's misgivings, she trained as a nurse and after travelling and writing in Europe went to London to practise her profession. In October 1854, the Secretary of War, a personal friend, invited her to take a party of nurses to attend British Army casualties in the Crimean War. There Nightingale implemented revolutionary care and hygiene routines, and the death rate of soldiers in her care dropped from 42 per cent to 2 per cent.

Nightingale's methods to improve patient care and drive hospital reform were driven by data, with which she was obsessed, calling statistics 'the most important science in the whole world'.

This photograph of Nightingale with a group of London nurses was taken in 1861 at Claydon House in Buckinghamshire, the home of her sister Parthenope. By the time it was taken she was in poor health with a chronic illness (possibly caught in the Crimea). Nevertheless, she lived an exceptionally long life, and by the time of her death aged 90 in 1910 her legend as 'the lady with the lamp' was already fully formed.

Angel of the Battlefield

For the first three years of the American Civil War, Clara Barton worked alone as a nurse and field surgery assistant, following reports of battles and going to where she knew she would be needed the most. Senior officers disliked her direct manner, but the care she gave to wounded and dying soldiers earned her the nickname 'Angel of the Battlefield'. After long stints working to save lives and give dignity to the dying, her face would often be blue with gunpowder, and her skirts soaked heavy with blood.

At the outbreak of the US Civil War in 1861, Barton was 39, and a former teacher working as a clerk in the Patent Office in Washington, DC. After encountering casualties from the Union Army she took a leave of absence from her job, and never went back. By the final year of the war, she was head nurse for two Union Army units and began the work of the Office of Missing Men, which tracked down and marked the graves of over 20,000 soldiers – including 13,000 killed at one prison camp, whose identification and reburial Barton personally supervised. A subsequent lecture tour of the US made her famous and rich for life.

Barton suffered from depression, and while convalescing in Switzerland in 1869, she discovered the work of the Red Cross, which led to her founding the American Red Cross in 1881 and the US National First Aid Society in 1905. She died in 1912, aged 90.

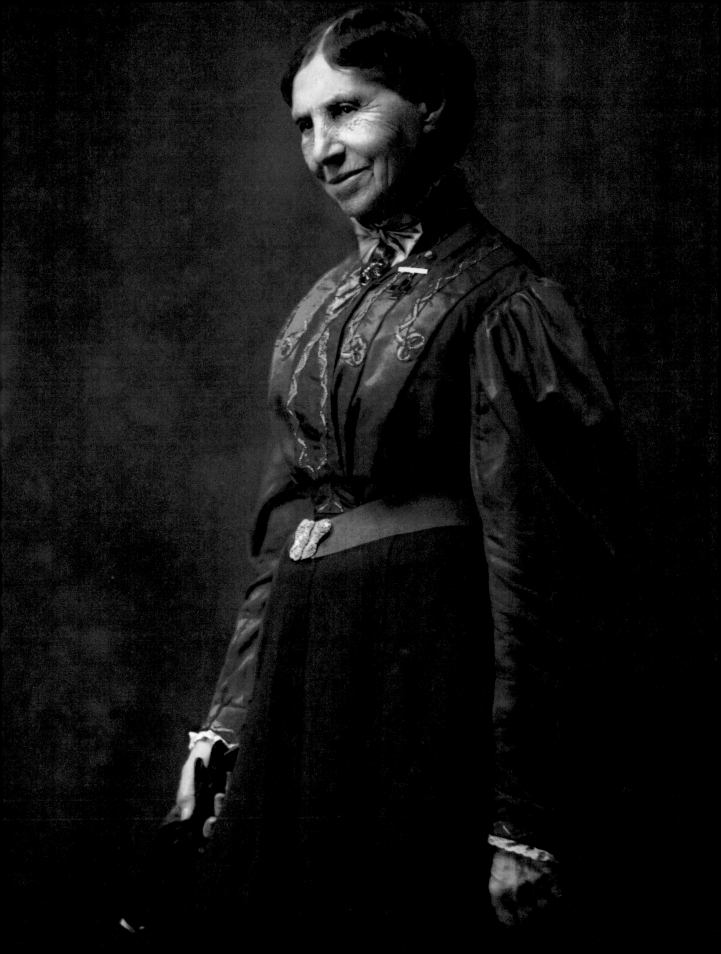

'The Army Mother'

Catherine Booth founded the Salvation Army with her husband, William, in the East End of London in 1865. She was known as the Army Mother for her influence over the organization's humanitarian ministry. William preached to London's poor and Booth addressed the city's upper classes, impressing upon them the need to fund the missionary work. She was a confident, persuasive speaker, in public and private alike.

Booth (born Catherine Mumford in 1829) had a strong moral conviction from childhood, when she wrote articles for a temperance magazine. In adulthood she combined her preaching, Christian ministry and charitable work with advocacy for a woman's right to speak the word of God and be heard. Her first notable publication was entitled *Female Ministry: Woman's Right to Preach the Gospel* (1859); in it Booth defended the controversial Methodist preacher Phoebe Palmer's right to speak on matters of scripture. Her pamphlet argued for common sense in Bible interpretation as well as the equal validity of male and female preachers.

As the scope and work of the Army grew, Booth became a well-known public figure. She was part of the campaign that led to the raising of the age of sexual consent in the UK to 16 in 1885. In 1888 she developed breast cancer and withdrew from public life – this image shows her deathbed, with William beside. When she died in 1890, her funeral in London drew a crowd of 30,000 people.

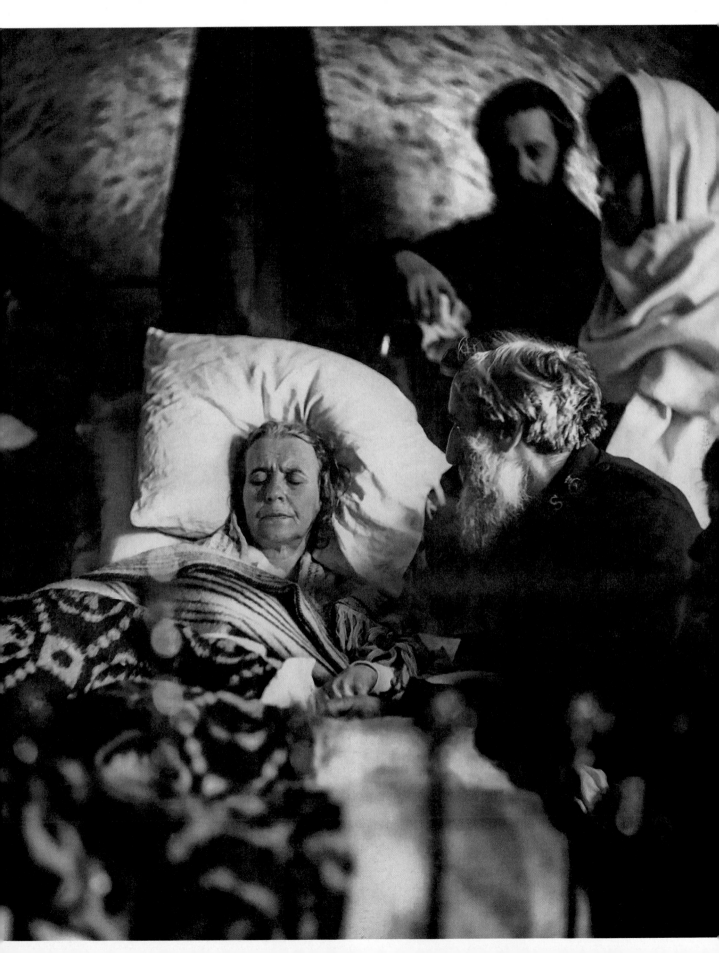

Mary Engle Pennington

When this photograph was taken in the early 1890s Mary Engle Pennington was a young woman studying biology and chemistry at the University of Pennsylvania, from where she took the equivalent of a degree and a PhD. After continuing her academic research at Yale, she worked for the Philadelphia Bureau of Health, helping dairy farmers establish best practices for milk production. In 1908 she was made head of the US government's newly formed Food Research Lab. This was the beginning of a career in which Pennington changed the way the world ate.

When Pennington had been a child in Philadelphia, food preservation was still rudimentary, and winter meant little or no fresh food. In the course of her career she developed techniques for storing and distributing chilled and frozen food, which effectively created the modern food industry. Her innovations allowed all Americans, and later people across the world, safely to eat meat and fish, fruit and vegetables and eggs and dairy products that had been transported over long distances from their source to the consumer.

In government, Pennington became expert in both the engineering of refrigeration and the biochemistry of foodstuffs. During the First World War, she took about 500 long-distance train trips across America to improve the standards of refrigerated train carriages. In 1922, she set up as a consultant in New York City, and was still in great demand at the age of 69, when a 1941 *New Yorker* profile of her said that 'for dessert, she serves ice cream more often than anything else'.

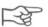

The Harvard Computers

In the 1880s, Edward Pickering, the director of the Harvard College Observatory (HCO), led a team of women in a remarkable scientific undertaking: mapping the visible universe. The project required the meticulous analysis of hundreds of thousands of glass plate photographs of the night sky, provided by astronomers at Harvard and around the world. Pickering employed only women for the job of 'computing'. Some had science degrees, while others were keen amateurs. Either way, Pickering said he preferred women's dedication and efficiency. It also meant he could pay them women's clerical wages, which were then half those of men.

Pickering was director of the HCO for 42 years and employed about 80 women, who were nicknamed first Pickering's Harem and then The Harvard Computers. They usually worked in pairs in a cramped observatory library, with one looking at a photograph and calling out observations to a partner taking notes. The work was arduous but led to groundbreaking discoveries.

While working at Harvard, Annie Jump Cannon developed a classification scheme for stars that is the basis for modern stellar identification. Henrietta Leavitt found a way to measure cosmic distances based on stars' brightness. Antonia Maury discovered a method of calculating the size of a star based on patterns of light in certain photographs. They and many other Harvard Computers, including Florence Cushman, Muriel Mussells Seyfert and Williamina Fleming, who had been Pickering's housekeeper, became important and influential astronomers.

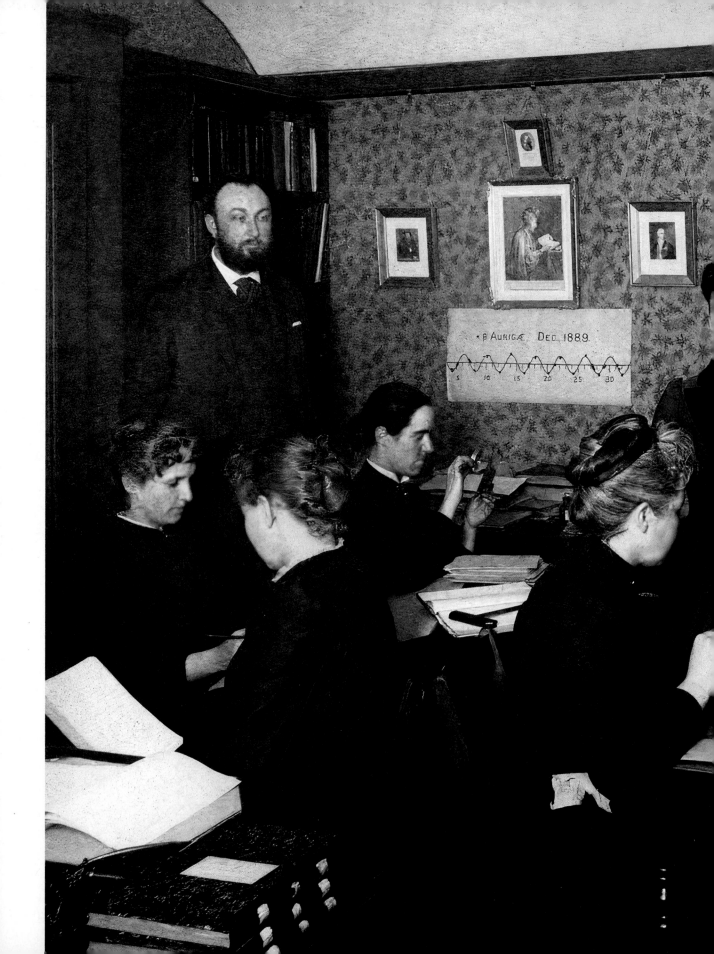

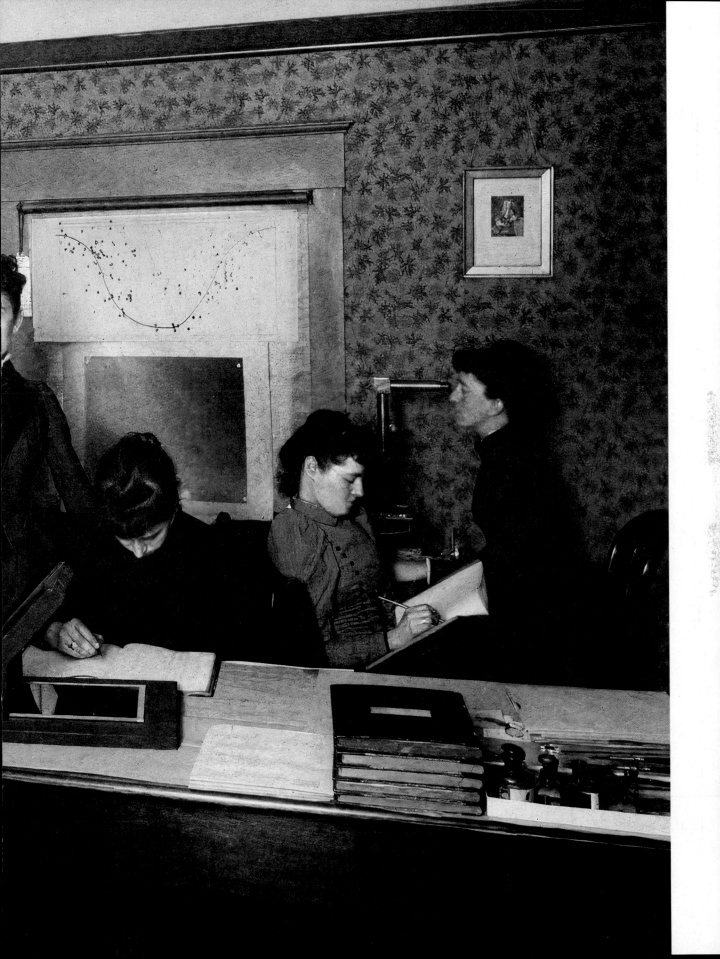

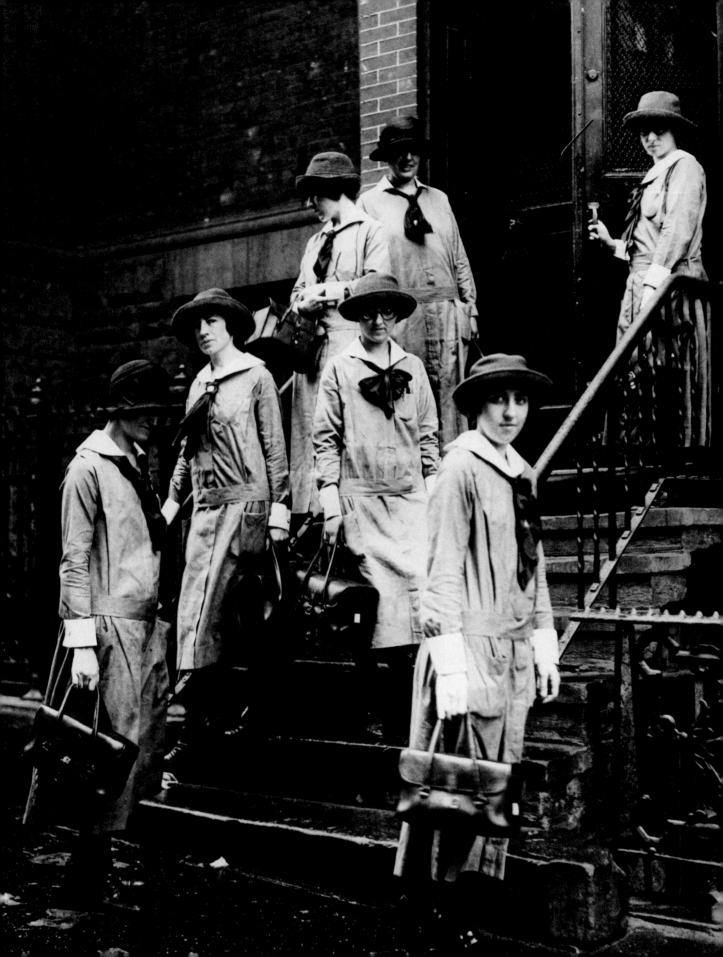

The Henry Street Settlement

This photograph shows nurses of New York's Visiting Nurse Service (VNS) heading out to work in Manhattan around 1900. The VNS provided care for patients at home, at a sliding-scale cost that made medical attention affordable for even the poorest. In doing so, the nurses provided the first public health scheme of its kind anywhere in the world.

The organization was the brainchild of Lillian Wald, who in March 1893 experienced what she called 'a baptism of fire' while teaching nursing classes in a Lower East Side tenement and witnessing widespread poverty and sickness. She quit her medical studies and switched to nursing school, convinced that nurses could and should be working in the poorest communities to the benefit of patients and hospitals, which would then be freed up for serious and urgent cases.

Wald established the VNS in the settlement house pictured here – located at 265 Henry Street, in the heart of the Lower East Side's slums – having convinced a wealthy banker and philanthropist called Jacob Schiff to buy the building. At first the staff consisted of herself and one other nurse. But Wald's ability to inspire others and raise funds meant that the VNS grew quickly.

By 1913, there were 92 VNS nurses, making 20,000 home visits a year; by the time of the Second World War there were around 300. Meanwhile, Henry Street had become a true community hub, providing social services, classes, exhibitions and arts performances, as well as the health care that became a model for similar schemes around the world.

Kate Marsden

When Kate Marsden was presented at the court of Edward VII in 1906 (the occasion pictured here) she was a famous, if controversial figure in England and Russia. She had devoted much of her adult life to finding a cure for leprosy, and her travels had taken her quite literally around the world. But she had also been dogged by whispers about her sexuality, her morality, and her motivations for helping others.

Marsden first saw lepers in 1877 when, aged 18, she travelled to Bulgaria with a party of nurses to help Russian soldiers wounded in the Russo-Turkish war. Meeting a pair of sufferers near the town of Svishtov convinced her of the urgent need to find a remedy for the condition. In England she lobbied Queen Victoria and Princess Alexandria for their backing. She then set out on a mission to investigate leprosy, travelling to Egypt, Turkey and Palestine, before heading to Siberia to look for a herb that was said to yield an effective treatment. Her 1893 book *On Sledge and Horseback to the Outcast Siberian Lepers* chronicled her journey, and in the years that followed Marsden raised funds to build leper hospitals in London and Vilyuysk.

Although her work established Marsden as a hero in Siberia, in London she was criticized by journalists and a St. Petersburg-based pastor who accused her of 'immorality with women', and suggested that she was a fraud. Investigators in Russia cleared her, but her reputation in England was ruined, as was her health.

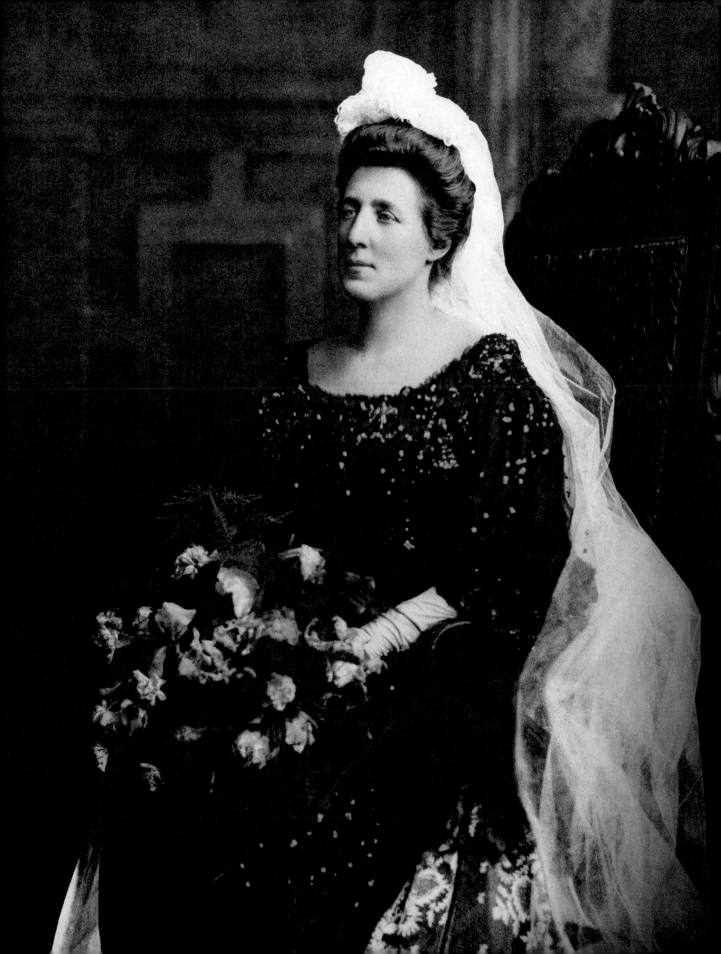

'Queen of the Corridors'

As founder and first president of the Norwegian Women's Public Health Association, Fredrikke Marie Qvam was a figurehead of health and social reform at the turn of the twentieth century. She served as the association's president from 1896 to 1933, while also campaigning for women's suffrage. Her husband, Ole Anton Qvam, was a senior politician in Norway, and between 1902 and 1903 served as prime minister. Fredrikke Marie used her access to power to lobby for women and women's health, which earned her the nickname 'Queen of the corridors'.

Personal tragedy informed Qvam's political life: three of her five children died before adulthood, two from tuberculosis. Combating that disease, and other common illnesses, was a central aim of the association, which also taught nursing and first aid and provided medical supplies.

There was plenty to be done. The rapid urbanization of the late nineteenth and early twentieth centuries, both in Norway and across the world, led to rampant outbreaks of diseases such as cholera, smallpox and tuberculosis, as well as appallingly high rates of infant mortality and maternal mortality. The Norwegian Women's Public Health Association accordingly focused on environmental health and hygiene.

Besides her work in public health, Qvam also campaigned vigorously for women's voting rights, particularly during the 1905 referendum on dissolving the political union that then existed between Norway and Sweden. Women were not permitted to take part in that vote, but eight years later, in 1913, full female suffrage was granted – a victory Qvam lived to enjoy.

'Lady Edison'

'If necessity is the mother of invention,' Beulah Louise Henry told a reporter for the *New York Times* in January 1962, 'then resourcefulness is the father.' Henry, a prolific inventor, was appearing in the newspaper with her latest creation, a combination envelope and return envelope she hoped to market to companies who sent out a lot of bills. This was just one of a vast array of innovations Henry produced during a five-decade career in which she devised toys, educational board games, audio equipment, sewing and typing machines and hair curlers.

Henry had no formal training in science or engineering, but she was possessed from childhood of a creative mind and restless nature. She registered the first of her 49 patents, for an ice cream freezer, in 1912 when she was 25. Some of the bestselling products that followed included a toy cow that mooed and could be milked; an umbrella with interchangeable fabric to better match a person's outfit and a bobbinless sewing machine, which was adopted by clothing manufacturers. Journalists called her 'Lady Edison' – a comparison with Thomas Edison, the prolific inventor and pioneer of electric lights and motion pictures, who was her contemporary. Where Henry differed from Edison was in the fact that during their lifetimes only 2 per cent of patents registered in the US were in the names of women. In this image from 1932, Henry is demonstrating her protograph, a typewriter add-on that produced four copies of the original typescript without using carbon paper.

Cornelia Clapp

Despite its title, the first edition of the biographical dictionary *American Men of Science*, published in 1906, did list women. And among the 4,000+ entries highlighted for 'most important' scientific work was that of Dr. Cornelia Clapp, the professor and teacher pictured here in at her desk in 1934.

Clapp was a zoologist with a particular interest in embryology and marine biology. Born in 1849, she studied and taught at a women's seminary in Mount Holyoke in Massachusetts. The seminary had a farflung network of Christian missionaries and alumni, and Clapp called on them to send her animal and insect specimens from all over the world. 'Study nature, not books,' was her watchword – a phrase she borrowed from the renowned geologist Louis Agassiz.

During the late 1880s Clapp played a leading role in Mount Holyoke becoming a college, before taking a three-year leave of absence to study at the University of Chicago, from where she received her PhD. When she returned, she was appointed professor of zoology. In 1888, a world-leading marine biology lab was founded at Woods Hole, also in Massachusetts. Clapp spent every summer there, serving variously as a researcher, lecturer, librarian and trustee.

Clapp was a superb teacher, but her first love was fieldwork, and she insisted her students observe nature first-hand where possible. 'I have always had the idea,' she said, 'if you want to do a thing, there is no particular reason why you shouldn't do it.' She retired from teaching in 1916, and died, aged 85, shortly after this photograph was taken.

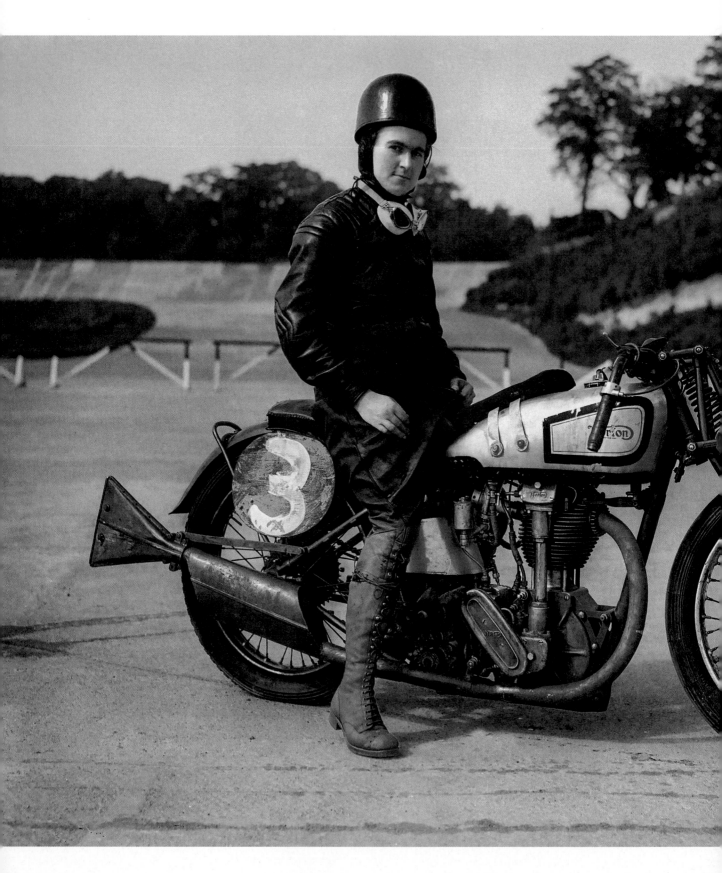

Miss Shilling's Orifice

There were many heroes in the Battle of Britain, but few who made such a practical difference to so many as Beatrice Shilling, pictured here in 1935. A mechanical and aeronautical engineer, Shilling worked for the Royal Aircraft Establishment, the R&D arm of the Royal Air Force, from 1936 to 1969. In November 1939, two months after the outbreak of the Second World War, she was promoted to head of the carburettor research department, which put her in position to solve an urgent problem.

The engines in British fighter planes, such as the Spitfire and the Hurricane, were prone to cutting out when the aircraft went into steep dives and fuel flooded the carburettor. Planes and pilots were being lost to this failing, which also gave German fighter pilots an advantage in dogfights, since they could dive sharply, knowing that their opponents could not follow. Shilling devised a fuel restrictor, known as Miss Shilling's Orifice, which prevented flooding and, crucially, could be fitted quickly to an aircraft without the need to take it out of service.

After the war, Shilling worked on several projects, including the Blue Streak ballistic missile programme. She was also a keen motorbike racer who switched to racing cars with her husband after they were married. Legend has it that she only accepted her fiancé's proposal once he'd matched her August 1934 achievement of a 100mph average lap at the Brooklands circuit, where this photograph was taken.

Hedy Lamarr

This photograph, taken in 1942, shows Hedy Lamarr selling US war bonds at a rally in Newark, New Jersey. Many celebrities joined this fundraising initiative in America during the Second World War, but Lamarr also made an additional, more unusual contribution to the war effort: she invented and co-developed an unjammable guidance system for torpedoes.

Lamarr is often remembered as an actress who appeared in 30 films from 1930 to 1958, but she was also an inventor. She had studied design in her home town of Vienna in Austria before drama school in Berlin and arriving in Hollywood in 1938. Although she was married and divorced six times, she generally tried to live her life away from public view. Instead of partying, she preferred to sit at the drafting table in the corner of her drawing room and flesh out her ideas and innovations. Of the many famous women associated with the businessman and aviator Howard Hughes, she is the only one credited with helping him perfect a design of aircraft wings.

In late 1940, Lamarr turned her attention to a means of countering the German U-boats that attacked Allied ships in the North Atlantic. Traditional radio-controlled torpedoes could be jammed so she came up with the idea for 'frequency hopping'. Her friend, the composer George Antheil, helped with the design, which was patented in 1942 and classified until 1981. Frequency hopping is fundamental to Bluetooth communication and was used for a time in Wi-Fi.

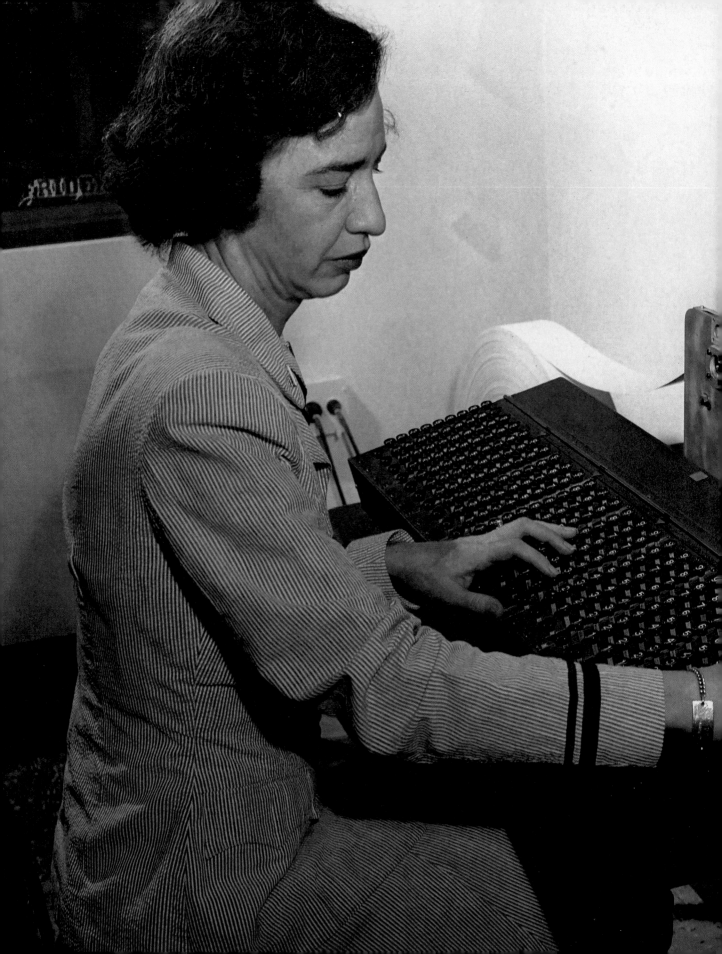

'Go ahead and do it'

Grace Hopper edited the manual for the IBM Mark I, the US's first programmable computer, and developed computer programming languages when few existed. A junior maths professor who enlisted with the US Navy Reserve in 1944, she was assigned to Harvard University and worked on the Mark 1. This photograph shows her in 1944, operating another IBM calculating machine.

Hopper lived during the early days of computing and her affinity for programming led her to do groundbreaking work. In 1952, she built the first compiler software that could translate computer languages, and later worked on language standardization – two key drivers of the computer's omnipresence in the modern world.

Hopper inspired the Bill Gates–Steve Jobs generation of home computer pioneers not only with her work but also with her experimental outlook. At the many talks and lectures she gave, to students and industry colleagues alike, she was fond of reminding her audience that creative thinkers don't always toe the company line. 'Go ahead and do it,' she would say, of the need to innovate, 'it is much easier to apologize than it is to get permission.'

In 1983 Hopper, then aged 76, appeared on the US TV show *60 Minutes*. Despite her relatively advanced age she was still on active duty for the Navy. In response to the show, she was promoted by President Ronald Reagan to the rank of rear admiral; she finally retired in 1986 but continued to consult to computer companies until her death in 1992.

The Atom Splitter

The Austrian-Swedish physicist Lise Meitner was one of four scientists who, in 1938, developed the theory for and proof of nuclear fission – the splitting of the atom. This brought into being the atomic age, with both nuclear power stations and nuclear weapons: at once the most potentially beneficial and potentially destructive technologies ever devised.

Born to a Jewish family in Vienna in 1878, Meitner earned her degree and PhD at the city's university, and in 1907 moved to Germany, where she spent almost three decades in the top rank of radiochemistry, split only by a stint in the Austrian Army in 1915 and 1916 during the First World War, working as a nurse and X-ray technician on the Eastern and Italian Fronts.

When Nazi Germany annexed Austria in March 1938, Meitner became stateless. A network of fellow scientists helped her escape via the Netherlands to Sweden, where, with her nephew Otto Frisch, also a physicist, she proved nuclear fission in collaboration with two chemist colleagues back in Berlin. Another of the chemists won the Nobel Prize for the work. Although Einstein called Meitner 'the German Marie Curie', she was nominated 48 times for Prizes in chemistry and physics, without winning.

In 1943, Meitner turned down an offer to work on the Manhattan Project, telling colleagues 'I will have nothing to do with a bomb.' The inscription on her gravestone reads: 'A physicist who never lost her humanity'.

Irène Joliot-Curie

This photograph of Albert Einstein hosting Irène Joliot-Curie in his study at Princeton, New Jersey was taken on 20 March 1948. Joliot-Curie had spent much of the previous day held by the US government at the immigration centre on Ellis Island; not arrested but detained and released without official explanation. She had travelled to the US to raise money for Spanish refugees and exiles displaced by the rule of the fascist dictator Franco.

Joliot-Curie's anti-war activism stemmed from her experience as a teenager of the battlefields of the First World War in France and Belgium, where she helped her mother, Marie Curie (see page 382), operate a mobile X-ray unit to help field surgeons find bullets and shrapnel in soldiers' wounds. After the war, she went into the family business, working in the Curie Institute in Paris and obtaining a degree and doctorate in physics. She also followed in her mother's footsteps by marrying a scientist with whom she would work closely and by winning a Nobel Prize in chemistry, for groundbreaking work in radiation. Like Marie, Joliot-Curie also likely died from prolonged exposure to radioactive materials, passing away in 1956 at the age of 58.

In December 1948, nine months after meeting Einstein, Joliot-Curie and her husband Frédéric were part of the leadership team that activated the first atomic reactor in France, which went on to produce most of the country's energy via nuclear power stations. Their daughter, Hélène, became a professor of nuclear physics; she is 94 years old at the time of writing.

Caroline Haslett

Problems Have No Sex was the title of Caroline Haslett's 1949 book about the advances made by, and hopes for, women in the sciences, particularly engineering. In the UK, as a senior member or leader of two dozen societies, boards and institutions in both the private and public sectors, her campaigning led to more women taking engineering exams and securing jobs in the industry. As an electrical engineer, she championed the use of electricity in the home, helping to gather British electricity suppliers into a nascent national grid.

Haslett learned how to use tools as a child in her father's workshop; after school she took a job as a secretary at an engineering firm that made boilers. During the First World War, she transferred into the firm's workshops, but unlike those wartime workers who went back to 'women's work' to make way for returning soldiers, Haslett committed to remaining an engineer. She was the first secretary of the Women's Engineering Society and a co-founder of the women-only engineering firm Atalanta Ltd with Rachel Parsons (see page 362).

Haslett was serious about her work, but also had a sense of humour. In 1947 she addressed the Royal Society of Arts – as the learned society's first female vice-president – a few weeks before she was made a Dame in honour of her professional achievements. She began her speech by saying: 'When I was a respectable person, and before I had descended to the basement of the Civil Service, and from the basement to the pit of politics, I used to attend learned society meetings…' She died, aged 61, in January 1957.

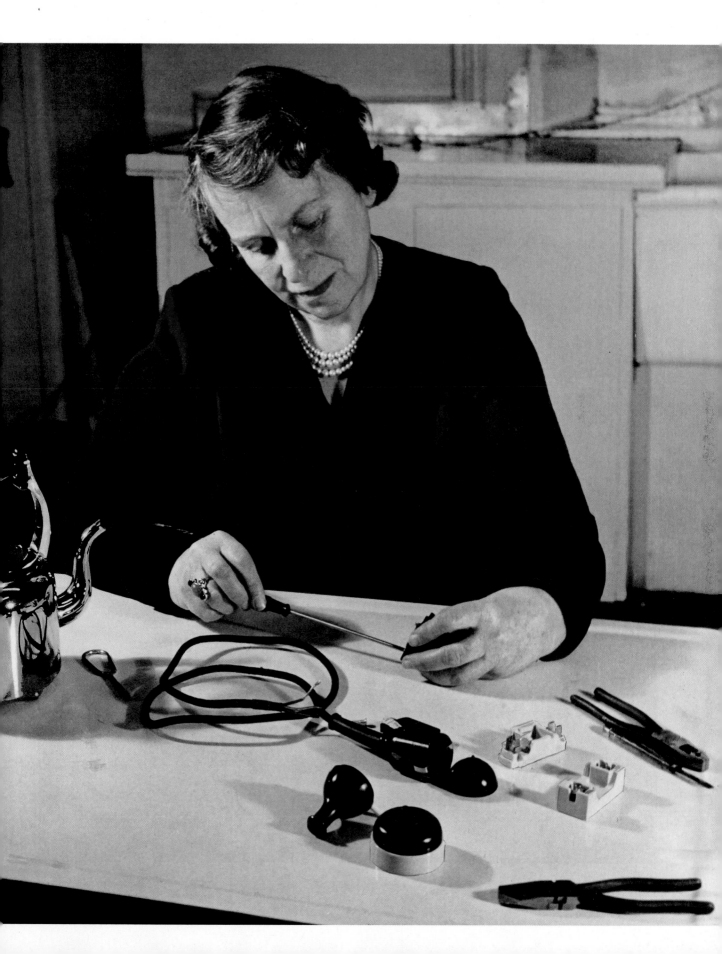

'The Forgotten Heroine'

Rosalind Franklin was the best X-ray crystallographer in the world. She did cutting-edge work in the late 1940s and early 1950s, making images that broke open the discipline of molecular biology. This work was fundamental to understanding DNA and, later, enabled Franklin to build the first ever structure of a virus. Francis Crick, James Watson and Maurice Wilkins won the 1962 Nobel Prize for their work outlining the structure of DNA, but they could not have done it without seeing an X-ray, made in Franklin's lab by her PhD student and assistant Raymond Gosling, in 1952.

When Watson gave the Nobel acceptance speech on behalf of the three winners, he thanked other people but not Franklin (or Gosling). Each man gave a Nobel lecture, a requirement of prize-winners; only Wilkins acknowledged Franklin and her 'valuable contribution to the X-ray analysis'. Watson's 1968 memoir *The Double Helix* cast Franklin in a negative light and opened a debate that has painted Franklin, in the words of her sister, as 'the forgotten heroine' of science.

What is undisputed is that science is collaborative: the Nobel committee rule that no more than three people can be awarded a prize does not reflect this and Franklin was not credited for her work by scientists whose ethical and moral reasons for not doing so died with them. Her early death from ovarian cancer in April 1958, at the age of 37, was a tragedy for those who knew her and for science.

Chien-Shiung Wu

Chien-Shiung Wu was known as the 'Chinese Marie Curie', but many of her peers felt she should be placed above the French pioneer in terms of achievement and contribution to the sciences. In a long career, which was her dream as a young girl, inspired by Curie, Wu was responsible for seminal discoveries in nuclear physics.

In particular, the Wu Experiment of 1956, which she devised and carried out over several months, proved a theory of atomic radiation that many of her peers dismissed, yet which shaped everything in the field that followed. The 1957 Nobel Prize for Physics was awarded to the two scientists who came up with the theory, but not to Wu.

Born in China in 1912, Wu earned her physics degree in Nanjing in 1934, and in 1936 emigrated from Shanghai to San Francisco. In 1940, she earned her doctorate at Berkeley and then taught at Princeton. In 1944, she joined the Manhattan Project at Columbia University. The project's lead, J. Robert Oppenheimer, had been among the committee impressed by Wu's presentation of her PhD thesis. She remained in Columbia's physics department for 37 years and won every major scientific prize apart from the Nobel.

The results of the Wu Experiment changed, and still change, fundamental ideas about the universe, including theories of how something emerged from nothing at the Big Bang – the very beginnings of life itself.

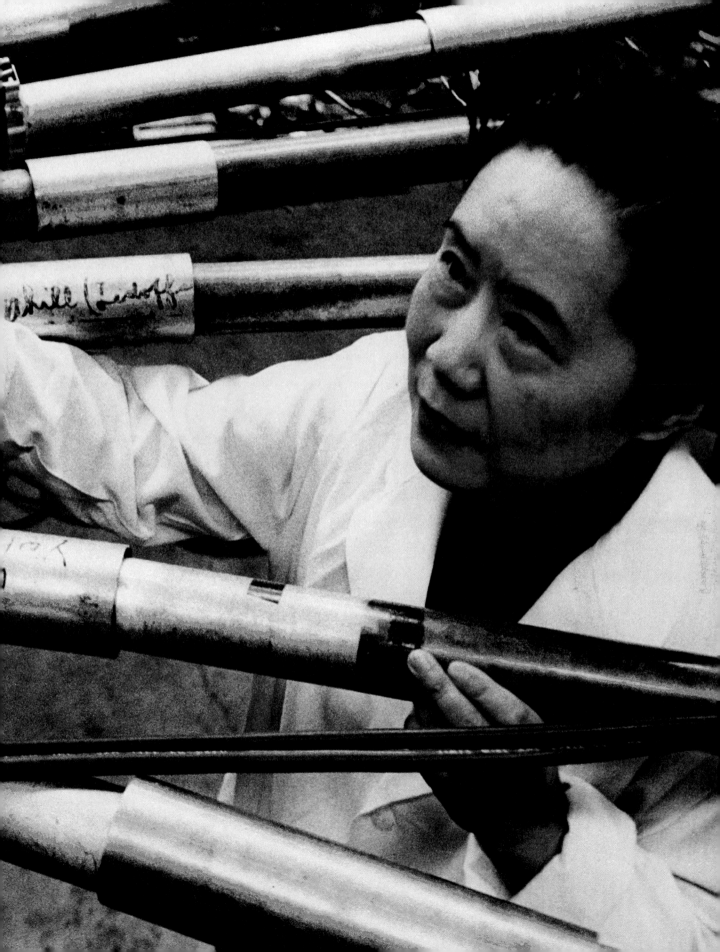

Appendix

Cambridge University
pages 58–9

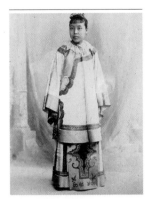

Dr Hü King Eng
page 61

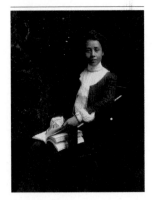

Anna J. Cooper
page 62

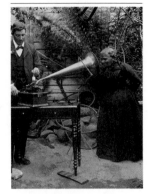

Fanny Cochrane Smith
pages 64–5

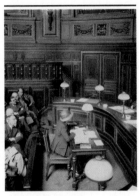

Thesis defence at the
Sorbonne
pages 66–7

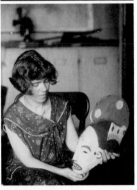

Margaret Mead
page 69

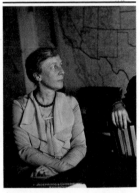

Lillian Gilbreth
pages 70–71

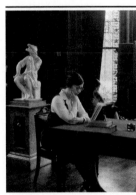

Girton College, Cambridge
pages 72–3

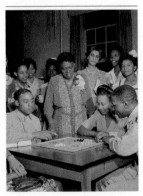

Mary McCleod Bethune
pages 74–5

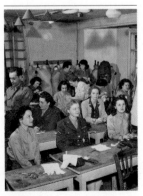

American GIs in Paris
pages 76–77

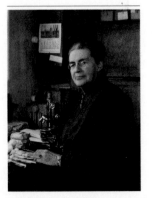

Johanna Westerdijk
page 78

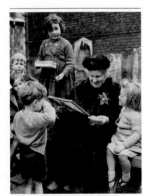

Maria Montessori
pages 80–81

Septima Clark
pages 82–3

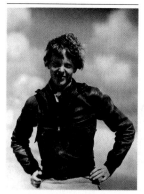

Amelia Earhart
page 87

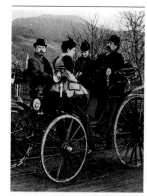

Bertha Benz
pages 88–9

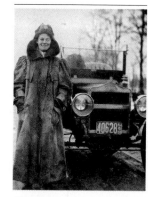

Alice Ramsey
pages 90–91

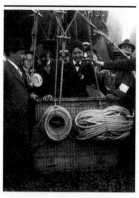

Marie Marvingt
pages 92–3

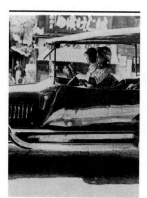

Chauffeurs in Tokyo
pages 94–5

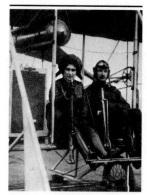

Evgeniya Shakhovskaya
pages 96–7

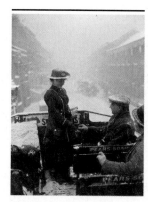

Bus conductors
page 99

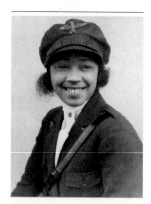

Elizabeth 'Bessie' Coleman
page 100

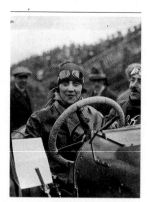

Maria Avanzo
pages 102–3

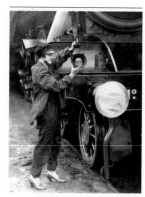

Karen Harrison
pages 104–5

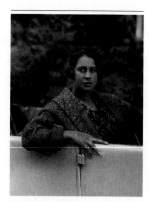

Clärenore Stinnes
pages 106–7

Elinor Smith and Bobbi
Trout
pages 108–9

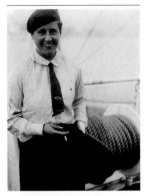

Jo Carstairs
page 110

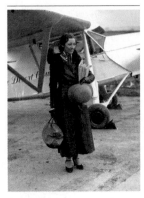

Amy Johnson
pages 112–3

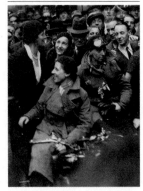

Florence Blenkiron and
Theresa Wallach
pages 114–5

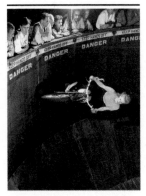

Terry Strong
pages 116–7

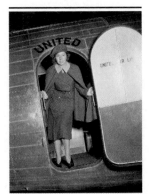

Ellen Church
page 118

Mary Parker Converse
pages 120–1

Lyudmila Pavlichenko
page 125

Anita Garibaldi
page 126

Frances Clayton
page 128

Edith Cavell
pages 130–1

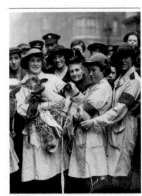

Women's Land Army
pages 132–3

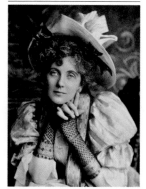

Lena Ashwell
page 134

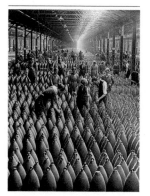

Munitions workers
pages 136–7

American nurses in the trenches
pages 138–9

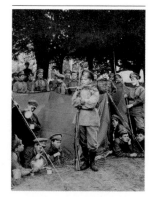

'Battalion of Death'
pages 140–1

Milicianas
pages 142–3

The WAC
page 144

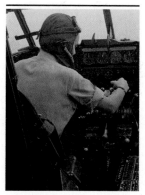

The ATA
pages 146–7

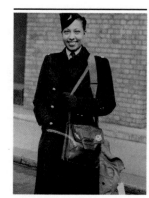

Josephine Baker
page 149

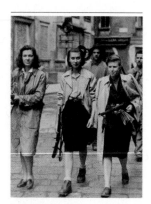

Italian Resistance
pages 150–1

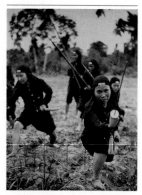

Hoa Hao
pages 152–3

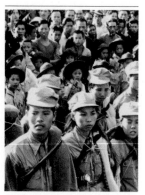

The People's Liberation Army
pages 154–5

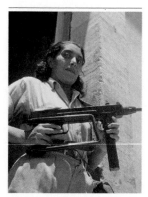

A Lone Gunwoman
pages 156–7

Mau Mau woman
page 158

Fidel Castro's Red Army
pages 160–1

Taytu Betul
page 165

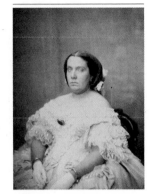

Queen Isabella of Spain
page 166

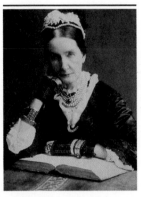

Angela Burdett-Coutts
page 169

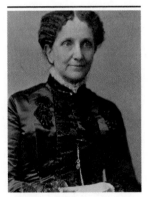

Mary Baker Eddy
page 170

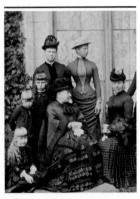

Queen Victoria
pages 172–3

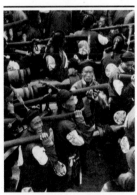

Empress Dowager Cixi
pages 174–5

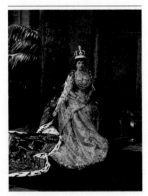

Queen Alexandra
pages 176–7

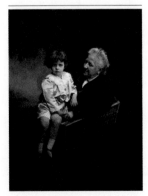

Isabel of Brazil
page 179

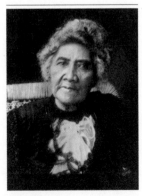

Liliuokalani
page 180

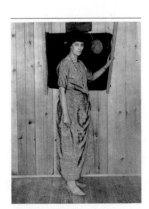

Constance Markievicz
page 183

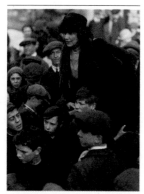

Nancy Astor
pages 184–5

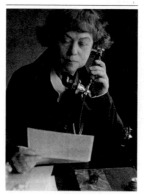

Alexandra Kollontai
pages 186–7

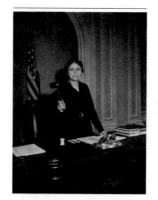

Hattie Wyatt Caraway
page 188

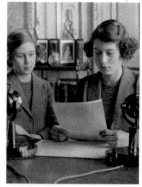

Princesses Elizabeth
and Margaret
pages 190–1

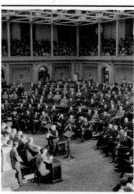

The House of Representatives
pages 192–3

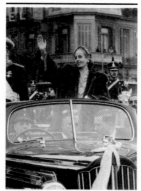

Eva Peron
page 194

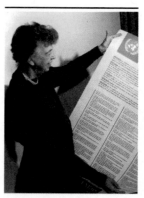

Eleanor Roosevelt
pages 196–7

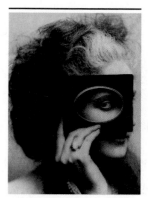

Virginia Oldoini
page 201

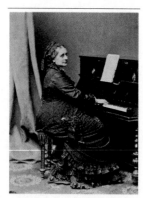

Clara Schumann
page 202

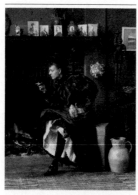

Frances Benjamin Johnston
page 205

Nampeyo
pages 206–7

Maud Wagner
page 208

Tina Modotti
pages 210–11

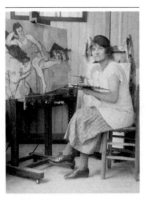

Suzanne Valadon
pages 212–3

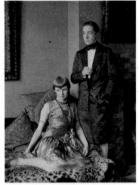

Virginia Woolf
page 214

Radclyffe Hall and
Lady Una Trowbridge
pages 216–7

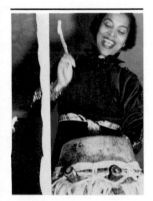

Zora Neale Hurston
page 218

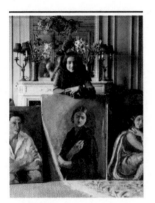

Amrita Sher-Gil
pages 220–1

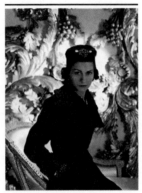

Coco Chanel
page 222

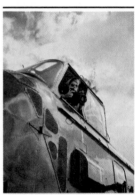

Margaret Bourke-White
pages 224–5

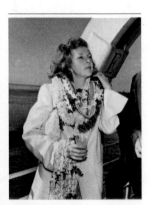

Martha Gellhorn
pages 226–7

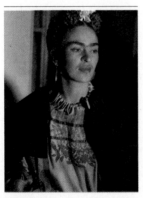

Frida Kahlo
page 229

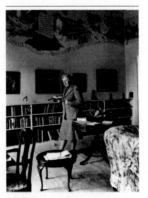

Agatha Christie
page 230

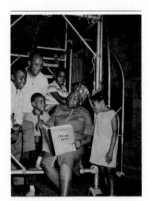

Eva Jessye
pages 232–3

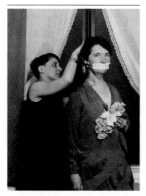

Margaret Sanger
page 237

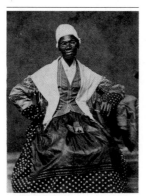

Sojourner Truth
page 238

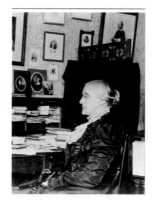

Susan B. Anthony
pages 240–1

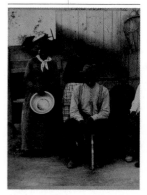

Harriet Tubman
pages 242–3

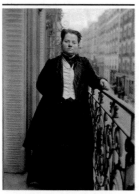

Madeleine Pelletier
page 245

Indian suffragettes
pages 246–7

Emily Davison
page 248–9

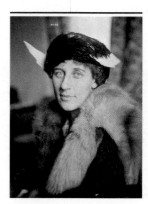

Inez Milholland
page 250

Jeanette Rankin
pages 252–3

Nationalist revolutionaries
in Cairo
pages 254–5

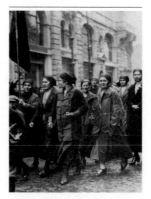

Marching against the Treaty
of Versailles
pages 256–7

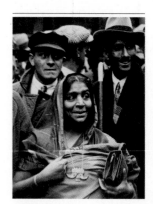

Sarojini Naidu
pages 258–9

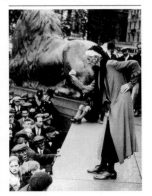

Charlotte Despard
page 261

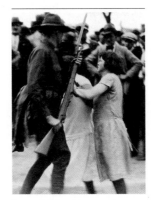

Blanca Canales
page 262

Loray Mill strikers
pages 264–5

Anti-apartheid protest
pages 266–7

Elizabeth Eckford
pages 268–9

Anti-American protest in
China
pages 270–1

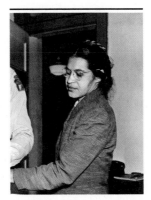

Rosa Parks
pages 272–3

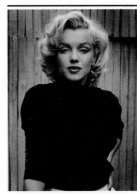

Marilyn Monroe
page 277

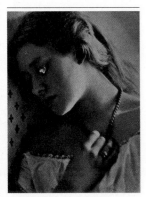

Ellen Terry
page 278

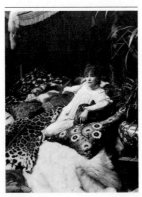

Sarah Bernhardt
pages 280–1

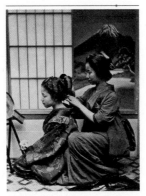

Japanese geishas
page 282

Mistinguett
pages 284–5

Sissieretta Jones
page 287

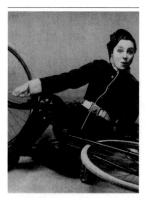

Vesta Tilley
pages 288–9

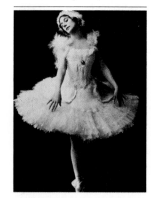

Anna Pavlova
page 291

Mary Pickford
pages 292–3

Anna May Wong
page 295

Jean Harlow
pages 296–7

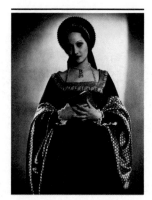

Merle Oberon
page 298

Gracie Fields
pages 300–1

Mae West
pages 302–3

Dorothy Arzner
page 304

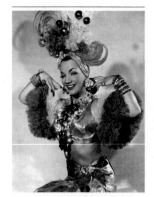

Carmen Miranda
page 307

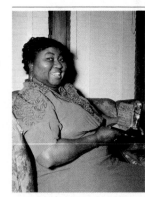

Hattie McDaniel
page 308

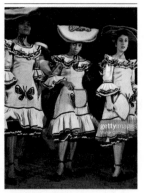

Katherine Dunham
pages 310–11

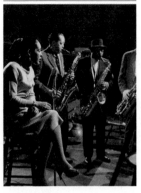

Billie Holliday
pages 312–13

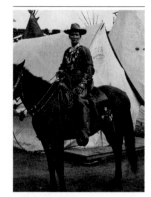

Nellie Bly
page 317

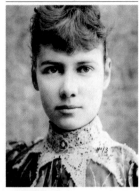

Calamity Jane
pages 318–9

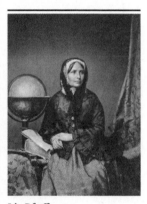

Ida Pfeiffer
page 320

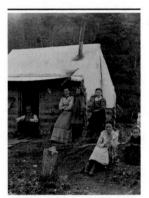

The Klondike Gold Rush
pages 322–3

Jane Dieulafoy
page 324

Osa Johson
pages 326–7

Aimée Crocker
pages 328–9

Gertrude Bell
pages 330–1

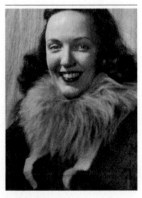

Jackie Ronne
page 333

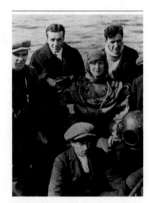

Margaret Naylor
pages 334–5

Marguerite Harrison
pages 336–7

Lady Hay Drummond-Hay
pages 338–9

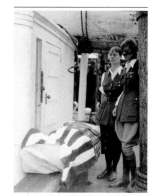

Aloha Wanderwell
pages 340–1

Ruth Harkness
pages 342–3

Rosita Forbes
page 344

Hetty Green
page 349

Antonia Ferreira
page 350

Marguerite Steiff
page 353

Emilie Flöge
pages 354–5

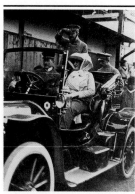

Bertha Krupp
pages 356–7

Maggie Lena Walker
page 359

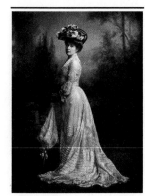

Syrie Maugham
page 360

Hilda Hewitt
page 362

Madam C. J. Walker
pages 364–5

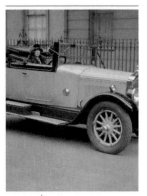

Rachel Parsons
pages 366–7

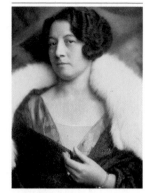

Betsy Kiek-Wolffers
page 369

Mary Texas Guinan
pages 370–1

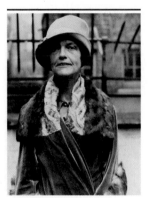

Kate Meyrick
page 373

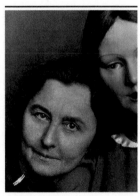

Käthe Kruse
page 374

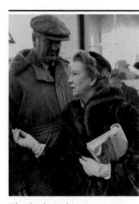

Elizabeth Arden
pages 376–7

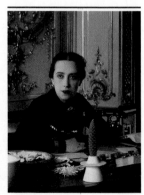

Elsa Schiaparelli
pages 378–9

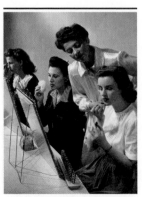

Helena Rubinstein
page 381

Jacqueline Cochran
pages 382–3

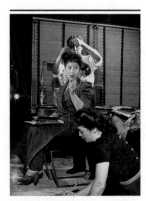

Lily Daché
page 384

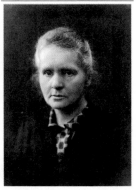

Marie Curie
page 389

Women's Medical College of Pennsylvania
page 390

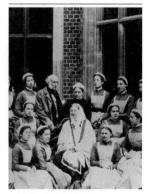

Florence Nightingale
pages 392–3

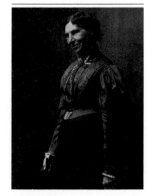

Clara Barton
page 395

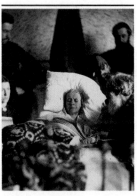

Catherine Booth
pages 396–7

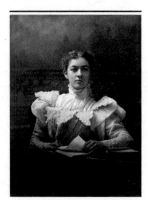

Mary Engle Pennington
pages 398

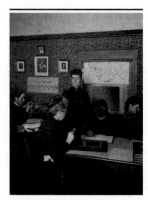

The Harvard Computers
pages 400–1

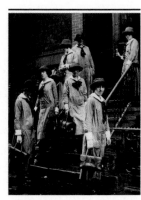

The Henry Street Settlement
page 402

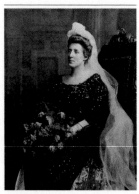

Kate Marsden
page 405

Fredrikke Marie Qvam
page 406

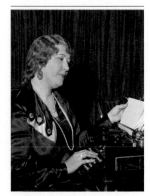

Beulah Louise Henry
pages 408–9

Cornelia Clapp
page 410

Beatrice Shilling
pages 412–3

Hedy Lamarr
pages 414–5

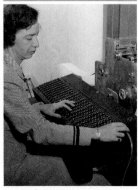

Grace Hopper
pages 416–7

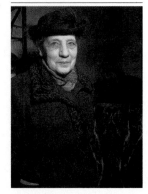

Lise Meitner
page 419

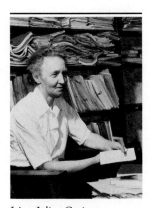

Irène Joliot-Curie
pages 420–1

Caroline Haslett
pages 422–3

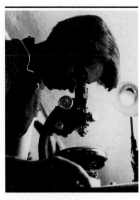

Rosalind Franklin
page 424

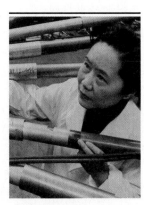

Chien-Shiung Wu
pages 426–7

The art of colorizing photos hasn't changed much since it was born in traditional mediums in 1839: while the watercolor brush has been replaced by a digital tablet, the process is still completely manual and hours of work are required to achieve the desired result.

Marina Amaral, 2022

Index